PHOTOGRAPHY AND YOUR
DIGITAL WORLD

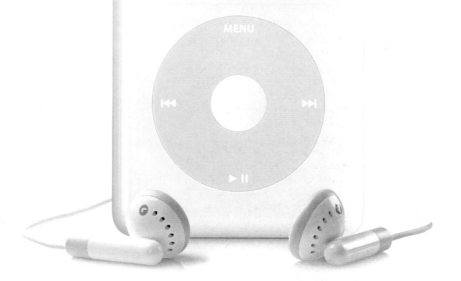

Photo Library

MENU

THUNDER BAY
P · R · E · S · S

Thunder Bay Press

An imprint of the Advantage Publishers Group

5880 Oberlin Drive, San Diego, CA 92121-4794

www.thunderbaybooks.com

Library of Congress Cataloging-in-Publication Data

Cope, Peter, 1958–

Photography and your digital world : the ultimate guide to digital technology / Peter Cope.

p. cm.

ISBN-13: 978-1-59223-546-9

ISBN-10: 1-59223-546-8

1. Photography--Digital techniques. 2. Digital electronics. I. Title: Digital world. II. Title.

TR267.C67175 2006

775--dc22

2005044546

Printed in Dubai

1 2 3 4 5 10 09 08 07 06

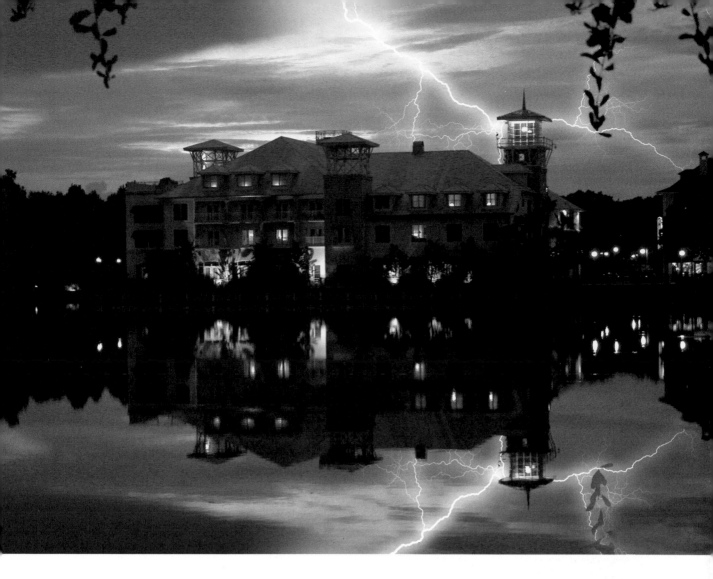

PHOTOGRAPHY AND YOUR
DIGITAL WORLD

THE ULTIMATE GUIDE TO DIGITAL TECHNOLOGY

PETER COPE

THUNDER BAY
P·R·E·S·S

San Diego, California

CONTENTS

INTRODUCTION

TWO HUNDRED YEARS AGO THE WORLD TOOK ITS FIRST STEPS INTO THE INDUSTRIAL AGE. FOR OUR FOREBEARS, WHO HAD ALWAYS LIVED IN AN AGRARIAN ECONOMY, THE CHANGES THAT SWEPT AROUND THEM CERTAINLY DEMANDED THE TERM "REVOLUTION." AS MEADOWS GAVE WAY TO FOUNDRIES AND WHEAT FIELDS TO MILLS, WHOLE WAYS OF LIFE WERE CHANGING—OFTEN FOR THE BETTER, BUT SOMETIMES FOR THE WORSE. INDUSTRIALIZATION OFFERED THE PROMISE OF A NEW GOLDEN AGE, A PATH TO A UTOPIA IN WHICH, ULTIMATELY, MACHINES WOULD TAKE ON THE DRUDGERY OF DAY-TO-DAY LIFE AND PEOPLE WOULD BE LIBERATED TO EXPRESS THEMSELVES THROUGH ART AND LEISURE.

Concepts such as these may have been the motivational vision for the factory owners, but few—very few—of those who stoked boilers or fed looms saw any of the benefits. But the revolution continued to gather speed, ensuring that the world would never be the same again.

It's probably hard for most of us to appreciate how tumultuous those years were, yet today we are in the middle of another revolution that, ultimately, is just as profound and promises to realize many of those dreams and visions. This digital revolution may appear lower key when compared with the industrial revolution that changed the face of the world, yet it is impacting on almost every aspect of our lives.

Think back barely a generation to when the silicon chip, which underpins this revolution, first appeared in consumer devices. Take just two of these devices—the television and telephone—and we can see the impact the technology has had. Televisions before this time were expensive, unreliable, and limited in their operation. Valve technology made sets large, slow to respond, and,

"In the future robots will do all the work we hate." Perhaps, one day. Meantime Sony's vision is much more entertaining.

to the bane of the television trade, uncomfortably heavy. Turning to the telephone, communications were largely limited to fixed landlines with handsets equipped only with the ubiquitous dial—instruments that today children believe come out of a museum.

A few years later, however, things had changed. The appearance of the microchip meant that television sets became more reliable, more effective, and could offer more features. Parallel technologies at the studio provided viewers with better-produced, better-quality, and more-entertaining programming.

Telephones lost their cumbersome dials in favor of push buttons, and built-in electronic memories made getting connected a snap. The quality of the phone lines improved as well, with the result that conversations became clearer, less prone to electronic noise, and, though you may still have been connected by landline to the other party, just as likely your call was being bounced off a low-orbit geosynchronous satellite.

Advances were not limited to just these two technologies; almost every

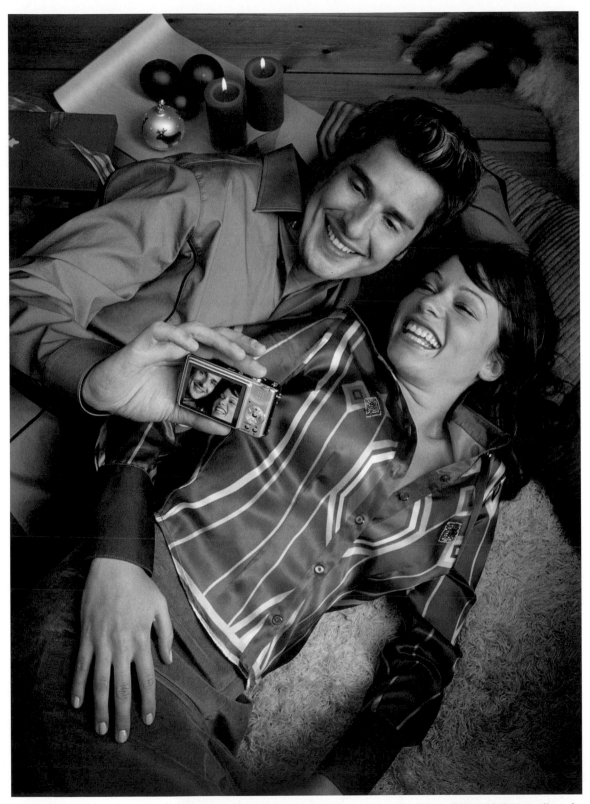

Digital photography has breathed new life into a medium that even its fans might admit was becoming a little staid. The immediacy of results offered by digital cameras has done much to introduce photography to new and demanding markets.

sphere of our daily lives became transformed. But in technology terms, the best was yet to come. This first minor technological revolution, profound though its impact might have seemed to those experiencing it, was essentially more along the lines of an evolution. One technology—that based on valves, relays, and mechanical switches—was being replaced by another, based this time on integrated circuits but still substantially trading the old technology for a solid-state equivalent.

Now we are in the middle of the true digital revolution. Building on these solid foundations, technology is empowering us as never before. But what exactly do we mean by a digital world?

A considerable mythology has built up around the term "digital." In popular culture, the term is used almost too freely to describe things that are

Digital techniques make it possible to combine many technologies in a single solution. The latest DVD recorders feature hard disks and allow us to compress stacks of traditional video tapes, camcorder tapes, and photo albums into a few compact DVDs.

cutting edge or just "modern." In the loosest sense, virtually every electronic device could be described as being digital, but for our purposes that definition needs to be more sharply focused.

The dictionary definition is: "Technique for recording, processing and transmitting information through the use of electronic or optical pulses that represent binary digits or bits (0 and 1)." At the crux of the definition is the conversion of data to binary digits. This data could be images, in the case of photographs, video, music, or even the spoken word.

Once the data has been interpreted as a numerical sequence, we have great power over what we do with it. We can, for example, copy the data almost without limit with no loss or corruption of the detail of the original. For a start, this means we can make copies of photographs, movies, or our favorite music without losing quality. Without digital technology, copies from originals were always inferior. And copies of copies . . . well, they were often not worth considering.

Second, we can manipulate this data mathematically. Then, when we decode the data back into its original form (whether it be a movie, music, or whatever), it can be altered, improved, or converted.

The result of this is that we could, for example, manipulate our digital images, combine them with movie footage, and add our favorite (or even a specially composed) soundtrack to produce a professional-looking multimedia adventure.

We can create movies on our mobile phones, edit them, and send them to family and friends in an instant; put our entire music collection—towers of CDs—in a tiny pocketable player; turn holiday movies into DVDs; even re-create movie theaters in our own home. And that is just the beginning. Through this book we'll explore just some of the many opportunities digital technologies offer. Best of all, we'll cut through the hype and jargon and see how you can exploit those technologies.

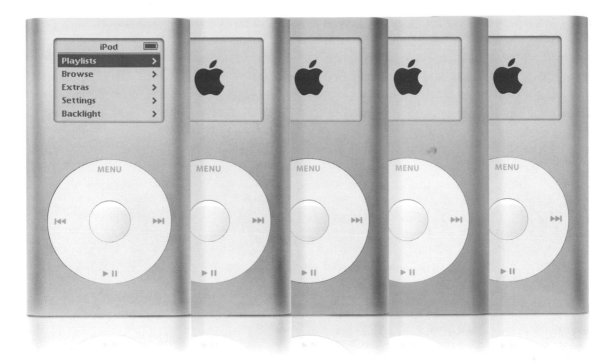

Is the iPod the archetypal digital device? Arguably so. It has succeeded because it uses technology in a way that makes it not only desirable but also nearly essential for many of us.

But this is not just a technical journey. It's a cultural one, too. Perhaps this is no better typified than in the way the Internet in a timespan that is even shorter than that of the microchip's emergence and maturity has now carved itself a pivotal role in our lives—in many aspects of our lives.

The Internet has superseded many shelves of library books as a repository for knowledge and a source of reference, and it has given us the opportunity to share our work and experiences instantly. But, most significantly for our purposes here at least, it has given new ideas the opportunities to flourish and has given us the chance to enrich our lives. We'll discover just

some of these as we go on our digital adventure.

Perhaps best of all, we'll discover that this adventure is for all of us. It's not just for the technophiles and geeks. And it's an adventure that becomes more exciting every time we experience it!

Throughout this book, we will be examining a number of technologies and the devices associated with them. The nature of these discussions is such that branded products are mentioned and, in some cases, used as the basis of demonstrations and tutorials. In these cases, we've tried to be as even-handed as possible; including a particular product does not necessarily represent our endorsement of that product. We feel our choice best illustrates, for the purpose of this book, the technology. Sadly, nobody has provided us with any free equipment, tools, or software in consideration for being included in this title! We've provided a list of resources at the end that gives, as far as is practicable, alternatives to many of the mentioned products.

Some products of the digital revolution are unexpected. The Segway personal transport relies on advanced digital technology to deliver its unique form of motion. True to the digital ethic, it's a liberating device in an unusually literal sense.

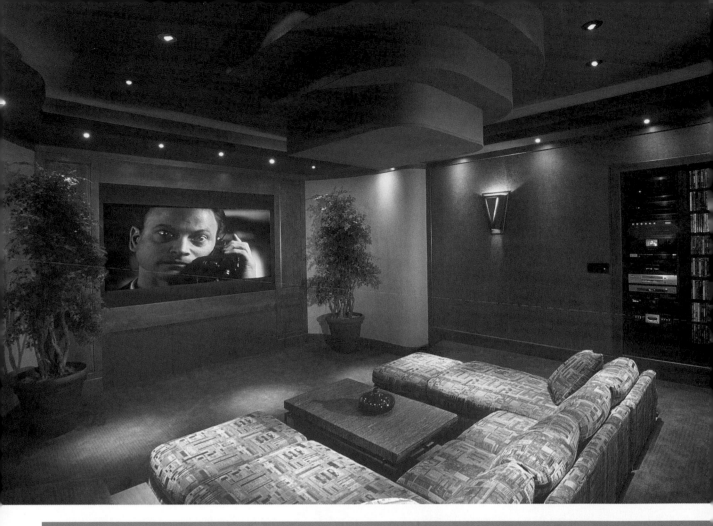

PART ONE: THE DIGITAL AGE

BRAVE NEW WORLD

"I THINK THERE IS A WORLD MARKET FOR MAYBE FIVE COMPUTERS." THOMAS J WATSON, CHAIRMAN IBM

"COMPUTERS IN THE FUTURE WILL WEIGH NO MORE THAN ONE AND A HALF TONS." *POPULAR MECHANICS* 1950

"THERE IS NO REASON WHY ANYONE WOULD WANT A COMPUTER IN THEIR HOME." KEN OLSEN, CHAIRMAN AND FOUNDER DEC COMPUTERS

"WE'LL HAVE TO THINK UP BIGGER PROBLEMS IF WE ARE TO KEEP THEM BUSY." HOWARD AIKEN, CODESIGNER OF HARVARD UNIVERSITY'S MARK I COMPUTER, 1944

Half a century ago, pundits were already making predictions about the future of digital technology. Now, with the benefit of hindsight, we can raise a wry smile as we read their informed but off-beam comments.

Our modern homes contain numerous computers, all weighing somewhat less than *Popular Mechanics* predicted. Some of these computers are obvious—the box that sits on our desk giving us access to the Internet; others are less so, living out their days embedded in the electronic equipment that we take for granted. Cameras, televisions, children's toys, even kitchen appliances owe their ability to function, if not their existence, to the microchip. To some, this second industrial revolution, built on silicon rather than iron, has been pernicious, giving rise to an insidious overdependence on technology.

For the rest of us, the outlook is optimistic. Not only has the microchip empowered us—just think how much smarter electronics are today—it has opened up new opportunities. The key to all of this is that often overused term "digital."

Fig 1—Communications are crucial for our private and business lives. Mobile communication devices, such as BlackBerry, provide all the benefits of a mobile (cell) phone with e-mail, no matter where you may be.

Fig 2—Digital technology can create new business opportunities no matter how incongruous they may seem. Thanks to Parkmobile, Londoners can pay parking fees simply by using their mobile phones.

There is nothing mystical about digital technology. Whether it's applied to television, telephones, or cameras, digital simply means that the essential data—the programming, voice, and photos, respectively—are stored as series of numbers (actually ones and zeros) that a computer chip can deal with.

This gives us some key advantages. First, the data is easily transmitted and received, for example, in the case of television, without degradation. You don't lose pictures because of environmental factors. Second, you can also copy the digital code without any degradation. Make copy after copy of a digital movie, say, and the last is as good as the first.

Try that with conventional videotape, and you'll soon see the limitations.

Third, and most significantly, this digital code is understood by computers. Throw a computer into the equation and suddenly the opportunities multiply manyfold. With the data in your computer, you can copy it, change it, manipulate it, and share it. In practice, this means we can take a photograph and improve it, take a movie and edit it, even create fantastic musical compositions from scratch. We can then go on and combine these disparate technologies—combine our photos and movies on a DVD and add a soundtrack, for example. We can take the movies from our camcorder and share them with friends via their telephone handsets. Take music from our old vinyl collection, from digital radio, or even our CD collection and carry it everywhere with us on an MP3 player. The possibilities are endless.

Fig 3—The days of the wired computer are long gone. Just as laptops freed us from the need for power cords, so wireless communications give us Internet access without the need to connect directly to a telephone line.

THE DIGITAL HUB

Here is an easy way to picture the ways different devices link together. It's called the digital hub, and although there is no definitive configuration, this is as potent as any. The core is the computer (though, as we will see later, this is not necessarily an essential component for anyone wanting to join the digital revolution). Arranged around it are the key digital technologies, linked by the ability, either directly or via a computer, to exchange digital code.

THE DIGITAL HUB IN YOUR HOME

Many consumer electronics companies have a slightly different vision of the digital hub. Theirs is built around the television—although that term might be a bit superficial for the interpretation they offer. In their world, the television links to digital television sources and DVD (as we would expect, and as already happens in an increasing number of homes), but further connections enable us to use the not-so-humble television to view digital photographs, surf the Internet, and video-call friends and family on their mobile telephones. You can also program your household appliances, heating, and lighting through the same television.

DIGITAL VIDEO

DVD

GAMING

Fig 4

MOBILE COMMUNICATIONS

PHONES

PERSONAL DIGITAL ASSISTANTS

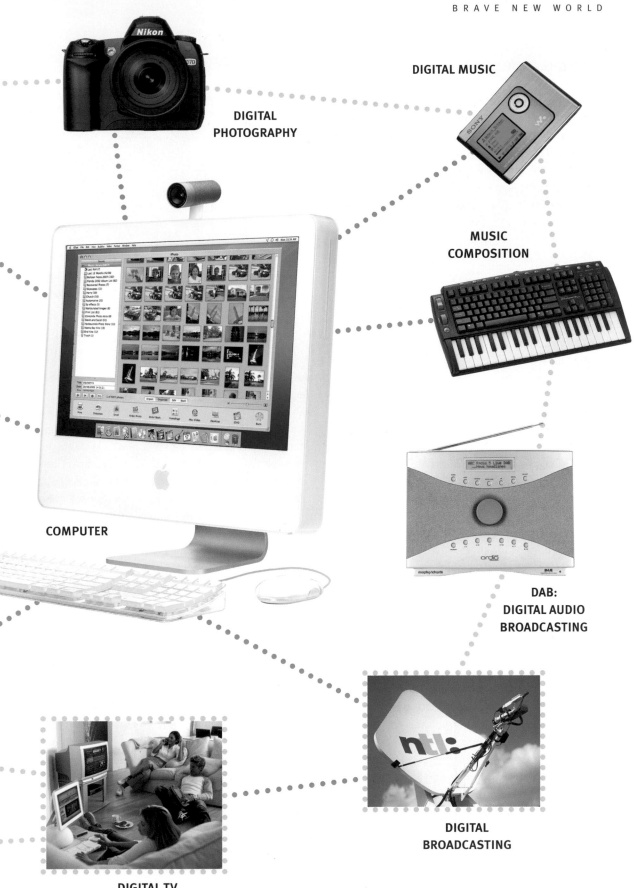

DIGITAL MUSIC

DIGITAL
PHOTOGRAPHY

MUSIC
COMPOSITION

COMPUTER

DAB:
DIGITAL AUDIO
BROADCASTING

DIGITAL
BROADCASTING

DIGITAL TV

Fig 5—Digital television is probably the most obvious manifestation of digital technology in the home.

THE DIGITAL LIFESTYLE AT HOME

The second half of the twentieth century saw something of a revolution in our homes. General affluence was rising, and our increased disposable income was looking for new outlets. These were provided by countless companies producing just about everything we needed, or thought we needed, to live comfortable lives. Not least, electronics companies capitalizing on the postwar technology boom were aiming to fill our homes with the latest in consumer innovations. The pace of innovation accelerated as the century drew to a close, and our homes were filling up with a wide range of essentials, luxuries, and gadgets.

The trouble was, all these exciting innovations tended to live a little in isolation. True, some home entertainment systems managed to cross traditional demarcation lines and offer you the opportunity to play television sound through your stereo setup or, perhaps for those at the cutting edge, the chance to distribute music right around the home.

It would take the exponential developments in computer technology to bring everything really together. Suddenly, cameras, camcorders, music systems, and even televisions could talk to the computer and, ultimately, each other.

So what of today's homes? What has digital technology delivered? Perhaps most obviously, it is the television which has had a major impact upon our way of living. Unrestrained by broadcasting restrictions, satellite and cable channels have always offered viewers greater choice. Once they "went digital," however, the capacities multiplied. Hundreds of new channels and stations have appeared, riding on the wave of cheaper transmission costs and—again thanks to digital technology—cheaper cameras and studio equipment. In addition, there is a growing market of viewers to be satisfied.

In a very few years, DVD has usurped the VCR as an alternate delivery method. And since it is a digital medium, DVD content is as equally at home on your computer as it is on your television. High quality, low cost, and lots of extras.

We could go on. But as many people are discovering, digital technology allows us to be creative. Activities such as movie-making and photography have been reinvigorated. No more looking at clichéd (and dull) home movies or albums of badly composed, poorly exposed photos. Just a modest embracing of digital technology gives each of us the chance to produce multimedia showpieces that other people may actually want to see.

THE DIGITAL LIFESTYLE ON THE MOVE

There is no need to keep your digital lifestyle at home. You can now carry it with you wherever you go. The mobile phone, for example, was the "must-have" item of the 1980s and 1990s. Today, it has become even more indispensable. Reinvented as the Smartphone, the mobile now lets us exchange photos as a matter of course and make video calls from (almost) anywhere in the world.

In the car, the same phone can even help you get quickly and easily to your destination. Navigation systems for your phone or PDA (personal digital assistant) are now commonplace, so there's no longer any excuse for being late for a date!

For a long time, music fans have been well catered for on the move. The Walkman from Sony revolutionized music-listening on the go, and the name Walkman has entered our everyday language. Its spiritual descendant, the MP3 player, has taken that concept a stage further and lets us take our whole musical world with us wherever we go.

Apple, with its ubiquitous iPod, has turned the MP3 player into a fashion and design icon. A triumph of marketing over design? Not a bit. The success of the iPod is due to clever and intelligent design combined with first-rate ergonomics. But iPod has never rested on its laurels—through a process of continual reinvention, it has stayed at the forefront of the market. With iPod Photo, Apple took the concept a stage further: not only can you carry your music with you, but you can also take your photo album, too.

Want to add to that photo collection? The digital camera is another of those "must-have" digital technologies that show the true impact of this technology. After mimicking conventional cameras, they have now moved on into areas undreamed of just a few years ago.

The moviemaker is even better served. Digital camcorders make the compact camcorders of yesterday appear positively monolithic. Stick one in your pocket and you'll never miss that once-in-a-lifetime event. And once you have recorded it, why not e-mail it to friends or family right away? Just a couple of clicks and your movie is on its way.

Of course, now that you can take your life with you, you won't be at home all that much. But don't worry, you can program your DVD or hard-disk recorder to record your favorite programs from wherever you are in the world; or you can let your personal video recorder predict what you would like to watch.

Fig 6—By adding simple-to-use photo-album capabilities to the iconic iPod, Apple has created the ideal tool for people on the move.

DIGITAL CONVERGENCY

Those working in the digital media and commentators on digital technologies have long had the vision—not dissimilar to Einstein's elusive Unified Field Theory, known affectionately as the Theory of Everything—of a Holy Grail that will unify all digital resources. For some, this is perceived in the form of a third industrial revolution, in which all traditional media will be consigned to museums and a new digital order will take effect. Back in the real world, many predict that with the differences between the key pillars of the digital hub—the computer and the television—becoming smaller and smaller, sometime soon we will see both replaced. In their place we will have media centers that, at least in the domestic environment, will cater to all our entertainment and work needs. One center that will provide us with television programming, music (whether originally from CD, DVD, or online), video resources, photos, and even books.

This convergent media center (which, in evolutionary terms, is some years away from the devices now described as such) would also control our home environment, from ensuring the lighting was set to our preferred levels at different times, controlling air-conditioning and central heating, to even monitoring Web sites to ensure that information we may want is there at the touch of a button.

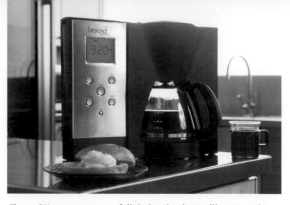

Fig 7—OK, so no amount of digital technology will prepare the breakfast rolls for you, but the Beyond™ Coffee Maker is just one kitchen appliance that can communicate with the Home Hub. It is a fine example of how digital technology helps make life easier and more enjoyable.

Pie in the sky? Convergency will work only if the solutions it offers are those that genuinely make our lives simpler and better. Let's face it, even today's computers with their slick graphical interfaces that are a cinch to use are not ideal for everyone. True convergency will depend on an even slicker system that, for general use, at least, breaks free of the keyboard.

It's possible that full convergence is unlikely, but further and tighter integration of many digital devices is just about on us already. And through the course of this book we will look at many of them.

Fig 8—Convergency on a modest scale: The Beyond™ Home Hub looks like a bedside clock/radio. As well as playing your favorite radio stations, it will wake you to important financial quotes, news reports, and crucial family reminders. It will even tell you if the coffee in the kitchen is ready before you get up.

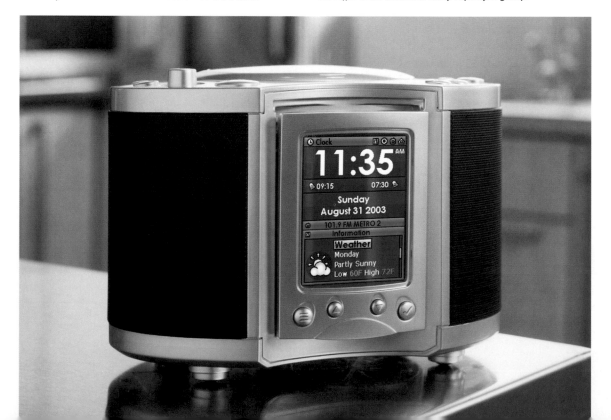

WHAT MIGHT HAVE BEEN

Think of the VHS video tape, CD, and DVD and you think of the standards in video and audio. But the path to these universal standards is littered with those that didn't make it. Some lit up the consumer electronics world for a brief time, others kept a dim torch burning for years. And some never found their way into the electronics stores at all. For some, this was down to the technology they incorporated—it just wasn't up to the job. But for others, the reasons are more complex and largely due to the fickle nature of the marketplace. Here's a selection of those formats that could have been universal but are instead teetering on the brink of obscurity.

Audio

ELCASET, Sony 1976

In the mid-1970s, before new tape formulations and precise engineering enabled the compact cassette to rival reel-to-reel formats, Sony thought that the only way forward was a bigger, better cassette. So it

Fig 9—DCCs and conventional cassettes are slot compatible. You can play the latter in players designed for the former. For a short while, prerecorded media in the DCC format was available.

introduced the Elcaset. Myth has it that the name derived from "L" or "Large" cassette. At about three times the size of a conventional cassette, the format differed from the design we all know by extracting the tape from the cassette, like a video tape, to run through a precisely engineered transport mechanism.

Technically superb, it was virtually ignored by the consumer marketplace (the key to any format's success) but adored by audiophiles. It was abandoned by Sony in 1980.

DIGITAL COMPACT CASSETTE (DCC), Philips early 1990s

The DCC was Philips's attempt to produce a recordable digital format that would improve on the original cassette while maintaining compatibility. DCC players could play conventional tapes but record only on DCC tapes. Quality was better than an analog cassette, but did not match that of a CD (compact disc). Its timing was also unfortunate as it came up against the better-quality (in audio terms) DAT (digital audio tape) tape and MiniDisc.

Philips dropped the format in 1996 when, after disappointing sales, it was clear that alternate formats would give better results in the marketplace.

Fig 10—A matter of scale: Elcaset recorders looked just like a compact cassette model but were 75 percent larger. This is the cover of a Sony catalog of the time.

Video

LONGITUDINAL VIDEO RECORDER (LVR), BASF late 1970s

Before VHS had assumed its dominant position in the videotape recorder market, there were several alternate designs. Tape giant BASF proposed and developed LVR. Rather than a slow-moving tape and spinning tape head producing the long recording tracks for video recording, LVR passed the tape at high speed over a static tape head. At the end of the tape, the direction would reverse and another track would be described along the tape.

LVR was mechanically simple and cheap to produce, but it demanded a robust tape format. It never made it into full commercial production, even though prototypes were demonstrated by companies new to video, such as the movie-camera manufacturer Eumig.

N1500, N1700, Philips early 1970s; SVR, Grundig

Distinguished as the first commercially available home videocassette format (in 1973), early adoption of the original N1500 format was slow. Prices were high, and tapes had a maximum recording time of seventy minutes. Units were bulky and almost entirely mechanical. Ongoing development resulted in a long-play version of the format, which was dubbed the N1700. Tapes eventually played for three hours, but this was made possible only by using a very thin tape base that was liable to damage.

Philips's partner company, Grundig, further refined the format to produce its SVR, which allowed recordings of up to four hours, essentially by reducing the tape speed. Although Philips licensed the N1500 and N1700 formats to other companies, SVR remained unique to Grundig.

VIDEO 2000, Philips early 1980s

With no more mileage in the N1700 format, Philips created a new competitor to the successful Betamax and VHS—Video 2000. This format offered a recording time of up to eight hours on a flip-over cassette. Special tracking circuitry gave it an edge

in terms of picture quality over its competition. Despite modest market penetration, it always lagged in third place. Those who know describe this as the success of marketing (of VHS, particularly) over technical prowess.

Videodiscs

LASERVISION, LASERDISC and CD-VIDEO, Philips early 1970s

With dual-sided disks measuring seven or twelve inches in diameter, LaserVision disks were capable of giving up to one hour of broadcast-quality color television per side. Using the same technology that would later lead to the development of the CD, users could skip through a disk in a similar way to DVD or CD tracks and, on certain disks, even pause, fast forward, or play in slow motion with perfect picture quality. The entire format—sound and vision—was analog. Longevity of the media means many are still in circulation and playable on the LaserDisc format.

LaserDisc, which appeared in the early 1980s, used digital audio from the compact-disc format to deliver better sound. CD-Video disks were CD-compatible audio disks with additional video content that could be played on a LaserDisc player. These formats remain in circulation, mainly supported by loyal fans who rate the quality above that of many DVDs.

CED VIDEODISC, RCA early 1980s

With LaserVision and LaserDisc very much both premium products, RCA launched the CED VideoDisc as a cheaper alternative. Offering only VHS quality, it scored an immediate hit with its well-priced machines and disks. CED stands for Capacitance Electronic Disc, the method used to encode video

Fig 11—Less idiosyncratic than its predecessors, the V2000 format video recorders missed the tide of popular acceptance.

Fig 12—*LaserVision disks were silver and carried analog video and audio signals. LaserDiscs (also known as CD-Video) were gold colored in many countries and carried digital audio and analog video.*

data. Using a grooved disc, a stylus reads variations in capacitance in the groove and decodes this into video and audio signals. Being just a replay system, it didn't do well in a marketplace enthusiastic about time-shifted recording. That, and its so-so picture quality, led to its demise.

VHD VIDEO DISC, JVC 1980s

Aiming to do for the videodisc format what it did for the videocassette recorder, JVC planned the format to be technically extremely advanced (for the day), offering a very high specification. Disks were ten inches in diameter and created in vinyl on standard "LP" presses. Despite starting to build up a commendable catalog of launch titles, JVC found that the format never really made an impression on the buying public.

Fig 13—*CDs with video were novel when Philips and Sony introduced the CDi format with VideoCD playback.*

COMPACT DISC INTERACTIVE (CDi), Philips and Sony mid-1980s

The CDi is a still-image, video and interactive format designed around media that is the same size and type as the CD. Interactive game titles were also available. The basic player was a stripped-down computer with CPU (central processing unit), memory, and operating system. For video, an additional processor unit had to be purchased and installed. Video quality was similar to VHS, though it was digital and encoded in the MPEG1 format. Cost and lowly specified machines hampered take-up, but the format did serve to prepare the market for the superior DVD format that would appear within a few years.

COMPUTERS AND THE DIGITAL HUB

IN THIS CHAPTER WE WILL:

- Look at how computers have evolved from industry workhorses to essential personal tools.
- Examine the key elements of the technology.
- Look at what we need to enhance our experiences of computers.
- Gain an understanding of the key communications that computers, and other digital devices, use.

THE COMPUTER IS PERHAPS THE FUNDAMENTAL DIGITAL DEVICE. ALTHOUGH WE NOW KNOW IT BEST AS A TOOL FOR STORING AND LISTENING TO MUSIC, MAKING VIDEOS, OR SENDING TREASURED PHOTOS AROUND THE WORLD, AT ITS CORE IS A COMPLEX PROCESSOR THAT HANDLES JUST DIGITAL DATA. WHETHER WE CHOOSE MUSIC, VIDEO, OR ANY OTHER MEDIUM, BEFORE WE CAN USE IT WITH OUR COMPUTER THE SIGNAL MUST BE CONVERTED TO A DIGITAL FORM. THANKFULLY, THE PROCESSES INVOLVED IN DOING THIS ARE BEYOND THE SCOPE OF THIS BOOK AND OF NO CONSEQUENCE FROM THE USER'S POINT OF VIEW. WHAT WE ARE INTERESTED IN ARE THE RESULTS! IN THIS CHAPTER WE'LL TAKE A LOOK AT HOW THE COMPUTER HAS GRADUATED FROM SCIENTIFIC AIDE TO THE ALL-PERVASIVE BUSINESS AND RECREATIONAL ESSENTIAL.

In the last chapter we recalled some famous— though now infamous—predictions in the form of quotes from some of the key movers and shakers in the computer business just a generation or two ago. We can point to a number of milestones that have taken us from that time to the here and now:

- The first IBM PC, ancestor of today's Windows PCs.
- The first Macintosh: a revolutionary step-change in the thinking about computer functionality and ease of use.
- WYSIWYG (What you see is what you get): early personal computers tended to be text based— WYSIWYG applications let you see exactly what your finished documents would look like.
- Adobe's Photoshop. A professional-grade application that lets photographers and graphic designers perform "magic" on photographs.
- Windows 95. Brought much of the ease of use of the Macintosh to the humble PC.
- Consumer digital-media application programs. Suddenly, applications that professional users had enjoyed for years spawned siblings that made digital music, video, and even DVD production available to the rest of us.

Of course, if you ask a range of people to produce their own list of milestones, they will all come up with slightly—or dramatically—different selections. But the message that comes through is that the computer today is now an accessible device for us all. Prices in real terms have never been lower, while the power and capabilities of the machine have never been greater. If you already own one, this comes as read; if not, then your choice has never been greater. And the good news is that virtually all computers today can sit at the center of your digital world and become the core of your own digital hub.

MAC, WINDOWS . . . OR LINUX?

When choosing a computer, the choice has been simple. A Macintosh or Windows PC. Windows PCs are very widely available, are produced by countless manufacturers, and command the lion's share of the market. Windows PCs also tend to be better priced and boast a considerable advantage when it comes to the total number of software applications that are available.

So why do some people continue to support the Macintosh? Ask an enthusiast, and he or she will

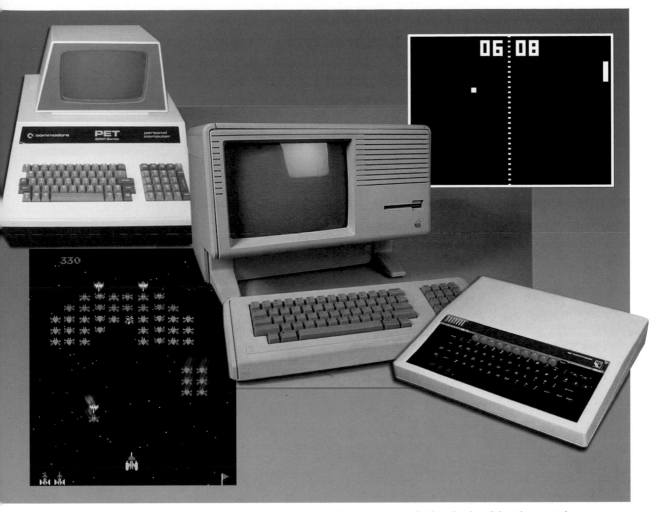

Fig 1 – Less than a generation ago, our computer hardware and software were somewhat less developed than they are today.

have a hundred and one (at least) reasons. Those of us who must be impartial will cite the Macintosh being simpler to use, better able to support graphical applications (such as photo-editing software), and boasting more efficient processors. Software may not be as common (nor as cheap), but you will find that all the key applications are compatible and that many of the most popular lifestyle applications (like iTunes, iMovie, and iPhoto) are designed for the Mac—even if iTunes has now migrated to Windows. It's often the case that Windows users shy away from Macs, but once they have realized how simple they are to use they never look back. There is a comment that is not attributed but probably sums up the difference in more tangible terms: "I always use a PC at work, but at

home, when I have to spend my own money, it's always a Mac."

There is also the question of design. Although most people don't choose a computer on the basis of its looks, Macs have always been pleasant to live with. They don't have that industrial look that makes them incongruous in most of our homes. Don't think of this as a fatuous comment. As stereo manufacturers have already discovered, we consumers no longer want to spend our hard-earned cash on anonymous, and often ugly, black boxes; quality performance—wherever we seek it—also needs to be stylishly packaged.

While most people opt for Windows PCs and the others for Macs, another operating system, which can sit on computers designed for Windows or the

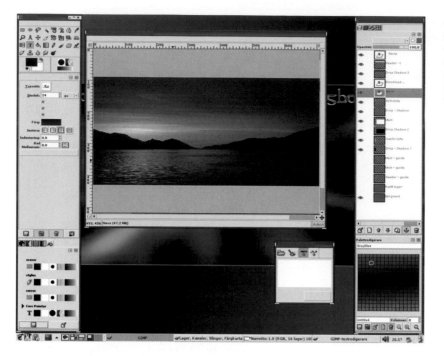

Fig 2—Linux may be the outsider, but the resources and programs available are growing in both number and complexity. This image editor, GIMP, is a good match for the industry-leading application, Photoshop.

Macintosh operating system, has been quietly gaining ground. Linux is an evolution of the UNIX operating system used by industrial and scientific computers. It scores in being an "open-source" operating system. Applications developed for the platform are generally made available free of charge or for nominal cost. Spiritual cousins of the mega-program applications found on Windows or Macs appear in Linux for a fraction of the price. If you can't afford the sometimes absurd prices of conventional software, Linux could be a solution. Drawbacks? Limited market share and sometimes unstable. Support, too, tends not to be the twenty-four-hour support lines provided by the big software houses; instead it is often restricted to news groups and forums on the Internet.

This has not stopped Linux from becoming the operating system of choice for many embedded computing systems—such as digital television receiving boxes and Internet file servers (fig 2).

MAKING A GOOD THING BETTER

If you have a computer—or you are shopping for one—what do you also need to make your digital hub complete? In the following chapters we will look at all those essential—and some not-so-essential—

lifestyle accessories, but what about your computer? What can you add to make your experiences even better?

Memory

Adding memory to your computer is arguably the simplest and most effective way to boost performance. Even those computers a couple of years old (veterans in IT terms) can show astonishing gains in performance by boosting their memory.

Increasing the RAM—Random Access Memory— gives your computer more headroom to work on large calculations and large files. Video and photo applications, particularly, need lots of memory to flourish. Digital cameras, for example, deliver ever-increasing image resolutions. This in turn gives better image quality but also larger image files. Increasing the available RAM lets you manipulate your images more effectively with less time spent watching the hourglass or stopwatch icon as your instructions are processed. Guidelines? Boost the 256MB of memory that most computers now come with to at least twice that amount. If you can install more, do so.

Incidentally, more and more computers make it

simple to add new or additional memory chips, but if you don't want to do it yourself, then the computer store that supplied the memory can usually arrange to do it for you, either for free or a nominal charge.

Hard drives

Once, our computers played host only to the most modest of files: documents and spreadsheets. We could comfortably accommodate most of these on a small hard disk and exchange them using a floppy disk. Today, the picture is very different. Photos, movies, and music collections are likely to comprise the bulk of what we store, and these files can be very large indeed. For those routine portfolios of photos and our collection of MP3 music, the enormous hard disks now standard on computers are usually just sufficient. But start editing your photos, and the free space shrinks almost as you watch. Start compiling and editing digital video, and any residual space will be gone in a blink.

With a big desktop computer, you will probably find that you have the space to add a second hard disk inside the enclosure. Adding one is not difficult (though opening the case—as in the case of adding memory—can be unnerving). Don't want to risk it? Then do what those with laptop or nonexpandable computers (such as the iMac) do: add an external hard drive.

External drives connect via your USB, USB2, or

Fig 3—Truly pocketable, the USB drive is the modern equivalent of the floppy disk, but it is eminently more portable, much smaller, and more robust.

Fig 4—Pocket drives let you store large amounts of digital video, huge music collections, and albums of photos—and take them with you.

Firewire connection and let you expand your disk space by tens or hundreds of gigabytes. You will have the choice not only of connection type (it's best to ignore USB, as it's too slow for digital video or large file copying) but also a desktop or portable drive. Desktop drives—as you might have guessed—are designed to sit on your desktop, whereas portable drives—sometimes called pocket drives (fig 4)—are smaller and more robust. You can use portable drives for carrying around not only your essential documents but also your photo album and movies.

Stick drives, or USB drives (fig 3), are rarely drives at all but rather solid-state memory (like you would find in a memory card). They offer similar memory storage to memory cards, much less than a pocket drive, but they are tiny and can even be used on your key chain. They are ideal for carrying those essential or important documents that you need all the time or as a way of easily copying resources—where it's legal to do so—from friends' computers.

Printers

Long gone are the days when printers were used simply to print out our correspondence and school projects. Now, one device can print out all those letters one minute and produce photo-quality prints the next. The good news is that photo-grade printers are affordable and reliable. The bad news is that they can cost an arm and a leg to run: inks and dyes suitable for long-lived prints don't come cheap.

It makes sense to buy a good-quality printer if you intend to print a great number of photos, but if you want lots of prints for albums and sharing, then dedicated photo printers can be a better bet. These produce high-quality prints from the computer or even directly from a camera.

Hubs

Not high in the glamour stakes, hubs help you manage all your peripheral devices (fig 6). New computers score high on connectivity—you can

Fig 5—Card readers are a fast way of transferring the data from cards in a host of peripheral devices.

attach a number of devices simultaneously. But even the most well endowed in the connections department may not offer enough if you are a power user. Think of those digital video cameras, stills

Fig 6—Hubs let you expand your connectivity in the manner of a power strip: use one socket and gain, in this case, three more.

cameras, MP3 players, PDAs (personal digital assistants), phones, drives, printers . . . and the list goes on. You could plug and unplug, but this can lead to the premature failure of cables or connectors. And you will always find that you need two devices connected simultaneously when there is only one socket free.

Hubs let you expand your connections (almost) without limit. Plug one of these into, say, a USB port, and you will have perhaps three, four, or even six additional sockets at your disposal.

Card readers

Memory cards are now the staple of digital cameras, movie cameras, phones, PDAs, and even some digital radios. Getting the information from one onto your computer—or loading information from the

computer—can involve connecting the device directly. A more elegant solution is to fit a card reader (fig 5). Often accepting up to eight different card formats in a single unit (see pages 54–5 for more about memory cards), they save the wear and tear on your cameras and other devices and can simplify the number of connections necessary to your computer. There are even built-in options for some desktop computers.

Connectors

Look around the back of any computer (or along the side of some laptops) and you will see all the connectors (fig 7). Sometimes they are color-coded to make connection simple, but often you will have to know them by their shape and by what they are used for. Fortunately, the last few years has seen something of a shakedown in connectors, with the old guard of relatively slow connections making way for a more limited but standardized collection. The table here provides a summary of those you are likely to find around the back of your computer—and what you will probably attach to them.

Fig 8—Small, but with a powerful punch. The FireWire cable can handle the high data speeds required for digital video and provide power to drive-attached devices.

Fig 7—The illustration here shows what the sockets look like. Fortunately, each type of connector is unique and, where relevant, backwardly compatible. Hence, you can plug a USB2 cable into a USB socket, but the attached device will then operate only at the slower USB speeds.

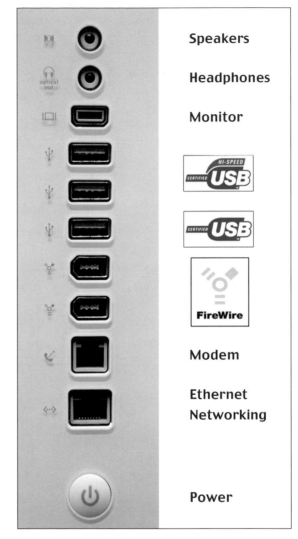

Connector type	Mostly used for	Also used for
USB	Keyboard, mouse, printer	Hard drive, camera, scanner
USB 2.0	Hard drive	Camera, scanner
Firewire	Video camera	iPod, hard disk, card reader
Firewire 800	Video camera, hard disk	
Wireless	Networking	Printing
Bluetooth	Printer, phone	
Modem	Internet connection	
Ethernet	Local networking	Broadband Internet
Line	Audio input/output	Speaker system

Home networking

If you have more than one computer at home—perhaps you have bought a new model and reckon there is still some mileage in the old one, or you have one in the study and the children have one in their bedroom—why not connect them? Once your computers start talking to each other, you can share resources and create a digital powerhouse. Here's just some of the things you can do:

- Share a single, fast broadband Internet connection.
- Share printers. Send your documents to the fast laser printer in the study and print out your photos on the photo-printer in the lounge.
- Access all your resources and, where relevant, programs.
- Use common hardware—such as hard disks and scanners—even if they are attached to another computer.

There are lots of ways you can network your home. The traditional method—if traditional is a term you can apply to such a new technology—is to use dedicated wiring. A special cable is laid around your home, much in the manner of telephone cabling. You can then connect computers to ports—like phone sockets—at selected points around your home.

This is the most expensive and, if your home is already built, the most disruptive system to install. Many new homes are now prewired with network cabling, which makes installation painless. However, the limitation of this system is the need to connect via a port, and you will need to ensure you have enough ports and that they are in the right places.

So, for most domestic installations, less costly and simpler systems need to be considered. These are power-line networking, phone-line networking, and wireless networking (fig 9).

Fig 9—Networking computers—and wireless networking in particular—can add tremendous versatility to your digital world, whether for pleasure or business. Courtesy SES Astra.

Fig 10—*This Powerline adaptor allows you to connect computers over your home electrical wiring without any additional hardware.*

Phone and power line networking

Phone-line and power-line networking take advantage of those networks of cabling already built into our homes (fig 10)—that for the phone system and electrical power, respectively. The systems are similar, though the power-line solution is the most effective since it allows you to connect a computer wherever there is an electrical socket. In most, if not all, homes, there will be more of these than there will be phone sockets.

Using special adaptors that plug into the electrical outlets, computer data can be sent into the home's household current. Any computer (or appropriate peripheral device) can be addressed by this data signal and, using a similar adaptor, filter out the data. It's convenient and requires no new cabling. Adaptors themselves are comparatively cheap and can be built into household plugs.

The drawback is the speed of the network, which tends to be slower than that of a dedicated wiring system or that of a wireless network. With many systems, there is also a chance of signal leakage—signals escaping to the wiring in the street and neighboring homes. But on a more positive note, power-line systems can score over others where it is impossible to install hard wiring or where walls are too thick for successful wireless networking.

Going wireless

Many users now see wired systems as inelegant and inefficient. After investing in a laptop computer that can operate without connection to a household power supply, it seems something of a compromise to then reinstate a connection, albeit only for networking. You don't have to connect through a wire now. Wireless networks are being increasingly built into computers, especially laptops. Wireless networks give you the ultimate in portability, not restricting you to specific locations in your home. You can wander freely—even into neighbors' homes—and still maintain your network. We'll take a look at the mechanics of networking wirelessly over the next few pages and see that the opportunities available are extensive.

WARCHALKING

At the turn of the century, as wireless networking made its first tentative steps into the commercial world, a new phenomenon began: warchalking. In the streets of cities around the globe, strange hieroglyphs were appearing. Although restricted to a shadowy underworld at first, these symbols indicated locations where those who owned wireless-enabled computers could find wireless networks. If you knew how to interpret the signs, you could identify the type of network and whether it was open or closed to outsiders.

Needless to say, this was quickly identified as a security risk by many organizations, who then realized how vulnerable they were to hacking from outside (even though most warchalkers' intentions were merely to gain Internet access). Passwords and encryption, features that lie dormant on the wireless networks, were invoked, and the networks closed down.

If you wander around now with a laptop, or even a PDA, you will be able to identify many wireless networks not just in cities, but in neighborhoods, too. Most of them are secure . . .

WIFI AND THE WIRE-FREE HOME

Computer networks are common in the workplace and increasingly so in the home. But while we find it acceptable to tear up floors, ceilings, and walls in the office to accommodate networking cables, we are less disposed to do this to our homes. So, unless you are involved in a new-build home project, you need to use an alternative.

That alternative is a wireless connection using a system dubbed WiFi. It's simple to install and simple to use. And once installed on your computer, it not only helps you create a home network: you can then connect to other WiFi networks in the neighborhood, at the office, or even at your favorite coffee shop.

In fact, many computers, particularly laptops, already come with the essential WiFi card built in. But even if yours does not, it is easy enough to fit one afterward. If you have a laptop with a PC card slot, you can fit a WiFi PC card and be up and running in moments (figs 13, 14). If you have a Macintosh that is not already fitted, add an AirPort card. Again, fitting it is simple—straight under the keyboard in the case of iBooks and Powerbooks (fig 11).

Fig 11—Installing a WiFi card is simple if you have the nerve to delve inside your computer. This AirPort card simply slips into a vacant slot in this iMac G5.

Hot spots

With your computer empowered, you next need to add a WiFi base station or, as they are usually known, hot spots. This is a box that connects to the Internet through a hard-wired connection and to the WiFi-equipped computers and peripherals wirelessly. In the case of Macs, the usual base station is the AirPort itself (fig 12). But since WiFi works independently of the computer platform, those PC users who fancy an AirPort base station are in luck. In fact, your choice of components will be governed by the speed you want your network to run at, always bearing in mind any limitations imposed by your hardware.

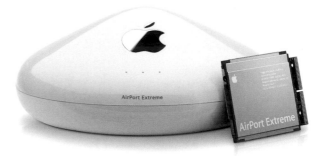

Fig 12—AirPort is a simple WiFi networking plan that works on Mac and PC systems with appropriate cards.

Whatever you choose, a hot spot will transmit over a range of about 100 feet (30 m) in the open or about 65 feet (20 m) indoors, allowing for walls and furniture. If you have a particularly large house, you can get booster units to extend this range.

Configuring

Unless some parochial security has been installed, most computers will identify a network and link to it automatically. This applies to most recent Windows

FAST OR FASTER?

When you go shopping for WiFi components, you will have a choice between fast wireless, which has been given the name 802.11b, or very fast, 802.11g. Apple has been more inventive in its naming strategy, and they call 802.11b AirPort, and 802.11g AirPort Extreme. Normally your network will only be as fast as the slowest component, so go for the faster option every time, unless you are limited by your computer. 802.11g is around five times faster, so it's worth the modest extra expense.

this frequency, you may experience interference. Only one way, however. WiFi will give bursts of noise on your television, but television transmissions won't affect WiFi. But if you make extensive use of a microwave, you will probably be used to video-sender interference.

Fig 13—Your laptop does not have WiFi? No problem. If it has a PC card slot, you can add a CompactFlash-based card such as this. And it still adds 256MB of flash memory.

Fig 14—Want to connect to your network (or any other) using your PDA? Use an SD-based WiFi card.

PCs and most Macs built since 2000. Older PCs will need to be manually configured to connect. Here is how to do it:

1. Identify and select the WiFi software. In Windows XP you will see it in the System Tray at the bottom right of the screen.
2. Click on the Search button to display a list of all the available networks.
3. Click on your network to select it.

Whether you have manually or automatically connected, you do need to be mindful of WiFi security. The fact that you managed to connect without hassle means that, theoretically, any of your neighbors could connect to your network, too, and use your Internet bandwidth or even scan your computers. This is of no consequence to many users, but if security is an issue, you can still secure your network so that only people in your household can access it. Create a WEP (Wired Equivalent Privacy) key—the WiFi software talks you through the process—and your system will be virtually impregnable.

Interference

WiFi uses the 2.4GHz frequency band. In the US, this is one of the frequencies used by video senders. If you are distributing video around the home using

FINDING A WIFI NETWORK

When you are out and about, how do you know if there is a network point near by? Once, you could seek out warchalk markings— chalk marks on the road or pavement where you could link into a network. Now, you can equip yourself with one of these WiFi Locators. The key-ring device from Intego will immediately identify a WiFi network.

BLUETOOTH

Bluetooth is a radio frequency wireless system but is principally designed as a low-cost communications system that can operate between portable devices. Devised originally by the Scandinavian mobile-technology company Ericsson in 1994, it is often described as a cable-replacement technology, since it is often used to cut down on cabling between devices. Because it requires very low power to operate, it can be built not only into laptops and desktop computers, but also mobile phones, PDAs (see pages 164–9), and headsets (fig 15).

The key differentiation between other wireless systems and Bluetooth is that Bluetooth is designed to be a very low-power solution, with a commensurate low range. This makes it ideal for communicating between, say, a phone and a headset or a computer and cordless keyboard, but limits power consumption and potential interference.

Bluetooth classes

When you examine Bluetooth devices, you will see them grouped into one of three classes:

Class 1 is high power (in Bluetooth terms) and has an operation range of around 350 ft (100 m). Computer dongles, which act as receivers for Bluetooth peripherals, are most commonly Class 1 devices. Also, the USB adaptors that enable the creation of Bluetooth networks are usually Class 1 (fig 17).

Class 2 is mid-powered and has a maximum range of around 170 ft (50 m). Class 2 devices are similar to Class 1, except in terms of their range.

Class 3, with the lowest power, has a modest range of only 35 ft (10 m). Phones, PDAs, headsets, and computer peripherals tend to be Class 3.

As with all wireless communications, these distances can be affected by environmental factors, such as furniture, walls, and buildings.

With regard to speed, a Bluetooth connection is midway between the faster infrared connections and slower ISDN phone lines. For most purposes, it can be considered similar in data-transfer speed to a modest residential broadband Internet connection.

Fig 15
Safety, security, and convenience have seen sales of Bluetooth headsets for mobile phones take off and become, arguably, the most popular of Bluetooth accessories.

For many applications—such as a wireless keyboard and mouse—there is little need for high speed, but Bluetooth can also be used to communicate with printers, for which this higher speed is important.

Security

There is the inevitable worry when we discuss any form of wireless communications that people can—accidentally or otherwise—eavesdrop on other Bluetooth devices. Or they can make use of

HOW BLUETOOTH AVOIDS INTERFERENCE

OK, so you won't have many Bluetooth devices at home. But when you move around or go to a crowded office, how do you avoid devices interfering with each other?

Bluetooth works at very low power. A typical device will radiate around 1 milliwatt. Compare this with mobile phones that can radiate 3,000 times as much power. It is this low power that also places the practical limit on the range of the Bluetooth devices.

Devices also use a technique called spread-spectrum frequency hopping. A device can use any one of 79 frequency channels to broadcast on and will rapidly—up to 1,600 times a second—change. This, too, ensures continuity of connection, and even if there is interference on one channel, it will last only momentarily.

Fig 16—Not all Bluetooth devices are serious or business focused. This toy car can be controlled by a mobile phone using Bluetooth to send commands from the phone keypad to the wheels.

Bluetooth resources to which they should not have access. In fact, this is rarely possible, because Bluetooth devices need to be paired: that is, each device needs to acknowledge the presence of the other and want to be linked to it.

There are also different Bluetooth profiles. These profiles determine how different devices can communicate and what data they can exchange. A computer, for example, needs the same profile as a keyboard or mouse in order to be able to communicate with it. That computer will also need another profile in order to share data with a PDA or phone. Likewise, a phone will need to possess a particular profile in order to

Fig 17—A Class 1 USB adapter enables communication between a computer and selected devices within a 350-foot (100 m) range.

Fig 18—Bluetooth makes the fitting of car kits for mobile phones much simpler, as each component connects wirelessly.

communicate with a wireless headset (for more about Bluetooth communications, see page 154).

What about the name?

There is something of an urban myth (that stands up to close inspection) that says the name derives from the nickname of King Harald Blatand, who was ruler of a substantial part of Scandinavia in the tenth century. He had a reputation for an insatiable appetite for wild blueberries, but also for uniting the disparate fiefdoms and kingdoms that proliferated in medieval Scandinavia. It was this unifying skill that Ericsson latched on to when deciding on the name.

Fig 19—Bluetooth Logo, Courtesy Bluetooth SIG.

AIRPORT AND AIRPORT EXPRESS

Whether you have a PC or a Macintosh, Apple's Airport lets you exploit wireless networking for your home office—and your music.

Apple introduced the AirPort (fig 20) as a Mac-based solution for home and business networking in 1999. Using a small base station and a WiFi card that could easily be installed in any Mac, computers—laptop or desktop— became free of the cabling that had so often restricted home office and business layouts. Four years on, AirPort Extreme (fig 22) appeared, increasing the speed of wireless communications (between computers and to the Internet) by a factor of nearly five times, using the fast, 802.11g WiFi standard.

Barely a year later, AirPort became a family of products, thanks to the release of a sibling product, AirPort Express (fig 21). This pocketable newcomer offers all computer users the option of affordable, easy-to-configure networking and audio and printer sharing.

For many of us, building up our collections of MP3 music, downloaded from the Internet, it's been the musical capabilities that have attracted the most attention. AirPort Express includes AirTunes, a cross-platform application that will allow you to use the ubiquitous iTunes music application across a network—and straight into your stereo (or to powered speakers). None of the components needs to be in the same room; AirTunes and AirPort Express ensure that the audio is delivered from your computer to your chosen device.

In the same way that a WiFi-enabled computer can automatically detect new computers and devices that connect on to a wireless network, AirTunes will automatically detect the connection of remote speakers and make them available for replay using a simple pop-up menu that appears in iTunes.

You can choose to replay your music library, use existing playlists, or create new ones to replay through your stereo. And if you want around-the-house hi-fi from your computer, you can invest in multiple AirPort Expresses.

When you are playing music, neither the host computer nor any other computer on the network is compromised; they can still communicate with each other and the Internet. Better still, AirPort Express has some other tricks up its sleeve. If you live in a large house, or you live in a house that has thick, radio-wave-absorbing walls, or you like to work at the bottom of the garden, AirPort Express can extend the range of your network. Place the AirPort Express at some convenient intermediate position, and you will have effectively made yourself a network repeater.

Printing, too, can be made more flexible. You may have more than one computer in your home, but you don't need to have a printer attached to each machine.

Fig 20—When AirPort arrived, it was a revelation—people could use their computers untethered and still maintain functionality. It quickly became a "must have" on technical and aesthetic grounds.

Fig 21—No larger than a power adaptor, AirPort Express makes enjoying your digital music around the home simple.

AirPort Express includes a USB link that can be used to connect to a printer. In fact, with this link you don't need any computer to be connected to a printer—saving even more cabling problems and logistics.

For even more capabilities, you could invest in a dedicated network music player, such as Soundbridge from Roku (fig 23). Connect this unit to your stereo or powered speakers, and you can not only hear the music but see details on the Soundbridge's display.

A large multifunction remote control ensures that you can access precise tracks and collections. For those of you who enjoy Internet radio, Soundbridge also includes an Internet radio station player to feed your favorite stations through your chosen speaker set-up. WiFi connectivity is included in most models and is available as a Compactflash slot–compatible card to upgrade those without.

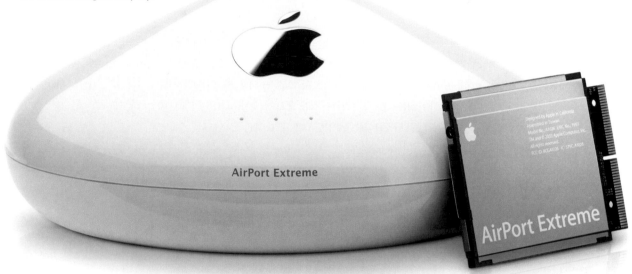

Fig 22—Upping the ante, AirPort Extreme made communications significantly faster, by a factor of five, by adopting the newer 54MB/802.11g protocol.

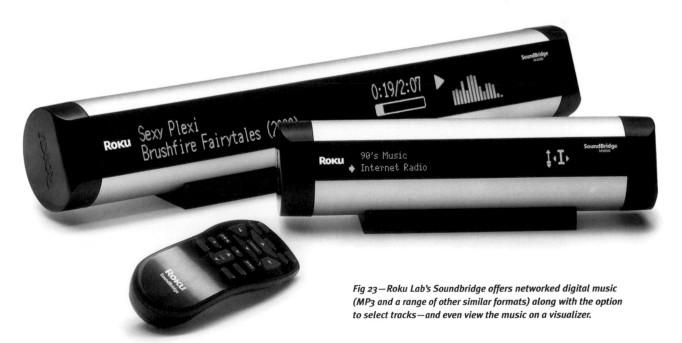

Fig 23—Roku Lab's Soundbridge offers networked digital music (MP3 and a range of other similar formats) along with the option to select tracks—and even view the music on a visualizer.

DIGITAL CAMERAS AND PHOTOGRAPHY

IN THIS CHAPTER WE:
- Examine the evolution of photography, from conventional to digital.
- Learn how digital cameras work and how they can help you take great photos.
- Discuss how to make good photos even better.
- Look at the opportunities digital photography gives us to use and share our images.

PERHAPS MORE THAN ANY OTHER DIGITAL ACCESSORY, THE DIGITAL CAMERA HAS BEEN ADOPTED AND ACCEPTED BY A HUGE PERCENTAGE OF THE POPULATION. THROUGHOUT MUCH OF THE 1990s—WHEN THE TECHNOLOGY BECAME VIABLE—DIGITAL CAMERAS WERE BEING USED BY A LOYAL BUT MODEST SELECTION OF PHOTOGRAPHERS. BUT WITH THE TURN OF THE CENTURY, COST, QUALITY, AND CONVENIENCE CONSPIRED TOGETHER TO MAKE THE DIGITAL CAMERA ONE OF THOSE "MUST-HAVE" ACCESSORIES. WHETHER YOU ARE INTERESTED IN SIMPLY RECORDING EVENTS (PARTIES, WEDDINGS, OR WHATEVER) OR YOU ARE MORE OF AN ENTHUSIAST OR PROFESSIONAL USER, THERE IS AT LEAST ONE DIGITAL CAMERA IDEAL FOR YOU.

AND YOU DON'T EVEN NEED TO HAVE A DEDICATED CAMERA. MULTIFUNCTION DEVICES—SUCH AS PDAs, DIGITAL VIDEO CAMERAS, AND EVEN MOBILE PHONES—NOW INCLUDE STILL-IMAGE CAMERAS IN THEIR SPECIFICATION. SO THERE REALLY IS NO EXCUSE NOT TO HAVE A CAMERA WITH YOU AT ALL TIMES.

THE DIGITAL CAMERA—THE STORY SO FAR

The history of photography is long and convoluted. The birth is variously ascribed to Niépce in France, Fox Talbot in England, and others in the first half of the nineteenth century. Others point even further back to, for example, the Wedgwood family in the previous century, who experimented with photosensitive materials to produce patterning for their pottery business.

Digital photography, on the other hand, is a much more recent invention, though it, too, has a complex heritage. To find the antecedents of today's digital cameras, we need to go back to the middle of the twentieth century, when the first practical videotape recorders were produced. For the first time, live images could be captured and stored as electrical impulses on a magnetic tape or disk. Of course, at that time the source television images, the signal recorded, and the output later were all analog. But the methodology would prove the foundation for all subsequent developments.

Space—the new frontier

The next milestone was—like so many of the technological breakthroughs of the 1960s—a result of the space program. With computers increasing in number and growing in ability, NASA scientists used an analog-to-digital conversion process when sending signals from space probes back to Earth. This process also allowed for elementary image manipulation, cleaning and sharpening the images, to remove noise and interference.

More covertly, the same technology was being used in spy satellites to enable photographs to be delivered from a satellite to a receiver on the ground. As part of this process, Texas Instruments issued the first patent for a camera that used no film in 1972. This was an electronic camera, rather than a digital camera. This distinction, though pedantic, was actually rather important, as electronic cameras were essentially still based on video technology—delivering still video images—rather than purely digital ones.

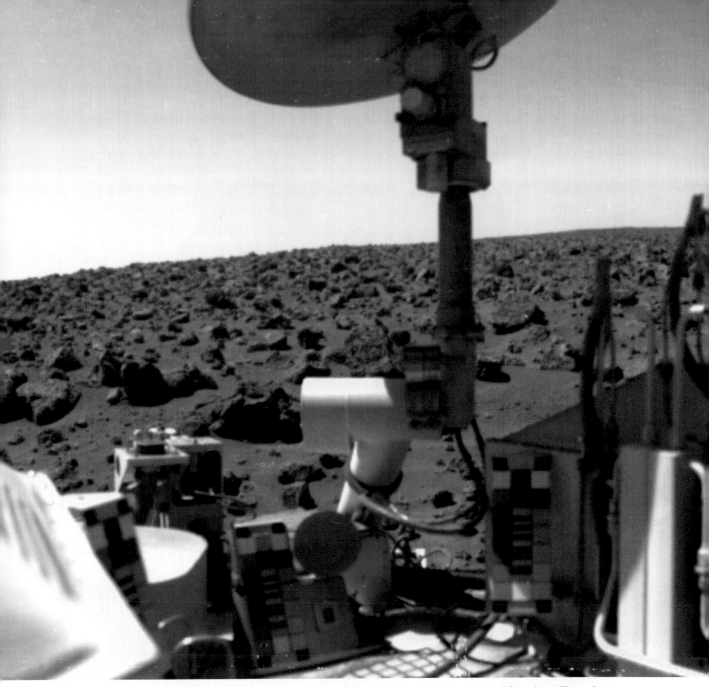

Fig 1—A Viking 2 image of the Martian landscape. Note the color patches on the lander that were (belatedly) used to calibrate the images to produce correct color. Courtesy NASA © NASA.

Shortly afterward, we saw digital images—true digital images this time—delivered from the surface of Mars by the two Viking probes (fig 1). Slowly but surely, using an array of photocells arranged vertically, the cameras scanned the landscape and built up remarkably detailed pictures of the planet's surface.

Interestingly, the first shots showed a landscape of browns and tans under a pale blue sky. Later, this was changed to stronger russet colors beneath a salmon pink sky. Color calibration—an essential feature of the modern digital camera—was first employed to correct an obvious mistake.

The solid state

Back on Earth, solid-state video cameras—which use a transistor array known as a charge-coupled device (or CCD)—appeared in the early part of the

1970s and were adopted throughout broadcast television within a very few years. By 1981, the Sony Corporation had used CCDs to produce the first embryonic digital camera, the Magnetic Video Camera, or Mavica. It is a name that Sony still uses today for many of its digital cameras.

Canon also entered the frame with its own still-video camera concept —the iON (Image Online Network) (fig 2). Also known as the Xapshot in North America, this was a compact camera that essentially captured still-video images at a resolution that matched that of VHS (which is OK, but no more) or SuperVHS (better, but still poor in photographic terms).

Images from iON cameras could be downloaded to a computer in the manner of normal digital images, but they were still analog at this point— analog-to-digital conversion took place when the images were transferred. This format flourished, with a number of cameras being released and finding widespread use among early users of

Fig 2—Canon's iON (or Xapshot) electronic camera seeded the market for digital cameras a whole decade before consumer models appeared on the dealers' shelves.

desktop publishing. When Apple introduced the Macintosh, it became viable to produce cheaply polished newsletters, internal communications, and even commercial documentation on your desktop. The iON camera made it simple to introduce images, too.

Good though the iON may have been, it was still not a true digital solution. In 1992, Kodak gave a preview of the capabilities of a true digital camera when it released a camera based on the Nikon F3 conventional SLR (single lens reflex). Adding a 1.5-megapixel CCD, a hard drive to store images, and a battery pack to drive the electronics added substantially to the bulk of an already weighty camera, but it proved a hit with the press. Sadly, a prohibitively high price tag kept it in that professional arena.

QuickTake and the digital revolution begins

As you might imagine, technology moves fast, and within a couple of years Apple gave us the first

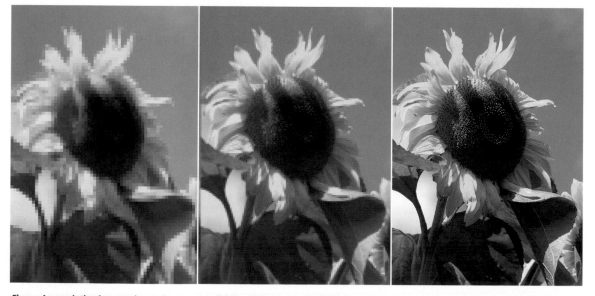

Fig 3—As resolution improved over the years, so did the digital camera's ability to produce accurate color and tone, as this simulation shows of typical cameras from 1995, 2000, and 2005.

mass-market digital camera: the QuickTake 100. On its debut in 1994, this camera, which could take pictures up to the resolution of most computer screens at that time (a modest 640 x 480 pixels), had the capacity to record only eight images at this resolution before needing to download those images from its fixed, onboard memory.

From that point, models proliferated. Prices and performance still precluded the adoption of the medium by mainstream photographers (who were quick to dismiss all digital technology as irrelevant), but things would soon change. Cameras with one-megapixel capacity (with CCDs that could record one million points in an image) gave way to two-megapixel models. Digital backs appeared for professional medium-format cameras, offering resolutions similar to film (fig 3).

In parallel, computing power mushroomed, enabling the storage and manipulation of digital images. Software for doing so—such as Adobe's ubiquitous Photoshop—flourished and spawned simpler derivatives designed to appeal more to the enthusiast amateur than to the seasoned professional.

Now we have digital cameras that fill just about every niche in the market, including some that the technology itself has created. Think about it. We have digital compact cameras and digital SLR cameras with interchangeable lenses and extensive accessories. Digital backs—replacing film-based ones— have breathed new life into the medium, and large-format cameras that are the essential tool of many professional photographers.

At the other extreme, miniature digital cameras are fitted to many phones and PDAs and can even be found on key chains. It has never been easier to capture an image. But now it's time to learn what we can do with the image once it's in the camera. How do we get it to the computer, and then how do we make it better? And having got this far, what else can we do with it? Let's discover all these things . . . and more.

PICTURES ON CD

We take the CD—and more recently the DVD—rather for granted as storage media for files of all sorts, but they are particularly effective for the storage of images. In fact, back in 1992, Kodak introduced the PhotoCD, a special computer CD-ROM that stored images at multiple resolutions. The rationale was set by the low resolution of contemporary digital cameras. When these were offering resolutions of only one or two megapixels, PhotoCDs could offer scans of conventional images that yielded files as large as eighteen megapixels.

The idea behind the PhotoCD was that photographers would take their pictures to their normal laboratory for processing. As well as receiving negatives, slides, or prints, their film would also be scanned to disk. It was the best of both worlds. Better still, PhotoCDs stored each image at multiple resolutions and could replay these images on dedicated CD players (sold as PhotoCD players by Kodak and others) and on the then-new CD-I CD players.

Despite a few years of modest success, the rapid rise in digital camera capabilities and the somewhat restricted capabilities of PhotoCDs, the format was relaunched for a professional market, where it could be used for more specialized applications of image storage.

Fig 4—The PhotoCD—digital and high quality—was launched years before cameras could offer the same.

CHOOSING A DIGITAL CAMERA

Which digital camera is right for you? The choice can be baffling, but if you determine your principal needs, that choice can become simpler. Take a look at the options in the table here and see how they stack up.

Type of photographs	Best choice	Good choice
Take snapshots anywhere, anytime	Phone-type camera	Ultra compact
Take hassle-free, good photos	Compact	Ultra compact
Take great photos, but without the need to carry a large, heavy camera	Power compact	Ultra compact
Take great photos in a wide range of conditions	SLR	Power compact
Take professional-quality photos anywhere, anytime	SLR	Top-of-the-line power compact
Take professional-quality pictures, as well as commercial and advertising photos	Digital camera back	SLR

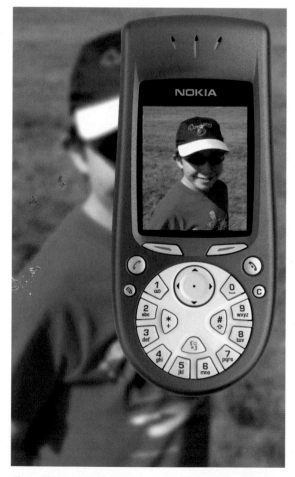

Fig 5—Phone cameras can take surprisingly good photos—like the LCD panel on the back of a digital camera, the resolution and quality of the image displayed is lower than that recorded.

Phone and PDA cameras

The cameras that were first added to phones were pretty rudimentary in quality and performance. Now they have shrugged off their low-quality "gimmick" mantle and can deliver commendable performance. Would you seriously buy a phone with a built-in camera if your primary intention was to take photographs? Unlikely. But a phone that ensures that you are always equipped to take a quick photo—well, maybe (fig 5). If you take photos regularly but don't need or want to take high-resolution shots, then you need carry only your phone with you. Better still, if you want to share those photos, you can send them to friends and family instantly, bypassing the usual image-sharing routes.

Remember that some types of PDA (personal digital assistant) can also provide camera facilities. The

Fig 6—Camera elements are small and discretely positioned on many phones—making them ideal for candid photography.

large display of these devices is also a great way to view your shots. And if you want to cut down on what you carry around, go for a model that includes a phone, too. You really can carry all your digital tools in one package (fig 6).

Ultra compact

Take the camera electronics and lens from a mobile phone, put them in a more conventional casing, and you have the makings of an ultra-compact camera. More so than even with a phone camera, you can slip one of these into any pocket or purse. In fact, with most of these cameras, the bulk of the device is made up of the batteries—unfortunately, battery technology has not kept up when it comes to miniaturization. Even so, size is a plus point with these cameras, some of which are so small that they are sold on key chains. On the downside, you generally need to connect them to a computer to access and download your images, and image quality will be no more than OK (fig 7).

Fig 7—This Sony ultra compact bucks the trend by offering very good picture quality in a tiny camera. It's waterproof, too.

Fig 8—No need to be square. Some compacts (such as this Fuji model) are more curvy. And the neck strap encourages you to wear the camera like a fashion accessory.

Compact

The compact is the biggest-selling class in both digital and conventional cameras. It's easy to see why. Compact cameras are relatively small, still just about pocket-sized, and offer good image quality (fig 8).

Digital compacts tend to use much larger CCD imaging chips than phone cameras and ultra compacts, with resulting increases in terms of image resolution (see page 48) and quality. Features unlikely to be found in smaller cameras—such as an LCD preview panel on the back and memory cards for image storage—are also standard.

Depending on the model (and how much you are prepared to spend) you will find either a fixed lens or a zoom (fig 9). Zoom lenses are preferred because, for the sake of a little more bulk, you get the opportunity to frame pictures better by cropping in on details and ensuring that superfluous elements are excluded. Most zoom lenses have a zoom ratio (that is, the amount they will magnify a scene) of around 3x, but some models offer 10x—though you

Fig 9—Traditional styling characterizes many cameras in the compact class, yet they still boast a good optical zoom and multi-megapixel performance.

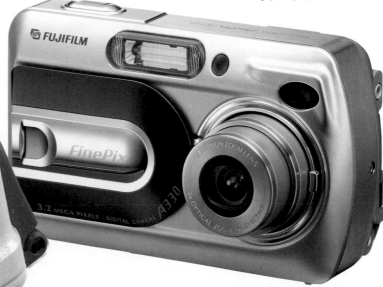

will have to pay a premium for this, both in financial terms and in terms of bulk.

THE DIGITAL ZOOM

The usefulness of a zoom lens is undoubted, but some cameras seem to offer prodigious zoom ratios, often at suspiciously low prices. Closer inspection of the camera's specifications shows that the zoom ratio is actually made up of two components. One is the conventional, optical ratio. This is the zoom achieved by optical means, adjusting the lens configuration to enlarge the image. The remainder, and often the larger amount, is attributed to a digital zoom.

The digital zoom merely takes the data from the central pixels of an image and enlarges them to the full size of the image. The result is a low-resolution image blown up to high-resolution dimensions. Frankly, avoid these. You end up with low-resolution images and large file sizes. You can achieve precisely the same result by enlarging part of an image using your computer's image-manipulation software.

Power compacts

At the top end of the compact range come the power compacts. These are the same compact size (or at least, nearly so), but with lots more features. Whereas a simple compact may have fully automatic exposure and focusing, these more serious machines will give you the opportunity to exercise at least some creative control. You can override the automatic

Fig 10—More features and more controls give cameras such as this the opportunity to be used in a wider range of conditions without sacrificing portability and pocketability.

controls to compensate for unusual lighting situations or vary shutter speeds and aperture to suit the type of photographs you are taking. Some models will feature preprogrammed "scenes" that configure the controls to meet the needs of, say, sports, portrait, night, or landscape photography.

The power compact (fig 10) is a great choice if you want to take good photographs but don't need the extra functionality (interchangeable lenses and flash modes, for example) of the SLR.

SLRs and SLR-style cameras

The SLR is the stereotypical camera for professional photographers and the camera of choice for many enthusiasts (fig 11). For those who have not come across the term before, it stands for single lens reflex—harking back to a time when there were also twin-lens reflex cameras in widespread use. In essence, the optical path through the camera means that the view you see though the viewfinder comes—via prisms and mirrors—through the lens of the camera itself. This makes it possible to compose and shoot a scene exactly as you see it in the viewfinder. In most—but not all—SLRs, the lens can be detached and exchanged for others—perhaps a telephoto for enlarging distant views or a wide-angle for shooting in restricted spaces.

By virtue of the design and target market, these cameras tend to have the highest resolutions and offer the optimum in image

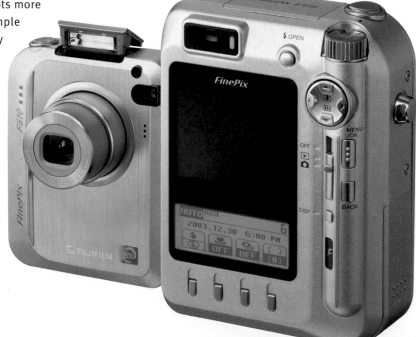

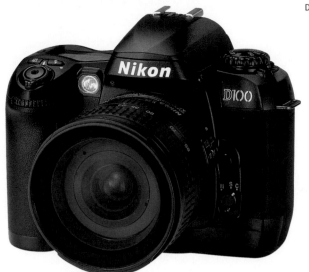

Fig 11—Digital SLRs look much like their conventional counterparts until you take a look around the back. The LCD panel betrays their digital nature.

quality. They will also allow more rapid shooting than most other cameras, in the manner of their conventional, motor-driven stablemates.

Because these cameras are produced in comparatively small numbers and are destined to be used by professionals and serious amateur photographers, they are expensive. This has created a market niche that sits between SLRs and the compact. Offering an electronic viewfinder rather than an optical one, and generally featuring a fixed-zoom lens rather than detachable, interchangeable lenses, these compromises are reflected in the better pricing.

Digital camera backs

In the rarefied atmosphere in which the professional photographer works, quality is paramount. This left photographers in something of a quandary. On the one hand, they needed the ultimate in quality; on the other, tight deadlines demanded fast results. For quality, film-based photography was required; for speed, it was digital.

The solution lay in digital backs for medium-format cameras (fig 12). Medium-format cameras—such as the Swedish icon, Hasselblad—use, as you might guess, a larger film format than 35mm compact and SLR cameras, and they typically produce negatives measuring

Fig 12—A digital back attached to a Hasselblad H1. If you have to ask the price, you can't afford it.

6 cm x 6 cm. By replacing the camera back (the interchangeable part of the camera in which the film is housed) with a large CCD sensor, the opportunity was created to produce large, high-resolution digital images.

The catch is the price. This really is a solution for the professional—for whom someone else is often paying the bill. But for several years, and probably many more to come, these systems offer the ultimate in quality. As a nod to the evolution in camera technology, Hasselblad's latest camera, the H1, has been designed from the ground up to accept either a digital or conventional camera back.

DIGITAL CAMERA FEATURES

Except for the most basic, digital cameras appear festooned with buttons and switches. What do they all do and what do the icons mean? Here you can see a "typical" camera. It may not look exactly like yours, but don't worry about that. Once you have discovered which button does what, everything becomes much clearer.

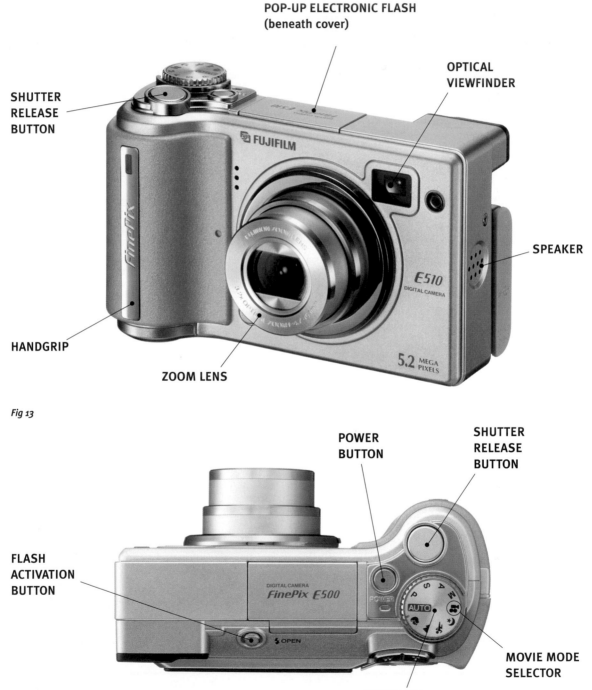

POP-UP ELECTRONIC FLASH
(beneath cover)

OPTICAL
VIEWFINDER

SHUTTER
RELEASE
BUTTON

SPEAKER

HANDGRIP

ZOOM LENS

Fig 13

POWER
BUTTON

SHUTTER
RELEASE
BUTTON

FLASH
ACTIVATION
BUTTON

MOVIE MODE
SELECTOR

MODE DIAL

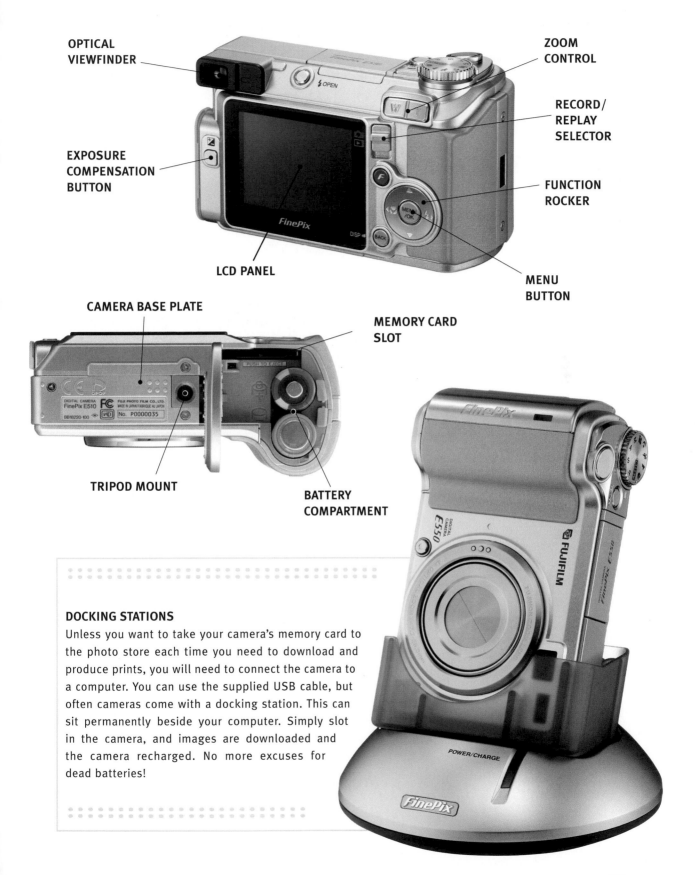

OPTICAL
VIEWFINDER

ZOOM
CONTROL

RECORD/
REPLAY
SELECTOR

EXPOSURE
COMPENSATION
BUTTON

FUNCTION
ROCKER

LCD PANEL

MENU
BUTTON

CAMERA BASE PLATE

MEMORY CARD
SLOT

TRIPOD MOUNT

BATTERY
COMPARTMENT

POWER/CHARGE

DOCKING STATIONS

Unless you want to take your camera's memory card to
the photo store each time you need to download and
produce prints, you will need to connect the camera to
a computer. You can use the supplied USB cable, but
often cameras come with a docking station. This can
sit permanently beside your computer. Simply slot
in the camera, and images are downloaded and
the camera recharged. No more excuses for
dead batteries!

MASTERING YOUR DIGITAL CAMERA

If you are adept at using a conventional camera, you will find the switch to digital pretty painless. In fact, some of the features—such as the LCD panel for previewing and reviewing shots—makes creative use simpler. This instant feedback makes it easier to interpret the controls and functions and use them to your advantage.

For all the similarities, you will find that some controls differ, but even these are easy to master. And if you have never used any kind of camera with serious intent, this is the place to start. Here are some of the key features of a digital camera—and how to get the best from them.

LCD panel

This panel is the obvious distinguishing feature of a digital camera (fig 14). Although rarely more than a few square centimeters, this is a powerful compositional tool that allows you to preview shots instantly before committing them to the camera's memory. For most users, this is a more effective way of composing than using the viewfinder, which, on all but the professional cameras, tends to be rather small and difficult to use.

When coming to understand the creative tools and controls of the camera, seeing how these are interpreted on screen is an incredible help. Moreover, it gives you the reassurance that you have been successful in capturing images the way you intended, not merely the way the camera interpreted your vision.

White balance

Although most light sources do not produce pure white illumination, our eye/brain combination is so remarkably adept at making corrections that we hardly ever notice. Conventional tungsten light bulbs, for example, produce a distinctly amber light, while overcast skies can produce a cold, bluish cast. And fluorescent lighting can deliver casts that are green through to purple-magenta (fig 15).

The auto white balance feature on a digital camera will attempt to correct any color cast by analyzing the colors in a scene and adjusting them to conform to a "neutral" standard. For most of the time, this feature works well and delivers accurate color results. But it can be too effective. Sunsets, for example, where we want to retain the strongly saturated pinks, reds, and purples, can look washed out as the auto color balance determines the color as an unwanted cast.

In these situations, take the color balance off automatic and set the control manually to one that is appropriate to the scene. In the example of the sunset, you might set the balance to Daylight. Setting the balance manually can also give better overall results in mixed lighting conditions, but it's a good idea to reset it to Auto once you have finished, to avoid taking a lot of pictures with the wrong color balance.

Sensitivity

When we load a conventional camera with film, that film has a particular sensitivity to light. This is described in terms of a standard scale—the ISO scale. An ISO200 film has twice the sensitivity of an ISO100 film, and an ISO400 film twice the sensitivity of an ISO200 film. The higher the sensitivity, the shorter the exposure needs to be. This makes it possible, for example, to select a fast shutter speed and then hand-hold shots in low light rather than having to use a tripod. It also means you can take shots in darker conditions than would be feasible with slower films (fig 16).

Why, then, don't we always use ISO400

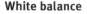

Fig 14—The rear LCD panel (a feature of virtually every digital camera) makes it simple to check that your photo was accurate.

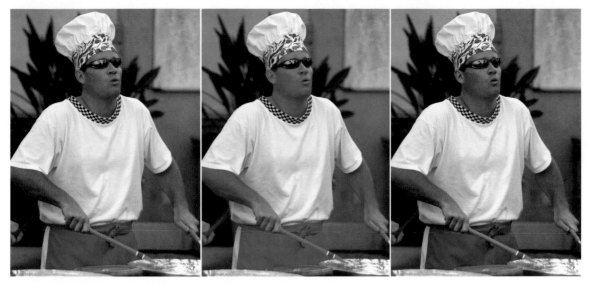

Fig 15—White balance: a correctly balanced image (Auto balance) compared with the same image shot with Tungsten Lighting and Fluorescent balances.

or even ISO800 films at all times? The trouble is that the faster films have a sting in their tail: the higher their sensitivity, the more grainy their images. If you want the sharpest results, you need to use a slower (less sensitive) film. Shoot with film rated at ISO100, or even ISO50, and grain is virtually invisible. Assuming you have a first-rate camera and lens, this film produces images that can be enlarged significantly before grain becomes apparent.

So what has this to do with a digital camera,

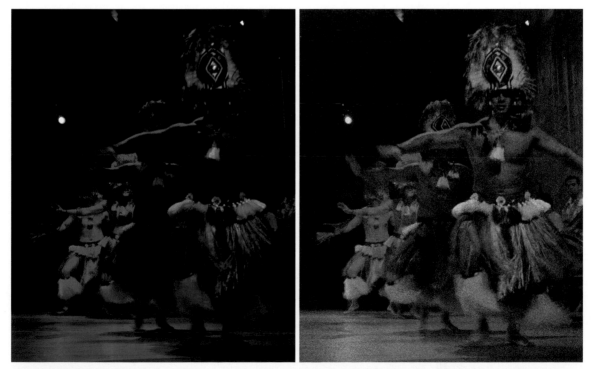

Fig 16—Increasing the sensitivity from ISO200 to ISO1600 has revealed more subject detail, but the "noise" (and the contrast in the image) has become noticeably worse.

which uses no film? In many respects, beyond the obvious, the CCD or CMOS chip of the camera behaves very like a film emulsion. In fact, we can change chip sensitivity: some cameras offer an effective range of ISO100 to ISO400, while other professional models offer a ISO50 to ISO1600 range. Like film, though, when we operate at a higher ISO rating, image quality deteriorates through the digital equivalent of grain—"noise."

Noise occurs in all electronic circuits, but normally the signals are much larger, so the noise has a negligible effect. But when working at very low signal levels (representing low light levels), this noise becomes obvious and manifests as spurious colors and general image degradation.

Such degradation comes into effect only at extreme ISO ratings, however, so when you use ISO100, ISO200, and even ISO400 with most cameras you can be sure of technically good results.

Resolution

The key selling point promoted by many manufacturers of digital cameras is the resolution (fig 17). This describes how detailed your image will be and how much detail can (theoretically, at least) be recorded. It is usually expressed in terms of megapixels—millions of pixels (or picture elements). The camera CCD will record the brightness and color at each of these points, so clearly the more points, the better the resolution and the better the image detail.

Digital camera experts might take exception here and point out that each pixel measures only one color—red, green, or blue—and the actual color of a pixel is determined by averaging adjacent pixels. But for our purposes, it is acceptable to consider each pixel as recording the appropriate color for that part of the image.

The more pixels that comprise the picture, the larger it can be printed before the pixel nature of the image becomes obvious. So if you want to produce a full-page photograph, a high-resolution camera is essential; if you want snapshots for your Web site, high resolution is not so crucial.

High-resolution cameras offer modes for recording images at lower resolutions, but why would you want to do this? If you were gathering

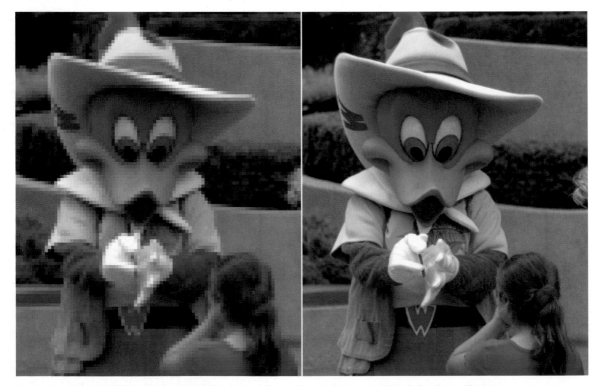

Fig 17—Increasing resolution allows more detail to be recorded, as these enlargements of part of an image illustrate.

images for Web use, for example, then the extra quality might be superfluous, and by opting to save images at small file sizes you will be able to fit considerably more on a memory card.

Shutter lag and recycling time

Here is an area where some digital cameras fall behind their conventional stablemates in performance terms. When you press the shutter release on a normal camera, the shutter opens momentarily afterwards. If it is in fully auto mode, the camera will determine exposure, set the focus, close the lens down to the correct aperture, and open the shutter. In a digital camera the CCD needs also to be primed, which adds to the delay, making the lag before the picture is taken slightly, but perceptibly, longer. Although this time is still short, it can be enough for you to miss that crucial moment for your photograph.

The solution is partly to press the shutter so that focus and exposure are set and the CCD readied prior to the shot. Then, when you press the shutter release further, the shutter is activated almost instantaneously.

The recycling time is the time taken for the camera to download an image from the CCD and prepare it for the next shot. Many cameras now use memory buffers that store the image data before writing that image to the memory card, which gives a short effective recycling time. But even these cameras will fill their buffers if you shoot several shots in rapid succession. If action photography is your speciality—where fast, consecutive shots are most likely to be used—it pays to check the shooting speed and recycling time for your intended purchase.

Sharpness

Some digital controls can actually improve the images you shoot. The white balance control is one of these. Sharpness control is another, but it is a more controversial option (fig 18). It adds to the perceived sharpness of the image by, essentially, sharpening the edges in an image. It is an artificial sharpening and does not make up for not getting an image sharp in the first place.

Most photographers turn this camera control off. You can add sharpness in a more controlled fashion

Fig 18—Sharpness: sharpening in the camera (lower image) can give an overly sharpened effect, one that makes the image look artificial, with the edges of subject details, particularly, looking too prominent.

later using image-manipulation software, but you can't remove the artificial sharpening from an image once it is shot.

RAW images

If you want to avoid the camera making any corrections or manipulations on your behalf, you need to set the camera to record RAW mode files. Not all cameras will do this; it tends to be middle-market through the top-end models that offer this feature. When you store an image as a RAW file, you have the data that has been recorded by the CCD without any processing.

Professional photographers often use RAW as a matter of course, because mostly—though not always—it gives the best results. But RAW files are larger and cannot be directly imported into many image applications. You will need to resort to a serious image editor, such as Photoshop, to process your images first. Large files also mean that fewer images will be stored on the memory card.

PRINTING YOUR PHOTOS

Printers today—even budget models—can offer astonishing quality, which, in most regards, is equivalent to conventional photos. But what if you want something different? A large, poster print? Or a specially bound photo album? Or even a personalized T-shirt?

You won't be surprised to know that all these great (and quite a few not-so-great) photo products available to conventional photographers are also available to digital photographers. And you can create and order online.

Here's how simple it is to create an album digitally. Not just any album—this is a fully bound and professionally printed one. To create this, iPhoto has been used, but other applications are available that enable you to make similar products.

1. Collect your images together. You will need to put them in a new electronic album folder. Make sure that they are in the right order. It will make your job easier if you drag the image that you want to use on the cover to the front of the list. Double check that all images are OK. Any that are below

Fig 19

Fig 20

Fig 21

Fig 22

Fig 23

Fig 24

Fig 25

Fig 26

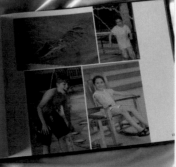

par will need to be either replaced or manipulated to improve them. When you are happy, click the Order Book button (fig 19).

2. Wait. iPhoto will now automatically compile your album. It makes a best guess at the layout, mixing styles and layouts to produce an album that will be interesting to look at (fig 20).

3. When the process is complete, begin by adding a title for the book. This will be printed on the cover and needs to be clear and concise (fig 21).

4. You can now start manipulating the content. Click on a page if you want to change the layout, and then click on the Page Design pull-down menu. You can now alter (either up or down) the number of images on the selected page. When you add images, those on subsequent pages are included; when you reduce the number, the last images on the page are pushed over to the next (fig 22).

5. In this case, the number of images on the page has been reduced to two. The two images that remain on the page are rescaled to make best use of the page (fig 23).

6. You can also drag images around manually to alter the look and layout (fig 24).

7. When you have finished, review the results to make sure that your changes to the layout have not produced any gaffes. Then hit Order. Your album is e-mailed to the photo lab, and a few days later, your book will be delivered! (fig 25).

8. High-quality printing via an archival printer will ensure that you have an album you can enjoy for years to come (fig 26).

Fig 28—Medallion 1

Fig 29— Medallion 2

Fig 27— Kaleidoscope 1

NOKIA IMAGEWEAR

Can any use of an image be as wacky as these from the mobile phone giant Nokia? Imagewear lets you take images (presumably with your camera phone) and turn them into head-turning jewelry pieces.

Medallion I (fig 28) is a choker-style necklace with a small square image panel onto which you can beam your selected image. You can also change the image at will—the medallion can store eight images and display them on the modest 96 x 96 pixel screen. Medallion II (fig 29) offers a similar display on a more conventional necklace.

Kaleidoscope I (fig 27) is for those who are a little more discreet. Up to 24 images can be stored in this compact unit, even more using an optional Multimedia Card. You can examine individual images or watch a picture show through the eyepiece.

MOBILE PHOTO SERVICES

When camera phones first arrived, they were scoffed at—their low resolution, small lenses, and awkwardness to use rendered them irrelevant in the eyes of photography commentators. But improved quality, performance, and operation have brought wider acceptance. Now they offer—by virtue of their connectivity—services that cameras alone cannot.

LIFEBLOGGING—MOBILE PHOTOGRAPHY FROM NOKIA

If you learn one lesson when you begin digital photography, it's how many more pictures you take compared with conventional photography. The same applies to those of us who use camera phones. Very quickly, your phone's memory limit is reached. So what do you do with the photos then? Nokia—one of the leading producers of camera phones—has the answer. It's called Lifeblog (Figs 30–32).

Lifeblog is a set of software applications, for both your camera and PC, that means you can use your photo collection as part of a multimedia diary. The great feature of Lifeblog is that it will automatically organize not only your photos but also, if your camera supports it, video, multimedia messages, and even text messages. By placing them all in chronological order, they become easy to track. Synchronizing computer and phone in this way means that you always have the most relevant photos and information on your phone. Anything that you don't designate as a favorite is removed but safely archived on your phone.

Because all your media is stored on your computer it becomes easier to sift through important and less-important material. And to make it more relevant, when downloaded to the computer you can add notes to the images and video.

Lifeblog is totally automatic—you don't need to have the software running on your phone. Once installed, it will begin building your diary, adding new images and video to the record. The next time you connect to your computer, all this new content will download and free up space on the phone for your next round of photography.

Of course, in your image collection there will be those images that you want to keep on the phone—photos of family or, perhaps, videos of some recent events that you want to share. By placing these in the Favorites section, you can ensure they are synchronized between PC and camera. You can use a version of the Timeline program, similar to that used on the computer, to find and navigate your media.

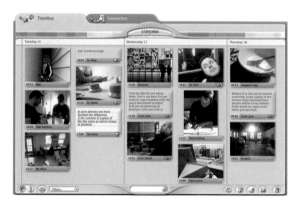

Fig 30—Downloaded digital assets—photos, messages, and video—are displayed in a pseudo-diary format that makes them easy to browse by date. You can also add notes to supplement your memories or explain the content that has been downloaded from your camera.

Fig 31—The timeline on your computer can also be displayed on your phone's display. This makes it easy to review your Lifeblog and share its contents, either by using your phone handset or by sending selected items to someone else with a compatible camera phone.

Fig 32—No matter how prolific your photography, you can track down all the photos and video you have recorded by simply using the Timeline view.

Fig 33—The Kodak Mobile imaging service is available from your phone handset or computer. If you take a great photo and you want prints made from it right away, you can order them with just a few clicks on your handset.

MOBILE PHOTOGRAPHY FROM KODAK

Launched toward the end of 2003 in the United States and about six months later in Europe, Kodak's Mobile Photography service (fig 33) is a resource offering camera-phone users access to both digital photos and digital video. It's a very comprehensive service that allows users to manage, print, and share photos and do much the same (with the exception of printing) with their video content. In particular, registered users can:

1. Store all the images and video from their phones in one central location.
2. Have prints produced and delivered from their phones or via the Kodak Mobile Web site.
3. Share all the resources on their phones or those stored at the Kodak Mobile central servers.
4. Organize, manage, and view all their images and video from the Web site or remotely via their phones.

The good thing about this service (and similar ones) is that the operators don't demand that you have the latest generation of phone. As long as you have a camera phone and it is capable of supporting the WAP 2.0 protocol (as virtually all camera phones can) you can set up and use an account.

Fig 34—You can also print images from your phone yourself using Kodak Print Kiosks. In this case, you can even perform simple edits on images or choose alternate sizes. However, images from camera phones with small megapixel counts should not be printed too large—results will look better when printed smaller.

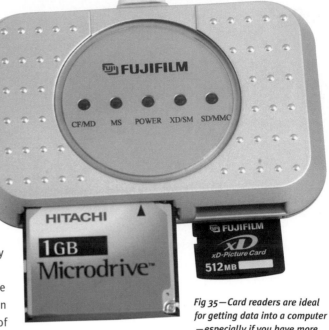

ALL ABOUT MEMORY CARDS

Memory cards have rapidly become a popular way of storing and exchanging digital data. We are familiar with them for storing digital images, MP3 music, and personal data on our PDAs, but memory card slots are also finding their way into mobile phones, digital radios, camcorders, and even televisions. Printers, too, will now accept memory cards from cameras and print images directly from them.

With capacities of up to eight GB, they are ideal for storing large amounts of information and provide a surprisingly robust method of doing so. At their core is a special type of computer memory known as flash memory. This is a nonvolatile memory that retains information when the cards are removed from a host device. Later, that information can be deleted and new data stored. The name, incidentally, is attributed to Toshiba, which found that the cards could be erased "in a flash."

Memory cards come in a variety of shapes, sizes and capacities. Some are compatible only with a single device; those used in game consoles are a good example. Others conform to a standard that makes them usable across a range of devices. Today, your digital devices are likely to be one of the following main types:

- CompactFlash
- SmartMedia
- Secure Digital
- MultiMedia Card
- xD Picture Card
- Memory Stick

Since you are likely to come across one or more of these, let's look at each a little more closely.

CompactFlash (CF)

The most bulky of the cards, CompactFlash (fig 36) is the staple of many digital cameras because its size offers a degree of ruggedness and space for high-

Fig 35—Card readers are ideal for getting data into a computer—especially if you have more than one card type to deal with.

performance memory. Dating back to 1994, the first cards had modest capacities of only a few megabytes, but this has multiplied and one-, two-, and four-GB cards are now commonplace.

Significantly, they feature a controller chip that handles onboard memory management. This makes it possible to store large quantities of data—such as from a fast-shooting digital camera—quickly.

A variation of the CompactFlash is the MicroDrive. Originally produced by IBM, this is nothing less than a tiny hard drive. Originally, they had the advantage of substantially higher capacity than solid-state cards, but this advantage has been lost as solid-state cards offer increasingly higher memory.

Fig 36—CompactFlash is the big daddy of cards—in capacity as well as physical size.

SmartMedia (SM)

Diminutive and wafer thin, SmartMedia cards (fig 37) are characterized by a gold chip on the front, similar to those found on credit cards. The size of the card means there is insufficient space for a controller to be incorporated: this needs to be built into the host equipment—the camera or PDA. Although small, SmartMedia cards are still larger than some alternatives, but they have topped out at capacities of 128MB, meaning they are now used

Fig 37—Commonly compromised by limited capacity, the SmartMedia card is distinguished by the gold "chip."

only in those digital cameras with modest performance.

Secure Digital (SD) and MultiMedia Cards (MMC)

We can discuss these two types together, since they share the same shape (or "footprint") and some devices can use either card interchangeably. Smaller than SmartMedia cards, they are available in a range of sizes up to one GB, though larger capacities will be introduced. The key difference between the two is that SD cards can be used to store copyrighted material and prevent unauthorized copying—important for ensuring that the copying of MP3 music and copyrighted images is properly managed. They are most commonly found in MP3 players, phones, and PDAs.

xD Picture Card

A comparatively recent introduction, xD Picture Cards were designed by Fuji and Olympus partly so as to overcome the capacity limitations of SmartMedia and partly to produce a small-sized card that could be freely used in their cameras. The discussion at the launch included the ability to produce smaller cameras. The cards—about the size of a thumbnail and of similar shape—are offered in capacities similar to those of SD cards, and they remain—at the moment—confined to Fuji and Olympus cameras.

Memory Stick

Sony, never shy about launching a new format, introduced the Memory Stick (fig 38) as a portable storage medium for camcorders,

FAST CARDS

Some memory cards attract a premium price because they have a higher rated "speed," often described at "20X," "40X" or more. What does this mean, and are they worth the money?

The speed describes a card's ability to have data written to or read from it. In approximate terms, a 20X card transfers data at 3 MB/second, 40X at 6 MB/second. This is particularly important, as has already been noted, for digital cameras, where image data can come thick and fast. If you plan to use your camera for fast shooting (such as sports photography), a fast card can give you the potential of better performance and more shots before your camera stalls.

cameras, music players, and computers. Now Memory Stick slots can be found in at least some models across Sony's broad portfolio. The original Memory Sticks offered a moderately large-sized card and fairly modest capacities, but this was enhanced with the launch of the Memory Stick Duo (smaller footprint) and Memory Stick Pro (larger capacities). The latter also comes in "Duo" form, offering the smaller footprint.

Compatibility between card types is an issue—the cards feature controller cards, and it is important to check that the more recent, larger-capacity cards will work in older devices.

Fig 38—The Memory Stick family, including Pro, Duo, and an adaptor to use with original format card-based devices.

FIXING YOUR PHOTOS

Even with years of experience, photographs never turn out quite as you expect them to. The weather may not be quite right, or you totally overlooked an electricity tower that now dominates your photo. Or the picture's too dark, too light, or lacking in color. Come to grips with image-manipulation software, and you can make poor pictures OK and good photos great. Here are some quick fixes you can apply in seconds:

RED-EYE

You probably know the effect. Stone-cold sober yet the photos seem to tell a different story. Eyes have a red, demonic look. It's called, naturally enough, red-eye, and it's due to the light from a camera's flash reflecting directly off the blood-rich retina at the back of the eye. Most cameras have an anti-red-eye setting on the flash, which uses a series of preflashes to make the iris contract before the main flash fires. They rarely work.

Don't worry—fixing this with image-editing software is simple. In some cases, you will find a red-eye brush that you can move over the offending color to remove it. But in most applications there is a correction tool something like this.

1. Here is the original photo. Children, and babies in

particular, are more prone to red-eye as their eyes take longer to adjust to lighting changes (fig 39).

2. Select the Red-eye tool. This may be from a button, as here, or a menu command, depending on what application software you are using (fig 40).

3. Using the mouse, drag a selection over one or both eyes. In some applications, the tool works by taking away the red color from the selected area. In this case you will need to make your selection of the areas just around the iris to avoid affecting the skin color too (fig 41).

4. When you release the mouse button, the red-eye is removed instantly. The result is entirely natural. From devil to angel at a stroke (fig 42).

Pets also suffer from this effect, but the result tends to be green- rather than red-eye. Red-eye tools don't usually work with colors other than red, so if you want to correct the problem in a favorite cat or dog shot, you'll need to use the Paintbrush tool to paint over the green.

ADDING COLOR

So we know how to remove color where it's not wanted, but what if we want to add more color? How many times have you returned from a trip or vacation and been disappointed by your pictures? Somehow the photographs never look as colorful as you

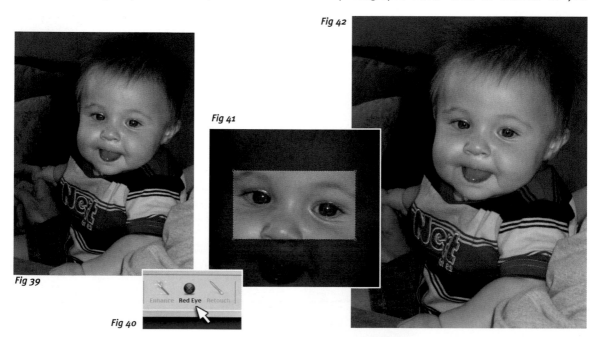

Fig 42

Fig 41

Fig 39

Fig 40

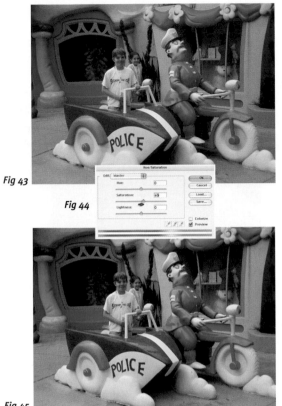

Fig 43

Fig 44

Fig 45

the Hue slider by just 2 percent, it was possible to make the sky less cyan and more blue in color (fig 45).

BETTER COLOR

Sometimes the color recorded by the camera is not entirely what you expected. It is not that the color is pale or weak, as has been described above, rather that there are color casts present. Sometimes casts occur because you set the wrong white balance on the camera (see page 46), or there were natural color casts due to overcast skies during the day or low, reddish-colored light in the morning or evening. Whatever the cause, there is a simple fix. It's called Auto Levels in some applications or Auto Enhance in others (figs 46, 47).

This useful cure-all analyzes your image and determines if the spread of colors, brightness, and contrast need to be adjusted in order to match those that would be expected in an "average" photograph. It can work wonders on most photos, adding a little sparkle missing in the original.

It's probably worth pointing out that this control does not work every time. Where you may have strong colors in the scene, Auto Levels can sometimes overcompensate and remove them. In these cases, stick with the original or explore some of the manual correction tools available.

remember the real thing having been. But it's simple to boost the color—either selectively or across the whole image—to produce a result that will make you the envy of your friends and family.

1. Here's a typical photo anyone might take. Although it's actually a pretty accurate representation of the scene, the colors are not vibrant. Wouldn't it be better if we could adjust them and make them more saturated, perhaps like those we see in travel brochures (fig 43)?
2. Using the Hue/Saturation control, it's possible to make our adjustments. This lets you increase or decrease the color saturation of a photo. In this case, the slider control was moved to the right to increase color saturation. It's important not to overcorrect—if the colors become oversaturated, they will look artificial and also produce problems when printing (fig 44).
3. Here is the finished image. By increasing the color saturation by less than 10 percent, a much more punchy result has been achieved. And by moving

Fig 46

Fig 47

CROPPING

The great thing about zoom lenses is that they allow you to frame your subject with a flexibility simply not possible using a fixed lens. You can zoom in and remove any distracting surroundings to your portraits—for example, cropping out distractions that might otherwise mar results—or zoom back and show your subject in its proper context.

The trouble is, the framing of the subject in the camera's viewfinder—even that of an SLR—is only approximate. The same applies to the LCD preview screen. The good news is that both viewfinder and LCD tend to err on the side of caution and show you less of the image than is actually recorded. So you can make your final crop of the image later. Here's how to do it:

1. It's all down to the Crop tool. Here you can begin by selecting the area of the image that you want to retain (in some applications, such as Photoshop Elements, you will need to select the crop tool first). In this case, the area outside the selection, is lightened (fig 48).

2. Hit the Crop button to effect the crop. If you make a mistake and have taken away too much, don't worry. In virtually every application you can select the Edit menu and then Undo or Step Backward to restore the image to its original state (fig 49).

3. Here is the cropped image. Superfluous detail has been trimmed away, and you can concentrate on the girl and the prized ticket in her hand (fig 50).

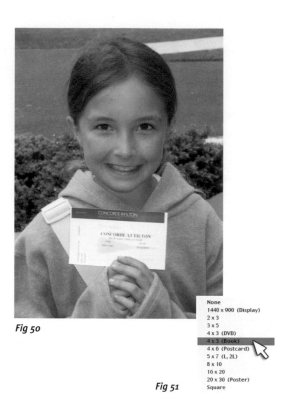

Fig 50

Fig 51

Sometimes it is necessary to crop images to a particular ratio. For example, you may want to trim an image to fit a photo frame or the dimensions of a television screen if you are preparing images for inclusion in a multimedia presentation. The Constrain feature lets you select an aspect ratio. When you drag your selection with a chosen ratio, the crop will be automatically scaled (fig 51).

ART EFFECTS

Most image-manipulation software includes a range of software filters that can transform your images into subtle works of art or something more eye-popping in nature. Used with care, they can make your photos really stand out.

"Use with care" is something to bear firmly in mind when using photo filters, as some are so crude in their effect that they immediately betray the fact that they have been used. There's a fine line between art and kitsch.

Here (figs 52–60) are examples of some of the more effective filters. Remember that you can play around with these and just hit the Undo button if the effect is not what you want.

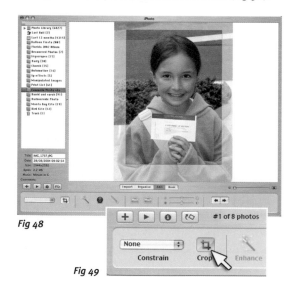

Fig 48

Fig 49

Fig 52—The original image.

Fig 53—Palette Knife simulates the effect of using a palette knife with acrylic or oil paints.

Fig 54—Dry Brush applies a subtle brushed effect.

Fig 55—Waterpaper gives the impression that the image has been painted onto absorbent watercolor paper.

Fig 56—Posterize reduces the number of hues in the photo to leave areas of well-demarcated areas of flat color.

Fig 57—There is no mistaking the Solarization effect, which essentially reverses some of the color and tone

Fig 58—Conte Crayon, with a canvas base texture, produces a subtle, hand-drawn appearance.

Fig 59—Stained glass breaks the image into small cells of even color and adds a border to each.

Fig 60—Craquelure is ideal if you want to make your photos look as if they are printed on a highly textured surface.

IMPROVING REALITY

Perhaps the most startling of all the image-manipulation tricks involves the Clone tool. Sometimes also known as "the Rubber Stamp", this is the tool that can be used to hide unwanted elements, move subjects (even between different pictures), or copy selected parts of your images.

Here the clone tool has been used to cure a problem that occurs all too often. The girl in this photograph blinked at the crucial moment. In this example, the eyes of the girl's brother are open, so we can clone these across (figs 61–63).

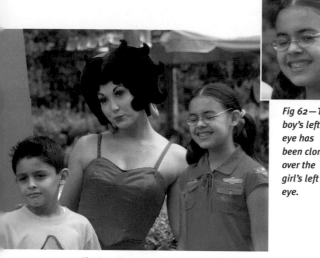

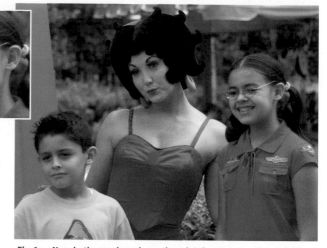

Fig 62—The boy's left eye has been cloned over the girl's left eye.

Fig 61—The original image showing the girl's eyes closed.

Fig 63—Now both eyes have been cloned. It is not as good as catching the girl with her eyes open, of course, but it certainly rescues a shot that would otherwise be consigned to the computer's trash can.

Fig 64

Fig 65

Here is a more extreme use of the Clone tool. This photograph of a cottage in a British village is undoubtedly picturesque, but from the photographer's point of view it is cluttered by cabling and other ephemera of contemporary living (fig 64). With some subtle use of the clone tool, we can replace unwanted parts of the scene using material copied from elsewhere (fig 65). To achieve this effect is painstaking and time-consuming, but not difficult.

MONTAGE

In digital photography, anything, it seems, is possible. Once you begin to explore all the tools and features embedded in even the most modest of software packages, you will come to realize the truth of this. Some call it cheating, others creative, but there is no doubt that montage is one of the best ways of creating new images from parts of others. Here you will see how to create a scene that never existed in reality.

1. Let's take this girl and astronaut and place them against a new background, the Mission Space pavilion at Disney's Epcot. Here are both the original images (figs 66, 67).

2. The first step is to cut out the girl and astronaut. We can use a selection tool called the Magnetic Lasso to do this. You drag it around the edge of the parts of the image you want to select, and it automatically aligns itself. Alternatively, you can use the Eraser tool to erase away the background. As in darkroom photography, digital photography often gives you several ways to achieve the same effect (fig 68).

3. We can now place our cut-out selection on the new background. Simply use the Copy command to copy the selection from the original image and then, in the new image, use the Paste command (fig 69).

That's all there is to it. Of course, it doesn't always work out as easily as this. If the two source images have a different resolution (for example, if they were taken with different cameras) or different color balance, you would have to adjust the images accordingly to marry them together seamlessly.

Fig 66

Fig 67

Fig 68

Fig 69

PHOTOGRAPHY WITHOUT WIRES

When you own a digital camera, at some point you will need to connect it to a device to download images. But this physical connection is increasingly irksome to users—now that computer peripherals, such as keyboards, mice, and even printers, can work wirelessly, why can't our cameras? The answer is they can.

Using both Wireless and Bluetooth (see pages 29–33), you can download images (remotely or locally) and even print. Bluetooth print adaptors will transform a compatible printer

Fig 70—By building Bluetooth communications into a CompactFlash memory card for printers designed to accept such cards, they can instantly be converted into wireless printers. Devices featuring Secure Digital memory cards (SD) can also be equipped with a Bluetooth-enabled card— you can then print direct from a PDA camera or (at a more mundane level) print out documents directly from your PDA.

into a wireless device that can (albeit with the usual "ifs" and "buts") print photos directly from a computer, a phone, or a PDA (figs 70, 72, 74), if they also have Bluetooth. This is a convenient way of printing out all those casual photos taken with your cameras without the hassle of having to download them to your computer first. True, you are a little limited in the way you can manipulate photos (limited to the controls on the printer itself), but for getting prints to hand out to friends and family, it is a great solution.

Bluetooth media players are an even better way to enjoy photos with your friends. With one of these attached to your television, all you need do is display photos on your phone and ensure that Bluetooth is on. Then create a live slide show directly from your phone —or from your friends'

Fig 71—Media players, such as this one from Anycom, make it simple to transfer media from a mobile phone or camera directly to a television using Bluetooth. The small media-player unit simply connects to an input in the same manner as a set-top box or camcorder.

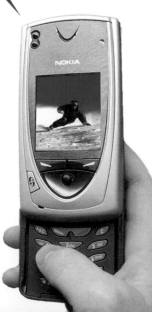

Fig 73—Concord Camera's WIT—Wireless Image Transfer—makes it simple and fast to transfer images from a camera via e-mail.

conventional mobile phone with GRPS. Even video transfer becomes more viable using this method of transmission.

This option is great for downloading images from your camera's memory card without the need to take a computer laptop with you, or even a portable hard-disk storage device. You can spend your time away from home safe in the knowledge that your images will be waiting for you in your e-mail in-box.

Ultimately, expect to see this technology included in some cameras. The extra expense and bulk that an integral device like this would add mean that we are unlikely to see all cameras equipped with it, but as an option in midmarket and professional cameras it is sure to be a winner.

Fig 72—Converting virtually any printer to Bluetooth operation requires only a simple adaptor connected to the USB socket. With this attached, data from a Bluetooth-enabled device is interpreted in a form that the printer can understand, as if directly connected to the device.

phones—to the screen (fig 71).

Although not commonplace, some cameras can also communicate directly with a printer—or a media player—via Bluetooth. Again, it's a simple way to get prints fast without the need to connect cables.

If you are further afield, you have had the capability for some time of using your mobile phone to connect to laptops and cameras to download images, but often the logistics and costs involved limit this option to professionals only.

For the rest of us, there is a solution in the WIT from Concord Camera Corporation (fig 73). The small, palm-sized unit connects to a camera's USB port and allows images to be transmitted wirelessly using fast 802.11g standards. Using this, a five-megapixel image can be transferred in well under a second—1,500 times faster than using a

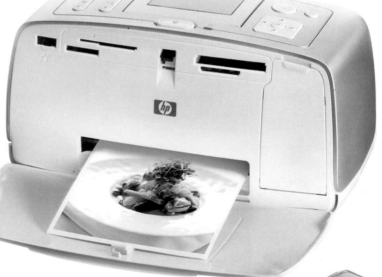

Fig 74—With a compact printer (such as the HP model shown here) and a Bluetooth adaptor (either built into the printer or connected via USB), a portable printer becomes much more viable.

CREATING WEB PHOTO GALLERIES

Web photo galleries are a great way to show your photos in a virtual album. A gallery is also a versatile medium: you can save your album to CD or DVD, on your computer's hard disk, a virtual disk, or on the Web itself. Anyone who has access to the disk or Web can use a Web browser, such as Internet Explorer or Safari, to view and explore your gallery.

Here you will see how to create a gallery using Photoshop Elements.

1. Gather together all the photos you want to use in an electronic folder. This will be your Source folder. If you want to edit your photos—say, trim them or correct any other problems—do it now. You will also need to create a second new Destination folder. This is where all the processed images and Web page files will be placed (fig 75).

2. In Photoshop Elements, choose File menu ····≻ Create Web Photo Gallery. The creation is automatic; you just have to configure the dialog box to get the results you want. From the Styles pull-down menu, choose a style. This will give a look to the Web page (a thumbnail image indicates the appearance of each selection). Also in this dialog box, enter a Banner name in the Options menu. The banner name will be displayed across the top of the page. Optionally, you can enter the photographer's name, date, and even a contact number or site (fig 76).

3. In the Folders section, use the Browse button to

Fig 75

Fig 76

Fig 77

Fig 78

Fig 79

select the Source and Destination folders. These can be placed anywhere, but the Destination folder must not be within the Source folder (fig 77).

4. Image Display. You can choose how images are displayed, along with those of the thumbnails. The thumbnails are the small images that, when clicked on, will display corresponding larger versions. If this is your first time, use the default settings already in place; you can always return later and alter them to get the precise look that you want (fig 78).

5. You can personalize the gallery further by choosing a color scheme using the Custom Colors selection from the Options pull-down menu. Try not to be too radical in your selection. The Web page should be a backdrop to your images, not compete with them for your audience's attention (fig 79).

6. Click OK to start the Web page generation. This will take a few minutes, but you can monitor progress on screen, seeing the thumbnails and Web images being generated. Once complete, the Web browser will open and display your Web gallery (fig 80).

PUBLISHING A GALLERY WITH iPHOTO

Creating and publishing a Web photo gallery with iPhoto is even simpler. Begin by selecting your images from the Photo Library or an Album. Then click on the HomePage button. Choose a theme, enter captions, and hit Publish. Job done. Limitations? You'll need to have a .mac account, and you are limited to the dozen or so themes. But you can have your page on the Web in minutes—great for showing off your day out.

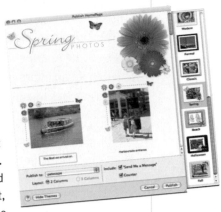

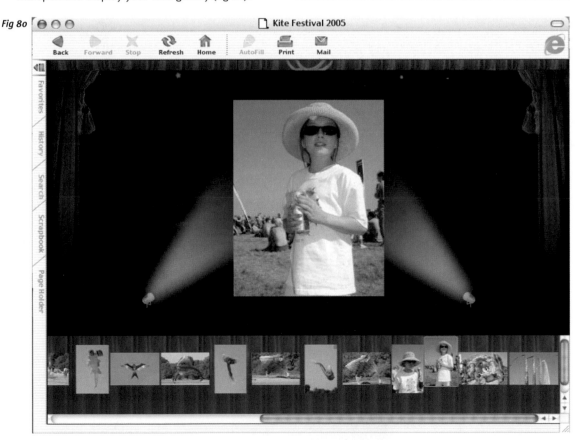

Fig 80

DIGITAL VIDEO

IN THIS CHAPTER WE DISCOVER:
• The roots of digital video.
• How to come to grips with the features and tools of modern digital video cameras.
• How to take an informal video you can be proud to show to family and friends.
• How simple it is to edit and embellish your movies using your computer.

THE MODERN CAMCORDER PROVIDES EXCEPTIONAL PICTURE QUALITY, IS EASY TO USE, AND HAS AN IMPRESSIVE TECHNICAL SPECIFICATION. EFFECTIVE AUTOMATIC EXPOSURE AND IMAGING MODES MAKE FOR GREAT MOVIES UNDER A WIDE RANGE OF CONDITIONS, WHILE THE DIGITAL NATURE MAKES IT SIMPLE TO EDIT AND ENHANCE THE RECORDED FOOTAGE. SOME MODELS EVEN LET YOU E-MAIL MOVIE CLIPS DIRECT FROM ANYWHERE IN THE WORLD.

THE WAY WE WERE

Go back just a few years and you would see things quite differently. First, there were no camcorders as we now know them. You would be restricted to using film-based movie cameras. Though smaller, more compact, and easier to use than those used in commercial filmmaking, they were by no means pocketable. This led to the second difference: moviemaking. Even on an informal level, such as recording family events, you definitely needed to be an enthusiast.

Once the film was processed, you would need to labor at an editing station to trim the movie footage and reassemble the component shots into a logical sequence. Your audience could then sit around the projector and enjoy (or, in most cases, endure) the performance. And a running commentary, rather than soundtrack, would be necessary to add to the atmosphere.

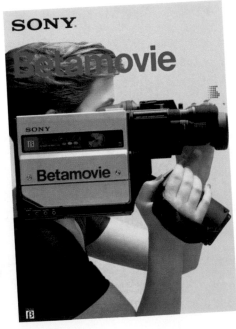

Fig 1—Using full-sized Betamax tapes, Sony's BetaMovie was a first—if bulky—introduction to moviemaking for many in the 1980s.

The dawn of portable video

When Super-8 movie cameras—those that used convenient film cartridges and could be described as the most user-friendly—were at their most popular, around the late 1960s, the first steps towards a convenient, portable video format were being taken. The Sony PortaPak was not portable in the sense we know today, but for a television camera and recording system that could be carried around by one person, it was a breakthrough.

Within a few years, the cameras had become smaller and smaller still, and, moving on from the early monochrome systems, color cameras and recording became possible.

The videotape cassette

Nineteen seventy-one saw the next breakthrough: U-Matic tape cassettes. Until this time, videotape recording had followed the basic format of audio recording, with reels of tape being fed through the machine (except the video tape's path through the

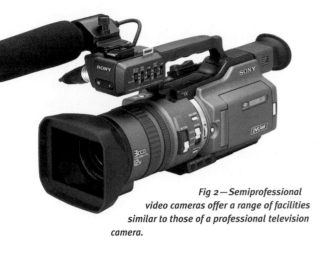

Fig 2—Semiprofessional video cameras offer a range of facilities similar to those of a professional television camera.

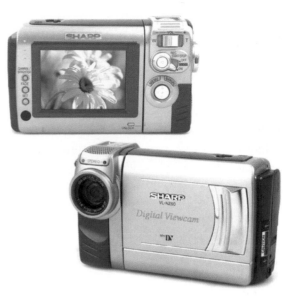

Fig 3—Sharp virtually invented the LCD panel viewing screens with its analog Viewcams. The ability to shoot overhead or at extreme angles was a hit that eventually saw all makers adopt the system. Sharp's Viewcam format—with the screen on the back panel—is now offered in digital form.

recorder was more cumbersome than that of audio tape). With U-Matic, narrow, half-inch tape was contained within a cassette that was simply dropped into the recorder.

Soon Sony revealed that it was working on another format destined for the consumer market. This would offer even smaller cassettes and longer recording time for only a modest decrease in picture quality. This was the format ultimately known as Betamax. In parallel, JVC was developing its own format, dubbed the Video Home System (VHS)—the same one that we still use—if in ever-decreasing numbers—today.

Both formats quickly established themselves for home recording, time-shifting, and the replaying of prerecorded tapes, but it took a little time for portable versions to appear. The first were two-piece units, aping those of a decade earlier. A video camera comprising imaging tubes (rather than the CCDs) would be connected to a substantial shoulder-mounted recording unit. The latter was very similar to its domestic counterpart in size and weight, but often without the timer and tuner features to save weight and cost.

The camcorder is born

In 1982 both Sony and JVC launched single-piece video camera recorders, a name that was rapidly contracted to camcorder. Sony's version was Betamovie (fig 1). A small (for its

day) camera that was generally shoulder-mounted, it contained a full-sized Betamax tape and recording mechanism. As another first, it also featured an electronic viewfinder.

JVC's offering promoted a compact version of the VHS cassette, VHS-C. Although models that used

Fig 4—Even professional cameras now adopt the LCD panel for ease of viewing. Especially convenient when using the camera on the move.

full-sized tapes were offered, they were too large for general use and required the same dedication on the part of the user as had been demanded of the old movie photographer.

Inevitably, size and weight decreased as more and more of the mechanical and electronic components were rationalized and miniaturized, but

VIDEO FORMATS COMPARED
Digital

MiniDV: The most widespread format, it records pictures and audio to virtually broadcast quality. Uses MiniDV tapes that offer recording, at best quality, for up to an hour (longer recording times are possible using slightly lower quality). Video and audio are compressed, but recordings can be easily edited.

Digital 8: This is a similar recording format to MiniDV but uses a tape cassette similar to analog Video 8. Larger tape cassettes (compared with MiniDV) lead to larger camcorders.

MicroMV: A tiny tape format introduced by Sony to enable subcompact camcorder design. Records in MPEG-2 format, similar to DVD. The compression regime can compromise editing, but quality remains high.

DVD: Uses small recordable (or rewriteable) DVD disks to record MPEG-2-quality video. DVD disks can be replayed by most DVD players and virtually all DVD-equipped computers. Editing and copying can be more problematic than with MiniDV or Digital 8.

Analog

Video 8: Sony format designed specifically for camcorders and portable devices. Uses tapes similar in size to audio cassettes. Picture quality is average, on a par with VHS.

VHS-C: Compact version of VHS, using similar-sized tape in a small-sized cassette. Can be replayed in a domestic video recorder with an adaptor.

Hi8 and SVHS-C: "Hi-band" versions of Video 8 and VHS-C offering substantially improved picture quality but still inferior to digital formats.

the next breakthrough would come from an unexpected source. Early in 1984, Kodak announced a new series of camcorders and home recorders based on a new format, Video 8. Sony, one of the codevelopers of the format, released its own version. Suddenly, shoulders were liberated as camcorders became devices that could truly be hand-held.

Throughout the 1980s, the cameras became increasingly complex and more reliable. And they continued to shrink. New recording formats based on a higher frequency of recording produced images

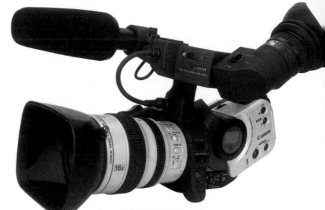

Fig 5—When MiniDV swept the camcorder world and cameras got smaller and smaller, Canon bucked the trend with its XL1. Built with no compromise on image quality or features, it was aimed at the serious enthusiast rather than professional user.

Fig 6—Sanyo's Xacti camcorder uses flash memory to store good-quality video and record still images. It also uses the MPEG-4 format.

of better quality. As users demanded better results, Hi8 and S-VHS appeared.

By the early 1990s the LCD panel appeared on a camcorder for the first time. In a still-bulky Sharp camcorder, video photographers now had the opportunity to photograph subjects successfully from extreme angles and no longer needed to squint through a restrictive eyepiece (fig 3).

The arrival of digital

All these formats shared one common feature: they were analog. We had to wait until 1995 for Panasonic and Sony to release the first digital camcorders. Promising higher image quality— nearly up to the standards of broadcast quality if you were to believe the advertising—and smaller camcorder sizes, they first appeared at the premium end of the market. Again, it was the enthusiast who recognized some of the then-hidden virtues of a digital format. First, the great image quality did not deteriorate in the same way as analog formats. Play an analog tape a few times, and the quality starts to drop. Copy an analog tape between two recorders, and image quality quickly deteriorates. Now, in the digital domain, no such compromises were inevitable—you could replay your clips indefinitely and edit them to your heart's content without losing the original's quality.

Now, digital cameras exist throughout the price and feature ranges, from basic to semiprofessional models. Editing on the computer has become simple and, thanks to new recording formats, you can even e-mail video files. Through this chapter we will explore more about the digital video camera and what can be done with the media. And, now that it's so easy to gather movie footage, we will also take a look at the basic techniques of the video filmmaker to see how to apply them to our own productions.

Fig 7— Samsung's DuoCam uses separate optical systems to record still and video images. As a result, it can record high-quality digital video footage and 5-megapixel still images. The discreet optical systems are precisely matched to each imaging mode. For good measure, it can also record short MPEG-4 clips.

Fig 8—This pocketable MPEG-4 camera can record 2.1-megapixel still images as well as video on a Secure Digital memory card.

CHOOSING A DIGITAL VIDEO CAMERA

There's no doubt that digital video cameras are immensely affordable, and the choice of models is enormous. But how do you make the right choice? You need to establish what you want from your camera. Here is a guide to help you through the maze of options and possibilities. With an eye to the future, you will also learn about the emergent new digital video format—HDV—that will allow us all to produce high-definition video programming.

Fig 9—This enthusiast's model boasts three CCDs for improved image quality and a cracking lens—but it is not the type of camera that you can slip into a pocket.

The following information looks at a range of needs and wishes with respect to:

- The imaging chip—with consequent impact on size and quality
- The lens
- Handling
- Features

The imaging chip

The core of a digital video camera, like its stills equivalent, is the CCD imaging chip. These come in a range of sizes and resolutions, which have an obvious impact on the detail recorded when shooting both movies and still images. Think first about what you will want to record with your camera.

The chip that does so well for still images does not fare quite as well when pushed through the punishing regime of recording the many images per second demanded by video. Shortcomings in the electronics (which for all intents and purposes are rendered invisible for still images) become all too clear. Three-chip cameras can overcome most of the problems. They work by dedicating each chip to record one of the three primary colors—red, green, or blue. The drawbacks are that the cameras tend to be physically larger than their single-chip counterparts, and because they are made in smaller numbers, they are also more expensive.

So how do we analyze the quality of the CCD? One way is to read all the reviews of the short-listed cameras, but this doesn't really address the subjective elements that are particularly important. The best way is to equip yourself with a DV tape (of a format appropriate to your intended purchase) and ask your photo store if you can shoot some footage with each of the prospective purchases. Of course, some stores will say no, but perseverance

Fig 10—Once, a camera like this would have been regarded as tiny. Now, this miniDV model is average sized. But it is fitted with a Zeiss lens and can provide excellent-quality movies.

will pay off and you will eventually find a store that values good customer relations.

Shoot similar footage with each camera. Try to include indoor scenes as well as outdoor ones, making a continuous transition between the two if possible. While outside, take some shots of foliage on trees and also power or telephone lines. The reason will become clear shortly.

With your footage recorded, it is time to study the results. Replay the recording on a television and a computer. Of course, this demands that you have a DV camera already; if you don't, beg or borrow one from a friend for a couple of hours. Check the following:

- *Color accuracy* Is the camera reproducing the scene as you remember it? Are colors faithfully reproduced, or are they washed out or even changed? CCDs are often poor at reproducing

blues—introducing color shifts and noise—so pay particular attention to skies and water. Reds, too, can be problematic, becoming oversaturated and lacking in detail compared with other parts of the image.

- *Tone* Certain cameras have color characteristics. Sony cameras are well known for (when using default settings) veering toward cold, blue tones, while Canon models can be biased toward warm reds. Some models have onboard compensation for these, and it is possible (as with digital still photos) to correct this later, but nothing beats getting a result that looks good (to you at least) in the camera (fig 11).

- *White balance* The automatic adjustment of the CCD recording characteristics to the lighting is crucial in getting quality, authentic results. Test the accuracy of this by recording areas of white under different lighting conditions to see if they exhibit a tint on playback. Test skin tones, too. Do they look natural when you review them?

- *Sharpening* The output from a CCD can be rather soft, and this softness is made worse when

Fig 12—The oversharpening of digital movie images can produce artificial-looking results, as shown in this image.

Fig 11—Different digital video cameras interpret the same scene "normally" in quite different ways. Here, one camera has a warm tone, the other a cold tone.

Fig 13—Even at night, most cameras are capable of giving very good results, maintaining detail until the light levels fall very low.

displayed on a television screen. Taking a cue from television cameras of all vintages, digital video cameras artificially sharpen the images they record so that they appear more detailed when displayed on a television screen. This often has a very positive effect, but the degree of sharpening can sometimes be too extreme and give movies an overprocessed look. Check for this when you review your test tape on both computer and television screens. This is where your footage of foliage and cables can come in handy. The cables will show light halos on either side if they have been oversharpened, while foliage becomes very pixelated (fig 12).

- *Sensitivity* More so than digital still cameras, digital video cameras can work in very low light levels and still produce acceptable results. If you plan to shoot indoors, after sunset, or in any other gloomy conditions, check your camera's performance. How do color and noise (displayed as graininess on the movie footage) change with decreasing light levels? Not all cameras react in the same way. And if you want to work in total darkness, you can even choose a camera that will work with (virtually) no light, using image-intensification techniques (fig 13).

The lens

The CCD may be responsible for ensuring picture quality at an electronic level, but the lens delivers the optical quality. Most digital video cameras feature fixed (that is, noninterchangeable) zoom lenses. These are invariably of very good quality and perform to very high standards. Assessing the lens—to tell a good one from a great one—requires that you look again at the footage you recorded. This time you need to pay particular attention to these characteristics:

Fig 14—Flare, to a degree, is a natural consequence of complex lens structures. To avoid it spoiling your images, ensure that the sun is always behind or to the side of the lens.

- *Flare* We all know the effect—when a camera turns towards the sun or a bright light, internal reflections produce blurred images of the light source. Often used to dramatic effect, some lenses are more prone to this than others. Although the effect does look pictorial, it is best to avoid lenses that produce the most flare. The net result of flare is a reduction in overall image contrast (fig 14).

- *Distortion* Does the image become distorted as you change the zoom from wide-angle to telephoto? Many (if not most) lenses tend to produce some distortion, varying from pincushion (in which rectangular shapes bow outward like the edges of a well-stuffed cushion) to barrel (in which the edges of the same rectangle swell like those of a well-rounded beer keg). Don't dismiss a lens that demonstrates distortion such as this, though clearly, if your main subject area architectural in nature, then this type of distortion will be more evident.

- *Vignetting* This is a name for uneven lighting. In the past, lenses on cheaper cameras of all types used to produce images in which the centers of images were brighter than the edges (the corners particularly). Modern lens design has

Fig 15—Vignetting looks most obvious against a plain background. Here, the sky is obviously darker in the corners.

MAKING AN INFORMED CHOICE

Choosing the right camera needs a little planning and consideration before you rush off to your local photography store. Here are some points to bear in mind:

- If you want movie clips that you can share with friends over the Web or by CD and quality is not of paramount importance, just about any digital video camera will do. The caveat here is that to transfer movies to a computer for editing and conversion, you will need to ensure that the camera has a DV-out connector. This may be marked Firewire or iLink. It is pretty much an essential feature—if not now, then it will be at some point in the future.

- If you are on a budget, don't worry about three-chip cameras. They cost disproportionately more than single-chip models for only an incremental increase in performance.

- If you want to be discreet or always want to carry a camera with you, aim for one of the small miniDV or microMV models (fig 16). As many of the compact digital cameras currently available are so small, they can safely be carried with you at all times.

Fig 16—To illustrate just how small some cameras can be, this microMV model is smaller than a Hi8 cassette.

- If you shoot—or plan to shoot—indoors or in dark conditions, check the low-light performance of your short-listed cameras. Digital video cameras are adept at shooting when darkness falls, but some are more efficient than others. Some will even offer a total darkness mode, which uses image-intensification techniques to shoot in minimal lighting.

overcome the problem, but you may still find occurrences (fig 15).

- *Focusing* Lenses today focus automatically. Some focus precisely all the time, while others tend to hunt for the point of focus—oscillating backward and forward. Hunting increases as light levels fall.

Remember, too, the advice given regarding digital still cameras and digital zooms. If anything, digital zoom ratios on digital video cameras are even more extreme and equally to be avoided.

Handling

No matter how good the optics or the CCD, they mean nothing if the camera is cumbersome or difficult to use. Handling quirks may seem superficial when you first examine a camera, but if they inhibit smooth operation, it will be your movies that suffer as a result.

Once you have analyzed the recordings made with your short-listed cameras, you need to return to the store to make your final decision. Play with your favorite camera. Does the zoom lens control fall easily under a finger or thumb? Can you operate it smoothly? Most zoom lenses now are pressure sensitive—the more pressure you apply, the faster the zoom operates. This is useful—if only to ensure that you never zoom too fast. As any good video photographer will tell you, the zoom feature should be used sparingly when the camera is running, and then only if the zoom is slow and smooth.

Next, listen to the camera. How well does it record sound? The built-in microphones can often give very acceptable results, but their potency can also be their downfall: they can often record the sound of the tape moving through the camera and that of the zoom mechanism, which is another reason for not using the zoom while filming.

As well as these specifics, just hold the camera. You'll get that instinctive feeling if the camera is right for you.

Features

Digital video cameras are loaded with features. Some—sepia toning, mosaics, and the like—are quite superfluous. If you want effects like this, you can achieve them later when you edit the movie on your computer. Others need a closer look.

It is worth reiterating here the need to have a DV-out connection. This, as has already been mentioned, is essential for getting digital video out to your computer for editing. It is also useful, too, to have DV-in. This will allow you to copy the edited video footage back onto videotape.

Most cameras are compatible with most movie-editing software. But if you have a particular camera in mind and already own software, it is wise to check compatibility.

Here are some other features worth considering:

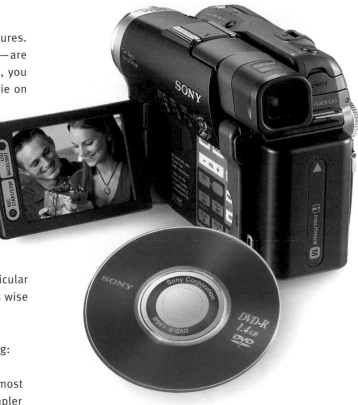

Fig 17—Not all digital video cameras use tape. An increasing number use recordable and rewritable DVD disks.

- *Image stabilization* We hand-hold cameras most of the time, so anything that makes this simpler is to be welcomed. Image stabilizers ensure that any unsteadiness in our hands is not recorded by the camera.
- *Manual controls* Although auto-everything cameras are great for those grabbed scenes, there are times when we need more creative control. This might be for exposure (to preserve low light levels) or focus (to keep the focus on the principal subject) or color balance (for either creative or technical control).
- *Still images* Camcorders have long been able to record still images, but more recently they have been able to vie with low-end digital still cameras in terms of quality. Some offer two megapixels or more, and most offer the option of storing those images on a memory card that is easily downloaded to a computer.
- *Progressive scan* Many cameras feature this, but few users understand it. In progressive scan mode, each frame of a movie is scanned from top to bottom in one pass. Traditionally, only the odd-numbered lines of a frame are scanned in one pass, and these are then followed by the even-numbered lines. The two frames are then interlaced to produce a single frame. Progressive scanning gives a better approximation to the look of the film.

DO YOU REALLY NEED A DIGITAL VIDEO CAMERA?

You may want to record digital video, but do you really want to carry a digital video camera with you everywhere? If you already habitually carry a digital still camera with you, it will probably be capable of taking good video movie clips. If you want to record some movie scenes (rather than create a jaw-dropping blockbuster), this may well be all you require. Quality falls a little short of true DV, and you will be limited in the amount of manual creative control you have, but this feature does come free, so why not give it a try?

HDV: DIGITAL VIDEO FOR THE HIGH-DEFINITION AGE

All the video formats we have explored so far have one thing in common. Although they may vary in quality and purpose, they are all designed for displaying on a standard-definition television, or the computer-monitor equivalent. Yet, as we shall see in Chapter 6, television itself is taking a leap forward. Not just migrating to the digital world, television is moving into the world of high definition, offering sharp, detailed pictures that do justice to large plasma, LCD, and projection screens.

High-definition television is seen by many as the preserve of the major studios—both television and Hollywood—but is that really the case? In fact, no. Creating high-definition movies is something we will all soon be doing.

Enter HDV: a new video-recording format for consumer digital cameras. It has been dubbed the "high-definition format for the masses," as it offers the opportunity to record true high-definition-quality movies but uses the same humble miniDV cassette that has been the mainstay of consumer digital video since its inception.

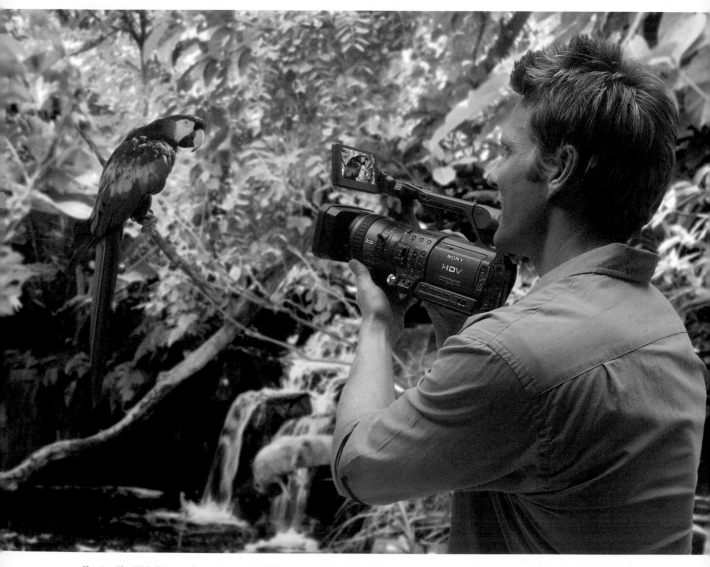

Fig 18—The HDR-FX1 was Sony's inaugural HDV-format camera. Not the first HDV camera (that honor goes to JVC's GR-HD1), it was both the first to offer three-CCD imaging and an excellent price point that puts it within range of enthusiasts. With critically sharp lens performance, it also permits the recording of a standard DV signal as well as HDV.

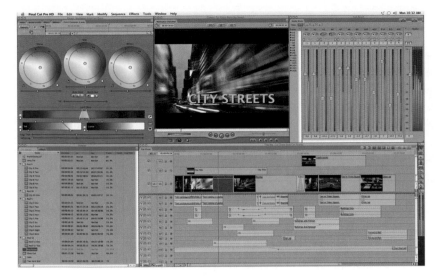

Fig 19 — One for the more affluent enthusiast, Apple's Final Cut Pro has an enviable position in many television production suites, and with the major networks, Final Cut Pro HD makes the powerhouse application compatible with high-definition editing.

format, it is still possible to record one hour of video on a 60-minute miniDV tape, the same as with DV itself. Compare this with the amount of data recorded when recording video from a high-definition television station: on average, it requires six times the space of a conventional, standard-definition station.

Recording HDV is only part of the story. For it to be a successful format in the enthusiast market it needs to be editable in a form similar to that of conventional digital video. Prior to the announcement of HDV, editing high-definition material required computers equipped with potent video accelerators (high-speed versions of the graphics cards so prized by computer gamers), powerful workstations, and professionally specified (and priced) software.

Within months of the announcement of HDV, key players in the software market had announced that they had, or would soon be, producing updates to popular editing applications that would process HDV video using standard Windows and Macintosh desktop and laptop computers.

One of the fundamental edicts of the HDV standard is that it must conform to existing desktop hardware. Hence, the compression of the video and audio is such that it can be passed in real time over FireWire connections, in the same way as standard DV. There is no doubt that HDV will thrive in the coming decade. Cameras are now on sale and at the sort of prices that just a very few years ago would have been attached to high-end consumer DV cameras. HDV is not for everyone, but for those who need the quality and want to exploit the potential of all aspects of high-definition media, it will soon prove nearly essential.

HDV was born, so far as we are all concerned, in 2003, when four of the largest video camera manufacturers—Canon, JVC, Sharp, and Sony (fig 18)—agreed on the format and the common standard that defines it. Since then, other companies have climbed aboard, most notably Adobe, Canopus, and Ulead, which are big names in consumer and enthusiast video-editing software.

The decision to use an existing tape format is, historically, an unusual one, but it is also rather clever. By using the same cassette, tape speed, and recording tracks as the basic format, the mechanical assemblies used for miniDV can also be employed, capitalizing on the all-important, cost-saving economies of scale. For a format that is—to a degree—specialized, but needs a large number of users ultimately to adopt it if it is to be successful, this is crucial in containing costs. It also means that the general market for accessories and add-ons can be shared.

So what does HDV have to offer? It can record either of the two common HDTV formats (based on 720 or 1080 vertical lines of resolution) compatible with both NTSC and PAL television broadcast and replay (though, as a digital format it is strictly independent of these broadcasting standards). Video is recorded in MPEG-2 format, the same as that used for DVD, with the sound recorded in MPEG-1 Layer II format. The latter offers better than CD audio quality.

Interestingly, although HDV is a high-definition

VIDEO-EDITING SOFTWARE

If you already have a perfectly good analog camcorder, why change to digital? I have already alluded to some of the reasons. Even if you have a hi-band analog camcorder (using Hi8 or S-VHS-C), you will notice a huge increase in picture quality and stability. Digital video is often described as being of "broadcast quality," and while it might be splitting hairs to discuss why this is not actually true, the results you see on your television screen at home could be better than much of what you receive over the air.

But for many users, the key attribute of digital video is the ease with which it can be edited. No longer is video editing the preserve of the enthusiast and those with too much time on their hands; with digital video, editing is for everyone. Imagine recording your child's performance at a school play in the morning and distributing edited copies on CD before the end of the day. That's how easy the editing process is.

Video-editing software

Central to all video-editing applications are the same key functions:

- Uploading digital video recordings from your camcorder.

- Cutting your raw footage into individual scenes.
- Allowing scenes to be assembled on a timeline.
- Enabling the editing of audio and the adding of new soundtracks.
- Creating transitions and fades between scenes.
- Adding titles.
- Exporting your finished movie to disk, tape, or whatever medium you choose.

And you may want some additional features such as:
- Filters and effects.
- The option of importing and converting video from other sources.
- Importing images for video slide shows.

Video-editing software, like image-editing applications, tends to fall into one of two broad categories: professional and consumer. The distinction between categories is rather fuzzy: many amateur users invest in professional-grade applications, and a surprising number of professional users use consumer-level products for some of their projects.

Professional video editors

Professional products are characterized by cost and functionality. Like their image-editing counterparts, these applications will enable you to do just about anything. The trouble is, they are so well specified that for most of us just knowing what to do first can be a problem. So comprehensive are the features that simple activities can seem overcomplex. This, of course, is ideal for the more experienced user, or the user who is seeking to make a totally professional-looking movie. But for the rest of us, it is probably overkill. And the price will probably exclude

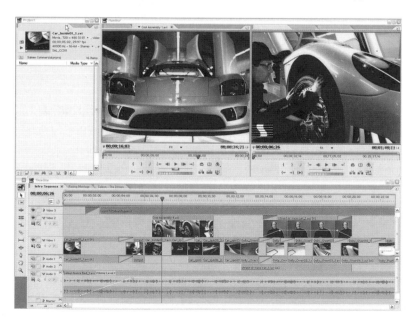

Fig 20—Adobe's Premiere is a professional-level product and is demanding on users. But if you are serious about moviemaking, it is a tool that will grow along with your skills.

Fig 21—Featuring many of the key functions that makes Final Cut Pro a market leader, Final Cut Express will satisfy the needs of many serious enthusiasts who have graduated from consumer-level products but can't financially justify going the whole way to a professional product.

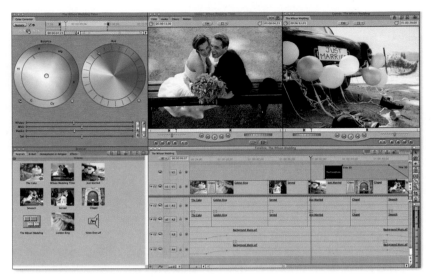

them from your short list.

If, however, you have had experience of the consumer-level products and have been bitten by the moviemaking bug, then do audition these professional applications. For the PC there is Adobe's Premiere (fig 20). Like its stablemate Photoshop, this is one of those applications by which all others are judged. It really does do just about everything.

If you are a Mac user, then it is Apple's Final Cut Pro (fig 21). This is another professional powerhouse of a program and one that is used extensively by semiprofessional users through to the big studios and television companies. With an eye to the increasingly demanding enthusiast marketplace, Apple has produced a trimmed-down version of Final Cut Pro called Final Cut Express. It is a great halfway house, offering much of the functionality of its senior, but without the sobering price tag.

Consumer video editors

At the other extreme—in price terms—come the consumer-level video editors. Simplicity of use is the keynote to these applications, but that doesn't mean they are short of functions. You can expect to see all of the key features we noted above included as standard and quite a few extras, too. The most popular of these applications, by virtue of being included with their respective operating systems, are Apple's iMovie (fig 22) and Windows Movie Maker (fig 23). There are also some great third-party products (from the likes of Ulead) that provide similar tools at a remarkably low cost. In fact, many digital video cameras feature such a product in the software bundle that accompanies them.

Fig 22—It can't claim to have created the digital video-editing explosion, but Apple's iMovie has launched many people into a new creative hobby. Intuitive interface and logical operation make movie generation and distribution simple.

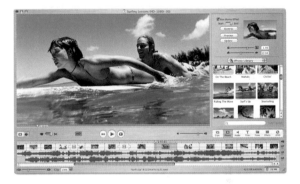

Fig 23—Aping many of iMovie's features, Windows Movie Maker is a great tool for quick movie editing. The only drawback is that the slightly limited features list may stunt the creativity of users as they gain experience.

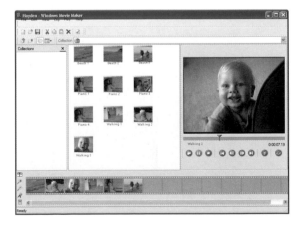

Fig 24

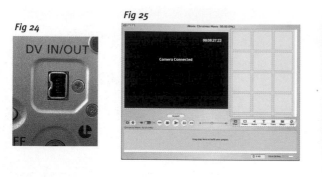

Fig 25

Fig 26

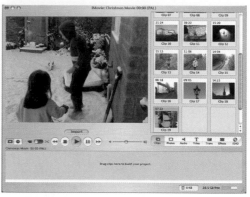

Editing your first movie

"Digital movie editing is simple." No matter how often it is said, most of us are cynical, often to the point of not trying our luck. Part of the fear is down to the software. To the uninitiated, even simple applications look complex. But approach a project in a step-by-step fashion, and you will be convinced that the process really is simple. You will soon be attacking all those archived video tapes with fervor. For clarity, the following work has all been based on iMovie, but the general method of working will be the same with most equivalent applications.

1. Connect your camcorder. The importance of a Firewire connector on your camcorder has already been mentioned (see pages 74–5). This is where you make use of it. Connecting the camcorder and computer by Firewire will enable the copying of the video data to the computer in real time. There is a great deal of data, so a fast, reliable connection is essential (fig 24).

2. Once connected, the software will recognize the camera and display "Camera Connected." This does depend on the software and the camera. Not all are immediately compatible, though even nominally incompatible pairings can often be "forced" in to communicating (fig 25).

3. The camera is now under the control of the software, and you can download the video recording. Watch as the tape plays. The software will automatically identify each scene. Each scene is automatically saved as a separate movie clip (fig 26).

4. Once downloading is complete, you can begin editing. Note that at this time you don't need to have your camcorder attached. Drag the clips from the panel (sometimes called the shelf) onto the Timeline. The Timeline represents the finished movie. You can drag clips here in any order, so if you have shot scenes out of sequence, you can reconstruct the storyline here (fig 27).

5. You don't have to leave each clip as you shot it. Chances are, you will want to trim off superfluous

Fig 29

Fig 30

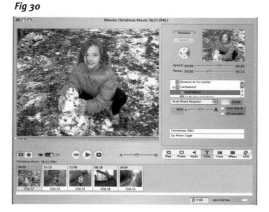

Fig 27

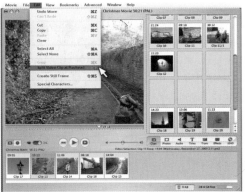

Fig 28

parts at the beginning or end. You can trim your clips precisely using the main window (fig 28).

6. You can improve the flow of your movie by adding transitions between scenes. Take a look at television programs and movies. See how scenes flow together better when one scene fades into another, or when one fades out to black before another fades in. You can use the Transitions folder to add similar transitions yourself (fig 29). *TIP: Don't add too many transitions, and try to refrain from using some of the wilder ones. They may look novel the first time, but your audience will soon tire of them.*

7. Add titles. Often the best titles can be caught on tape, by recording, say, the program for the play or musical you are filming or perhaps the entrance of a theme park if your movie features a day at that park. But if you need to create your own, click on the Titles tab and make your choice. Again, go for simple, bold titles. Those that have too many words or use a difficult-to-read font (typeface)

tend to annoy viewers, who will struggle to read them (fig 30).

8. If you want to, or if your story requires it, add special effects. Special effects are many and varied but can, for example, turn your movie into black and white (and perhaps give it a jerky, silent-movie look) or sepia-toned, or they can give it a soft-focus appearance. These can be really effective when used appropriately but can be equally irritating if used often or recklessly (fig 31).

9. Save the finished production. Give your movie a critical appraisal and, if nothing needs changing, save it. You can save it on your computer's hard disk, but as movies tend to consume large amounts of hard-disk space, a better bet is to record it back, at the original quality, to DV tape. You can do this by reconnecting your camcorder and recording to a new tape. Never delete or record over the original footage—you may need to recompile a video later and will then need this source material (fig 32).

Fig 31

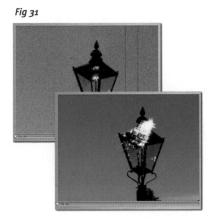

Fig 32

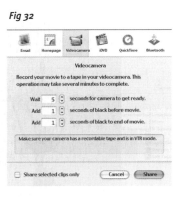

Sharing your movie

Exporting your finished movie ensures that you preserve it at the highest possible quality. DV provides the optimum quality for your work, but it is not necessarily the most effective for sharing. How you share your production will depend on the audience. Here are the options:

- VHS video
- DVD
- CD-ROM
- E-mail

VHS video

Although recordable DVD is rapidly replacing the humble VHS video recorder as our recording tool of choice, the wide user base and our enormous collections of video material will ensure that the VCR remains with us for some time to come. You can copy your movie to VHS video tape in two ways.

The first method uses the DV recording you made back to the camcorder. You can now hook up the camcorder to your VHS video, using the cabling that is normally supplied with the camcorder (or replacements that are widely available). Set the camcorder to play and the VHS video to record simultaneously. With the television set to the video output, you can monitor your recording while it is in progress.

The second method requires a digital-to-analog

ANALOG-TO-DIGITAL CONVERSION

The digital-to-analog converter already mentioned for making VHS copies of your DV videos can also be used in reverse—to make digital video copies of your VHS (or other) analog videos. You can connect your video player (or even your television) to the input and then import the video in digital form. Many video-editing applications will recognize the converter as a camera and import the recording in a similar way (fig 33).

converter. This connects your computer and the VHS video, and the device will, in real time, convert the digital video output of the computer to analog video that can be recorded on the videotape. It is fast and effective, but it does require the additional hardware. These units are getting progressively cheaper, so it could be a good investment if you plan to make many copies of your movies.

Use: when compatibility with computer nonusers is important.

DVD

With DVD burners proliferating, you can easily convert your DV movie on your computer to DVD-format media files. If you have used iMovie, you can

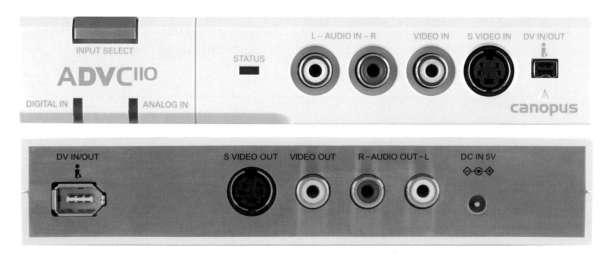

Fig 33—Analog-to-digital converters (such as the ADVC110 from Canopus, shown here) allow two-way conversions between digital video and analog video. Connectors on the front and back provide pathways for signals in either direction.

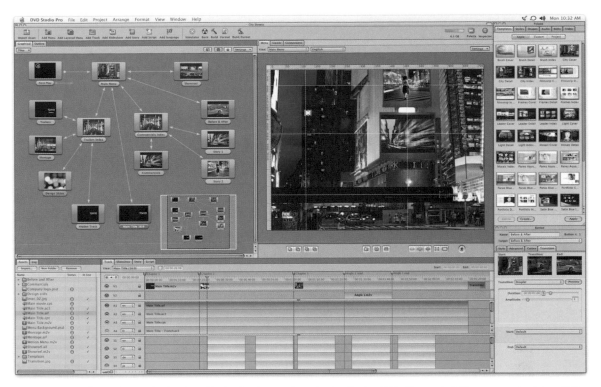

Fig 34—DVD Studio Pro is a professional application for those serious about authoring DVDs. You can build in very complex interactivity and animated menus—if that sounds familiar, it is because this is the tool used by many studios in creating their commercial DVDs.

click on the iDVD button to compile these directly. Otherwise there is a range of applications that will produce the respective files for you. You can even add animated menus, chapter breaks, and submenus, just as in a commercially produced DVD. Compiling the media files can take some time (there is some serious reprocessing to be done), but the result is a DVD that best displays the quality of digital video.

If you have a DVD recorder attached to your television and that recorder has a Firewire link (iLink), you can even record directly from your computer to the recorder. This is a great option if your computer does not have a DVD burner, but it doesn't give you the option of adding menus and breaks.

If you have a CD burner on your computer and your movie is short, you can make a Super Video CD or miniDVD. Take a look at page 103 for more about these obscure but useful formats.

Use: when quality is paramount.

CD-ROM

If you don't want (or need) the highest of quality, you can record your production to a conventional CD. Your image-editing application will have several qualities available—usually encoded into Quicktime format—from which to choose. If you are distributing your production by CD, it makes sense to choose the best quality that will fit on the disk.

Use: when maximum compatibility with computer users is essential.

E-mail

The most compact of the Quicktime formats produces a small, compressed version of the movie that is ideal to e-mail to people. Such e-mail-quality movies can still be quite large, so you will need to establish that your recipients can receive large attachments before sending. Or you could try using a format like DivX (see page 86), which can compress a video to a much higher degree than other formats without significant loss of quality.

Use: for the delivery of the smallest possible file size.

TIPS FOR SUCCESSFUL (AND WATCHABLE) DIGITAL VIDEOS

Whether you are new to digital video or an old hand, you will be in no doubt about the superlative quality of the medium. But does that make your movies watchable? Often the answer is "No." Even your closest friends will feign illness or book a vacation to avoid an invitation to see your latest production. Here are some tips for making your movies stand out—for the right reasons.

Be dispassionate

What you consider the best parts of your movie may not be what others enjoy. Your children are lovely, and photogenic, but friends may not want to see them onscreen for hour after hour.

Tell a story

Whether you are creating a blockbuster or documentary or even recording a sports event, you need to tell a story. People expect a storyline no matter what the subject. Scribble a storyline first. Even if your subjects don't obviously suggest a story, begin by noting down your aims, objectives, and intended conclusions. Making a documentary? You still need to set the scene and describe your intentions; then, at the end, you'll need to wrap up the production with some form of conclusion.

Think first, shoot later

The beginning of a movie project is characterized by a high level of enthusiasm; as the project progresses, it becomes more workmanlike. This is unfortunate, because the audience picks up on your enthusiasm, or lack of it. When shooting, think about what the audience will appreciate. If you are shooting a long stage production at your children's school, for example, vary the shots so that you don't simply have a view of the whole stage all the way through. Shoot cutaways—shots of the audience smiling and applauding. You can intersperse these in your recording if you need to trim out sections without loosing the continuity (fig 35).

Keep still!

There is a terrible temptation with any movie camera to move the camera around while shooting. Nothing is more certain to induce vertigo and motion sickness in your audience. Unless there is a real reason to move the camera, perhaps to follow a moving object, let the subjects create the motion. If your camera does not have an image stabilizer, if you

Fig 35—Audience shots and other peripheral scenes are great for cutaways—scenes that can be used to link two other shots, usually where you have deleted parts.

Fig 36 — Poor-quality shots such as this have no place in the finished movie, no matter how much they mean to you. Cut them.

don't have a particularly steady hand, or if you are using the zoom at its furthest extension, consider investing in a tripod or other support to minimize unwanted camera shake. Improvise using a wall, fence, or even a chair if you are caught without any custom support.

Think sound

When shooting movies, we tend to labor over the images and neglect the sound. Until you come to edit, you don't realize how much superfluous noise there is or, worse still, how little valuable ambient noise you have recorded. Consider an accessory microphone. These will ensure better sound quality, and many models let you "zoom" with the lens to record relevant sound rather than too much of the distracting environmental noise.

Consider, too, the sound that you want to use as a soundtrack later. You can add any music at the editing stage, but it can be useful to record some movie footage purely for the sound. Street carnivals, the beach and sea, even city noise can all add to the atmosphere of your finished movie.

Cut the junk

Quantity is no substitute for quality. When you tell a story, remember that it is the essence of the story that is important. If you want to convey your journey to a distant country, shots of the departure lounge, aircraft, and arrival are quite sufficient. There is no pictorial, emotional, or storytelling benefit in endless footage of airport terminals—even if you

want to tell everyone about the interminable wait you had. Any blurred, badly composed, or irrelevant shots? Cut them. You'll still have the shots on the original tape if they are important to you, but the tightly cut finished movie will run so much better without them (fig 36).

Don't shoot the movie in-camera

Many video photographers aim to shoot the whole movie sequentially, in-camera, thinking that it will save work later. In fact, the amount of work saved is minimal—you will still have to trim shots and delete some altogether. By shooting in a linear manner, you can compromise the content; be prepared to shoot elements out of sequence and reassemble later.

Shoot visual titles

Shoot scenes that imply what you would otherwise need written captions for. Wordy titles can be used sparingly, but if you can achieve a similar inference with a visual, go for it. A shot of the sun rising, for example, or a caption saying "Morning" (figs 37–39). Which do you think your audience would prefer?

Fig 37 — A scene like this implies morning.

The Big Day

Fig 38 — Effective, but dull.

Fig 39 — It may be the wedding day, but the scene implies morning again.

DIVX: MP3 FOR MOVIES?

Once MP3 became the standard for digitally distributed music, it seemed inevitable that an equivalent system for video media would appear. And it did. It is called DivX (note the capitalization—it becomes important later), and, like MP3, it enables high-quality files to be produced from original media that are substantially compressed. With DivX encoding, you can squeeze a DVD's worth of movie material on to a standard CD-ROM disk.

DivX achieves its impressive compression by employing MPEG-4 (see page 346) rather than the MPEG-2 used in DVDs. Like MP3, the compression is substantial—files are between 12 and 20 percent the size of the original. Also like MP3, software for DivX encoding is freely available on the Web.

What you need for DivX

Take a look around the Web, and you will see not only encoders but value-added tools that make the process simpler. If you want to enjoy DivX content (and there's a lot of it about), all you need is a DivX codec. You can download one from www.divx.com for any computer platform. Unlike some codecs—the software applications that replay video media—this basic and free installation will play back absolutely any DivX file. It acts as a plug-in to Quicktime (or other media players) and will replay your movies in that player, giving you all the control you're used to.

You don't have to stop with simply replaying existing DivX media. You can create your own DivX movies from your own movies. Encoding is virtually as simple as replaying. Read the blurb on DivX and it will extol the power of the format and how you can enjoy your movies without loss of quality. A little caution is required, however. With MP3 there are audiophiles who will immediately detect and point out shortcomings that limit the audio quality. Likewise, those with a sharp eye will spot visual compromises brought about by the compression. But for most users, this will be a small price to pay for the amount of hard-disk space that is liberated.

Spreading the enjoyment

It is likely that you will use DivX extensively on your computer, but you can also enjoy DivX-encoded disks throughout your home using one of the increasing number of compatible DVD players. Just as CD players can, increasingly, also play MP3-encoded disks, so it is the same with DVD players. You can enjoy a DivX-encoded disk in the same way as a traditional DVD. Expect to see this functionality spread and, in the same way that MP3 music can be shared around the home from your computer, wireless and Ethernet connections delivering DivX directly from your computer's hard disk. You will also find an increasing number of PVRs (see page 91) offering the option of compact DivX recording.

CREATING YOUR OWN DIVX RECORDINGS

Once you have downloaded the free DivX encoder, you really are ready to go. Here is the encoder dialog box from DivX Pro (fig 40). You can refine the encoding by altering the parameters (though most encodings will be fine using the default settings). You can use DivX recordings across a range of devices, ranging from hand-held PDAs through home theater television systems and high-definition television. Make sure you click the appropriate button for optimum performance.

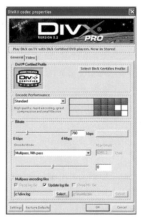

Fig 40—The main screen of the DivX encoder.

Fig 41—Make your encoding suitable for the replay device by clicking on the appropriate button.

DivX & MPEG-4 FREQUENTLY ASKED QUESTIONS

Q: What do I need to play DivX movies or programming?

A: You'll need to install a DivX codec on your computer. These are available for all computer platforms at Web sites such as DivX.com or DivXmovies.com. Some computers now come preloaded with DivX players. You can also play DivX movies that have been written to CD on many compatible DVD players, direct to your television.

Q: Will any computer play DivX movies?

A: Assuming the codec is installed, most computers will play back programming. The better specified, the better the overall quality will be. DivX experts suggest that a Pentium 300Mhz Windows PC and a G3 Macintosh are the minimum-spec machines.

Q: Can I find DivX programming and movies on the Internet?

A: Yes, there are a number of resources available. Try a Google search for some suggestions. You'll also find sites like DivX.com featuring showcases of programming. Take care not to download illegally encoded material, however!

Q: How long does it take to download a movie over the Internet?

A: It will depend on your connection. Cable modems will download two minutes of movie in one minute; other connections will take proportionately longer.

Q: What is H.264?

A: Not a memorable name, but H.264 is another MPEG-4 codec that can offer quality akin to that of MPEG-2 but at only half the data rate. It is a scalable format, which means it can be used in devices with limited bandwidth (such as 3G mobile phones) though to high-definition television broadcasts.

Q: Is H.264 the same as DivX?

A: Not quite. They are both derived from the MPEG-4 standard, but the coding is slightly different. H.264 is sometimes known as AVC or JVT.

Q: Who uses H.264?

A: You will find H.264 in Quicktime 7. It has also been made mandatory for the Blu-ray and HD-DVD formats, assuring that it will be a key feature of the future developments in movie formats.

Q: How do DivX, MPEG-2, and H.264 compare?

A: Here's a visual demonstration of the qualities of each. Don't worry if you don't see major differences in quality—each is very subtle, and overall quality ranges from very good to excellent (fig 42).

Fig 42—DivX, H.264, and MPEG-2. Differences are clearer in detailed areas (such as foliage) that are the most difficult to encode fast.

VIDEO & AUDIO RECORDING

IN THIS CHAPTER WE:

• Explore the evolution of video-recording formats from early reel-to-reel systems to today's PVRs.
• Examine different formats for recording sound and audio at home.
• Look at how simple it is to produce DVD video recordings of treasured videotapes and even off-air programming.
• Look at the future of recordable media.

THE VIDEOCASSETTE RECORDER WAS, FOR SEVERAL DECADES, A PIECE OF "MUST-HAVE" TECHNOLOGY. WITH IT WE WERE FREED FROM THE SHACKLES OF THE TELEVISION SCHEDULES, AND IN A WORLD WHERE THERE WERE ONLY A HANDFUL OF TELEVISION STATIONS, IT PROVIDED THE MEANS TO PLAY ALTERNATIVE PROGRAMMING.

THE DAYS OF THE VIDEOCASSETTE RECORDER NOW SEEM NUMBERED AS NEWER TECHNOLOGIES SUCH AS RECORDABLE DVD AND PERSONAL VIDEO RECORDERS—PVRS—BECOME COMMONPLACE. BUT THE NEED, THE RATIONALE, OF VIDEO RECORDING IS AS IMPORTANT AND SIGNIFICANT NOW IN OUR WORLD OF SEVERAL HUNDRED TV CHANNELS AS IT HAS EVER BEEN.

VIDEO ON FILM

In the 1950s the only viable option for recording television pictures and sound was the Kinescope, often called telerecording. This was a specially constructed 35mm and 16mm movie film camera whose speed of shooting was precisely matched to the frame rate of the television monitor, mounted in front of the lens. Today, this seems a remarkably

Fig 1—Looking for all the world like the reel-to-reel audio recorders of yesteryear, the first video recorders aped their audio cousins. These models from the 1960s used one-inch magnetic tape to record in black and white (in the case of the Ampex) and color (the Sony). The size and cost limited use to professional and semiprofessional studios.

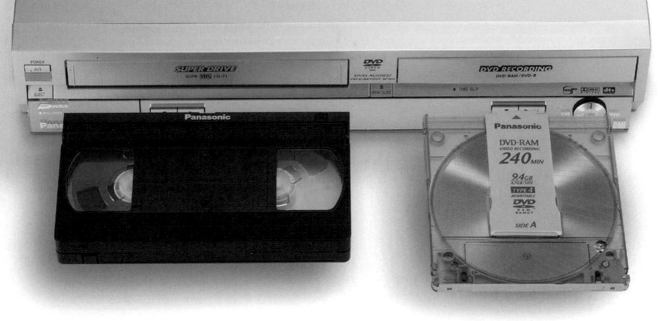

Fig 2—Combined DVD and video machines allow users to access their library of media and make the best possible recordings of contemporary programming.

crude system, but it was one that survived for many years, even after video recording onto tape became viable. For the studios it allowed overseas sales—often overseas markets were able to screen 16mm film stock but not videotape.

Surprisingly for a system that notionally demands a very professional configuration, there was a thriving enthusiast market for telerecording equipment. And "enthusiast" was a very apt term. Unlike the essentially passive nature of video recording today (where the recording activity takes place in the background and does not influence our live viewing preferences), telerecording required that the television screen used for the filming be shrouded in a box or curtain that excluded all external light. This would make the television program impossible to watch live.

There's evidence that organizations like the BBC were still making telerecordings in the early 1980s because it was often cheaper—at the time—than using one of the handful of quality video recorders then available. Ultimately, telerecording gave way to the use of domestic video recording techniques for those recordings that did not demand the highest quality.

GETTING IT TAPED

But what of video recording itself? We explored the broad chronology of video with regard to digital video in the previous chapter. The story of off-air video recording (that is, recording broadcast or prebroadcast programming) is much the same, though the highlights are somewhat different.

The first high-profile use of a color videotape recorder was in 1958 when manufacturer Ampex took a unit to Moscow to record a meeting between Richard Nixon and Nikita Khrushchev. The recording was aired in the United States on their return. Prior to this, monochrome systems, using 13mm reel-to-reel videotape was used with moderate success in

the training films market. Similar systems were used to distribute programming to schools and colleges well into the 1970s. If it were connected to a suitable television (one of the rare "studio-grade" monitors offering direct video-out signals), it was even possible to record television programs manually.

Around this time, as we've already seen, Philips introduced its original videocassette format. Although the recording time was only one hour, this compared favorably with the reel-to-reel systems. The crucial difference (apart from the obvious one of the simple-to-use tape cassette) was that these domestic units featured a tuner. Users could now set the timer to switch the recorder on when a program was due to begin and record that program unattended (or at least until the tape ran out). With analog timers (which owed more to the timer units found on kitchen stoves than electronics) and a paucity of prerecorded tapes, take-up of these machines was limited.

FORMAT WARS MOVE INTO THE HOME

It would be the end of the decade before Sony's Betamax and JVC's VHS became widely available, joined later by Philips's V2000 format. The former two formats entered the fray with large, cumbersome machines that often featured mechanical rather than electronically based controls. Timers were digital but still limited. Often they would offer only one program-recording option, requiring any user to preselect a channel from which to record.

Despite its clear technical superiority, Betamax languished in the sales tables, up against the marketing muscle of the VHS camp. Although it survived as a minority format for some years (and longer still in the United States), it eventually—and rather quietly—disappeared, supported only by a few devotees. Many reasons are quoted for the success of VHS.

At launch it offered longer recording times— essential for recording long programs, and a more economic option.

Marketing: JVC licensed many companies to produce VHS machines, allowing brands ranging from the prestigious to the budget to produce equipment. More market sectors could be catered

to, yet JVC would get their royalty payments all the same. Sony, by contrast, only had limited licensing that essentially only included Sanyo and their respective affiliates.

VHS offered the largest library of prerecorded programming. Video stores were loath to stock multiple copies of each title in two formats, so they tended to skew their stock towards the biggest-selling format, adding pressure on those buying new machines or upgrading

In reality it was a combination. Yes, Beta was technically better, but for many consumers price was the most important issue. Average television screen sizes at the time were around eighteen inches (45 cm), and many were badly tuned. Performance gains owing to Beta would be largely lost.

Ironically, quality did become an issue with an increasing number of users. JVC's answer, as we've seen, was the higher (but not high) definition of Super VHS. Sony had also released—on a more limited basis—similarly engineered improvements to the Beta format: Super Beta and, best of all the analog formats, Extended Definition Beta. But for the declining format it was too late. Although quality was promised and delivered, by now most users had cupboards and shelves full of VHS recording they needed to replay.

VHS'S DIGITAL EDGE

For the digital age, aiming to ensure that VHS survived the impending DVD recording formats, JVC announced yet another variation on the VHS theme: Digital VHS. Backwardly compatible with VHS and Super VHS— ensuring that people's tape collections were not

Fig 3—Sticking with VHS to the bitter end, DVHS gives the edge of Digital to a format that has been in use for decades.

disenfranchised—Digital VHS can support high-definition broadcast recordings (see page 111) and can store up to forty-nine hours of recording (standard resolution) on a single tape.

No manner of embellishments to VHS could stave off the onslaught of DVD. Cheap, robust media, easy access to content, and compactness meant that the day of DVHS was short-lived, again save for the devotee market.

DVD, then, seemed to have a clear run. And it would have were it not for the rise of an interloper: the Personal Video Recorder, or PVR.

Not personal in the sense of a personal CD or MP3 player, PVRs are video recorders that use computer hard disks to record on. There's actually nothing novel in that (you can record DVD-quality video and audio to and from your computer hard disk), but the "personal" element comes to the fore with the programming capabilities. Rather than the problematic timing programming offered on conventional tape or DVD recorders (how many of us technophiles have recorded the wrong program, wrong station, or failed altogether?), PVRs offer intelligent programming that can, from historical data, predict programming we like and automatically record. We'll look at these in more detail shortly.

GOODBYE TO TAPE?

So does it mean that tape—as a recording medium—is about to enter the history books? Quite possibly. Tape—and the same applies to audiotape as to videotape—is a reasonably robust medium that can, when looked after, provide many years of great service. It has the benefit of being cheap: you can store many gigabytes of data (or the equivalent of many gigabytes of data) for far less than you could an equivalent amount using, for instance, solid-state memory chips.

Tape, though, has lost its competitive edge in other areas. One, as we have observed already, is access. We are used, today, to being able to access a specific track or recording on a CD, DVD, or hard disk in just a matter of seconds (and often less). The need to wind tape and then detect a recording's start position takes far longer. In the modern world we no longer have the patience!

Being a contact medium, tape also wears, resulting in continual degradation. Video recorder manufacturers have been particularly adept at minimizing the wear of tape (and, indeed, the recording heads themselves) by careful use of air flowing over the heads to provide a microscopically fine "air cushion." Even so, after repeated recording and playback cycles, or playback cycles alone, tape does wear.

In analog recordings, this means the picture gets steadily worse, with softer colors, lower contrast, and noise. Digital recordings survive better to begin with: error correction and digital techniques ensure that playback quality is maintained for as long as possible. But, ultimately, the recording will fail—completely. When it becomes impossible for the error correction to correct worn parts of the recording, it gives up. The screen goes blank.

So, for our consumer recording formats, expect disk and solid-state memory card–based recording to see us through the next few decades. The day of tape recording is fast coming to a close.

CREATING YOUR OWN DVDS

Creating your own DVDs—with all the features that you would expect from a commercial product—is now simple and provides an excellent way to present your old movies, photos, and even television archives (fig 4).

The process can be split into simple steps:

1. Collecting media and starting the project.
2. Choosing a theme.
3. Adding a movie or programming.
4. Creating menus.
5. Optional additional resources.
6. Burning the DVD.

Collecting media and starting the project

Think of those commercially available DVDs. They usually comprise a movie or, perhaps, a television series. Then there will be the extras. Perhaps a "making-of" documentary, outtakes, and even a gallery of still images. When you prepare to create your own DVD, you need to gather the corresponding resources. These may comprise a movie (or movies), photos, and even audio files.

These will need to be in a format that the DVD-authoring software will accept. Often this is the same format used for the conventional storage of such media, such as DV for digital video, JPEG for images, and MP3 for audio (MP3 is defined, after all, as the audio component of DVD video).

It makes good sense to gather all these resources together in an electronic folder. Prior to this, you need to ensure that you have edited the video to your total satisfaction and manipulated your images so they are as you want them to look.

Now you are set to start creating your own DVD. Here, iDVD is being used. This is a simple application that actually behaves in a very similar manner to other applications and follows logically from iMovie (see page 79).

Fig 4

After opening iDVD, you are prompted to open a project or, if you have no saved projects, to create a new one. Choose a location to save your project (which will include all your media, ultimately) and click Create.

Choosing a theme

When you play a commercial DVD you rarely play the main feature movie directly; instead you are presented with an often-animated front-screen menu. In the world of DVD creation, this page, its menu, and any submenus are described as a "theme." You could spend a lot of time creating your own, unique theme, but it is often easier to choose one of the many preset themes provided with DVD-creation applications (fig 5).

Fig 5

Fig 6

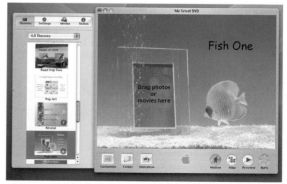

Fig 7

AUTOPLAY MOVIES

Back to those commercial DVDs. Remember how some have a short movie that plays before the menu appears? Sometimes it is an all-action highlights trailer of the main movie, sometimes a promo for other titles from the same studio. You can add your own movie that plays automatically when the DVD is put in a player—it is called an autoplay movie. Only some themes include the option to feature an autoplay—these are indicated in iDVD by the disk icon in the top left-hand corner of the theme thumbnail.

- In iDVD, you can see the available themes in the Customize drawer. Click on the Customize button to open the drawer and then the Themes button at the top. To see all the available themes, click on Choose All.
- Some of the themes contain animations, slide shows, or even movies. Click on the Motion button to see these features in action accompanied, where configured, with an audio soundtrack (fig 6).
- Select a theme. In this selection, Fish One, there is an animated background (the fish) and a photo frame (fig 7).
- Click on the Media tab at the top of the Customize pane. You can choose, from the pull-down menu,

Audio, Photo, or Movies. If you choose movies or photos, you can drag a selected item, or items, to the area on the theme window labeled "Drag movies or photos here." This is known as a drop zone. If you choose photos, you can select more than one image to be displayed; they will then play in the window as a slide show. Here, three images have been selected and placed into the drop zone (figs 8, 9).

- Some themes feature multiple drop zones. These can be useful for displaying a clip from different parts of a movie, but don't go overboard. Make it simple for your viewers to navigate your production.

Adding a movie or programming

Adding a movie or other programming material to the DVD is also a matter of dragging and dropping.

- Drag the movie (or rather, the movie icon) from the folder to the theme window, taking care to avoid the drop zones. You will see the file name of the movie appear in the window. Two buttons are then created: a Play button (which lets you play the whole movie from the start) and a Scene Selection button. This will link to the scene-selection menu (which will be examined more closely in a moment) and will ultimately allow you to choose individual scenes in the movie.
- Scene selections are possible only when, in video-

Fig 8

Fig 9

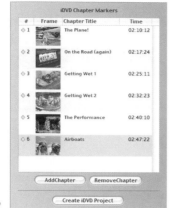

Fig 10

Fig 12

editing software, you have added chapter marks. Increasingly, more and more video-editing applications provide this option; alternatively, some DVD-creation applications allow you to add breaks retrospectively. Here are the chapters created for this movie, generated from iMovie (fig 10).

- Where there are no chapter marks, you will usually see only one button with the same title as the movie. When you click on this, the movie will play in the same way as if you had clicked on the "Play" button described above.

- If you now click on the Scene Selection button, you will see buttons for each of the chapters that were created in the movie, each named according to the name that you gave the chapters when

compiling the movie. Again, depending on the theme, you can display images to correspond to each chapter; these may be still images dragged from a photo folder or could be still-image thumbnails taken from each of the chapters. Here is the same scene menu using two different themes, one with thumbnails, one without (figs 11, 12).

- Want to give your menu window some background music? Click on the Media tab again and choose Audio. You can now pull in an audio file from the folder containing your resources. In this case, with iDVD you can also access the iTunes library of music (fig 13).

Fig 11

Fig 13

- It is worth mentioning copyright here. If you are creating a DVD of family events for your own enjoyment, there is no practical restriction on the resources you can use. But if you want to show your production—even to close friends—including copyrighted music might be illegal. Make sure that you use copyright-free or royalty-free music (often produced specially for the purpose) to avoid any possible litigation.

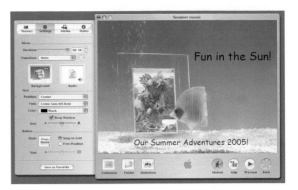

Fig 15

Creating menus

Themes make it simple to get great menus fast, but often you will want to refine them slightly. Perhaps the text size is too small or maybe an inappropriate (to your movie) color. Some changes have already been made (by adding music), but here are some other personalizing options:

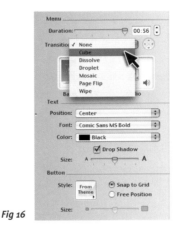

Fig 16

- To add more text to the window (a description of the options, some helpful hints on which button to press, perhaps) click on Project ⋯⋗ Add Text. Text will appear automatically, and by clicking on it, you can overwrite it with your own words (fig 14).

Fig 14

- In the Settings pane of the Customize pull-out, you also have the opportunity to change the text color, font, and size. Here, a subtitle has been added, the poorly visible white color is now black, and the font of the title has been changed to a more informal Comic Sans (fig 15).
- The Transitions option on the Menu option's subwindow of the Customize panel will let you

control the way the menu and movie (or menu and submenu) link together. You can choose from a number of transitions akin to those you might find in a video-editing application or a PowerPoint presentation. It is a good tip to choose something simple, such as Dissolve. You want your audience blown away by the content of your movie, not assaulted—in visual terms—by the special effects leading up to it (fig 16).

- Should you wish, you can now change or add an audio file, too. Click on the Preview button below the main menu window to see how the results will look when the DVD is compiled. Click the Preview button again to leave this mode.
- Anything you do in the main menu, you can repeat for the submenu; you don't have to use the same theme for the submenu, but you will find that the movie hangs together better if you use the same or a similar theme throughout.

MAP VIEW

The Map button displays your DVD project in the form of a flow chart. It shows each of the individual stages that you have added to the project in the form of thumbnails. In the case of the

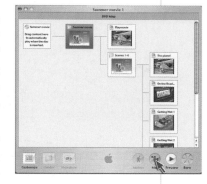

project you have been building here, it is easy to grasp the menu and submenu arrangement, but as you begin to create DVDs of ever-increasing complexity, the Map view becomes invaluable.

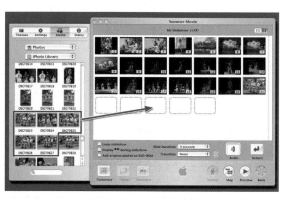

Fig 17

Fig 18

Optional additional resources

You have added your main movie and assigned section breaks to it so that viewers can rapidly navigate to selected passages. You may want to add additional movies or, like with this vacation DVD, you might want to append the best photos you took. You can add additional movies to your main menu in the same way you did with the original. Adding

photos, which will take the form of an automated album, requires a slightly different process:

- Click on the Slideshow button at the base of the screen to create a new entry (labeled "My Slideshow") in the main menu. Select this text and type in your own title, such as "Photo Album," as here.
- Double click on the title to open the slideshow creator. You can now drag images from a folder onto the workspace. Thumbnails of the selected images will be created, but be warned: this can take some time, particularly if your original photo files are large (fig 17).
- At the base of the screen you can see the slide show parameters. These are largely self-explanatory, but here is an overview of the options:
 ○ Click on the Loop Slide show box to let the slide show play continuously.
 ○ Click on the Display ⟨⋯ ⋯⟩ during the slide show to place left and right arrows on the screen so that viewers can move manually from slide to slide, forward or backward.
 ○ If you want to add copies of the original images (rather than the reduced-size images), click on the Add original photos on DVD-ROM button.
 ○ Use the pull-down Slide Duration menu to set a time for each slide's display.
 ○ Use the Transition pull-down menu to create a transition between each slide.
 ○ Drag an audio file (or multiple files) to the Audio button to give the slide show background music (fig 18).

Once you have added any movies or photos and provided a soundtrack, you have just about completed the project. It is a good idea at this point to select File ⋯⟩ Save Project to save all your hard work up to this point.

Burning the DVD

The simple stage: click on the Burn button, drop a blank DVD into the drive, and wait. It is a good idea (no, it is essential) that before doing this you preview your production. Once the burning process begins, you can't stop and change anything. If

something is wrong, you will have wasted time and the cost of a blank disk.

While the burning is taking place, consider what you want to do next with your project. Like a movie you have created, you may want to preserve it for future use, perhaps to burn another copy (remember, DVDs are not indestructible and are prone to failure). If so, you need to make an archive copy of the project. This ensures you have a repository that contains all the resources used in making the DVD, along with all the links and theme modifications.

In iDVD, once the disk has been burned and ejected, click on File ---} Archive Project. A dialog box will open and advise you of the size of the archive and give you the option of including the themes themselves and also saving encoded files. If you save these, it will save you time when it comes to assembling the DVD next time.

And finally

You should now have a DVD you can put in your domestic DVD player and have friends and family watch and enjoy. But what if the disk doesn't play? Check these possible causes:

1. DVD-authoring and burning applications designed for consumer use tend to use low data rates (low bit rates) for encoding to enable two hours of material to be recorded on a 4.7GB DVD. Some DVD players don't play low-bit-rate DVDs. You will need to ensure that either the DVD players are compatible (by burning a test disk), or else burn a shorter length of material at standard bit rates.

2. Many DVD players (particularly older machines) are not tolerant of recorded DVDs. Many will play DVD-R-format disks, but fewer will play the rerecordable DVD-RW or alternate format DVD+RW disks. Again, check compatibility with a test disk.

3. Fast-moving action requires higher data rates to record accurately and with good definition. Fast-moving subjects and heavy action scenes can appear soft-focused when recorded with low data rates.

DVD CREATION GOES WIDE AND HIGH DEFINITION

2005 saw many movie-editing and DVD-creating software applications offer high-definition capabilities and wide screen.

From version 5, iDVD is compatible with HDTV. Even if you don't have an HDV video camcorder, you can produce breathtakingly detailed slide shows from your digital image.

DVD BURNING TIPS

• Always use high-quality media. Try out different brands. If you look closely, some cheap media have blemishes on the writing side. Give these a wide berth. When you find one that gives consistently good results, stick with it.

• Handle disks with care—before and after burning. Although DVD disks are resilient, fingerprints on the surface before burning will lead to a rejected disk; afterwards will make it difficult to read. It's also a good idea to keep disks in sleeves or cases when not used. This will keep them free of dust and other marks.

• Run only DVD burning on your computer when burning a disk. Other open applications can make demands on the computer's processor, interrupting the flow of data to the drive and causing the recording to be aborted. Even background applications can cause problems—including virus-checking software.

• Keep your hard disk tidy! Run a disk defragmentation utility to ensure that data is stored in a relatively contiguous way prior to being copied to the DVD. This ensures that the computer doesn't have to waste time jumping around your hard disk retrieving data and—possibly—interrupting the data flow again.

PERSONAL VIDEO RECORDERS

We mentioned earlier that the personal in Personal Video Recorder (PVR) actually relates to the content recorded. Once you have set up a few recordings, the system tends to know the programs you enjoy and can even predict the type of programs you might want and will record these, too. You can also pause live television, skip commercials, and access, where available, interactive features.

PVRs are proliferating, but the names that started the trend include TiVo, popular in the United States and with more modest penetration in Europe. More PVRs are now being bundled with digital television receivers. The biggest of these are the satellite television systems such as Sky+ in the UK (working with Sky distributed digital satellite) and the corresponding American system, DirecTiVo, which is an amalgam of the TiVo system and DirecTV reception.

The rationale behind PVRs was to make things for us, as consumers, as simple as possible. Despite all the attempts made to simplify the programming of video recorders, there is still a huge percentage of users who have never used timer programming; many of these have never even set the clock on the recorder, and time-shifted recordings merely mean starting the recorder when leaving the house and capturing perhaps two hours of irrelevant material before the desired program is recorded.

Attempts to simplify the timer recordings have been made before, with VideoPlus being the most successful of these. But this requires a degree of familiarity with the programming system and also demands that you have the VideoPlus code (a list of numbers that the system interprets as start time, end time, and station) to enter.

PVRs are much simpler. You can select a program to record by choosing it from an electronic program guide (these are offered, in the case of Sky or DirecTV, by the broadcaster or—with independent PVRs—via the box's manufacturer, often via a Web site).

Once you have set up for a program, the PVR software will assume that you want to record further programs in the series; if it is a daily or weekly series, subsequent episodes will be recorded, too. But because each program has a PVR code, which not only identifies the program itself but also the type of program, the PVR will store programs with a similar identifier. The hard-disk basis of the PVR allows for extended recordings—far longer than a VHS videotape will offer—so there is little chance (unless you rarely view your recordings) of running out of space. And intelligent

Fig 19—TiVo Central is the key to managing your television viewing. From here you can check the programs to record, view live television, or access other value-added features.

Fig 20—No need to miss the action when there is a distraction. When the phone rings or someone comes to the door, you can just click on the pause button and live television is frozen until you are ready to continue. You can pick up the program or event just where you left off. Courtesy British Sky Broadcasting.

management means that if you do run low on space, predictive recordings—those you haven't specifically asked for—will be sacrificed in favor of those you have requested.

In day-to-day use, it is the ability to pause—even rewind—live television that is the most useful feature. So how, exactly, can you pause live television? In fact, what you pause is a live recording of your television program. That program is being recorded to the hard disk of the PVR and, when you pause, recording continues. Then when you are ready to resume, you can continue by playing back the recording from the point you left off. Like a computer hard disk, you can record and read from the same disk simultaneously. Using the same recording mechanism, you can also rewind the "live" recording.

sky guide	9:30am Tue 5 Oct SKY+ PLANNER		
			Free 97%
Simpsons	VIEWED	Sky One	
24	VIEWED	Sky One	
Friends	VIEWED	E4	
Lord of the Rings: The Two...	RECORDED	Sky Movies	
Deadwood	RECORDED	Sky One	
Stargate SG-1	RECORDED	Sky One	
Battlestar Galactica	RECORDED	Sky One	
Premiership Football	RECORDED	Sky Sports 1	

Fig 21—The Sky+ Planner, an extension to the electronic program guide, helps you keep track of recordings, identifying those you have already viewed and those that have been recorded automatically.

TIVO AND DIRECTIVO

TiVo and its satellite companion DirecTiVo are examples of PVRs, although the term PVR isn't too prominent. And that is deliberate. TiVo is designed to make life simpler for viewers, but it is considered that mentioning "PVR" might compromise the perception. With TiVo you can:

- Use the electronic program guide to plan your recordings.
- Pause and rewind live television.
- Record a series of programming automatically.
- Use one-touch recording.
- Record interactive services.
- Record enhanced sound (such as Dolby Digital 5.1) broadcast with the programming.
- Record one (or, ultimately, several) satellite stations while viewing another.
- Watch one recording while starting another recording.

Fig 22—This DirecTiVo PVR (personal video recorder) supports conventional and high-definition television programming.

Moreover, the software that controls the box can be automatically updated by using a digital data-stream broadcast via the same satellites used for program distribution. So, as new facilities become available they are automatically delivered to the box. You can also enjoy recordings from the DirecTiVo box in another room while those connected directly to the box watch another (this requires the Multiroom upgrade).

YOUR COMPUTER AS PVR

You may have figured out by now that a PVR is essentially a cut-down computer, featuring a hard disk and controlling software. So it should not come as too much of a surprise to hear that you can use your computer as a PVR. There are numerous software solutions that let you use your computer's hard disk to record programming, but the most effective solutions combine this with some auxiliary software.

You will find there are different options. For example, El Gato and Hauppage make solutions that cover

Fig 23—The EyeTV 400 solution for digital terrestrial broadcasts. The box provides the necessary decoding of the incoming signals.

Fig 24—EyeTV 500 offers a PVR compatible with high-definition television broadcasts.

simple television replay on your computer through digital terrestrial PVRs, digital satellite, and even high-definition systems.

Just as with stand-alone units, you can pause live television, repeat a selection, or fast-forward through the commercials. The electronic program guide for a computer-based PVR is typically accessed through a Web site. Often this gives you the added benefit of being able to schedule a recording using an Internet connection remotely. Great for recording those shows you forgot to schedule before going away.

Another benefit of using your computer is that the programming that you do download can be treated in much the same way as digital video downloaded from a digital camcorder: you can edit the output and save it to an external disk. EyeTV (and many of its equivalents) include simple editing software that will allow you to trim scenes and, for example, make your own highlights program from a sports event or concert.

Once you have edited the material, you can transfer it to DVD, Video CD, or Super Video CD to archive it.

Like stand-alone PVRs, you can also record high-quality sound (Dolby Digital 5.1) and receive updates to the software (in this case, via the Internet). This means, as television technology evolves, your hardware and software can keep pace and you won't be left with redundant equipment, as can so often be the case. Drawbacks? You may be limited with regard to the encrypted channels available (most systems offer access only to the unencrypted "free-to-air" channels). A conditional access module (CAM) can be fitted to some units to allow the conditional access smart card to be fitted to authorize those stations.

Fig 26—Computer-based PVRs include their own interface for setting recordings, but these are often augmented with a link to a Web site for programming. In the case of EyeTV, this is Titan TV in the United States and TVTV in the UK and mainland Europe.

MOBILE PVRS

A PVR essentially creates its own television schedule that you can watch when you want. But what if the cabling were to be dispensed with so that you were able to watch when and where you wanted? That was the inspiration behind the Mobile PVR. From the set-top box manufacturer Pace comes PVR2GO, a portable television viewer that allows you to view downloaded content and programming while on the move.

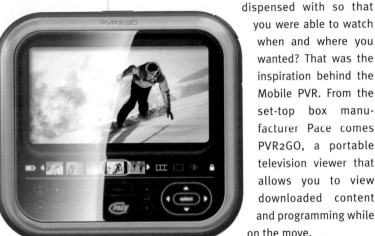

Fig 25—PVR2GO lets you enjoy your digital television recordings anywhere.

The unit offers all the features of a PVR—pausing, rewinding, and selecting programming —and it can also handle standard MPEG (2 and 4) recordings and deliver its content to a large-screen television. For use on the go, you can use the built-in speakers to produce a three-dimensional sound stage. PVR2GO will also decode all conditional access programming that the owner has personal access to. This makes it ideal for recording encrypted services for later viewing on the move or in the office.

SECRETS OF THE SILVER DISK

CDs and, latterly, DVDs are now widely used for music and video distribution and have, for all intents and purposes, usurped the compact cassette and VCR. But the ubiquitous silver disk has other strings to its bow. Hidden under the glare of CD and DVD are other disk formats. Some are useful in that they allow those of us without DVD burners to produce DVD content that we can share. Others address acknowledged shortcomings with the audio on CDs. Let's take a look at some of them.

DVD-Audio

When people talk about "DVDs," they generally mean DVD-Video—the format used to distribute movies and TV series. There is also an audio-only version that uses the enhanced capacity of the DVD (compared with CD) to deliver very high-quality sound, including surround-sound options. It can also provide video and image replay and even limited interactivity. DVD-Plus disks, sometimes called Dual Discs, are double-sided versions of DVD-Audio disks that have a standard CD version of the audio content on the "B" side of the disk. DVD-Audio players will play standard CDs, but they also have, optionally, Internet connections to enable track and other information to be downloaded.

Fig 27—New technology—Super Audio CD—needed new expression. The Shanling Super Audio CD "Tube Disc" player makes an obvious statement visually but also ensures that the ultimate quality is delivered.

Fig 28—The Super Audio CD format required new methods of recording. The first DSD recorder was released by the UK-based audio pioneer Genex in the shape of the Genex GX8500 shown here.

Super Audio CD (SACD)

Super Audio CDs are audio-only disks (though limited video content or interactivity has been offered on some disks) that give very high-quality sound. These are generally offered as twin-format disks, with a standard CD version of the audio provided for those listening with conventional CD players.

The benefits of SACD is a recording and reproduction system that better represents the original music. It is a process called Direct Stream Digital, and it follows the waveform of the audio being recorded rather than sampling the waveform, as in the case of standard CD audio recording.

Video CD (VCD)

Video CDs are based on a standard CD but contain video and audio. A standard 700MB CD can accommodate up to eighty minutes of full-motion video and stereo sound. This is recorded using the inferior MPEG-1 format that was superseded by MPEG-2, the format that requires greater capacity but offers better quality and is used for DVD video. Video CDs are rarely found now because we, as

consumers, demand the better quality of DVD. Video CD's MPEG-1 offers picture quality on a par with VHS video. The format is still hanging on in the Far East, where you can even find dedicated Video CD players. Note that Video CD is not the same as CDVideo. The latter format is based on analog video and digital audio. CDVideos offer great picture quality but limited capacity—perhaps five minutes on a CD-sized (gold) disk.

Fig 29—Many innovative artists—such as Jean Michael Jarre here—were among the first to adopt new formats like Video CD.

Fig 30—Now that DVD has become the de rigueur standard for video, Video CD has become something of a fringe medium used, as here, for bootleg recording.

Super Video CD (SVCD)

Similar to a VCD, though with a slightly reduced capacity (up to sixty minutes on a 700MB disk), SVCDs use the MPEG-2 recording format to offer enhanced video quality. SVCDs can be produced using appropriate software on computers that don't have DVD burners, and the disks can be replayed on most DVD players (as well as computers). Menus and chapters can be included (as with DVDs) on disks, and disks can be produced that include photo slide shows. Many of the more popular CD-burning applications can produce SVCD-format disks.

CVD

The Compact Video Disc is essentially an SVCD that has been recorded using a slightly lower video resolution. By using a lower resolution, you can record higher data rates (reducing the possibility of

pixelation-type artifacts), but the result is a slightly softer image.

Extended SVCD (XSVCD)

This system uses higher data rates and higher resolution than SVCD to give the best video quality. XSVCD disks can be played on many (but not all) DVD players. Some DVD players are not able to read data sufficiently fast from a CD, although they can read at the required data rate from DVD. Most computers can read XSVCDs, but some will need the installation of a software VCD/MPG player.

miniDVD

The miniDVD is not the DVD equivalent of a mini CD, a recording made on an three-inch (8 cm) disk rather than six-inch (15 cm). Rather, it is DVD content that has been recorded in DVD format on a CD. These are sometimes called Compact DVD or cDVD. Because it uses the highest quality throughout, miniDVDs tend to have running times of around twelve to fifteen minutes. Disks can be played on a very limited number of stand-alone players—many DVD players are not configured to read DVD data from a CD.

DivX

This is an MPEG-4 recording format that is looked at in more detail on pages 86–7.

DVD: THE NEXT GENERATION

When recordable CD-ROMs became widely available, they were a revelation. True, power users had for some time been using Zip disks and magneto-optical disks, but for the rest of us it was the 1.44MB floppy disk that was the most widely available recording medium. The enormous headroom provided—650MB—was regarded as excessive for many. Soon, however, as digital photographs and MP3 music libraries blossomed, disk makers squeezed even more onto each disk—up to 700MB—to satisfy demand.

Those who had enjoyed the benefits of CD-ROM were quick to jump aboard the recordable DVD format. This afforded for those who needed to back up their libraries a convenient medium. Better still, this medium, by virtue of its "Versatile" nature, could also be used for producing programming and video content to be played on DVD players. As a result, it is rapidly overtaking VHS as the preferred video-recording format.

Now, with high-definition television and with digital video and images increasing in their file sizes, even the DVD is proving too small for many demands. Although the DVD format allows multiple layers and two-sided recording, there is still a ceiling of 18GB. This capacity, once only dreamed of, is now considered too small.

Recording the blues

So enter a new generation of disk-based recording formats, spearheaded by Blu-ray. Designed originally to support the recording of high-definition television programming, it is now seen by most manufacturers and industry pundits as providing the definitive recording medium across digital technologies for the next decade.

Fig 31—Blu-ray logo

The name "Blu-ray" describes the difference between this system and previous ones: it uses a blue laser to read and write. Blue lasers have shorter wavelengths, allowing the beam to be focused with greater precision than the red lasers of earlier devices. Data can thus be more precisely packed

Blu-ray

What formats are there?
• BD-ROM: a read-only format for prerecorded content.
• BD-RE: a rewritable format for (principally) HDTV recording.
• BD-RL: a recordable format for PC data/media storage.
• BD-RW: a rewritable format for PC data storage.
Other formats are also planned.

What is the storage capacity?
• Single-layer disks: 23.3GB, 25GB, or 27GB.
• Dual-layer disks: 46.6GB, 50GB, or 54GB.
Four-layer 100GB+ disks are currently under development.

How much can you record on a Blu-ray disk?
• On a 25GB disk, you can record twelve hours of conventional, standard-definition television, or about two hours of HDTV.

Do you need to use a cartridge for disks?
• No. But like early CD-ROMs, early Blu-ray disks may require cartridges.

Can you replay DVDs in Blu-ray players/recorders?
• Yes, though individual models may not support DVD replay.

Is Blu-ray the same as HD-DVD?
• No. Like VHS and Beta, these are two competing, incompatible formats. HD-DVD also uses a blue laser but records data in a different way.

onto the disk. The word "Blu" in Blu-ray is deliberately spelled in this way to allow the copyrighting of the name. The good news for users and prospective users is that Blu-ray players and recorders will be backwardly compatible with the red laser disks, DVD and CD, allowing one machine to play back disks of all formats.

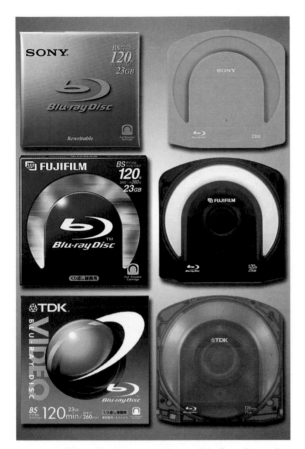

Fig 32—Caddies will protect some Blu-ray disks from dust and fingerprints.

(you can record two hours of HDTV or twelve hours of standard-definition television on a 25GB Blu-ray disk), it will also feature in new PlayStation models. Sony, eager to promote the digital-hub nature of the PlayStation concept, sees new PlayStation models from PlayStation 3 using Blu-ray. This will give game designers more freedom in multithreaded gaming but will also be used to stimulate interest in delivery of prerecorded material, especially that from Sony's Sony Pictures subsidiary.

The other kid on the block

Now we are used to new formats getting a rough ride as competitors offer similar, yet incompatible, systems. Think back to the battle between VHS and Betamax video, DCC and DAT, and more recently DVD-R and DVD+R formats. At one point there were no less than five formats vying to succeed DVD, but now there appears to be just one serious competitor—HD-DVD. More than an evolution of DVD, it also uses blue lasers for increased capacity. HD-DVD (high-definition and high-density DVD) disks can hold 20GB on a single-side single layer.

At the time of writing, both Blu-ray and HD-DVD were working hard on getting the major film and television studios to back their respective formats. With the benefit of hindsight—from earlier video and disk formats—both camps have realized that it is the software that is crucial to a format's success. In this case, software means programming and movies.

By the beginning of 2005, Blu-ray remained the only format to have demonstrated—and sold—working players. By the time you are reading this there may well be a victor in the battle. But with so much to lose, don't expect either to throw in the towel without a major fight.

Although Blu-ray is able to store up to 50GB of data—an amount that will see it welcomed by many digital moviemakers and archivists—it will be the proliferation of high-definition television services that will bring the format into the mainstream. When the format was originally specified, it was optimized for directly recording the digital television signals used globally, avoiding the need to transcode—the decoding and recoding required for DVD-based recording. This removes the need for extra processing and avoids the potential for quality loss. And like DVD-RAM, you can watch a recording while recording on another part of the disk.

Blu-ray for gaming

Although HDTV recording will be the primary aim of Blu-ray

Fig 33—Sony's BDZS77 was the first widely available Blu-ray recorder.

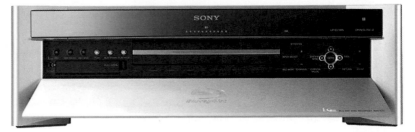

DIGITAL BROADCASTING

IN THIS CHAPTER WE WILL:

- Discover the history and evolution of digital television—and radio.
- Look at the virtues of digital television.
- Explore how digital television works and how it can make life easier.
- Look at home cinema.
- See what digital audio broadcasting—digital radio—has to offer.

Fig 1—How do you keep up with hundreds of TV channels? If you're a digital satellite broadcaster, with a video wall like this. Courtesy of SES Astra).

FOR MOST PEOPLE, DIGITAL TELEVISION HAS BEEN THE MOST OBVIOUSLY PROMOTED DIGITAL TECHNOLOGY IN RECENT YEARS. ALTHOUGH CDS HAVE BEEN DELIVERING THE DIGITAL GOODS FOR A COUPLE OF DECADES, THERE IS NO DOUBT THAT DIGITAL TELEVISION HAS HAD THE BIGGEST IMPACT, PERHAPS REFLECTING THE SIGNIFICANCE OF TELEVISION IN OUR LIVES.

THE TWIN PILLARS ON WHICH THIS TECHNOLOGY HAS BEEN PROMOTED ARE EXTENDED CHOICE (MORE CHANNELS, GREATER INTERACTIVITY) AND BETTER PICTURE QUALITY. THE FORMER IS CERTAINLY TRUE, BUT THE LATTER WAS NOT IMMEDIATELY OBVIOUS TO MANY PEOPLE. ONLY WITH THE INTRODUCTION OF HIGH-DEFINITION TELEVISION (HDTV) HAS THE PROMISE OF ENHANCED QUALITY BEEN DELIVERED. LET US NOW TAKE A LOOK AT HOW TELEVISION BROKE FREE FROM THE ANALOG WORLD AND HOW IT IS DELIVERED TO OUR HOMES, WORKPLACES, AND EVEN OUR COMPUTER OR MOBILE DEVICES.

WE WILL ALSO TAKE A LOOK AT DIGITAL RADIO. BORN BEFORE DIGITAL TELEVISION, IT HAS BEEN DEVELOPING MODESTLY IN THE SHADOW OF ITS VISUAL COUNTERPART.

DIGITAL TELEVISION

It might be useful first to explain what we mean by digital television. The description for the purposes of this book applies to the transmission to our homes of television signals in digital form. This clear statement has to be made because, in fact, television studios have been working in the digital domain for some years. Studios and producers have long recognized the benefits of recording programming on digital videotape and editing digitally since the late 1980s. Even the delivery of programming to transmitters has often been digital. It is only more recently that the onward transmission to our homes has also been digital.

From the 1950s and 1960s, analog color television has been broadcast around the world. There were two incompatible standards—NTSC in North America and Japan, and PAL in Europe and many other countries. A variation on PAL—SECAM—could be found in France and Eastern Europe.

The terrestrial broadcasting of television requires an enormous amount of bandwidth—the range of frequencies over which data is transmitted—which limits the number of television channels that can be broadcast to any one location without interference. As the demand for more and more channels increased, broadcasters sought other methods and techniques for broadcasting. Cable is a well-established method, but for widely spread communities this is often not a viable option.

Satellite broadcasting was another. In fact,

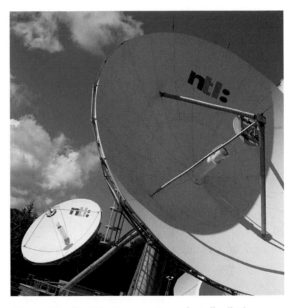

Fig 2—Dishes like this are now commonplace, distributing television stations and receiving signals from satellites. Courtesy NTL.

satellites had been used for some time to feed signals from studios and broadcasting centers to cable heads (fig 2). Cable heads are the ground stations of networked cable that receive programming for distribution to their customers.

Direct broadcasting via satellite

Direct Broadcasting Satellite television (DBS) was something different. Unhindered by the constraints placed on terrestrial broadcasting, companies could explore new strategies. In the UK and across Europe,

Fig 3—The ill-fated BSB Direct Broadcasting Satellite service introduced electronic program guides and wide-screen long before a true digital service rediscovered them.

a new pair of similar broadcasting standards were devised, D-MAC and D2-MAC, respectively. Although largely analog, these formats (short for D Multiplexed Analog Components) separated out the color and brightness parts of a television picture and, along with a modest digital control signal, broadcast these components in a multiplex. Multiplexes allow large amounts of differing data to be combined and transmitted in a stream and then separated when received. The principal benefits of the MAC formats were clearer pictures and the opportunity to transmit digital data. This usually comprised basic (but, for the day, very welcome) electronic program guides.

There was no doubt that MAC and DBS offered quality benefits, but they came at a cost. In Europe the MAC broadcasts fell victim to Astra programming. Set up to feed cable heads, the signal strength proved high enough to broadcast directly to homes (DTH). Based on the cheaper PAL and SECAM systems, Astra-based services dealt a fatal blow to D-MAC (fig 3).

It seemed as if television broadcasting had also been dealt a technological blow, taking a big step backward. But it proved only a momentary one. The insatiable appetite for new channels across Europe—particularly in the UK, the newly unified Germany, and a liberalized Eastern Europe—meant that a whole group of satellites were positioned along with the original Astra satellite (fig 4). Still, there was not

enough capacity. Rather than launch more and more satellites, the economics and logistics required that broadcasters and operators come up with a different solution. That solution was digital transmission.

A digital broadcast effectively takes up less space in bandwidth terms, allowing more channels to be broadcast in a similar frequency range. In fact, broadcasters use multiplexing, broadcasting five or more television channels using the space normally allocated to a single analog channel. The nature of digital television is such that the amount of data transmitted for one channel can be varied: the more data that is transmitted, the more detailed and authentic the pictures. Transmitting a lower amount of data results in a less-detailed image that may show artificing, digital effects that resemble pixelation, particularly in fast-moving scenes.

In some cases, ten or more channels can be squeezed into the space of a single channel, along,

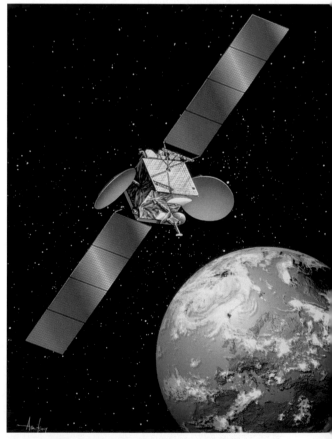

Fig 4—Satellite broadcasting is free from many of the technical constraints that affect terrestrial broadcasting. Courtesy SES Astra.

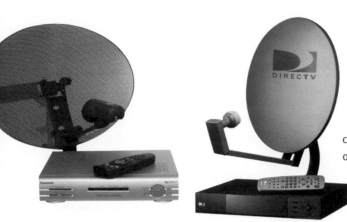

Digital text services make teletext transmissions look very dated, while the audiences of big sporting events have the opportunity to choose different camera angles or (for example, in the case of the Wimbledon tennis championships) any one of the games currently in play.

Additional services offer simple Internet-like facilities for shopping and banking using a telephone connection as the return path from the satellite.

Fig 5—The rapid adoption of digital direct-to-home television services was driven by simple, easy-to-use equipment, such as these from DirecTV (USA) and Sky (UK).

sometimes, with some radio stations. Typically, mainstream networks (those with high audiences) use a higher data rate to deliver better-quality pictures. Those from minority channels use the slower (and cheaper) rates.

Digital satellite television (fig 5) made its mark across the world—principally in North America and Europe—in the late 1990s, driven by simple dish and set-top box systems that made it easy to receive and easy to navigate the hundreds of channels that quickly appeared.

Since launch, we have seen interactive services piggybacking on the normal television services.

Digital cable

Not to be left behind, the cable companies went digital, too. Despite having the capability of delivering many tens of channels, this once-impressive number was now looking rather tame; digital cable can offer channel numbers on par with those of digital satellite. Often faced with harsh competition from the satellite broadcasters (in the UK, Sky Television gave away satellite systems, charging only a nominal installation fee), cable companies have had to add additional services. Bundled telephony and broadband Internet connections are typically the unique selling propositions of cable, offering well-priced packages.

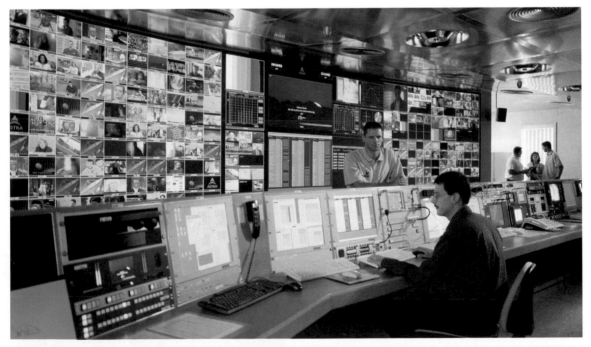

Fig 6—With hundreds of channels to monitor, the control room of a satellite digital television service is a busy place. Courtesy SES Astra.

THE DIGITAL ADVANTAGE

To sum up the advantages of digital television:

- Better image quality for a given bandwidth.
- The ability to broadcast multiple channels in the space of one analog channel.
- Multiple delivery methods: satellite, terrestrial, cable, phone, and Internet (fig 7).
- Compatible with computers and computer-based devices.
- Greater interactivity options.
- Good audio quality, with the option for multiple languages.
- Reception more reliable and less prone to environmental interference.
- Upgrade paths to HDTV.

Fig 7—Digital television blurs the boundary between television and Internet.

Digital terrestrial television

Digital broadcasting brings a new lease of life to the conventional airwaves. A digital multiplex, broadcasting in the bandwidth space equivalent to a single channel, can accommodate six television stations (in standard definition) and even more if a lesser data rate is used. Fortunately for the crowded bandwidths found in most parts of the world, digital multiplexes are less likely to cause interference to existing stations and can be placed closer together across the frequency band. In the UK, for example, in a crowded wave band that could accommodate no more conventional stations, four multiplexes offering thirty stations have been launched.

In its original incarnation, digital terrestrial television (DTT) included all the original free-to-air stations, new free-to-air services, and a raft of subscription services. The original subscription service, Ondigital, later rebranded ITV Digital, made little headway in the face of competition from the digital cable and satellite broadcasters and closed down. Part of the lack of success was down to pricing—it cost about the same as the competing satellite service but offered a far smaller range of programming. It also offered poorer picture quality. But enhanced picture quality was one of the raisons d'être of digital television. Consumers were confused and opted not to subscribe.

Later, the DTT service was rescued and rebranded as Freeview. As the name suggests, it offers all the programming for free, comprising the free-to-air services from the original service along with some specially commissioned new stations. Freeview also allocated more bandwidth to many of the stations, so overcoming the hurdle of poor picture quality. This proved a winner. No subscriptions and wider choice at no extra cost. Adoption of Freeview has been exceptional and proved a successful model for elsewhere in the world.

Ironically, Freeview has had a subscription service bundled with it, using up spare capacity. But unlike previous services, this offers only a small number of the most popular subscription stations for a nominal fee and without ongoing contracts. Again, another (if more modest) winner.

Fig 8—Digital terrestrial broadcasts deliver digital quality from the same transmitters that deliver conventional broadcasts. Courtesy NTL.

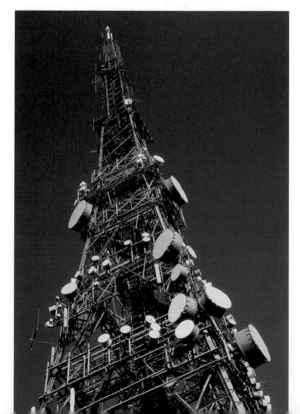

Down the line

The nature of digital television also makes it possible to deliver transmissions in ways impossible for conventional, analog signals, such as down a phone line. Using fast digital phone connections, you can have broadband Internet access along with digital television stations on demand. Services tend to offer a more limited choice than satellite or cable but include free-to-air and the pick of subscription services. There are often unique channels offering local interest or specialized programming. You also have the option, found on some cable stations, of replaying programs from the most popular channels on demand— either momentarily after they are transmitted or for a full seven days afterward.

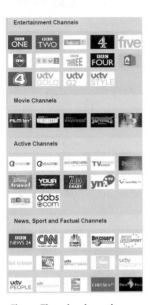

Fig 9—Though using only a standard telephone line, digital television by phone line offers a wide choice: here is just part of the portfolio offered by London-based Homechoice.

Video on demand (VOD) takes this one step further along, by offering a bank of programming (which might include movies, drama, comedies, sports, or news) and allowing you to select a feature to watch on demand. Just like selecting a DVD or videotape, but all at the push of a button.

High-definition television

So far, the rationale for digital television may not have appealed to the videophile. Greater choice, which digital television clearly offers, doesn't necessarily equate with better quality. The quality issue is now being addressed through high-definition television.

The concept is nothing new: Japan has offered HDTV services for some time on both analog and digital television platforms, but now the digital version is spreading worldwide. For HDTV, the vertical resolution (and hence the detail) in a television picture is increased from the 625 lines of PAL and SECAM systems or 525 lines of NTSC to between 720 and 1,080 lines (fig 10). In this new format, all programming is produced in wide-screen format (see pages 112–13) with Dolby Digital 5.1 sound (see page 116).

HDTV is increasingly important as we get used to—and demand—larger television screens. At 32 inches (81 cm), we reach the limit at which a conventional digital or analog channel (dubbed standard definition) can be displayed. Any larger and the picture becomes soft and less well defined. This rather negates the reason for large, wide-screen televisions: being able to sit close so that the screen fills out peripheral vision. Increase the resolution by a factor of three or four, and you get a much more detailed image that you can enjoy close, or closer up.

The drawback here is that HDTV demands a higher bandwidth. We are talking bandwidths on par with conventional, standard-definition analog stations. This means that the satellite—with its much broader bandwidths—has been the first to exploit the medium.

Fig 10—The difference between HDTV and standard-definition television is marked. Examine part of an image in both (that indicated by the red frame), and the increased detailing is obvious.

UNDERSTANDING WIDE-SCREEN FORMATS

Although wide-screen is not synonymous with digital television, it is the format that is now normal for digital broadcasts. But in a world where there are still conventional-format televisions and programming that was produced in this format, how are these represented on screen? And how are wide-screen images presented on a conventional (or "narrow-screen") television?

A conventional television picture is produced so that the ratio of the width to the height, the aspect ratio, is always 4 to 3, or 4:3. So a television screen that is 18 in (45 cm) high will be 24 in (60 cm) wide. Wide-screen television is produced with an aspect ratio of 16:9, so that a screen 18 in (45 cm) high will now be 32 in (80 cm) wide.

VIEWING WIDE-SCREEN ON A CONVENTIONAL SCREEN

Until wide-screen broadcasting is the norm, not all programming will be compatible, in terms of making best use of the picture area, with our televisions. Often the set-top boxes used to decode digital television pictures (whether from a digital satellite, terrestrial, or cable) allow us to switch the display format to match that of the television being used or to optimize the picture. Take this original wide-screen image. This is the shape of the television picture being sent to the television (fig 11).

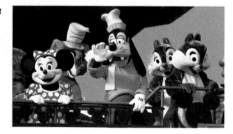

Fig 11

If we watch this on a conventional-format television, it clearly won't fit. One option is to enlarge the center area of picture so that the height of the picture matches that of the television screen. Because the picture is wider, parts of the image on each side will be lost, as here (fig 12).

For most programming, this option is perfectly adequate. Most of the action, whether in sports, drama, or documentary, takes place in the central

Fig 12

region. With only a limited loss, then, most viewers will be happy with this compromise.

Increasingly, however, filmmakers in all genres are learning to make the best use of the whole frame. Where this is the case, you have the alternative of displaying the picture in total. To accommodate the full width, the height is reduced and the characteristic letterboxed view is produced. This is familiar to many of us—it is the way wide-screen cinematic movies have been presented for many years (fig 13).

Fig 13

VIEWING A CONVENTIONAL PROGRAM ON A WIDE-SCREEN TELEVISION

Fig 14

Watching wide-screen programming on a wide-screen television makes the maximum use of the format, filling the screen at all times. But what about displaying a conventional image, such as this? (fig 14)

Fig 15

We could choose to display the picture in its entirety. This involves displaying the full height of the picture. Now the picture is not sufficiently wide to fill screen, so rather than letterboxing, you see side banding (sometimes called pillar boxes) (fig 15).

For those who have invested in wide-screen televisions, this option is often not acceptable, presenting a picture about 25 percent smaller than the screen is capable of delivering. So you could zoom in, making the width of the picture the same as the width of the screen. Now, you lose parts of the picture along the top and bottom (fig 16).

Fig 16

This gives a successful full-screen image, but with a couple of problems. For people who need subtitles, the text will often be lost or truncated when the picture is zoomed in this fashion. In addition, when viewing conventional-format news programs, the news broadcaster's head is often trimmed at the top of the screen. Many televisions avoid either of these drawbacks by offering additional picture modes that move the displayed part of the picture up or down accordingly.

Back when there was little wide-screen programming, it was customary to offer an additional picture mode variously described as "wide" or "stretched." This involved keeping the height of the picture the same but stretching the width to that of the screen.

The result is obviously stretched (although smart stretching modes, which stretched the less-important edges of the picture more than the center, are often used) and did the progress of wide screen in the consumer market no favors in the early days. But if you don't mind the compromises, it is a good way to get the immersing experience of wide screen with your collection of pre-wide-screen media (fig 17).

Fig 17

MORE FORMATS

Television stations that broadcast in conventional format (often an analog station simultaneously broadcast with a wide-screen digital one) often use a 14:9 aspect ratio. This gives a mild letterboxed effect but ensures virtually all the important action is displayed. The modest letterboxing is also less likely to provoke complaints from viewers feeling shortchanged by narrower letterboxes.

Fig 18—A 2.35:1 movie compared with wide-screen format (white rectangle) and 4:3 (black rectangle).

Some theatrical movies are produced in wider aspect ratios than 16:9. At 2:1 or greater, these will appear letterboxed even on a 16:9 wide-screen television. Some televisions allow zooming, but this can often compromise image quality. For most wide screens, however, the loss is a good trade-off when enjoying the sweeping panoramas.

HOME CINEMA

Creating a home cinema can be exciting, but it needs a good deal of forward planning. Here is a step-by-step approach to its design and implementation, along with details of some of the key components.

First, what is needed to create a home cinema? The term tends to be bandied around a lot and gets applied to everything from a minitheatrical cinema to a simple television with extra speakers. For our purposes here, the concept is based on a large-screen television, a source (or sources) of high-quality programming, an audio amplifier, and a set of speakers.

Budget and space

Your first considerations need to be practical: budget and space. If you have a modest budget, it might not be inappropriate to consider a home cinema; a high-quality television with DVD player may be a better option even if it does not provide the full theatrical experience. Similarly, if you don't have a lot of space, your aspirations may also be curtailed. A home cinema does require enough room to accommodate all the hardware elements with sufficient space for the speakers to project their sound.

Vision

Assuming you have met the relevant criteria, a good place to start is with the television (we still tend to call it a television, even though in some setups it may not be connected to a television tuner—it may receive its input from, say, a DVD player). For the true cinematic experience, you need a screen that is as large as possible so that the images fill as much of your vision as possible.

The traditional route of a large conventional television is falling increasingly out of favor on account of cost (alternatives are more viable these days) and bulk. About 36 in (91 cm) is the biggest conventional screen size that can be accommodated, and the cabinet that houses it will be colossal. Already a large part of your prospective cinema's floor space is lost just to the television.

Nowadays, it is more likely that you will opt for a projection television system or a flat-screen monitor. Projection televisions have come along in leaps and bounds in recent years and are capable of projecting images up to five feet (1.5 m), even in a brightly lit room. The drawbacks are that the screen is still not as bright as you would find with other options and projector bulbs can be absurdly expensive to

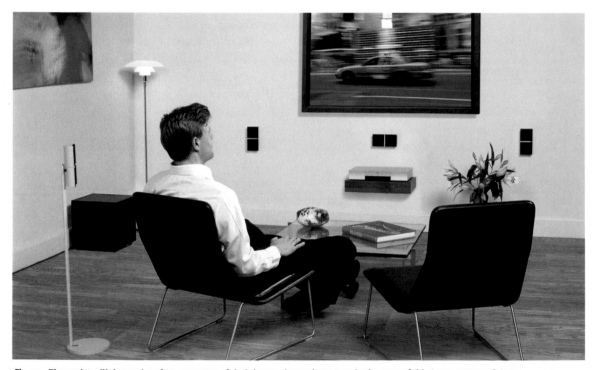

Fig 19—The purist will demand perfect geometry of their home-cinema layout, as in the case of this Jamo system. © Jamo.

FLAT-PANEL SCREENS: LCD VS PLASMA

Criteria	Plasma	LCD	Best
Screen size	36–60 in (91–152 cm)	10–50 in (25–127 cm)	Plasma
Refresh rate (ability to display fast-changing action)	Equivalent to conventional television	Slower, but technology is improving	Plasma
Viewing angle	Wide (155°)	Wider (up to 170°)	LCD
Life expectancy (based on 24/7 use)	Up to 30,000 hours	Up to 60,000 hours	LCD
Durability	Fragile	More robust	LCD
Weight	Heavy	Lighter	LCD
Burn-in (stationary images leaving a mark on screen)	Susceptible (but improving)	Not susceptible	LCD
Contrast ratio (ratio of light to dark areas on screen)	250:1	400:1	LCD
Thickness	3 in (7.5 cm)	2 in (5 cm)	LCD
Perceptual image quality (what viewers prefer)	High	Moderate	Plasma

Fig 20—Plasma (and now LCD) screens offer large picture sizes for a cinema-like experience in the home.

replace: up to 40 percent of the projector's cost. But if you have a room where you can dim the lighting and want a really big picture—beyond five feet (1.5 m)—this is the ideal solution.

Flat-panel televisions have been the stuff of science fiction for decades. Now they are a reality and make it possible to hang a large television on your wall in the manner of a painting. Two technologies offer flat displays—plasma and LCD. Time was when plasma was the obvious choice, but LCD has been making up ground fast. The differences are highlighted in the table here (see

above). It is best to audition your short-listed screens and see how they compare: in qualitative tests, plasmas tend to score higher, size for size. But with the technology evolving continuously, benchmarks can quickly become out of date.

Audio

Getting a great-quality screen for your cinema is crucial, but, as many enthusiasts will attest, the sound is of equal importance. Again, you have choices. On the one hand there are all-in-one systems that deliver all the audio components (and often a DVD player, too) in a single package. Everything is perfectly matched, and all you need do is make some simple connections. This can be a very effective solution, especially for novices. This is also a great solution when your home cinema has to serve other purposes, such as be a family room. Compact and unobtrusive speakers will not compromise your lifestyle.

By the same token, modest speakers rarely

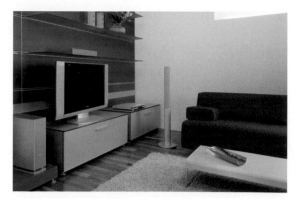

Fig 21—This Panasonic home cinema manages to integrate well into the owner's home. Here it is easy to see the 106 cm (42 in) screen along with front stereo speakers, center channel and subwoofer, but none of the elements intrude visually on the room. Courtesy Panasonic.

essentially ensures that voices appear to come from their on-screen images), and a subwoofer, which gives the omnidirectional deep sound that adds "body." These are all connected to an amplifier that decodes the sound from the television or DVD into the separate channels. Today, cinema-grade sound is usually transmitted in Dolby Digital, DTS, or Dolby Pro-Logic. This can be replayed in conventional stereo (or even mono), but when it is run through an appropriate decoder you can get the full range of sound channels that you can feed to the speakers.

Sometimes it can be cost-efficient (not to mention space-efficient) to get a television that includes an integral Dolby decoder. This removes the need for an external amplifier and (through the use of a single remote control) can simplify operation. At the other extreme, the audiophile will demand a two-stage sound processor. The first stage decodes the signal into its separate components, and the second performs the amplification. But these cost serious money and demand a dedicated home-cinema room to appreciate the full effect. Likewise, at the more rarefied price levels come decoders for more advanced sound systems, such as THX Surround EX, Dolby EX, and DTS ES.

Speakers

If you are going for separates—that is, components from different manufacturers—you will next need to choose your speakers. A matched set is the best way to ensure that speakers are matched for their

(although there are exceptions) give the best in sound performance; nor do they help create the best "soundstage," the optimum re-creation of the sound environment as the movie director intended.

Conventionally there are six speakers: left and right front, left and right back, center channel (which

respective roles and that there are no incompatibilities. The most important speakers are those that comprise the front stereo pair. These will be put through their paces on every occasion, made to reproduce every type of sound across a wide frequency range. These will also be the speakers you use if you listen to the radio or conventional CDs through your system. Next in importance comes the center channel. Reproducing realistic dialogue is the essential characteristic of this.

The rear speakers reproduce environmental sounds only and help to build atmosphere. We say "only," but that is still no excuse to compromise. They need to be of equal quality to the others, or there is a risk of them detracting from the overall sound quality.

Finally, the subwoofer. Working at really low frequency, this speaker can really boost the sound quality of any movie, giving true floor-shaking sound. Big and often ugly, they don't have to be precisely placed in the room. At such low frequencies (20–100Hz), your ears will find it impossible to detect where the sound originates, so the subwoofer can be placed in a corner, behind a sofa, or beside a cupboard.

Programming sources

Once you have built your system, you will need programming sources. DVD is generally the staple of home cinema, but with satellite and digital terrestrial television also now providing high-quality source material, these are gaining ground. It makes sense not to economize at this stage. You will need a DVD player that offers good video quality and also handles the sound system used by the DVD recordings and the audio system. Again, it is crucial that you audition the DVD players you have short-listed. It is surprising how different units playing the same disk can look and sound.

Fig 22—In this configuration it is easy to adjust the position of the television and front speakers. This flexibility works well when the room needs to accommodate different uses (and different numbers of people) at different times. Courtesy Panasonic.

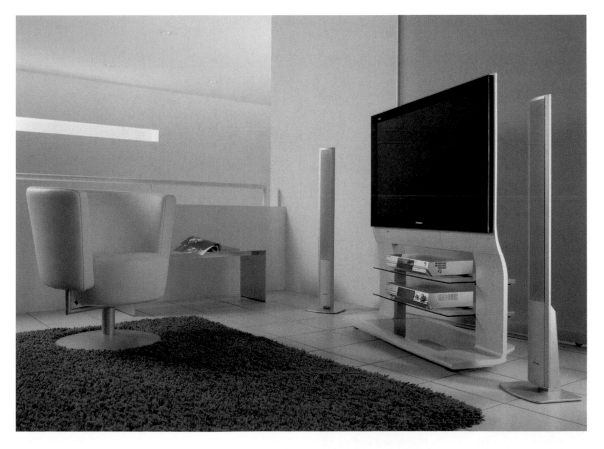

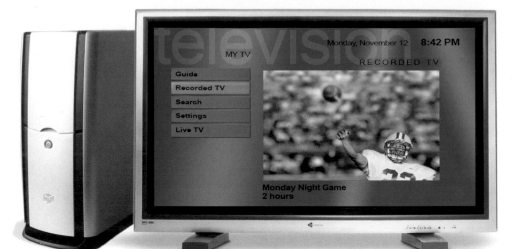

Fig 23—This Gateway Media Center PC features a plasma TY–style monitor and—the obvious giveaway—a remote control to allow easy access to all the features.

WINDOWS XP MEDIA CENTER: A BOLD STEP TOWARD DIGITAL CONVERGENCE

Windows XP Media Center Edition is an extension to the standard Windows XP operating systems. Taking a step beyond Windows XP, it lets you extend your computer's power and resources to home entertainment. Rather like Apple's iLife, you can store, play, and share digital music, photos, video, and even, by virtue of an onboard PVR, TV.

Windows XP Media Center Edition, the operating system, is installed on Media Center PCs—it doesn't normally come installed on conventional Windows computers. Nor is it available as an upgrade to standard-edition Windows. Media Center PCs come equipped with all the additional hardware and components required to make the Media Center live up to its name and act as a digital hub.

Inside the Media Center PC

So what is it that makes a Media Center PC? Included in the package you'll find:

- A computer unit equipped with high-speed processors—essential for handling video and television.
- A large amount of RAM memory: an amount normally substantially higher than that provided in conventional computers.
- DVD drive. Most models now feature a DVD recordable drive to enable video and television programming stored on the PC to be downloaded.
- Top performance hard disks for supporting the recording of high-speed data.
- Uniquely, a full-function remote control. This gives the same functionality that you'd expect from multi-device remote controls.
- An advanced graphics card optimized to deliver the best performance when replaying games, television programming, or video.
- A TV tuner. This can be a tuner designed for terrestrial, satellite, or cable television transmissions.
- A hardware encoder. This converts the incoming televisions signal or video input (say from a video camcorder) into a digital data stream that can be recorded to disk.

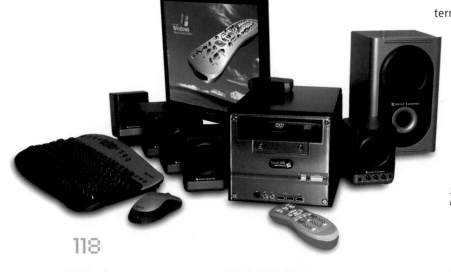

Fig 24—Part computer, part home-cinema kit, this Media Center PC comes with all you need to install an impressive digital resource.

Extending your Media Center

One of the reasons that Internet-through-TV has not taken off to the degree that the proponents of the technology have often expected comes down to the nature of the TV-Internet system. Offering Internet access through the TV can be confrontational. What happens when one member of the family wants to surf the Web and others want to watch a movie? A conflict in which there is always one loser. Unless you have a very easygoing family, it's a recipe for family strife.

This limitation becomes more marked in the modern home where we are used to multiple TV and computer installations, each capable of obeying different commands. So it will come as no surprise that Microsoft has come up with a solution that means the capabilities of the Media Center PC can be enjoyed around the home (it goes by the name of a Media Center Extender Set-top box, or "Extender" for short):

- Access to all the resources on, or accessed through, your Media Center PC, wherever there is an extender unit installed.
- Enjoy one Media Center PC resource in one room while others are using different resources in another. An end to conflicts!
- No need for a special TV or monitors. The extender box will link up to almost any TV or TV system.

You can have up to five extenders feeding off one Media Center PC. Extenders feature simple and intuitive installers that make local configuration simple. You can even exploit any wired or wireless networks you may already have installed to distribute the signals around your home.

For devotees of Microsoft's Xbox, there's an extender pack designed to stream content from your Media Center PC directly to a remote TV attached to an Xbox. This is not a set-top box but rather a software application that is loaded in exactly the same way as a conventional Xbox game. A remote control—and receiver—ensure that you get exactly the same functionality and convenience with your Xbox as you would with a dedicated extender box.

Fig 26—This Media Center Extender box hails from the HP stable and brings all the benefits of the Media Center to any television or monitor it is attached to.

- A TV and audio output. This lets you output your video and audio to an external television and stereo system.

Virtually all Media Center PCs also feature more "lounge-friendly" styling, designed to make them more suitably placed at the heart of the home. The workmanlike beige or industrial gray styling of typical Windows PCs is eschewed in favor of more curvaceous designs or those that ape conventional audio-video components.

Fig 25—The Media Center PC remote betrays its origin by virtue of the centrally located "Windows" button.

Media Center PCs in the Home

So how does a Media Center PC fit into your home and into your life?

Normally, computers find themselves, probably with deference to their styling and purpose, relegated to the study or den. As ostensibly a learning and communications tool, this is an ideal location in many ways. When we use the computer for composing and creating letters, we need to refer to correspondence files in our filing system. Likewise with our accounts. Often this is also where we'll find our Internet connection entering the house, too.

For a Media Center PC, the balance of use is tilted away from these more prosaic roles toward home entertainment. Suddenly, the computer is at

the heart of our leisure-time pursuits. It can now graduate to the living room!

Placing a computer—no matter how aesthetic the styling—in your key living space will probably need a little more than cursory consideration. It will need to fit into your daily life and not jar with it; it also needs to conveniently offer its enhanced capabilities to users. Previously, exclusive features of the computer—Internet access, word processing, image editing, and moviemaking are now combined with the corresponding entertainment tasks: television watching, listening to music, and video recording. The former require us to use a keyboard and mouse, while the latter are conducted via a well-specified remote control from the comfort of our favorite chair.

Most users find that the new experiences of the Media Center PC are also enjoyed from a comfortable seat, using a large-screen television as the central informational display. This, though, is not always ideal. Many large-screen televisions lack the crisp resolution that we've come to expect from even a midrange computer monitor. This can make it difficult to read computer-generated text across the room.

In many practical installations, a large-screen television—used to enjoy the television programming, video recording, and still images stored on or accessed through the Media Center PC—is best accompanied by a large computer monitor. This makes it possible to get the best from your movies and images but also retain all the benefits of a conventional computer monitor. It's simple to configure the computer to relay images to both screens simultaneously.

Much of you entertainment—whether Web surfing, streaming video, PVR programming, or humble e-mail—will depend upon a broadband Internet connection. A hard-wired connection to the computer is ideal, but a wireless connection is often more practical.

Now we need to make sure all the other connections are made. When you unpack your Media Center PC, you'll find a plethora of familiar and unusual cables and devices. Here's a quick guide to what goes where.

USB Cables: use these to connect the keyboard and mouse. If you opt for the flexibility of an infrared keyboard and mouse, you'll need to use the USB cables—and extenders—to place the infrared receiver at a convenient location. Somewhere reasonably adjacent to where you'll be using the keyboard most often.

SVG Cable: use this to connect a conventional monitor to the Media Center PC.

SVGA, Composite, SCART, RCA Cables: you'll have a choice of these, depending on your computer and where you live. Use the appropriate set to connect your PC to the TV monitor.

Coaxial Cables: for connecting your computer's tuner to a television signal source (satellite, cable, or terrestrial aerial).

Infrared keyboards and mice give you the same flexibility of use for these devices as a remote control. Don't expect either to have the same range as a remote control, though. In larger rooms, it may pay to invest in a Bluetooth-enabled keyboard and mouse. These don't just have greater range, they are also more robust—signal-wise—and less prone to interference or disruption.

Sound is often the Cinderella in any computer-based entertainment system. Media Center PCs often come with better-quality speakers than a standard computer. But if the Media Center PC really is going to be the pivotal home-entertainment device, it makes sense to use the best possible speakers. And these will be those that you currently have on your stereo system. You could connect the speakers directly to the computer, but connecting via your stereo will often be a more practical solution. Hooking up in this way will also let you enjoy "legacy" formats—such as vinyl albums or cassette tapes—which don't feature in the Media Center PC's arsenal.

Opposite: Like TiVo or Sky+, the Media Center PVR lets you instantly access previously recorded programming and schedule future programs for recording (fig 27)
If you subscribe to Instant Messaging, you can be alerted to an incoming message by a discreet flag over the TV or video program that you are currently enjoying (fig 28)
Your collection of photos and videos can be reviewed using these simple access screens. When you've found your chosen media, you can replay the video or review the photos at will (figs 29, 30, 31)

GUIDE

10:37PM

Mon, July 9		10:30PM	11:00PM	11:30PM	12:00AM
10	KTBW	Teen Talk and ad	Egypt's Secrets	Home Tips	Remember When
11	KSTX	KSTX News	Comedy Improv		Color Me
12	KMYA	Bicycle Racing		Golf Series 2004	Beach Volleyball
13	PCQR	Bella Luna	PC News	Stock Tips USA	
14	RTBY	Art of Monet	Entertainment in Hollywood		Music Picks
15	KIMO	Travel the Southwest – Route 66			Alaska Fishing
16	MTVH	Court TV	Today's Music Stars		Best Hits 2004

Bicycle Racing
"2004 World Tour: Stage 12" – Live coverage of stage 12 from Pasano, Italy.
This program is currently recording

Fig 27

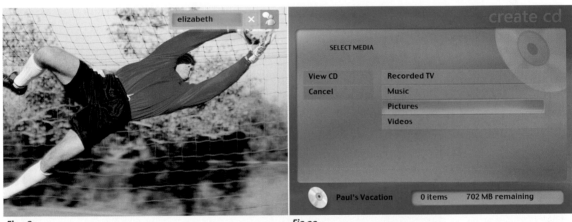

Fig 28

Fig 29

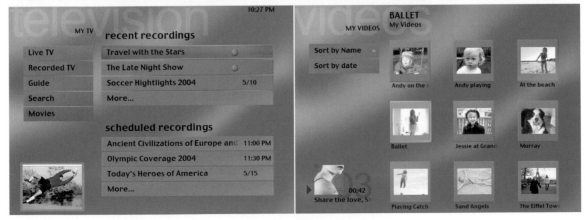

Fig 30

Fig 31

LOOK NO SPEAKERS! DOLBY'S VIRTUAL CINEMA

More and more people are building home cinemas with high levels of quality and great attention to detail. Most of us, however, don't have the luxury of the space or the budget. But that does not mean we have to settle for second best. In fact, even if we don't have the space to install even a modest home cinema, or if the room does not lend itself to one, we can still enjoy glorious theatrical sound, thanks to the genius of Dolby Labs.

Dolby is a name that crops up time and time again when talking about television and cinema sound, and in its Virtual Speaker Technology it has provided something special indeed. Dolby bills its Virtual Speaker Technology as a practical alternative to multispeaker systems. Using new techniques made possible by digital technology, you can simulate surround sound with just two speakers.

Although you may have doubts, Virtual Speaker Technology really can deliver a soundstage akin to that normally provided by a five-speaker system. The good news is that it can be applied to many sound systems, including those of a television, a DVD player, PCs, personal speaker systems,

and, of course, home cinema. This technology works alongside Dolby Digital and Dolby Pro-Logic II decoding (two of the most popular sound-encoding systems) to give the surround-sound experience whether the source is high-grade 5.1 sound from a digital satellite or "old" audio CDs.

Dolby is eager to promote the manyfold benefits of the system. These include:

- *Only two speakers* Cost savings are obvious but, more significantly for many users, it negates the need to install additional speakers and rearrange a room to make the best use of them.
- *Spatial cues and localization* There are no compromises in the sound, so the result is a realistic and detailed soundstage that replicates the original audio environment.
- *High sound quality* The original sound

Fig 32—Home cinema is often a major investment for any household, but when the home doesn't lend itself to the precise layout of five (or more) speakers, that investment may be compromised. With Dolby's Virtual Cinema, the requirement for only two speakers means it becomes much simpler to make a system fit your lifestyle. Here, a conventional Panasonic plasma television, with two detachable speakers, is able to create a remarkably effective soundstage. Home-cinema purists may balk at the idea, but the effect is compelling and, in an audio sense, immersing. Even better performance could be achieved by moving the speakers a short distance from the respective edge of the screen.

DOLBY HEADPHONE

Dolby has been successful in removing the need for additional speakers beyond a conventional stereo pair. But the company did not stop there. Its next target was headphones. Headphones have always been something of a compromise: they offer us private listening, or listening on the move, but in audio terms they have not been able to deliver a three-dimensional soundstage that compares with that generated by conventional speakers.

Much of the advanced-modeling technology employed in the Virtual Speaker has been used to overcome the key problem with headphones. Unlike speakers, which use the acoustics of the room in which they play to create depth and width in the soundstage, headphones deliver sound directly to your eardrums. This direct delivery prevents any spatial information being conveyed.

By using powerful and very advanced digital-signal processing, Dolby Headphone processes the sound to simulate the echoes and delays that would normally affect sound delivered from speakers. The result is a sound that appears to come from outside your head and mimics the effect of five speakers. Not only that, it can also create a virtual subwoofer to ensure that the deep, booming tones are maintained.

Creating the signature of a room could be contentious. What room do you sonically re-create? In fact, Dolby chose to create three, which it dubbed Dolby Headphone (DH) modes 1, 2, and 3.

DH1 is a small room, a lot like most living rooms, with soft furnishing to dampen echoes.

DH2 is what Dolby calls a more acoustically live room, where echoes and reverberation are sharper and more pronounced. This, apparently, is better for movies and general music listening.

DH3 is conceived as a "larger room," which we can interpret as a concert hall or commercial movie theater.

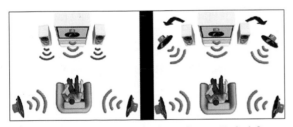

Fig 33—Dolby Virtual Speaker Modes: Reference Mode, left, Wide Mode, right.

quality is maintained despite the large amount of signal processing and filtering required to create the soundstage. The net result is natural and realistic without any audio artifacts.

- *Expanded soundstage* When Virtual Speaker Technology is used with stereo sources (rather than surround-sound sources), the system works in conjunction with Dolby Pro Logic II to create a realistic surround-sound environment. This can work with CDs, MP3s (and equivalent formats), and even with FM radio broadcasts.

- *Listening comfort* Because the original soundstage is faithfully reconstructed, the result is a restful listening experience. Other, inferior systems can produce artifacts that, subconsciously, lead to listening fatigue.

Dolby Virtual Speaker provides for two modes offering different surround-sound effects. Reference Mode produces the five-speaker surround-sound effect with the width of the soundstage determined by the actual width between the front speakers (see above far left). In Wide Mode you get the sonic effect of wider-spaced speakers, providing a broader soundstage (see above left).

In-car audio proved the salvation. Let's face it, for most of us it is in the car and on the move that we listen to most radio and, despite the benefits of RDS, reception can still prove problematic and discontinuous. This was the perfect opportunity for DAB. With prices still high, they proved their worth in the luxury-car market where the quiet car interiors could demonstrably deliver the sound quality benefits.

Of course, it was not long before the prices fell and digital-only stations appeared, catering specifically to the specialized markets that DAB would need to appeal to. Now prices continue to fall and, by virtue of low-power compact chip sets—required to receive and decode digital radio—we have a choice ranging from top-end audiophile units, through conventional radios, to in-car units and even portable, Walkman-style receivers. In many areas you can also receive many more digital stations via digital satellite—either using a dedicated digital satellite radio receiver or a digital television service, where the stations piggyback on the signals.

HOW IT WORKS

The audio signal picked up from a microphone—as in the case of "live" voice programming—or output from a music source is encoded in much the same

DIGITAL RADIO

Digital radio, or DAB—Digital Audio Broadcasting—preceded digital television onto the airwaves, but for many of the more formative years of digital broadcasting it was seen as something of a Cinderella product. It was much easier to discuss and then show the benefits of digital television. Interference-free pictures, more choice, and the ability to use existing televisions made an immediate impact.

The benefits of DAB were less easy to market. The core capabilities—interference-free signals, virtual CD-quality sound, more stations that are easier to identify, and added informational services—were no less significant but were lost to the consumer due to the high prices of early models.

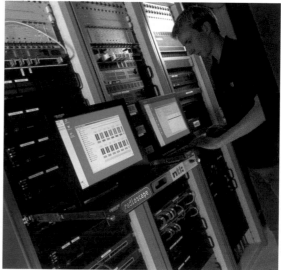

Fig 34—Digital studio and transmission equipment provides the encoding of the analog sound sources and then bundles several stations' output into a single multiplex.

way as music coded into MP3 on a computer, the format used by many digital music services and players. The digitized signal is then transmitted over the air to be decoded at the receiver. Because the signal is digitally encoded, it will not be degraded even if the signal is prone to interference. The receiver can filter any interference that might compromise the signal.

The key difference to the transmission method is that, like digital television, radio stations do not transmit on discrete, separate frequencies. Rather, a group of stations transmit over the same frequency in a multiplex with the receiver, again, filtering out the required signal from this complex composite. This means, again like digital television, that a larger number of stations can be broadcast over a limited number of frequencies, and that cross-frequency interference can be eliminated. Since there is no frequency to find, DAB receivers can identify stations by name.

Reading the radio

Riding on the back of the audio signal is a text signal. This can be used (or not used, according to the station) to transmit additional information and is displayed on the receiver. Information might include details on the current program, song lyrics, or contact details for call-in shows.

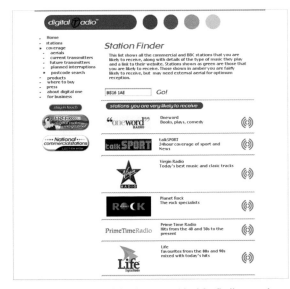

Fig 35 — Location-based databases are ideal for finding out the stations available from your home or workplace. This one is from the UK's Digital One multiplex operator.

A PVR FOR RADIO?

We are becoming increasingly familiar with PVRs— such as DirectTiVo for digital satellite—giving us the ability to pause live television, make automated recordings, and flexible replay. You will find similar services offered on many DAB receivers. Hit a button when you have to leave the broadcast, and you can then resume your listening when you return.

Some radios will record using a memory card, recording between one and four hours of content on a single card. Not only can you replay the recording on your radio later, but you can also transfer the card to a computer or PDA to listen when and wherever you want.

Reception is area-dependent, and the mix of stations also varies according to location. The digital nature of the signal also means that you will get very good reception even at the edge of signal areas. In the UK, www.ukdigitalradio.com has an extremely effective system that will confirm your reception by entering a postcode. The Federal Communications Commission (www.fcc.gov) provides information on similar services in the United States.

DAB RECEIVERS

Like their conventional counterpart, DAB receivers come in an increasingly wide range of shapes, sizes, and applications. As has been mentioned—and you have probably already discovered if you have the facility—digital television provides a convenient (if not portable) option. But when you take a look at dedicated receivers, you will find four key options: the portable, home, in-car, and PC-based.

Portable receivers

In recognition that it comprised a major market segment, the portable receiver has been addressed by many manufacturers. Determined to differentiate DAB models from their analog stablemates, digital models tend to be more dramatically styled than the tired-looking conventional models. Styling, to a

Fig 36—L-R:
Traditional styling marks out this DAB from Roberts Radio—only the enlarged dot-matrix display betrays the digital nature of the set; another Roberts model includes a digital record feature activated by simply pressing the orange button on the dash; Perstel is a new name to radio that has debuted with the DAB revolution, offering models in the spirit of the iPod in size and operation.

degree, is determined by the need to provide a larger display and different controls, often including the "record" feature that lets you record or time-shift programming.

As the chip sets for DAB have shrunk, so have the receivers, with true pocketable receivers now commonplace. Some of these will also include memory—whether in the form of memory cards, built-in memory, or a hard disk—allowing programming recording or storage of prerecorded music.

Home receivers

DAB debuted with home units, tuner decks designed to integrate with home stereo components. Again, as a result of the decreasing size of the receiving components, DAB is increasingly integrated into one-piece audio and audiovisual equipment, with most major manufacturers offering the medium.

In-car audio

DAB reception is now only one of many functions offered by in-car units, along with, say, MP3 playback from CD, hard-disk audio storage (which allows DAB signals to be recorded for later replay), and more. In the United States and some other regions, satellite-based digital radio—rather than

Fig 37—*Apart from the comprehensive informational display, there is little to tell this Antex home receiver apart from a conventional tuner.*

digital terrestrial—is the norm for direct broadcasting and has given rise to receivers that can be used in the car and at home. A mobile-phone-like car mount makes it simple to take the receiver with you.

More conventional digital car units can operate with services such as Sirius. A lot like CD changers, additional components for the reception of digital satellite radio can be housed elsewhere in the car and controlled from the dash-mounted head unit.

Fig 38—*A receiver suitable for car or home use was the motivation for this JVC Sirius model. You need to connect it to a suitable antenna when using it in different locations.*

PC receivers

You can listen to digital radio via your computer. To listen to "real" DAB (rather than the broadcast feed of the radio station streamed over the Internet) you need to fit a decoder card or an external decoder and install the appropriate software. Then you can either exploit the speakers of your PC or, undoubtedly a better solution, connect the computer to a stereo system.

A unit such as Psion's Wavefinder (fig 39) is essentially a signal receiver (which includes an antenna) and decoder. It works by feeding the output directly to the computer where the Wavefinder software allows you to access a chosen channel via an electronic selection and program guide. You can also see any text that is being transmitted along with the selected station. In using a system such as this one, you will be able to record to the computer's hard disk any content from the radio stations for later replay—but as always, however, you need to be mindful of copyright considerations when doing this.

Fig 39—Wavefinder incorporates an antenna and receiver in a simple, compact unit that is connected direct to a PC.

Modular Technology's DAB solution comprises a computer card and software. You will need to install its card inside your computer (not as difficult a task as it may sound) or have your dealer do it for you. Then connect an antenna, install the software, and you are ready to go.

An elegant interface makes it easy to select stations, as with Wavefinder. Here, you can also tap into program guides produced by the

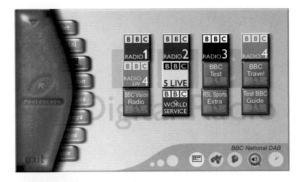

Fig 40—An elegant interface makes it easy to select stations, as with Wavefinder. Here you can also tap into program guides produced by the broadcaster to receive enhanced schedule and program information.

broadcaster to receive enhanced schedule and program information.

THE DIGITAL RADIO EVOLUTION

For a medium that is still in its comparative infancy, how will it develop? The nature of radio is such that we are unlikely in the short term to see the same pressure to drop analog services, so "simulcasting" will carry on for some time, driven more by commercial than political pressure.

Technology will mean that the added services—currently text-based—can expand in scope to provide further supportive material. Pictures, maps, and diagrams that could enrich a broadcast are possible now. Also possible—but not necessarily probable—is Digital Radio Mondiale (DRM). This is digital radio for the AM frequency band, bringing the benefits of digital radio to these wavelengths. Quality will be better than conventional AM but not up to the quality of FM. Good enough for speech and undemanding music-based services.

MUSIC IN THE DIGITAL AGE

IN THIS CHAPTER WE WILL:

- Discover how the digital music you now enjoy came into being.
- Take a look at digital music devices and determine which is best for you.
- Look at what else you can do with music players.
- Study the iPod phenomenon.
- Examine how you can create and record your own music.

ONE MESSAGE IS EMERGING AS UNDERLYING THIS ENTIRE EXPLORATION OF THE DIGITAL WORLD: DIGITAL TECHNOLOGY EMPOWERS. THIS IS PARTICULARLY THE CASE WHEN WE TURN TO MUSIC. THE MATHEMATICAL MANIPULATIONS THAT ALLOWED US TO EDIT AND CREATE FANTASTIC IMAGERY IN DIGITAL PHOTOGRAPHY AND HELPED US CREATE PROFESSIONAL-GRADE DIGITAL MOVIES ALSO LETS US CREATE IMPRESSIVE MUSICAL PIECES. AND, THANKS TO THE MP3 RECORDING FORMAT, WE CAN TAKE, SEND, OR DELIVER THAT MUSIC WHEREVER WE WISH. IF YOU HAVE EVEN A MODEST MUSICAL BENT, YOU CAN UPLIFT YOUR PERFORMANCE TO NEW HEIGHTS. THE REST OF US, WITH NO COMPOSITIONAL SKILLS WHATSOEVER, CAN RELY ON CLEVER SOFTWARE TO INTERPRET THE MOST BASIC OF IDEAS AND DELIVER SOMETHING REMARKABLY TUNEFUL.

ONE OF THE REASONS FOR THE SUCCESS OF DIGITAL MUSIC HAS BEEN THE ONLINE MUSIC STORE. UNHEARD OF UNTIL THE TURN OF THE CENTURY, ONLINE STORES OFFER AN INTRIGUING MENU OF TRACKS AND ALBUMS THAT ARE EASILY DOWNLOADED TO A COMPUTER, TO PLAY ON THAT MACHINE, YOUR DIGITAL MUSIC PORTABLE PLAYER, OR EVEN YOUR HOME STEREO. IT HAS NEVER BEEN EASIER TO GET HOLD OF YOUR FAVORITE TRACKS OR EXPLORE CATALOGUES FOR TITLES THAT YOU WOULD PROBABLY NEVER ENCOUNTER IN A TRADITIONAL MUSIC STORE.

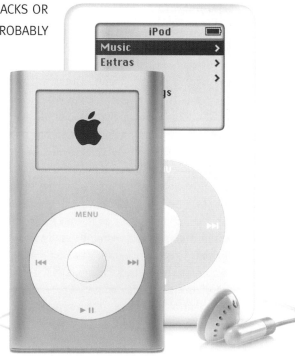

MP3: THE STORY SO FAR

MP3 is a term that has become synonymous with digital music. This is slightly ironic, since much digital music today is no longer in this format. But the history of MP3 is that of the development of digital music and recording, and the technology also underpins other digital media. To cut through the jargon, MP3 provides the means for high-quality music and narrative to be delivered over the Internet and stored in a fraction of the space normally required to store digital music.

Fig 1—After the terrific impact of the iPod, the iPod Mini extended the concept and would be joined within a year by the solid-state iPod Shuffle.

ENJOY THIS!

To commemorate the 75th anniversary of their celebrated car styling studio, Italy's Pininfarina created a special car, the Enjoy, to be built in a limited run of just 75 (fig 2). The description harks back to the classic days of the Fiat Barchetta but with the ability to adapt into an open-wheel race car in seconds. But all this was done with a modern twist that extended to the audio system. Within an interior styled by Louis Vuitton, Pininfarina chose to include the remarkable Beosound 2 MP3 player from Bang & Olufsen. Housed in small door enclosures, they provide driver and passenger with the ultimate in music entertainment on the go.

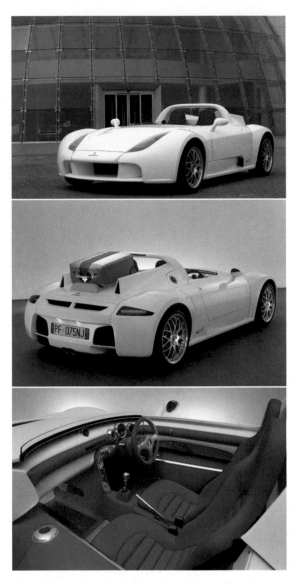

The name MP3 is a contraction of the more cumbersome MPEG-1 Layer III, sometimes described as MPEG Audio Layer III. As such, it is an element of the multimedia standard MPEG defined by the International Standards Organization (ISO).

The development of what was to become MP3 began in the late 1980s at the Fraunhofer Institute in Germany as part of a European Union "Eureka" project, which was laying the foundations for digital audio broadcasting (DAB). The Fraunhofer Institute can be regarded as a European equivalent to MIT in the United States and has the same business-academic partnership at its core.

To tell the story of MP3 is to tell the story of the work of Karlheinz Brandenburg, a Section Leader at the Institute. The Eureka project (Project EU147) was originally concerned with ways of delivering high-

Fig 2—Discreet Beosound units are housed in small enclosures in each door, surrounded by red leather. The his-and-her devices can easily be removed and used on the go when out of the car.

PERSONAL MUSIC: AN ILLUSTRATED HISTORY

In creating the original Walkman, Sony revolutionized personal entertainment on the move. Since then the market has flourished in scope and variety. Here's just a taster.

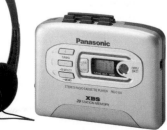

1980s
The cassette-based player is still popular because of low cost and the amount of media that is still available.

1990s
From a simple tape replay device, the modern tape Walkman has some of the functionality you would expect to find on digital music devices—such as the display panel on the earphone cord.

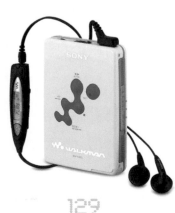

quality audio through a conventional telephone line.

The research of Brandenburg and his colleagues was based on creating a mathematical formula that could be applied to sound to compress the data without compromising the audio quality. They worked hard to determine how much of the data in a sound file could be removed before deterioration became noticeable. The embryonic formulas were applied to various sound files, but the urban mythology suggests that it was Suzanne Vega's *Tom's Diner* that provided much of the working material. The quiet tracks, apparently, were the most problematic to compress and so provided an effective test. Although it is stretching the point a little, Suzanne Vega can claim to be the first recording artist to be represented in MP3.

The Fraunhofer Institute received a patent for MP3 as far back as 1989, but it would be another four years before MPEG—the Motion Pictures Expert Group, a division of ISO involved in creating standards for digital video—incorporated it into the specification of MPEG-1. MPEG-1 was the first standard in digital video. Offering a quality similar to that of VHS video, it achieved momentary success as the basis for video on the CD-I format in the early 1990s. But audiences' expectations had been raised, and they were demanding more from video.

By 1995 MPEG-2, the format used in DVD video, was announced, and this, too, featured MP3 as the audio component. Our demands for a high-quality video format had now been satiated, and we would shortly see the results in the first DVD players, but the audio format was still lurking somewhat in the shadows.

Brandenburg was increasingly aware of the opportunities of MP3 and protected his creation—on behalf of the Fraunhofer Institute—with worldwide patents. But Brandenburg also realized the importance of open standards in advancing technology and thus his and, by association, the Fraunhofer Institute's approach to licensing was liberal and open. As a result, by the beginning of 1999 the first music tracks were being released on MP3 and rather than direct transmission over a phone line, they were being shared over the Internet. The market was ready for the widespread sharing of music over the Web. All it needed was a catalyst.

The Napster age begins . . .

That catalyst was Napster (fig 3): a music-sharing system that allowed MP3 files stored on any computer connected to the Internet and the Napster service to be shared with any other computer. The rise of Napster as a corporation was meteoric. It had tapped a latent need and filled it unequivocally. Huge numbers of MP3 files were shared on a regular basis as users of the free service passed files around the world.

Fig 3—Napster: the site that kick-started the MP3 revolution.

Unfortunately for the Napster generation, and as was clearly pointed out by the music industry, "sharing files" was really a euphemism for "copying files." Rather than sharing files in some egalitarian musical nirvana, the users of Napster were being painted as copyright transgressors.

For some time there was something of a standoff. The demand for MP3 music continued to grow while the music industry continued to flex its muscles. In

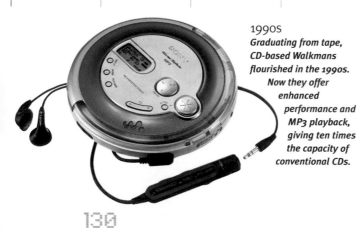

1990s
Graduating from tape, CD-based Walkmans flourished in the 1990s. Now they offer enhanced performance and MP3 playback, giving ten times the capacity of conventional CDs.

1996
Sony's pioneering of new media formats meant that it was inevitable that a MiniDisc player would appear. Before recordable CDs, the MiniDisc was the perfect medium for recording music from your own collection.

late 1999 and through to 2000, court proceedings were initiated that saw the Napster operation shut down and then reopened. The music industry argued the case that free sharing denied legitimate royalties to the artists whose music was now passing freely across the 'net.

... and ends

Ultimately the industry had its way and Napster—or, as we should now say, the original Napster—closed down. But the public appetite remained unfulfilled, and Napster wannabes came to the fore. File-sharing utilities like LimeWire (fig 4) found new followers in an MP3-starved world. Because it was not specifically designed to exchange MP3 files (but rather provide an easy exchange of any digital file), LimeWire escaped the same fate as Napster because its file-sharing methods did not depend on a central interchange file-sharer—files simply passed from user to user.

Faced with this, the music industry changed tack. Realizing that it was the music listeners who were purloining services such as LimeWire, which had been created for the most innocent of reasons, it turned its attention to the downloaders of illicit MP3 files. After a few test cases, a shiver went through the downloading community that stopped trafficking

Fig 4—In the gray area of file sharing, LimeWire flourished.

by all but the most committed and, dare we say it, foolhardy.

With an uneasy truce in place, some hard questions needed to be faced by all parties. MP3 music distribution was clearly in demand. But the music industry was strongly against unrestricted distribution. A solution needed to be found fast before another service, this time one that was more covert than Napster, could start trafficking again.

After many meetings, discussions, and much planning (often behind closed doors), a new generation of music library began to appear. This time it would be legitimate, but it would come at a cost. A real cost: users would have to pay for their music either in the form of a fee for each track they downloaded or by subscription to the service. Moreover, the MP3 recording would be fingerprinted so that, once downloaded, it could not be freely or easily distributed onward. Digital rights management would be introduced to ensure that the music downloaded by an individual could be enjoyed only by that person or their immediate circle of friends and family.

For the music downloaders, these restrictions seemed rather draconian; for the music industry, it had too many loopholes. But as a solution it was one that both parties realized they had to work with.

2000
Solid-state memory—in the form of the memory card—overcame the drawbacks of disk- and tape-based systems. They could survive knocks and rapid movement while playing.

2004
Now, the ultimate for the active lifestyle. Sony's latest Network Walkman is not only totally digital but is designed for action-sports use.

ALL ABOUT MP3 PLAYERS

Digital music players—sometimes known imprecisely as MP3 players—have in the space of just a few years become an essential lifestyle accessory. Conceptually, they received a major fillip with the advent of legal online music stores, which make it possible to select and download music on demand, without the need necessarily to buy a complete album. The partnership of iTunes and the ubiquitous iPod (fig 5) brought a level of simplicity to portable digital music that has won over many users not normally classed as technophiles.

The marketplace is now awash with digital music players offering a wide range of features. Manufacturers have been quick to recognize that there is no one-size-fits-all solution. So there is a diverse portfolio of units that you need to investigate in order to find the solution that best fits your lifestyle. Over the next few pages, you will be able to explore the different types—including multifunction devices—and compare specifications with the needs of different types of users.

As an aside, the term MP3 player tends to be used as a generic for these devices, yet many now also play alternate formats—but don't necessarily assume that every device will play all available formats. Formats and their differences will be discussed later, too.

Hard-drive players

If you are after maximum storage capacity, the hard-drive player is the solution. These are based on small computer hard disks of the type found in portable external computer drives. These drives are small and, for a mechanical device, particularly robust. Even so, most manufacturers advise against putting them through too much stress. Their large capacity also means that they can store other media—video files in some models—and can double up as an external disk drive for your computer. They are ideal for backing up or transporting large files between home and work computers.

Micro hard-disk players have a lower capacity and tend to be built around the one-inch (2.5-cm) IBM Microdrive (now produced by Hitachi and others). The maximum capacity of these players tends to be around 4GB.

FOR: High capacity, lowest price per megabyte of storage.
AGAINST: Hard drive requires more power and so tends to consume batteries faster; less suitable for power workouts.

Memory-card players

Using the same memory cards as you will find in digital cameras or other portable devices, memory-card players (or flash-card players as they are also known) have no moving parts and are, hence, more robust than hard-drive players (fig 7). They are also much smaller—their size is often governed by the size of the battery pack. With several interchangeable memory cards, you can store a large library of music but without the ultimate convenience

Fig 5—Unlike its larger siblings, the iPod Shuffle uses a flash-card solid-state memory to store up to 1GB of music.

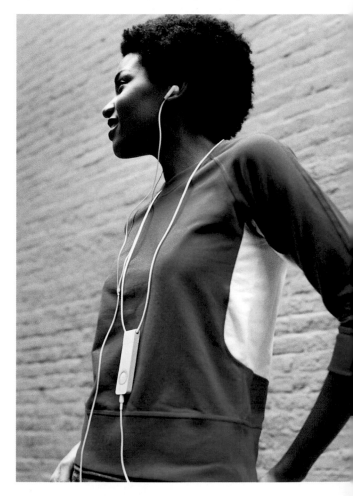

THE SCIENCE

For most of us, the mechanics of getting music on to a digital player—whether it has been sourced from our CD library or online—is of little significance. The process is so transparent that we just select tracks and then enjoy the music wherever we may be. But let us spend a moment taking a look at how digital music systems deliver the goods.

Digitizing

The first process in delivering music digitally is digitizing. This is the conversion of the analog sound (the singing, instrumental, or narrative sounds) into a digital form—that string of numbers that a computer can interpret and manipulate. If you have bought your music on CD, then this process has already been done for you. Somewhere within the vast enclave of the recording studio—either at source or subsequently—an ADC (analog-to-digital converter) has sampled the music. Otherwise you can now digitize analog sound in real time using your desktop or portable PC.

Sampling involves measuring the volume, tone, and pitch and assigning a numerical value to these parameters. The more samples taken per second, the closer the digital code is to the original analog sounds. Of course, the more samples you take, the larger the amount of data and greater the size of the digital file that represents the original sounds.

Compressing

If you were to convert a digital file to CD-quality digital signals, you would find that each second of recording would take 1MB of space or even more. This would very quickly fill even a generous-sized hard disk with very little music. That is why the digital files need to be compressed to make them substantially more compact.

Compressing sound files is a process rather like that for compressing image files. It involves discarding some information (usually) but not so much that we would notice, except under the most critical of analyses.

Sound engineers and scientists called on the services of psychologists to help them produce compressed sound files. Together they investigated how we perceived sound. In particular, they examined which parts of a sound signal our ears (and brain) are most highly tuned to and which components they are not. This led to the creation of mathematical algorithms known as codecs that can be applied to a digital signal. This removes all those elements that we are unlikely to perceive when listening to music but leaves the most obvious components untouched. Like image files, the greater the compression, the greater the degradation. But for sound files, the bit rate—the number of samples per second—also has a bearing: the greater the rate, the better the quality. The box on page 137 explains more about the common file format codecs.

Downloading

Once the music has been compressed (the process is achieved automatically when the music is imported into iTunes, or an equivalent), we now need to download the files to an MP3 player. Again, this is largely an automatic process. In the case of the archetypal iTunes/iPod combo, synchronization ensures that when the iPod is connected to the computer, tracks are automatically downloaded.

For flash players—where the capacity of the player is likely to be far less than that of even a modest music library—you will need to use the software that accompanied the player to download selected tracks.

Replaying

With the digital files now resident in the player, how is this digital data converted back into high-quality sound? It is essentially the reverse of the encoding process, this time using a DAC—digital-to-analog converter. In an ideal system, this should lead to sounds similar to those recorded. In practice, the sound is compromised slightly by the compression but it is also colored by the DAC circuitry and, once in analog form, it can be prone to modest amounts of interference.

Fig 6—Downloading songs to the MuVo is simple. Detach the memory unit and plug it right into the computer's USB connection.

of having all your favorites on a single device.

FOR: Smaller than any hard-disk player, and since they have no moving parts they are more resilient to knocks and rapid movement. Expandable capacity using more memory cards and good battery life.

AGAINST: Expensive on a per-megabyte basis.

Flash players

Imagine a memory-card player with the memory card sealed for life within the player (fig 6). That is the principle behind the flash player. It is a single unit—not expandable, but incredibly compact. Since there are no moving parts (not even a memory card to insert or remove), these can lay claim to being the most robust and durable.

FOR: Very small and very robust.

AGAINST: Limited, fixed capacity; limited power (small batteries to maintain small size).

Fig 7—Freed from the Enjoy (see page 129), the Beosound 2 from Bang & Olufsen uses interchangeable memory cards to extend the capacity.

Multifunction devices

Many digital devices feature MP3 replay. Phones, PDAs (fig 9), and even some watches have the option of using on-board or card-based memory for music storage. These devices rarely have the small size of a dedicated music player, but they have the advantage that, if you need to have a phone with you all the time or are never without your PDA, you don't have to carry a second device to enjoy your music library.

FOR: Need to carry only a single device.

AGAINST: Functionality may not be as comprehensive as with a dedicated music player. Some PDAs can be expensive if they are used primarily for music.

CD-based players

Based on the portable CD player that has been around for years, CD-based digital players (fig 8) will play conventional CDs and also CDs that have been recorded in MP3 format. These disks have a capacity for around ten times the music of a standard CD, so it is quite possible to keep twelve albums on a single disk.

FOR: The cheapest player, compatible with CDs.

AGAINST: Also the largest of players, uses more power, and can skip when bumped.

Fig 8—The Beatman from Freecom is a CD-based MP3 player, but it overcomes the usual associations of bulk by using small, 3½-in (8-cm) CDs.

Fig 9—PDAs let you organize your life—including music—in a single device.

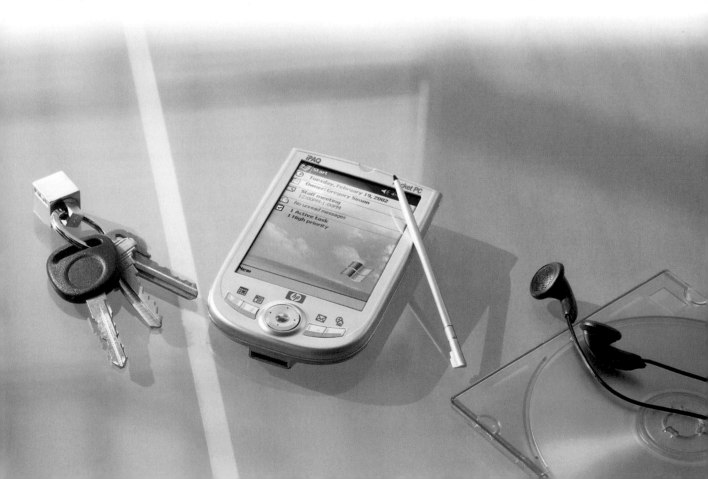

CHOOSING YOUR PERFECT MP3 PARTNER

As has been mentioned earlier, there is no single ideal MP3 player but rather a range of devices each with powerful attributes and capabilities. This is just as well, because there is an equally diverse range of users. Here, users have been divided into different groups—to find the best machine for your needs, simply identify which category matches you most closely. If you straddle more than one group or inhabit two entirely different categories, you may need two devices.

The car driver

Spending most of your time in the car, you will not be too concerned about size. CD-based players will

Fig 10—Although CD-based, the Beatman has great antishock facilities that make it possible to bend the rules and use a CD player while undertaking strenuous activity.

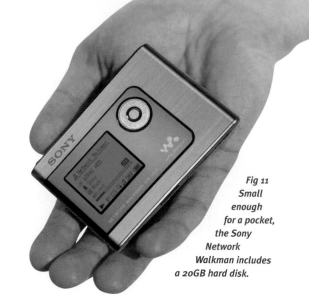

Fig 11 Small enough for a pocket, the Sony Network Walkman includes a 20GB hard disk.

be OK and robust enough to use in the automotive environment. Hard-disk players will also be suitable. Some, such as the iPod, even have car kits (a lot like those for mobile phones) that enable them to be mounted in a car and feed their output to the car's stereo system. If you listen to music only in the car, you may find it better to invest in an MP3 player/hard-disk recorder in-car unit.

The commuter

Those who use public transportation or even bicycle to work will want to look at something more pocketable (fig 11), for both convenience and security (like mobile phones were a decade ago, MP3 players are now increasingly targets for street muggers). Mini hard-disk and flash players will be ideal. If cost is a principal consideration, you might do well to reserve a little more than you would otherwise for a good pair of headphones. Those supplied with even the top MP3 players tend to be poor at blocking external sound.

The jogger and gym freak

Jogging and gym workouts don't just put a high degree of strain on the body, they will affect your MP3 player, too. CD and hard-disk systems (fig 10) are pretty resilient to the knocks and jostling that is inevitable in these conditions, but ultimately they will suffer. Flash systems are best in this situation. Even under violent motion, they will continue to play unhindered. But do take care of them—even the most robust player will succumb to repeated knocks.

DIGITAL MUSIC FORMATS EXPLAINED

MP3 virtually created the digital music genre, but it no longer has the field to itself. Other formats now vie for popularity, offering similar or better quality or added functionality. Most players can handle multiple formats, though not necessarily all.

MP3 Short for Motion Picture Experts Group Layer 3. The format was originally designed for encoding MPEG audio tracks for DVD video. It achieves a compression of around 90 percent for most audio files with negligible loss of quality.

MP3PRO An "upgrade" to MP3 devised by the licensors of MP3, designed to give better sound quality at the same bit rate (in other words, with the same degree of compression). Not widely adopted.

AAC Advanced Audio Coding is the default coding used for iPod downloads. More compact than MP3, it also supports DRM coding—digital rights management—to prevent unauthorized copying of the files.

WMA Microsoft's Windows Media Audio offers a quality similar to MP3PRO and can also be encoded with copy protection.

AIFF The standard, uncompressed audio file found (mostly) on Macintosh computers.

WAV The standard, uncompressed audio file found (mostly) on Windows computers.

OGG VORBIS High-quality compressed audio format that is "open source." That is, the format is in the public domain so that users don't have to pay licensing fees to use it. Gaining ground as music vendors aim to cut costs.

Fig 12—Creative's Zen Extra Jukebox features a 60GB hard disk, which is sufficient for all but the largest of music collections.

The style guru

If appearance is the most important aspect—and with MP3 players all offering very good sound quality, this is not as trivial a consideration as you might think—there are really only two choices. First the iPod and second the Beosound 2. Both can claim style credentials through their associations with celebrity. But on a more practical level, both have been annexed by the fashion houses, which (especially with regard to the iPod) produce custom cases to be seen with.

The audiophile

Sound purists have rejected MP3 on the grounds that any form of compression will compromise sound quality. They would rather carry around two high-quality recordings than two days' worth of MP3. But, mindful that modern codecs do provide a very good representation of the original and that, on the move (in a car, plane, bus, or even walking), it would be hard to get the best from a top-notch recording, they would most likely go for hard-disk players that have the capacity to accommodate high-bit-rate recordings.

The music devotee

If you were among the first to get an iTunes account and helped Napster flourish in the bad old days, you have probably found that your hard disk is virtually dedicated to music; you will have copied your CD collection to disk and likewise digitized your vinyl albums. To ensure you have music wherever you go, you will need not only a hard-disk player but also those with the highest capacity (fig 12). That means something like Creative's 60GB models or, at a pinch, the largest iPod.

EXPANDING YOUR HORIZONS

As you might expect, in this digital domain, it is unusual now for a device to have just a single role. Phones can be PDAs, and vice versa; cameras can take still or movie images and even act as voice recorders. So what else can you expect from an MP3 player? Here's a rundown of some of the extended functions possible.

1. Radio

Remember how early Walkmans played cassettes and had a radio? Some MP3 players let you access radio, too. Mostly this is FM, but digital radio (DAB) is now a viable alternative. In a useful crossover of technologies, some DAB/MP3 players will allow you to record radio programs.

2. FM broadcasting

Sometimes you don't want to listen to your music though small headphones or earphones. FM broadcasters—such as Griffin's iTalk—connect to the MP3 player's headphone socket and broadcast the output over an FM frequency. This means that you can tune your car radio, portable radio, Walkman, or even home receiver and (as long as you are within the very limited range of the device) and listen to your music library over the airwaves.

It is important to note that even though these devices are widely available, local regulations may limit or ban their use.

3. Voice recording

Although they are not suitable for high-fidelity recording of music and concerts, built-in or auxiliary microphones (fig 13) let you use your MP3 player as a tapeless voice recording system. You can replay the files through the headphones or even transcribe them on your PC.

4. File storage

There is little difference between the memory in any MP3 player and that used in a computer, so you can treat your player as additional storage. Most commonly, people use their players to transfer files between home and office and also to store image files. The capacity of a modest MP3 player is many times that of the memory cards in a camera so, to avoid taking your computer away with you on extended trips, you can download your memory cards' contents to your MP3 player. Apple raised the stakes when it made the music iPod compatible with image libraries (fig 14) (iPhoto on the Macintosh or Adobe Photoshop Elements on Windows PCs).

Fig 13—Use your iPod for note taking by adding this small microphone unit.

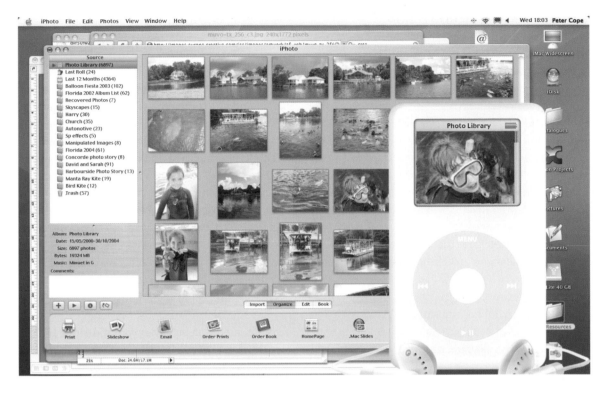

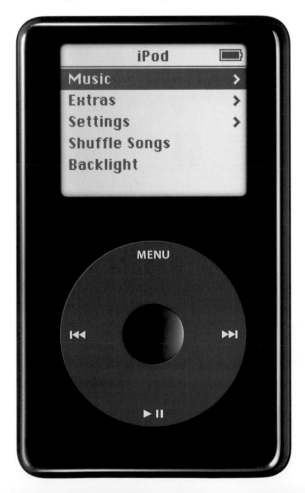

Fig 14 — iPodphoto allows storage and display of images as well as tunes. Fig 15 — The U2 iPod is signed on the back by the band.

5. PDA

Nobody will pretend that your MP3 player can replace a PDA (though, to a degree, a PDA can replace your MP3 player), but many MP3 players store useful information that is downloaded from your computer when the two devices are synchronized. Phone numbers and contacts, along with calendars and appointments, are the most common data downloaded.

6. Stereo controls

One of the beauties of the MP3 player is its simplicity. It really lives up to the plug-and-play philosophy that so many digital devices promised but so few delivered. But there are still a number of controls that we have become familiar with from our other music players that are creeping on to MP3s. It is now possible — either straight out of the box or via a software upgrade — to create playlists on the go. Like the playlists created in iTunes and its peers, these are ideal for impromptu partying and DJ-ing.

Moreover, you can now also change the tone and sound quality to get the best perception of the sound, despite using headphones that can rarely be described as anything but average in their sound quality.

BUILDING YOUR MUSIC COLLECTION

When Sony released the Walkman, enjoying music was simple. You inserted a cassette and pressed play. If you had music on vinyl, then you taped the albums—copyright permitting—and listened in the same way.

Then when tape gave way to CD, things got simpler. You stuck in a CD and enjoyed the music. You gained the benefits of CD music in terms of quality and functionality, but, with recordable CD out of sight, you were limited to your purchased music.

Now with MP3 there is a multiplicity of sources. And choice. You no longer need to accept what the big record labels decide that you should enjoy. Here are some of the opportunities now available.

A legacy collection

Chances are, you have a collection of MP3 or equivalent files already on your computer. When you install your MP3 player's software, it might well sweep your hard disk to retrieve files for you and make them easily available to listen to or to download to your player.

Online music stores

There is no doubt the official music stores—typified by the iTunes Music Store (fig 16)—have made music accessible to us all. Seamless integration of the store and downloading routines make it simple to identify, purchase, and enjoy your favorite tracks. There will be some issues: for iTunes, for example, tight copyrighting and rights management restrict your use of the music (but not so any legitimate user need express concern). Also, iTunes is tightly integrated with the iPod—difficult if you prefer a different MP3 host player. Some stores charge a per-track price for songs, with a slightly cheaper price for album downloads. Other services offer a subscription basis, allowing a fixed or unlimited number of downloads for a specific monthly price.

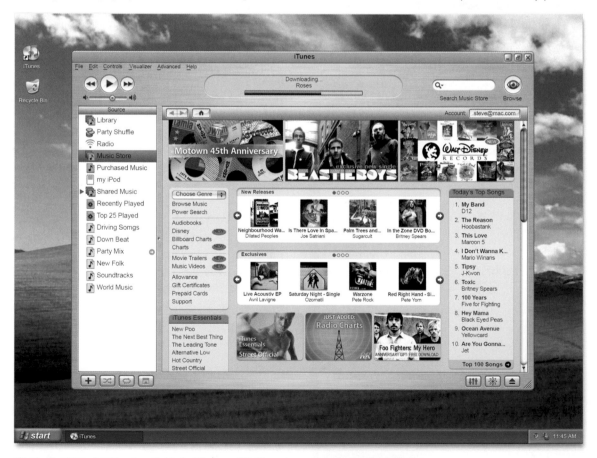

Fig 16—By virtue of making it available for Windows, PCs iTunes has garnered a massive following.

Remember, too, that different services don't just have different pricing systems; they may also have different catalogues. If your favorite artists are carried on different services, you will need to subscribe to each.

Fig 17—Artists' sites (this one is for the Danish band Swan Lee) are a good source for the more obscure tracks.

Titel ▲▼	Genre ▲▼	Længde	Lyt	Pris	Køb
Enter	Rock	00:43:54		110.00	☑
Swan Lee	Rock	00:43:44		110.00	☑
Bring Me Back	Rock	00:05:14	◀)	10.00	☑
Don't Take My Love	Rock	00:03:37	◀)	10.00	☑
Dream Away	Rock	00:04:08	◀)	10.00	☐
Enter	Rock	00:03:45	◀)	10.00	☐
Find My Way Home	Rock	00:04:03	◀)	10.00	☑
Flowers In The Wintertime	Rock	00:03:50	◀)	10.00	☐
Go On	Rock	00:04:07	◀)	10.00	☐
I Don't Mind	Rock	00:04:02	◀)	10.00	☐
I don't mind (DJ Asle's full blown bass mix)	Electronic	00:08:43	◀)	10.00	☐
I don't mind (DJ Asle's full blown radio edit)	Electronic	00:04:12	◀)	10.00	☐

Official—and unofficial—artists' sites

Often you will find a limited number of MP3 files on the official Web sites of artists and bands (fig 17). These may be direct transcriptions of recordings from CDs, new mixes, or even new material that is unavailable elsewhere.

Unofficial sites can also contain material, but download it with caution. If the content is unauthorized, you may, no matter how inadvertently, fall foul of antipiracy laws.

Compact discs

Your collection of CDs can easily be converted—or "ripped"—to MP3, AIFF, AAC, or even OGG format in a matter of minutes, and you can then import them to your player. But here are a couple of notes of caution. There is no problem transcribing your own disks for your own use, but encoding borrowed disks again means you fall foul of antipiracy laws. Just because you will never actually get caught does not make it legal.

Secondly, a few CDs have anticopying technology built into them. At best, this means it will be difficult to rip them to MP3. In the worst case, you could compromise your computer's CD drive. There are many documented cases of CD drives becoming jammed or disks being trapped in drives due to anticopying software. Keep clear of these CDs.

Old formats

Ripping CDs to MP3 is relatively straightforward. We are converting one digital format to another. But what if our source material is a cherished analog recording on vinyl or tape? You will need software that can encode your recordings as they play out on your stereo along with suitable recording cables (fig 18) to connect your computer and stereo. Some software will encode to MP3 directly, saving you considerable time.

You might even find that some applications can remove the inevitable hiss and crackle that you find on old records to give you a recording more pristine than you have ever experienced. Purists, however, will decry software that removes any interference. Their argument runs that, in the same way as the dust and scratch software used to process photographs scanned in a film or print scanner affects the integrity of the original, so, too, does the software that removes the unwanted elements from the sound of the music.

Fig 18—A simple adaptor like this enables a conventional (and increasingly rare) turntable to be connected to the computer and record LP sound digitally.

THE iPOD INDUSTRY

Why has the iPod achieved such iconic status in a marketplace where technology of this type is normally more ephemeral? It is due in part to clever design. It looks sensational, but that look is not at the expense of function. Form doesn't so much follow function as run neck and neck with it. It also evolves, both physically and operationally. Next to the svelte latest manifestation, the first generations look ever so slightly bloated. Then there is the integration with iTunes. Closed systems—those that don't allow other hardware or software to interface—can be considered regressive, but in this virtually unique pairing you have a solution that makes it simple for anyone to collect, enjoy, and take their music with them.

That the iPod is not transient is reflected in the industries that have grown up around the product, providing essential accessories and add-ons. Some of these, given the slightly delicate surfaces of the iPod, are cosmetic; others are more practical. And some are downright wacky. Here's a look—a snapshot, if you like—of what you can do with your iPod.

Cases

Every variation of design, from soft neoprene to hard, armored protection, is available. Even designer names, such as Gucci, have confirmed the diminutive player's fashion credentials (fig 19).

Radio frequency transmitters

These allow you to broadcast the output of your iPod to pick up on your radio at home or in the car. iTrip is a self-contained unit, whereas Roadtrip combines a transmitter with a charger that can recharge your iPod in the car (fig 21, see more on the next page).

Microphones

Ostensibly a replay device, the iPod can also act as a voice recorder. Discreet microphone units, such as the iTalk, let you record many hundreds of hours of notes and annotation (fig 13).

Fig 19—Every conceivable case design can be purchased for your iPod. With this one, you really can take your whole life with you in a single package.

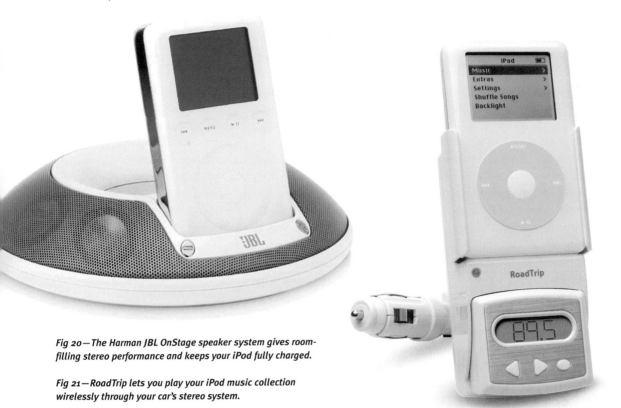

Fig 20—The Harman JBL OnStage speaker system gives room-filling stereo performance and keeps your iPod fully charged.

Fig 21—RoadTrip lets you play your iPod music collection wirelessly through your car's stereo system.

Speakers

It might be designed as a personal player, but why not share your musical tastes? There is a range of speakers available (fig 20)—some costing many times more than the iPod itself.

Lights

Turn your iPod into a flashlight? Not as absurd as it sounds. Plug in the iBeam, and you can light your way to the front door at night or use your iPod as a laser pointer.

Memory card storage

Think of your iPod as a large hard disk, and there is no end to the storage opportunities. Belkin and others have media readers that can be used to download your camera and PDA memory cards in the field (fig 22).

Remote control

You don't always want to wear your iPod. But how do you operate it when it is connected to your stereo or external speakers? Simple: add a Navipod remote from Ten Technology. Looks the part, too.

Fig 22—Before the iPodPhoto, Belkin's media card reader could also download images.

MAKING MUSIC

Listen to any aging rockers discussing how they got started, and you will hear tales—no doubt embellished by the passage of time—of how they began in their bedroom or garage, recording onto reel-to-reel tapes. Tomorrow's rock legends (or their folk and pop equivalents) can still record at home, but now they have the capacity to produce polished productions. And even if your aspirations are more modest than this—creating music for your own pleasure, for example, or perhaps for a movie soundtrack—it can be great fun.

The hardware

Like producing movies or photography on your computer, music generation and production demands a well-specified computer. Below you will see that software exists for both Windows PCs and Macintosh computers, but whichever you use, make sure it is up to the job. If you are using a Mac, you will need to have at least a G4 running at 1GHz. PC users should be running with a 2GHz Pentium as a minimum specification.

If you are already practicing the visual arts on your computer, you will know how important memory is. Well, it is just as important for audio. Don't be seduced into thinking that, with MP3 tracks clocking in at around 5MB and even the original CD-quality tracks at around 50MB, a modest memory allocation will be sufficient. Creating a five-minute musical piece comprising, say, five tracks, will consume more than 100MB of disk space. Processing that live needs lots of RAM. The software you choose will make recommendations, but these tend to be minimum specifications. If you aim to have at least 512MB of RAM, you will be OK for all but the most ambitious of orchestral productions.

There are some useful parallels to be made with digital photography and moviemaking. A multitrack musical piece is rather like a multilayered image. The more layers, the greater the size. But music is a dynamic, constantly varying medium, just like movies. So you will also need from your computer the means to read and write data quickly. This means the hard disk—something that we usually consider only in terms of the amount of data it can

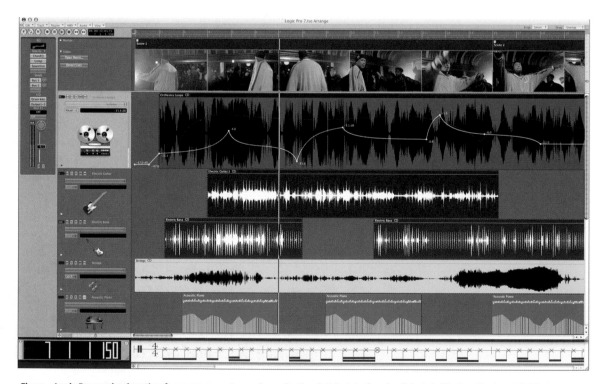

Fig 23—Logic Pro can be daunting for anyone new to music production, but its interface is slick and effective. If you need ultimate control and versatility, Logic Pro is hard to beat.

MUSICAL PLUG-INS AND MP3

Applications such as GarageBand and Acid come with a good selection of loops that you can use to produce an almost infinite number of combinations. But you can extend your musical arsenal further with additional plug-in loops.

GarageBand (fig 24), for example, has a number of add-on packs that you can buy and integrate into the host application. Some of these are produced by Apple, others by third parties. Third-party plug-ins tend to be more erratic in quality. That is not to say they are bad—just a little more uneven in quality. They are also less predictable, so if your musical tastes and ambitions are rather more eclectic, they can be a good source of inspiration.

You can also import other musical files in most formats (such as MP3, WAV, or AIFF) and use these as part of your composition. There is no problem in using commercial music in your own compositions for your own use, but if the original material was subject to copyright (and most is) you will not be able to play the results publicly.

Fig 24—Jam Packs offer extensive (around 2,000 per volume) additional loops to add to your GarageBand project.

GarageBand
Jam Pack 2
Remix Tools

store—must now be considered in terms of the speed at which data can be written to and read from it.

If you are serious about making music, it makes sense to use an external hard disk. You can reserve this for your music-making activities and leave your computer's built-in hard disk for more mundane (and less speed-critical) activities. Go for a Firewire or USB 2 drive. These will give you the essential speed and performance that is required.

The software

The key to good music production is the software. Software needs to be able to interpret the music you give it, whether recorded by you or sampled from elsewhere, and allow you to arrange and manipulate it.

Again making the comparison with digital photography, there is a wide range of applications vying for our attention. Your choice will be limited by the type of music that you want to produce. For the serious musician and aspiring professional, that choice might be for one of the powerhouse applications, such as Logic Pro (fig 23), the preferred software of many producers and musicians. As Photoshop is to photographers, so Logic Pro is to musicians. If you can't do it with Logic Pro, then it probably isn't worth doing. The latest versions even allow you to edit, in perfect synchronization, video footage to make music videos of your productions.

Logic Pro, and its Windows equivalent, Cubase, are professional tools that are professionally priced. They also offer so much functionality that it would be wasted on most of us. Fortunately, there are better-priced alternatives that, despite the lower cost, don't inhibit creativity. Favorites are Sony's Acid (fig 25) on the PC and GarageBand (fig 26) on the Mac. GarageBand is part of the iLife suite, along with iPhoto, iMovie, iTunes, and iDVD.

Fig 25—Acid from Sony appears to be as cluttered as Logic Pro, but even a short association with it shows you that it is a very simple application to use.

Fig 26—Like all iLife applications, GarageBand combines a powerful application with a simple, intuitive interface.

These applications allow you to put together tracks of music created from the extensive raft of instruments provided. But once you have created your own tracks—or loops as they are more often called—you can add a rhythm track and even some recordings made with real instruments.

Electronically synthesized instruments have something of a bad name; they have a reputation of only sounding "like" the instrument that they represent. Musicians, being (by and large) perfectionists, want an authentic sound. The good news is that today's synthesized instruments sound very good indeed. Play them well and they will reward you well. But you don't need to be an expert musician to begin using these applications. You will find

libraries of loops that you can drag and drop to produce your own melodies. And yes, some of these

Fig 27—The Prodikeys keyboard from Creative combines a conventional Qwerty keyboard with a piano keyboard and is the ideal solution for the enthusiastic music creator.

will sound truly awful, but soon you will get the hang of it and start to produce something that sounds good. In fact, many of the loops provided with these applications are designed to sound good together.

Here are some options for creating new music, based on your skills:

The complete novice: using loops

1. Begin by using the loop browser to gain familiarity with loops and how they sound (fig 28).

Fig 28

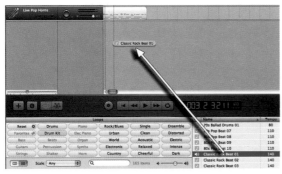

2. Add selected loops to the Timeline by dragging and dropping. You can add multiple loops if you wish, or repeat the same loop continuously (fig 29).

Fig 29

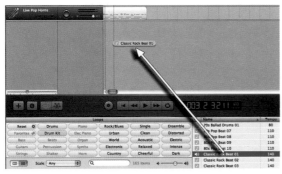

3. Apply effects to the loop. You can vary the volume (say, to fade in or fade out) or add acoustic effects, such as reverberation and echo (fig 30).

Fig 30

4. Listen. Your efforts may not get you recognized in the musical world, but they can be a great way to add a unique (and pertinent) soundtrack to a movie or multimedia slide show.

The casual musician: keyboard magic

1. You can use an electronic keyboard to create and record your own music. When you create a musical track, you can choose not only the type of instrument from the very many available but also the characteristics of that instrument (fig 31).
2. Record your music using the settings you have selected. This all happens in real time so it is up to you to ensure that you keep to the timing and rhythm.
3. Add more tracks. You can accompany yourself on another instrument or add a backing track. You can also select appropriate loops to add to your lead track.

The experienced musician: real music

1. Using audio recording equipment (you will find details of what is needed with your music software), directly record your music. If you are part of a band, you can all record your respective tracks (fig 27).
2. Add more tracks or loops if you need to embellish your own sound.
3. Add effects, manipulate the tone and volume, and edit out any blunders made by you or your fellow musicians.
4. Burn a CD and share your sound with friends.

Fig 31—M-Audio Keyboard

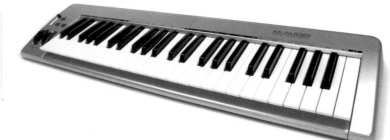

GARAGEBAND

Over the previous few pages, you have seen how simple it is to use an application such as GarageBand to produce music. Here is an overview of the GarageBand interface and its key elements. Even if you are using an alternate application (perhaps Acid), the key elements will be the same.

Familiarize yourself with just a few of the features, and you will begin to understand the compositional process and, even without a traditional music background, you will be creating music yourself. Jamming has arrived on the desktop.

Fig 33—The power of GarageBand (and its equivalents) lies in the number and variety of instruments available. Some are shown in icon form, above. Each (or most) have additional variations, and there are a number of melodies (loops) for each.

TRACK INSTRUMENT TYPE

INSTRUMENT NAME

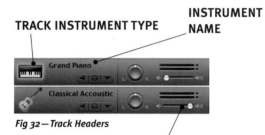

Fig 32—Track Headers

VOLUME CONTROL

Fig 34—Not satisfied with the countless default settings? In Track Info you can modify settings at will.

REPEATED LOOP

Fig 35—Main interface

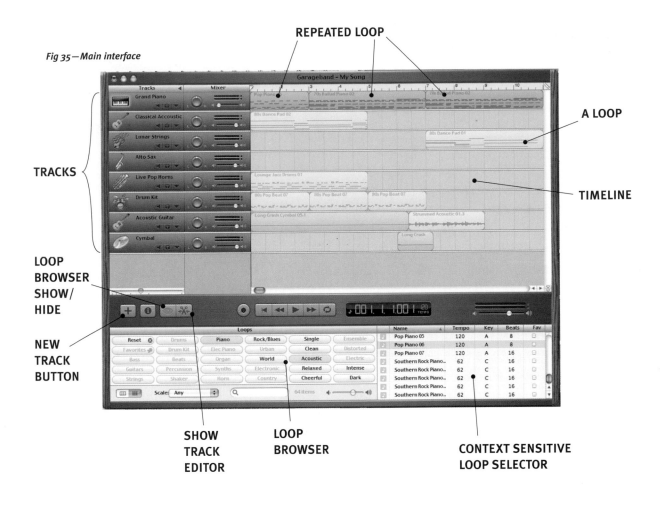

A LOOP

TRACKS

TIMELINE

LOOP
BROWSER
SHOW/
HIDE

NEW
TRACK
BUTTON

SHOW
TRACK
EDITOR

LOOP
BROWSER

CONTEXT SENSITIVE
LOOP SELECTOR

Fig 36—Track Editor. You can create musical notes and times directly in the track editor. Option-drag a note to the new position.

Drag out these bars to
extend the note

PORTABLE LIFESTYLES

IN THIS CHAPTER WE:

- Discuss the remarkable history of the mobile phone.
- Examine the capabilities of the latest 3G phone networks.
- Look at how we can share images and video content by phone.
- Take a look at the PDA (personal digital assistant) and the difference it can make to our lives.
- Take a glance at how the game platform giants are muscling in on the portable marketplace.

IT SEEMS SLIGHTLY IRONIC NOW, WHEN WIRELESS COMMUNICATIONS IN COMPUTING IS THE NORM, THAT THE TERM "WIRED COMMUNITY" WAS LONG USED AS A EUPHEMISM FOR A CONNECTED DIGITAL WORLD. THE FREEDOM NOW AFFORDED BY TECHNOLOGIES SUCH AS BLUETOOTH AND WIRELESS ARE TAKEN FOR GRANTED AND FULLY EXPLOITED.

BUT WE HAVE TAKEN MOBILE TELEPHONY FOR GRANTED FOR A BIT LONGER. FOR SOME YEARS WE HAVE HAD ACCESS TO PHONES FREE FROM WIRES. IN PRACTICE, WE MAY HAVE BEEN LIMITED BOTH BY THE TECHNOLOGY (WHICH, FOR A LONG TIME, FELL A LITTLE SHORT OF CUSTOMER EXPECTATION) AND THE COST, BUT THERE IS NO DOUBT THAT THE MOBILE PHONE IS NOW AN ALL-IMPORTANT TOOL AND ACCESSORY FOR MANY.

LIKE THE MOBILE PHONE, THE PDA (PERSONAL DIGITAL ASSISTANT) SUFFERED SOME BIRTH PANGS, BUT IT IS INCREASINGLY SEEN AS INDISPENSABLE BY MARKETS AS DIVERSE AS THE TIME-CONSCIOUS EXECUTIVE AND BUSY MOTHER. WITH ADDITIONAL FUNCTIONALITY—IN-CAR NAVIGATION, MEDIA PLAYER, AND EVEN AS A MOBILE PHONE—IT CONTINUES TO DEVELOP AND REINVENT ITSELF.

THIS CONFLUENCE OF FEATURES BETWEEN THE PHONE AND PDA MEANS WE NEED NOT LOSE ANY OF OUR CONNECTIVITY WHEN WE STEP OUTDOORS. WHETHER THIS ENRICHES OUR LIVES OR DEVALUES WHAT LITTLE TIME WE HAVE FOR OURSELVES IS ARGUABLE.

THE MOBILE PHONE: THE STORY SO FAR

The digital mobile phone today embodies some of the most advanced technology anywhere. The capabilities that are delivered in so compact a package are astonishing. It may come as a surprise, then, to discover that we can trace the origins of the mobile cell phone back to the gray days of the immediate post-World War II era.

The false dawn

Researchers in both the United States and Britain, equipped with potentially redundant electronic equipment developed since the end of the war, began to investigate how the existing radio communications systems used by emergency services could be improved. They realized that they could increase the capacity of the radio networks using a novel approach. By limiting the range of signal transmitters, rather than increasing their range and installing more of them over a geographical area, they could accommodate more communications over the limited frequencies allocated for broadcasts.

So the concept of the "cell" first appeared. The cell is a small area (which may be as little as a few hundred yards across in densely populated urban areas) over which a phone transmitter tower makes and receives calls. When a phone user moves to a

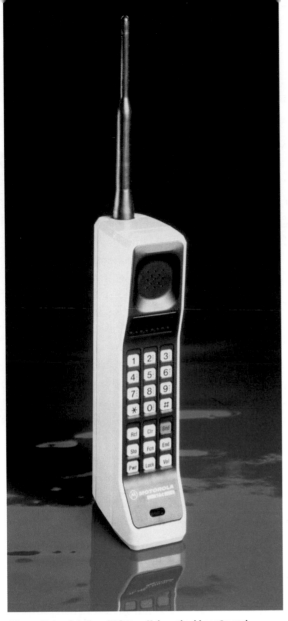

Fig 1—Motorola's DynaTAC 8000X, launched in 1983 and weighing nearly two pounds (1 kg), was the first commercially available cell phone.

neighboring cell, the call is seamlessly transferred to the transmitter in that cell.

The practical result of this is that many users can use phones in the same area, and (for those with safety concerns) there is only a need to broadcast signals from a phone to a nearby transmitter.

But the cell phone was effectively stillborn when an application to create the first network in 1947 by AT&T in the United States was granted conditionally. The conditions made it impossible to create a network that would support more than twenty-five calls simultaneously. Even given the more modest uptake of the technology likely then, this was a nonstarter.

The dream is realized

It was not until the early 1970s that the call to arms was heard again. A low-key technology battle between staff at Motorola and Bell Laboratories ended with Dr Martin Cooper of Motorola calling his counterpart at Bell, Joel Engel. In a story that has become part of urban mythology, Cooper called Engel on the phone with the intriguing question: "... guess where I'm calling from?"

Although Bell had produced a cell-based communications network for the police, it was Motorola that delivered the first cell phone that could be used practically anywhere (and specifically, away from a vehicle). The new age of communications began. By 1982, within a decade of Cooper's phone call, the FCC (Federal Communications Commission) finally acknowledged the technology and authorized commercially based cell-phone services in the United States.

Portable?

The UK followed, with British Telecom and Vodaphone opening cell-phone networks. These first-generation machines may have been mobile cell phones in name, but they stretched the credibility of the term "portable." The early adopters—who, owing to the high price of the hardware and the calls, tended to be limited to city financiers and stockbrokers—were faced with handsets that were both large and heavy, drawing unkind (though not inaccurate) comparisons with house bricks.

Callpoint: a blind alley?

This was no mass-market device. They were perceived as prestige items that were impracticable for most users. But there is no doubt that—even then—they attracted the attention of a broader market. Both the cell-phone networks and the conventional-phone network providers were mindful of the opportunities ahead but were restricted by practicalities. The result was the launch of the callpoint phone.

Callpoint phone networks were a curious hybrid of mobile phone and traditional pay phone; the hardware was an equally curious cross between the compact cell phone we know today and a conventional cordless phone.

Fig 2—Another Motorola model formed the basis of some callpoint phones, and introduced the "flip phone" concept to an expectant public.

Handsets were cheaper than cell phones, but calls could be made only in range of a base station—there was no contiguous network of cells. Base stations were installed in train stations, public areas, and even in restaurant chains. The phones also worked as cordless phones when the owner reached home.

In the UK, four networks were licensed: Mercury Callpoint, BT Phonepoint, Zonephone, and Rabbit. But with the limited range of facilities alongside advances in cell-phone technology, their impact was minimal. From the first launch in 1989, the last callpoint service ended just five years later in 1994.

Elsewhere, particularly in Asia, the networks were more long lived, with the discrete networks proving to be more cost effective at the time than full-blown cell networks.

Mobile cell phones: the next generation

Before callpoint phones had come into their stride, cell phones were casting off their "brick" heritage and showing the first signs of a more inclusive pricing strategy. As cellular networks spread around the world, the potential for handset sales brought many entrants into the market. Rapidly falling prices and more creative tariffs widened the appeal and ownership of the mobile. Electronics shrunk in size, and batteries—themselves a significant component of early models—also took on more diminutive proportions.

Fig 3—Sony's "Mars Bar" model introduced many to the delights of mobile communications.

PHONE GENERATIONS

Mobile phone developments fall into "generations." The first generation was the original analog network. Second, 2.5, and third generations describe those networks offered today. Here is how they compare.

Features	2G	2.5G	3G
Type	Digital	Digital	Digital
Description	Basic mobile phone	Best non-3G services	High-speed data for phone PC and TV
Voice calls	Yes	Yes	Yes
E-mail	Receive simple	Send and receive	Send and receive
Web browsing	No	Yes	Yes
Navigation and maps	No	Yes	Yes
Upgradable*	No	Yes	Yes
Still digital images	No	Yes	Yes
Movie clips	No	Limited	Yes
Video calls	No	No	Yes
Global roaming*	Limited	Limited	Yes
TV streaming	No	No	Yes
PDA integration	No	Limited	Yes, and PC
Data rate	10kb/sec	64–144kb/sec	114kb/sec–2Mb/sec
Download 1 min MP3	10–15 minutes	2–3 minutes	4–30 sec

Characteristics apply to the phone standard—networks or handsets may offer different services *Depends on handset

The iconic phone of that age was the Sony CMH-333. As if to distance itself from mobile phone "bricks," it attracted the description of "Mars Bar" to describe its shape—and weight!

The digital dawn

As the customer base swelled, the networks were busy preparing the first digital cell-phone networks. The conventional cell phones had all the problems of analog networks—interference, poor sound quality, and so on. So, alongside the existing networks appeared digital equivalents, holding out the promise of an enhanced service.

The needs of international travelers would be met by establishing worldwide standards—known as GSM, or Global System for Mobile Communications—letting travelers use their phones no matter where they were.

In the UK, four networks launched between 1991 and 1994, including Orange—a phoenix that rose from the ashes of the Rabbit callpoint network. The parent company, Hutchison Telecom, later sold this network to concentrate on third-generation (3G) cell phones.

As the decade advanced, the cell phone entered the mainstream. Clever marketing, made possible as a result of continuing price reductions, made the cell

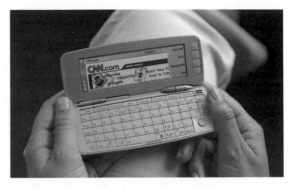

Fig 4—Some mobile phones offer additional Web browsing capabilities from within a compact-form handset that apes many features of a PDA.

phone a "must-have" accessory by the end of the decade as well as an indispensable tool in business.

A new age in mobile

Just when you thought cell phones were as feature packed as possible, along came the third-generation networks, often described as 3G. In 3G we see the true coming together of several digital technologies. Video calling, so often promised but rarely delivered, mobile videoconferencing, television, and movies on the go and fast wireless networking are all available with 3G phone networks. That is what we'll take a closer look at next.

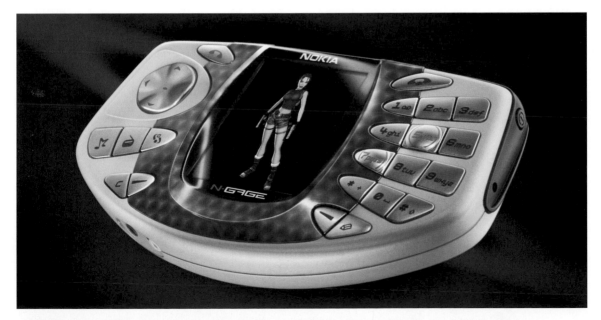

Fig 5—N-Gage from Nokia not only allows games to be played on the handset (like many) but also competitive gaming between handsets, thanks to Bluetooth compatibility.

MOBILE COMMUNICATIONS: TALKING THE TALK

Mobile telephony has its own terminology and jargon that can baffle even the most ardent technophile. Here are some of the key terms and features you will be bombarded with in the mobile world.

Bluetooth

We discussed the mechanics of Bluetooth earlier (see pages 32–3). In mobile phones the key use of Bluetooth is to allow communications between a phone and headset. With this link you can use a discreet headset (a lot like a modern take on a traditional behind-the-ear hearing aid) for talking and listening, while you keep the phone securely out of sight.

Some hands-free car kits also use Bluetooth: useful if you change your phone handset more often than your car. In addition, Bluetooth makes it simple to synchronize between computer and phone in order to store and back-up calendar or name information.

GSM

Global System for Mobile Communications is the most popular mobile-telephony technology, boasting more than a billion subscribers. It is the system that allows secure voice and data services with roaming and interoperability across different networks within one territory or across multiple countries. Different frequency bands are offered by different networks, but handsets typically operate on two frequencies, or all three.

GPRS

General Packet Radio Service essentially piggybacks on GSM, allowing data services based on conventional Internet Protocols (IPs). With GPRS, enabled connections can be "always open," rather in the manner of a broadband Internet connection, so that data can be sent or received on demand, rather than waiting for a dial-up connection to be established. Fortunately for consumers, costs are usually incurred only when data is exchanged.

i-Mode

An alternative to WAP (see below) that allows Web browsing from a smart phone handset.

Instant messaging

Instant messaging allows the exchange of text messages, images, or video clips between handsets. Unlike e-mail messages (which reside on a central server until the recipient chooses to download it), instant messages are delivered to the recipient immediately.

Java

Java is a programming language originally devised by Sun Microsystems but now implemented across a wide range of platforms. As such, it is platform-independent. In programming terms, it differs from

Fig 6—Look, no wires! Bluetooth car kits make it easy to install the latest technology—and change that technology at will.

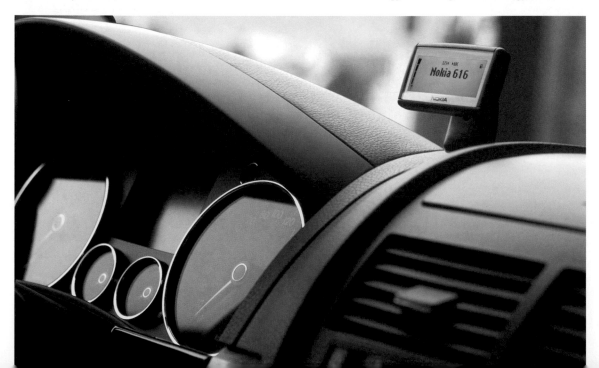

Fig 7—An obvious antenna (which thankfully retracts) characterizes an Iridium satellite phone.

other languages in that it is not compiled but interpreted as run; this makes it fast. In mobile phones, it is used extensively for games and also for onboard applications.

Mobile e-mail

Mobile e-mail services permit the sending or receiving of e-mail messages from a mobile phone. Depending on the network, you may also be able to use your computer e-mail address. Often, advanced e-mail software can be employed to retrieve only selected parts of an e-mail (usually the header) so that you do not incur costs downloading whole messages.

RFID

Radio Frequency Identification. A wireless bar code used to identify items uniquely, and in mobile telephony it is typically used to identify a phone handset securely in a way that cannot be reprogrammed. A small chip with a unique identifier is embedded in the antenna of some phones, from which radio frequency signals can be used to read the code.

SMS

Short Messaging Service. A method of sending basic text messages (which can include a limited range of special characters) of up to 160 characters in length between mobile phones.

Fig 8—The Symbian OS makes it possible to build ever more impressive functionality into your phone handset. Here, BBC World news is delivered to your palm, thanks to the Nokia 7710.

PIE IN THE SKY? IRIDIUM'S LAST LAUGH

Imagine a phone system you could use wherever you were in the world—with no boundaries and not conditional on being within a cell. That was the promise of operator Iridium. It planned a network of satellites that would create dynamic "cells," enabling people to use their phones anywhere.

When the system launched, there were major drawbacks. Phone handsets were large (bringing back memories of the bricks), calls costly, and—perhaps most damning of all—calls needed clear lines of sight to a satellite. But the original concept has evolved, and the net of sixty-six satellites still provides a convenient phone network, which tends now to be marketed to those users who would be out of sight of conventional cell-phone networks rather than aiming to compete with existing national systems.

Symbian

An operating system designed for mobile devices, specifically smartphones. In such phones, the Symbian OS (operating system) drives all the applications and processes found on the phone and, being a standard, it is easily implemented on a wide range of handsets. It also integrates with GSM, GPRS, WiFi, and Bluetooth.

WAP

Wireless Application Protocol: A secure communications protocol used for displaying basic Web content on mobile phones. It is optimized for the small screens of nonsmart, non-3G phones and for simple one-handed navigation using the standard phone keyboard.

CREATING MOVIE CONTENT FOR 3G PHONES

As 3G (third-generation) networks evolve and more features (included in the original specification) become accessible, it is becoming viable to create content ourselves and deliver it to family or friends over the network.

Here is how you can create a short movie using movie clips that might have originated on your 3G video handset, digital video camera, or even your digital still camera, when recording using the movie mode.

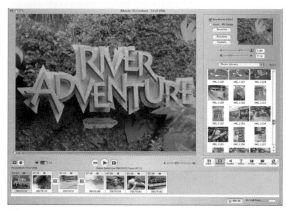

Fig 9

1. Begin by piecing together the movie clips, still images, or camcorder footage as we did earlier when we examined digital video (see page 80–1). It is particularly important now to be ruthless with unwanted or material that is below par. When aiming to send a video to a mobile-phone handset, you want only the best, and then only a précis of all the shots you have taken (fig 9).

2. Since most video-editing software won't feature an option to convert the video in a form that is

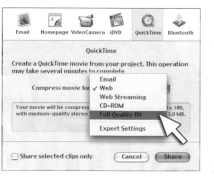

Fig 10

directly accessible to 3G telephones, save the movie in the best quality offered by the application. Here, the QuickTime option in iMovie, saved in DV quality, has been used. You don't need the highest quality, but since you will be exporting this content, it makes sense to start with the best quality you can realistically achieve (fig 10).

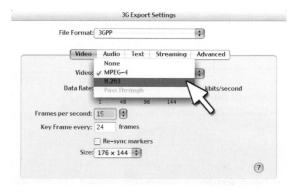

Fig 11

3. QuickTime Pro (PC and Mac) will let you edit your movies in a compatible format. It will also open your movie created elsewhere and allow you to export it in a suitable form. Select Movie to 3G from the drop-down menu (fig 11).

4. Select a video format. For most applications the default MPEG-4 is fine (fig 12).

Fig 12

5. Select a file format. Again, for most applications the 3GPP default setting is fine. If you have any

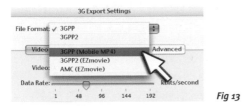

Fig 13

concerns, check a compatible handset and see which formats are used for video clips (fig 13).

6. Repeat for the Data Rate and Video Size. Bear in mind that a greater data rate will give a better video result, but it could then take longer to send, thus compromising performance. A larger video size will also demand a higher data rate. For most telephone handsets, the smaller size is fine (figs 14, 15).

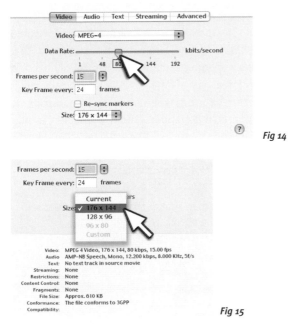

Fig 14

Fig 15

7. Select OK to export your movie. This may take a few minutes, depending on the settings chosen. When complete, the video will open in a new window. Check the performance and, if necessary, make changes to the settings and export it a Aim to achieve the lowest data rate that gives good, watchable results (fig 16).

8. Select Send to transmit your movie. You can se it by e-mail or as streaming content. Check the network preferences. You will find them in the

VIDEO ON YOUR MOBILE?

Do you really want to send a movie to a mobile phone, and will the recipients really want to watch it? That is similar to a question that was asked about the sending and receiving of text messages: why would anyone want to use a mobile phone to send written messages?

So there is a clear precedent—3G-handset users have demonstrated a wish to receive video clips and are avid savers of video messages, so the answer has to be "Yes" to both questions. Remember that you can save the video on your phone handset either by e-mailing it onward to the e-mail address you access from your computer or by making a direct PC connection and downloading it.

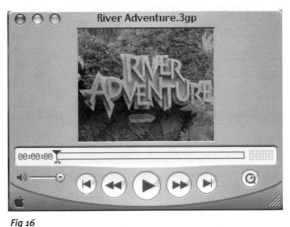

Fig 16

handbook that accompanies your handset (this is one occasion you will need to read it). Once received, your movie can be played and replayed at will (fig 17).

Fig 17

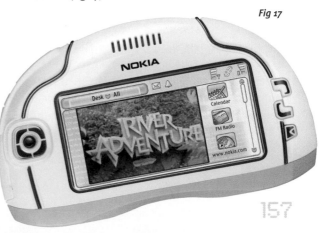

TIPS FOR GREAT PHOTOS FROM YOUR PHONE

Although more serious photographers might scoff at phone cameras, you can still get some great pictures with them. You just need to exploit—rather than fall victim to—their limitations. The rules of photography we discussed earlier (see pages 56–61) still apply, but here are ten tips to help you get the best from your phone camera.

1 DISTANCE

Don't try to include too much in your shot. Small details, whether of a sweeping landscape or general views of activities or sports, just don't work. Instead, get in close, or closer, and concentrate on one part of the scene. Getting in close helps you capture, for example, expressions on people's faces that make for more interesting shots.

Fig 18—Distance: closing in on your subject makes for a more powerful shot.

2 CLOSE AND CLOSER

Phone cameras often allow you to shoot very close up to the lens. This can lead to some fascinating perspective effects. Get to know—through practice or by referring to the manual—how close you can go.

3 RESOLUTION

Like digital cameras, phone cameras offer different resolutions. Remember, a high resolution will give better results, but the files will be bigger (and more expensive to e-mail from the camera). Choose a high resolution for those images you want to download later and produce prints from. Use lower resolutions for those grabbed shots that you will want to e-mail right away.

Fig 19—Resolution: increasing resolution gives more detailed shots—but at the expense of file size.

4 LIGHTS, CAMERA, ACTION

Digital cameras tend to offer a range of sensitivities that allows successful photography in even very subdued lighting conditions. Phone cameras will struggle in low light, delivering blurred results where there is any subject movement—and that includes a shaking camera due to a wobbly hand. If your camera has a flash or auxiliary light, use it when the lighting level falls. Or, if blurring is inevitable, use it creatively, as if you meant to blur the shot.

Fig 20—Low light: when the light levels fall, camera shake is inevitable. Modest flash light helps to restore sharpness.

5 KEEP IN THE LIMELIGHT

Or rather, keep your subjects that way. Unless you are being deliberately creative, keep the main lighting behind you so that it shines directly on the subjects. Phone cameras tend to react to backlighting by underexposing and rendering subjects in silhouette, which is rarely a flattering effect.

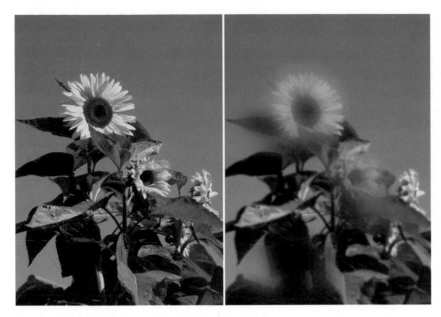

Fig 22—Clean up: just one fingerprint can degrade an image.

images from your phone as often as you can. Use the connection cable provided with the camera or, if your phone has Bluetooth or infrared capabilities, use these. In this way, you won't just protect the shots you have, you will also ensure that you have plenty of memory in the camera for new ones.

10 EXPLORE

You have your phone with you all the time? What better way to experiment with photographs? Experiment with shots at odd angles, strange positions, and including subject movement. You will shoot some real howlers, but you will also get some jaw-dropping shots to send to your friends.

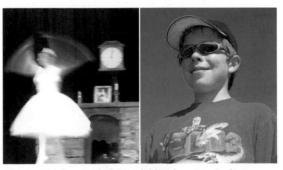

Fig 23—Weird or wonderful: exploiting the camera's short-comings or using unusual angles can produce intriguing effects.

6 BE SUPPORTIVE

Even when you have enough light, an unsteady hand can give results that lack critical sharpness. If you are already struggling with the light, use a convenient support when shooting. Rest the camera on a table or against a wall when you press the button. Simple but effective.

7 CLEANLINESS IS NEXT TO . . .

The nature of phones means that they are being handled often and with little regard to the optical surfaces of the camera lens. Unlike those of cameras, phone lenses tend to be exposed most of the time and so are prone to picking up fingerprints from careless handling and dust and lint when slipped into a purse or pocket. Use a soft, clean cloth to clean the lens periodically—or invest in a case that keeps the entire phone covered when it is not in use.

8 DISCRETION

Although your actions will be above reproach, people can still feel uncomfortable being photographed, especially when the camera is also a phone. It is perceived as being somewhat sneaky. Be mindful of sensitivities, especially when there are children around.

9 SAVING FOR POSTERITY

Since there is only limited memory, download the

VIDEO TIPS

If you are recording video, then the tips given here for your camera phone will also give you great video clips. Remember, too, that you need to keep your shots interesting. Avoid long clips—around seven seconds is the best length (unless there is some activity in progress). And let your subjects move while you keep the camera still.

PODCASTING: PERSONAL RADIO SCHEDULES ON THE MOVE

Here is the solution for those of us who would love to listen to more radio, but find that our favorite programming is broadcast at inconvenient times. It is called "podcasting" and it has been described as a PVR—personal video recorder—for radio.

Whether commercial or public service, the biggest radio audiences are delivered during the so-called "drive time," the daily commute of millions of us from home to office and, at the end of the day, back home again. This is when commercial stations make their money, with the assurance that advertisers really are playing to large, essentially captive, audiences. But by the same token, in order to appeal to this crucially important mass audience, programming at these times can be a little . . . bland. It is designed not to be controversial or highbrow; rather, it is easy listening in its most literal sense.

For many of us, this is the ideal wind-down time at the end of a long day, but for others it could be an opportunity to catch up with all that programming they might otherwise miss. This is where podcasting comes in. It gives you the opportunity to download selected programming to an MP3 player and enjoy the programs you want, when you want.

The term "podcasting" is a relatively recent one. It first appeared in a British newspaper feature in 2004 as a concise term to describe the process. That process was one of identifying program types that you want to listen to, pulling them down to a computer desktop in MP3 form and then downloading them to an MP3 player for listening to at your leisure. The "pod" in podcasting refers, as you might imagine, to Apple's iPod, though the medium is not exclusive to that unit.

Podcasting is essentially a value-added service that is a hybrid of broadcasting and webcasting.

Fig 24—In Our Time *is a BBC Radio 4 program that is now enjoyed around the world thanks to podcasting.*

Unlike either of these services, both of which deliver content to the listener by pushing it out from their studios to essentially passive listeners, podcasting is a pulling process in which the listener drags the requested content from a Web site. This can be a fully manual process (rather like selecting MP3 tracks from a music site), or it can be automated so that a program on your computer will trawl selected sites automatically for preferred programming types and then download them for your consideration.

Anyone who has news feeds or stock market figures delivered to their desktop will be familiar—in operation terms if not by name—with an "aggregator." Aggregators automatically gather news and information from various Web sites and deliver them to you in a convenient package. You don't need to visit a Web site or log onto an e-mail service.

Podcasting applications do much the same, but this time aggregating audio content and downloading it to your mobile device. It is a completely seamless operation—once you have configured your podcasting application, all you need do is place your device in its PC cradle each day for the most recent content to be downloaded. Then when you next get in the car and play, it is there for you.

Initially podcasting was seen as somewhat geeky, with most of the output derived either from unique programming or from selected Internet-only radio stations, but toward the end of 2004 a more mainstream option appeared. Offering at first only a trial, the BBC in London offered selected programming in MP3 format as well as directly streamed in real time over the Internet. The MP3 version of programs could be downloaded and pulled right into iTunes (for iPod users) or used with a generic utility, such as iPodderX, to podcast straight on to any MP3-compatible player.

Although promoted as a test, it was very well received around the world and has alerted commercial interest in what was, at its inception, a noncommercial venture.

It is probably also worth noting at this point that an MP3 file per se is not a podcast; to be a proper podcastable file, it needs to be presented in a form that a podcasting application (like those you will find on Web sites such as www.podcasters.org or www.podcast.net) can handle. This usually means that it is provided as an RSS enclosure feed. But you don't have to worry about these technicalities—when you subscribe to a service, all these are taken care of for you. So, strictly speaking, downloading via iTunes is not podcasting, but for all intents and purposes, the process is identical.

As for the future, as well as commercial interventions, there is no reason why images and even movies could not be downloaded in exactly the same way. When this becomes viable, we might have the ultimate in truly personal PVRs.

Fig 25—iPodder is a popular tool for gathering and downloading podcast programming.

Fig 26—Popular podcasting sites let you select from a wide range of podcast material. This list is growing exponentially, carrying new and archived programming along with Internet radio broadcasts.

GAMING ON THE GO

No study of digital technology would be complete without at least mentioning gaming. Since the earliest days of Pong, through Space Invaders, Donkey Kong, and Super Mario, video gaming has been in both commercial and social terms a massive, ongoing success story.

We have seen now how games of varying complexity feature on devices as diverse as the ubiquitous Playstations and Xboxes to mobile phones and even watches. Like computers, gaming platforms (which are, essentially, optimized computers) continue to offer greater and greater power and ever-increasing flexibility. In this case, this upward progression manifests itself by offering better and better graphics capabilities and true- (or truer-) to-life visuals.

"State of the art" in video gaming today is arguably represented by Sony's Playstation Portable—the PSP. Forget the low-resolution graphics of older devices and the compromises in quality; this is a fully fledged gaming platform that makes no compromise in the quest for portability. Not intended as a successor to the Playstation 2 (more of an adjunct), the PSP inherits the same operational characteristics of its tethered siblings and offers a screen that, at a resolution of 480 x 272, gives a quality virtually unique in the portable gaming world. The inclusion of Wireless connectivity enables a whole host of new opportunities for

Fig 27—The PSP handset clearly has a new look, yet the detailing—such as the buttons and controls—makes its heritage obvious.

connecting to other devices in the home, on external networks and also in the wider world. The immediate opportunity is the capability of online gaming right out of the box or peer-to-peer gaming between different machines in the vicinity, à la Nokia's N-Gage.

As games have grown in complexity, so has their physical size—more and more Playstation 2 games have been driven from the use of CD-ROM to DVD-ROM. The compact footprint of the PSP has forced Sony to rethink storage. Moderate data transfer can be effected by the use of a Memory Stick (or, specifically, a Memory Stick Pro Duo), the staple data-transfer mechanism for Sony devices, but even with the high capacities now offered by these cards, it is not the most viable of delivery methods for game programs.

For game delivery, Sony has produced a new format: the UMD, or Universal Media Disc. With a capacity just shy of 2GB and a footprint size of nearly 2½ inches (65 mm) square, UMD disks allow large amounts of rich content (including full motion video) to be delivered to the PSP.

Doubling up

Sony's Nemesis in the gaming world, Nintendo, has enjoyed success for many years with the Game Boy. Not wanting to be eclipsed in the handheld stakes by Sony, the company is now offering the Nintendo DS—and stole several months' march on its rival. "DS" stands for Dual Screen. Featuring—as you would expect—two gaming screens, it allows new levels of interaction in multiplayer gaming. You can see, for example, the conventional view from a race car on one screen and an overview (or aerial view) of the race in the other. Or you could play a game on one screen and watch (or send) messages or e-mails with the other.

Although featuring two identically sized screens, the lower one packs an additional punch: it is touch sensitive. Using a stylus (or your finger) you can use it in the same manner as you would a screen on a PDA, or you can move game characters in unique ways, perhaps changing perspective as you go.

Like the PSP, the DS includes Wireless capabilities that, in this case, can enable gaming between as many as sixteen players. Unlike the PSP, the DS features backward compatibility with the Game Boy Advance, allowing you to play your favorite Game Boy Advance games, albeit in single-player mode. This overcomes many of the objections gamers have concerning hardware upgrades—the need, sometimes, to have to buy new versions of games to play them on the new hardware.

Fig 28—The PictoChat feature of the Nintendo DS allows owners to send images and handwritten text wirelessly to other DS devices in the vicinity. Even when in sleep mode, the DS can detect other possible devices to communicate with nearby and will spring into life to allow PictoChatting.

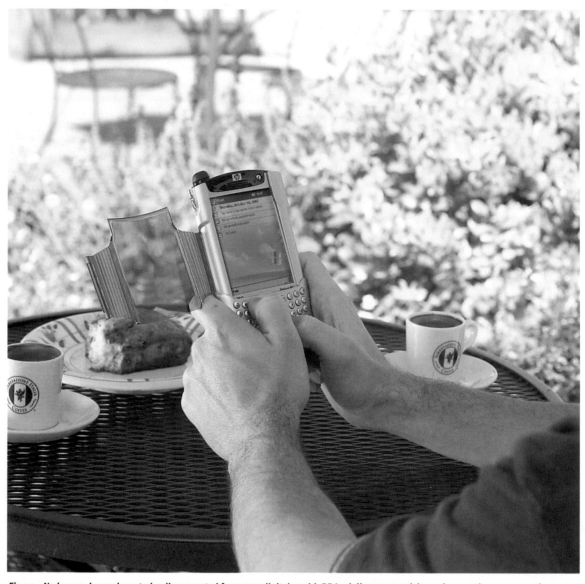

Fig 29—No longer do you have to be disconnected from your digital world. PDAs deliver connectivity and computing power on the move.

PERSONAL DIGITAL ASSISTANTS

It is surprising how much we can come to depend on our computers. They store our music collections, photo albums, correspondence, and so on. But, despite the proliferation of the laptop, there are limitations to where we can take all this information. That is where the PDA (personal digital assistant) steps in. Sometimes called simply a "handheld," the PDA is small mobile computer that help you carry your most valued information with you everywhere. And much more.

PDAs were born in the early 1990s when Apple released the Newton. It comprised a screen on which you could write directly and some useful applications. A cut-down spreadsheet, calendar, and mathematical tools were accompanied by a word processor that added, for its day, extra punch. Special handwriting-recognition technology meant you could write freehand and have your words converted on the fly into printed text. Clever and surprisingly effective.

But the Newton, despite becoming increasingly powerful and comprehensive, was never the hit that Apple expected or needed for its continued

development. Some argued that it was the lack of a color screen, others the size—somewhat larger than a paperback. The project was dropped and never again figured in the Apple lineup.

Those working on the project were convinced of its viability and, shortly after, it was resurrected as the PalmPilot, later known simply as the Palm PDA. With an ultracompact size—but still boasting a usable screen size—and improved handwriting technology, it proved a modest success. Its loyal following grew in number until that critical mass that had eluded Apple was reached—a sufficient number of users to ensure ongoing development.

Now color screens are the norm and, more significantly, other entrants—some featuring a cut-down version of the Windows operating system—now market PDAs. It has moved from toy of the gadget lover to the device that organizes the lives of millions on the move and at work every day. Ideal for those who need computing power but demand something smaller than a computer, most now work seamlessly with computers—desktop or portable—to ensure not only that information is shared but that it is also synchronized, so that both devices share the latest information.

Choosing a PDA

The question arises: "Do you need a PDA?" Most of us could justify a simple electronic organizer. Something that can take the place of a conventional

Fig 30—Not to be left behind by the more humble mobile phone, PDAs (here a Sony Clié) can take—and display—pretty good photographs.

diary but add a few alerting features, alarm clock, and the like. But would it not be great if we could also browse our e-mail on the go? Or review our picture or song collection or read a book?

At one time, the PDA was an alternative for a computer for those who found themselves intimidated by the latter; now, the functionality of each is on a par. Indeed, many PDAs offer tools not found on computers. So how do you make your choice?

Price

Price can be a deciding factor. If all you want is a simple calendar and note-taking tool, the cost is comparatively low; go for a well-specified Pocket PC, and the price can stretch to that of a basic PC laptop. But saving money can be a false economy. Unless you know that you do not need some of the more advanced features and will not, over the lifetime of the device, then it is better to aim for a midpriced machine. They may have more functions than you will need now, but they will grow with your PDA skills.

Operating system

The key element of a PDA's functionality is the operating system it runs with. It is a similar choice that faces someone choosing a PC. There you choose between a Windows PC and a Mac. Here, the choice is between Palm OS and Pocket PC.

Pocket PC is a derivative of Windows specifically engineered to run on mobile devices. Like its elder sibling, it is produced by Microsoft, though Microsoft doesn't make any hand-held devices. You will, however, find those stalwarts of the Windows operating system—HP/Compaq and Casio, in particular—also offering handhelds using this operating system. Expect to find these devices offering a broadly familiar screen layout and functionality but under the control of a pen and sensitive screen rather than a mouse. You will also find that these include software tools familiar from Windows, including the Notepad and cut-down versions of Word and Excel. Extensions to the operating system also allow for MP3 music playing (often using an expansion memory card), voice recording, and e-mail sending and receiving.

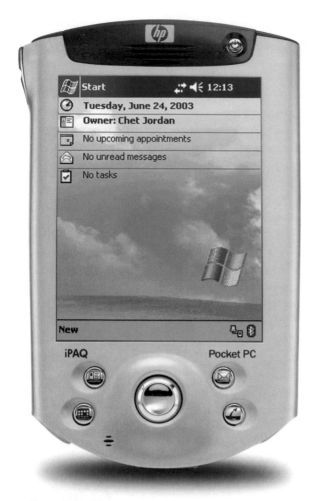

Fig 31—Pocket PCs run a trimmed-down version of Windows.

in regard to its licensing of third parties—Palm hived off the software division to a new company called PalmSource. So you can now find the Palm OS on devices produced by other manufacturers, notably Sony in its Clié handhelds. The Palm OS has also been developed for the so-called smartphones, which combine many of the functions of a PDA with those of a mobile phone.

How do you choose between these operating systems? Like the perennial Mac vs PC debate, much comes down to personal choice, familiarity, and functionality. And like these two platforms, Pocket PC and Palm OS have their strong devotees.

Devotees of Palm OS will point to it being a lean and mean operating system. It is also easy to use, is easy to configure, and tends to offer more efficient power consumption. Pocket PC users are accustomed—in most models—to greater power and flexibility in applications. If you want a real trimmed-down PC in your pocket, this is the obvious choice. If you want a no-nonsense digital companion, go for the Palm OS.

Fig 32
Palm OS is an alternative operating system designed specifically for PDAs.

The Palm OS is the spiritual successor of the system used on the Newton devices. To help the development of the operating system—particularly

BLACKBERRY

A more specialized PDA, BlackBerry devices pioneered mobile communications, including mobile phone, Internet access, and e-mail in a single robust pocketable device. BlackBerry devices tend to be used more in corporate situations where an enterprise-wide solution can be implemented, attaching value-added services specific to the corporation.

Displays and controls

The distinguishing feature of a PDA is its display. Nominally, it is an LCD panel, similar to that of a computer's flat panel, but with the obvious distinction in virtually all cases of being touch sensitive. A fine membrane over the surface—virtually invisible—interprets touch commands. Color screens are now the norm on most machines, though budget models will still feature

Fig 33—The BlackBerry is optimized for mobile communications.

grayscale displays. The color displays obviously tend to consume more power, principally because they need to be backlit at all times to present a clear image. Docking cradles, which recharge the on-board batteries, will ensure that the battery power is always sufficient for a few days' remote working. Grayscale displays don't require permanent lighting and can run for several weeks on disposable batteries.

Other controls generally comprise shortcuts to, say, e-mail, contact lists or frequently used applications. Some more specialized devices may sport compact keyboards—often so compact as to defeat all but the smallest and most delicate of fingers.

Keyboards and text entry

If you find that you do need to enter substantial amounts of text, then you can either learn to be dextrous with these micro keys or invest in one of the accessory keyboards offered for many Palm and Pocket PC devices. Folding away into a package smaller than the handheld, these keyboards are virtually the same size as conventional keyboards and offer the same touch-typing feel, with real "clicking" keys.

If you don't expect to enter a great deal of text, perhaps just the odd note, calendar entry, or e-mail, then Palm OS handhelds offer Graffiti—a software application that builds on the character-recognition skills of the early Newtons. Using a simplified letter-writing technique, easily learned, you can achieve virtually 100 percent successful character recognition at commendable speed.

Size

The term "handheld" tends to suggest that there is little difference in size between types. In fact, some are little larger than a credit card, while the Pocket

Fig 34 — This smartphone from Kyocera offers the convenience of a flip phone with the power of a Palm OS PDA.

PCs are around twice the size of an iPod. As you might expect, functionality expands with size, with the smaller machines offering only limited capacity for data. Larger ones give the prospect of a larger screen, larger batteries (for enhanced performance), and the option of slots for memory cards.

E-mail

Do you need (rather than want) e-mail on the move? Then make sure your handheld will allow Internet connection. Check compatibility before you buy, as many handhelds will link to the net (to allow Web browsing as well as e-mail) using a mobile phone, but some don't. Smartphones, clearly, combine both functions and make remote e-mail and browsing far simpler.

Games on the go

Now that phones offer games on the move, it is hardly surprising to find that PDAs offer a wide range of games that make use of the enhanced screen sizes and memory capacity of the PDA. Games such as 3D Star Fighter Pilot (from the PalmSource Web site) let you while away many an hour when you should really be checking your e-mail or bank account.

THE USPS OF PDAS

For many of us, there needs to be at least one USP (unique selling proposition) that makes a PDA essential. Gone now are the days when it was the gimmick value or cachet that made it worthwhile to own one. Now, with so many other devices competing for our pocket or purse space, PDAs need to deliver something unique.

Here is a selection of great applications that, for some users, have justified the purchase of a PDA. For many, the ability to stay in touch—with e-mails as well as by phone—is reason enough, but for others there needs to be something more compelling. And the manufactures of PDAs, along with their software partners, have been quick to deliver.

Pocket-DVD Studio

The high-quality screen of a PDA may not do full justice to the quality offered by DVD movies, but it is still pretty cool to be able to watch a DVD on your PDA, and Pocket-DVD Studio lets you do just that.

Fig 34—DVDs can be shrunk to fit on your PDA.

The software lets you make a copy of your favorite DVDs in a video format that can be replayed on your PDA's screen. Surprisingly, any movie that lasts up to three hours can be mightily compressed when accommodated on a Palm screen—sufficient to be stored on a 256MB memory card in most cases. Because the movie replays from a memory card, power consumption is modest.

eBook readers

All right, we don't all like playing games or even watching movies on our business or family trips. For those who want something potentially more cerebral, how about eBooks? These are versions of traditional books, along with new works that can be downloaded to your PDA and replayed on screen. You can carry multiple eBooks with you on your PDA, lightening the load in your luggage, and you can enjoy them on your home computer or laptop, too.

There are thousands of titles available, covering all the genres that you would expect to find at your favorite bookstore. And they are available through online retailers at the touch of a button. Those with

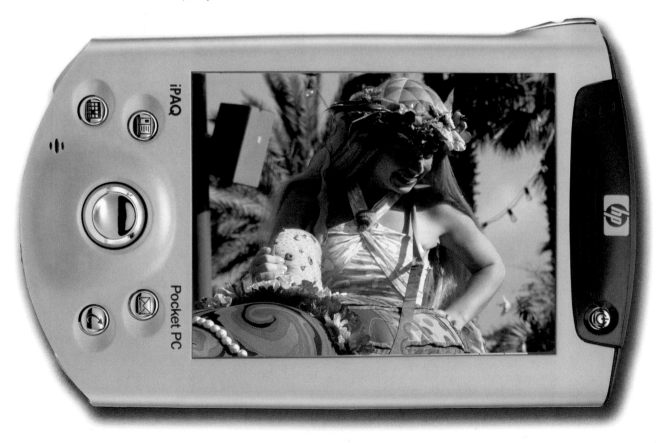

Fig 37—Web sites such as www.ereader.com provide easy access to an enormous number of eBooks to enrich your PDA-based life.

Navigation

A particularly fine USP for the PDA has been navigation aids. Aping the in-car navigation devices, but at a nominal cost, these give you clear, concise directions on any journey using the PDA's screen to present virtual views of the road ahead. Dynamic calculations also mean that, should you ignore advice and make a detour (perhaps to avoid traffic jams or roadwork that the system could not have known about), the system will automatically redesign your journey.

To use these, you need a receiver to receive and interpret the signals from global positioning satellites (GPS). This can be an add-on box (often car-mounted and communicating with the PDA via Bluetooth) or built-in. An increasing number of top-of-the-line PDAs offer a GPS solution right out of the box.

something to say can even produce their own—you will find software readily available to help you produce your own eBooks for sharing or selling.

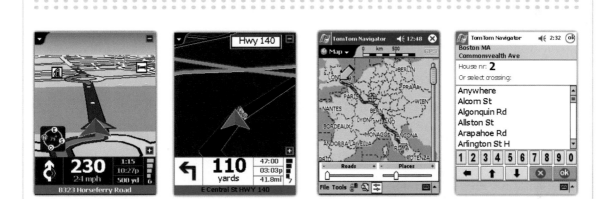

Fig 36—Navigation displays clearly show road layouts and enable destinations to be selected easily.

PDAs on the move

The TomTom navigation system is available for Pocket PC and Palm OS PDAs and also as a stand-alone device for those without PDAs, and it offers a comprehensive navigation and informational service that puts many OEM (Original Equipment Manufacturers) automotive systems to shame. In normal use, the system uses the PDA screen to display three-dimensional plans of the road ahead. You can configure the system to choose a route for you or enter your own—perhaps taking in places of interest along the way.

If you need to ensure that your route avoids certain areas—for example, one that excludes routes in the London city-center Congestion Charging Zone—you simply hit the "Plan Alternative" button. Similarly, if you want to visit a restaurant or a landmark, you can program these into your route.

The stand-alone version offers the same functionality in a device that is easily moved from vehicle to vehicle.

OUR DIGITAL FUTURE

THE CONNECTED HOME

Technology is nothing new in our homes, but the proliferation of devices is a comparatively recent affair. The digital age, as we have seen throughout this book, has brought together equipment and devices that would otherwise be considered quite separate. Now our homes can truly act as digital hubs. Here, we have shown how devices are deployed in a typical home today.

Let us take a—very—virtual tour and see what today's digitally connected home has to offer us.

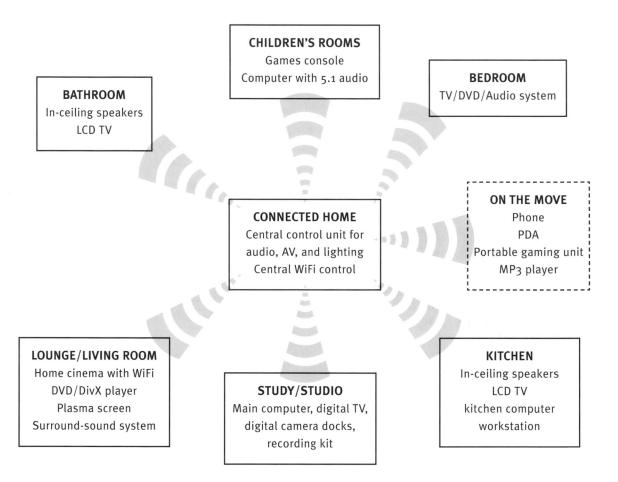

Home networking

Wireless and Bluetooth networks underpin the communications. Wireless networks allow the main computer of the home, those in other rooms, and other devices to talk to each other and, via a broadband Internet connection, the wider world. Some homes also have a centrally located repository for media: a single location where the family's entire collection of CDs and other entertainment media are stored. They could be accessed by control units scattered around the home. The rapid move of media from CD and tape to computer hard disks, made possible by MP3 and its equivalent formats, has rendered monolithic storage cases redundant. Music and, increasingly, video collections are now more likely to live on the one or more computers that now comprise the home network.

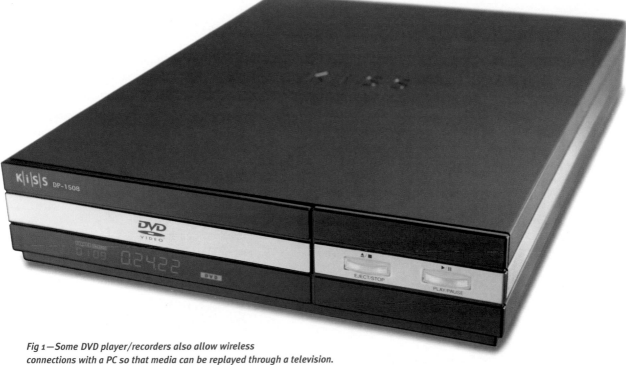

Fig 1—Some DVD player/recorders also allow wireless connections with a PC so that media can be replayed through a television.

Study

The study has updated its role, defined in the Victorian age, of being a home to the family's book and ephemera collection by evolving into a creative studio, a place where digital media is downloaded, manipulated, and created. This will typically be home to the main computer of the household. Packed full of memory and with an enormous hard disk, it is ideal for image editing, movie making, DVD creation, and, with a suitable antenna connection, acting as a PVR. PVR recordings can then be downloaded to DVD or, if you are exploring the HDTV world, Blu-ray disks.

Lounge

The lounge, or living room, tends to be multi-purpose. And one of those purposes is as an integrated home theater. Plasma screens now offer quality akin to traditional televisions but with larger screen sizes at only a fraction of the bulk. Direct recordings are possible with a hard-disk PVR, which might also store your favorite DVDs in the manner of a digital jukebox. If you don't like doubling up your PVRs, you could opt for a DVD/hard-disk unit with Internet connection that can access the media on the hard drive of your main computer or any other in the house. KISS Technology is one of the trailblazers in the connected home with its wireless DVD players that can access content from computer hard disks.

Audio shares the same speaker arrangement, but it may use conventional media (such as CD and its variants) or MP3 music streamed from a computer source somewhere within the house. You might even use an MP3 player to deliver the music right to the stereo.

Fig 2—Wake to the latest Internet feeds.

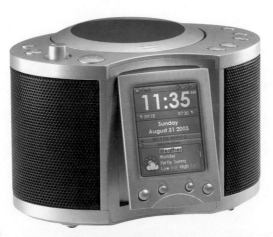

Bedroom

Modest home-theater kits are now cheaper than basic VCRs used to be just a few years ago. So it is perfectly viable to have a compact home theater in the bedroom for those late-night movies or if you want to escape from the surround-sound sports presentation in

the living room. After those late-night movies, you don't want to waste any time in the morning. A device such as the Beyond Home Hub looks like a bedside clock radio, but in addition to offering CD music to wake up to, it also gathers all the essential facts that you need to start your day via the Internet. Weather forecasts, stock market figures, news reports, and even important "to dos" are all presented.

Children's rooms

Chances are, the children's rooms will boast a computer, even if it is an older machine that has cascaded down through the family as new machines take pride of place in the home. You will find that these, too, may feature surround-sound speaker systems, ideal for immersing games and watching DVDs. Of course, there may also be a Playstation or an Xbox there, too . . .

Fig 3—This unit from Beyond offers audio and video entertainment along with Internet connectivity. Courtesy Beyond.

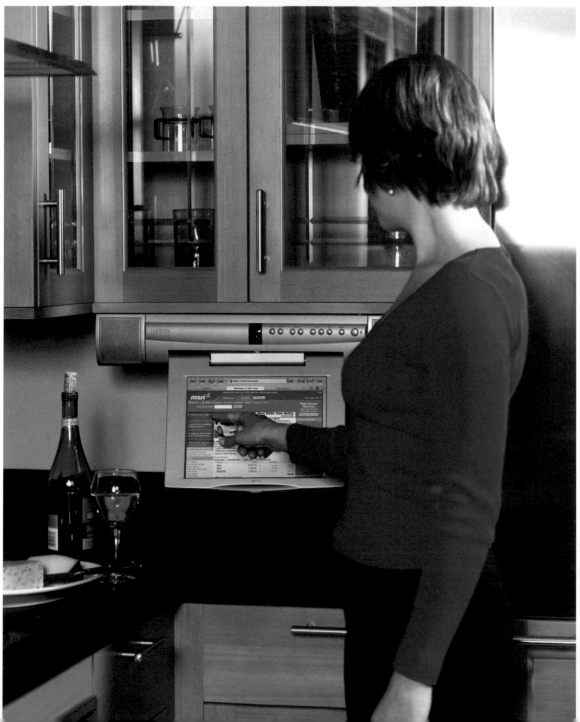

Kitchen

We have already seen that the kitchen, since it is used for family gatherings and meals, can have its own media center computer, along with a television and DVD player. Meanwhile, discrete speakers ensure that the music you enjoy elsewhere in the house can be played there as well. Portable DAB radio can make the kitchen chores less of a, well, chore.

Bathroom

Relaxation time is as important as ever, so the bathroom boasts similar speakers to those in the kitchen. You could even add a flat-panel television to enjoy your favorite shows as you relax.

Control and mood throughout the home

Once, a remote control could only control your television. Then came VCRs, along with another remote. Satellite receivers, DVDs, lighting, audio system, all debuting with their own remotes. Some manufacturers managed to integrate several of their devices into a single unit, or even allow limited cross-brand control.

Today, you need have none of this chaos. Universal remotes—more so than their earlier namesakes —are your gateway to a digital lifestyle. Conventional models sport a large number of buttons, many of which assume different functions according to the device. PDA-like models have a touch screen that morphs according to the device selected to control. These tend to have the ability to connect to the Internet (via a computer) to allow new device controls to be programmed.

Mood? It is lighting that provides the mood throughout the house. Dim, indirect lighting for relaxation; bright task lighting when you need to work. Remote-control lighting has been with us for some time, but for real effect you need to be able to set light scenes, too. Light scenes are light levels applied to multiple lighting sources so that lighting moods can be more effectively set. With one press of a button you can, for example, turn off an overhead light, turn down side and table lamps, and activate wall lights for subtle, glare-free illumination.

Fig 4—Multifunction remote controls let you manage all the technology in your home.

Fig 5— Universal touch-screen remotes show only relevant buttons.

Fig 6—Lighting control is now simple, thanks to infrared sets.

MONEY NO OBJECT?

If you have to ask the price, so the saying goes, you can't afford it. For those who will make no concessions in their quest for theatrical authenticity, perfection is possible—at a price.

Home cinema has never been so cheap or easy to implement in even the most modestly scaled home. The advent of high-grade speaker systems at affordable prices, and even capable wireless speakers, has meant that many of the obstacles that previously excluded many people from enjoying the audio pleasures already encoded in much of their tape and DVD library have been overcome.

We can now almost all install a discreet audio system in our living room without seriously compromising that room's use. But for some, any compromise is too great a price to pay. For them, nothing short of the full cinematic experience will do. That means not only the best video and audio quality but also a custom-made environment in which to enjoy these productions. Creating a real movie theater in your home demands money and

space—in equally abundant quantities—but the results can be breathtaking.

CEDIA is the international organization that represents some of the major home-cinema installation companies and hosts annual awards for the best installations. A glance through the entrants shows just what you can get if your pocketbook knows no limits. Here are just a few examples of CEDIA members' work.

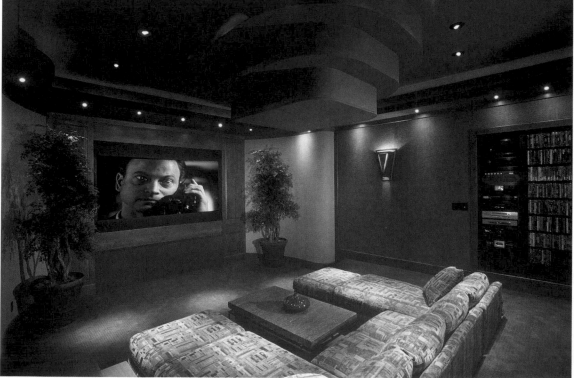

Figs 7 & 8—Connected Technologies in Colorado Springs produced this theater for one of its clients. No cinema that I have ever visited boasted this luxury, yet the furnishings are clearly residential. Courtesy CEDIA/Connected Technologies.

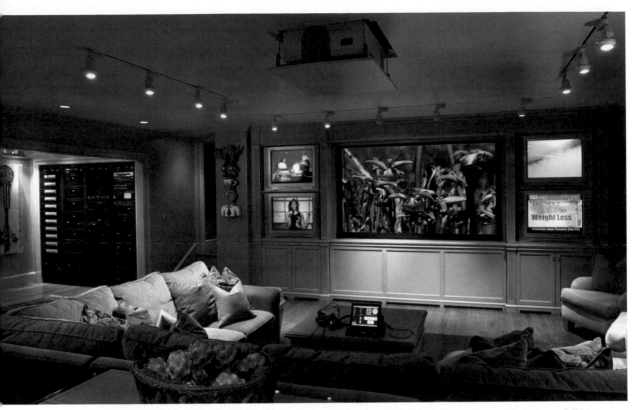

Fig 9 — Not everyone wants their home to rival the golden age of Art Deco movie houses; some people want their cinema fully integrated. For this information hound, one screen was not enough. Four satellite screens keep a watch on additional channels or transmissions; should anything catch the viewer's eye on one of these screens, it can be quickly swapped with whatever is on the main screen. Courtesy CEDIA/All Around Technology.

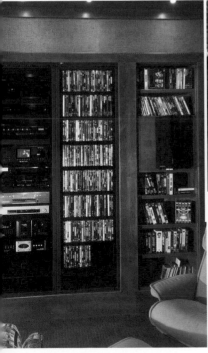

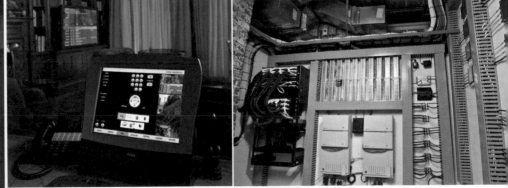

Fig 10 (left) — The key to getting the best from the installation is the hardware. No simple DVD player here; high-quality components include discrete audio decoders that squeeze every last drop of quality from the sound sources. Courtesy CEDIA/Connected Technologies.

Fig 11 (above) — Controlling a mega-system like this is child's play, thanks to a comprehensive but intuitive touch-control panel, which has been integrated with a PC for additional flexibility. Courtesy CEDIA/All Around Technology.

Fig 12 (above right) — The downside of an installation on this scale is that it is no longer a DIY job. A quick look around the back of the media cabinet gives you some idea of how complex the installation actually is; once it leaves the cabinet, the cabling is carefully and successfully concealed to make for a very neat look. Courtesy CEDIA/All Around Technology.

NOW YOU SEE IT . . .

Some time ago, stereo and AV manufacturers discussed the ideal system, a system to which they should all be aspiring. On the one hand, consumers seemed to be demanding more features and equipment that offered more switches and flashing lights. On the other hand, there was increasing resistance on the part of many users to the intrusive nature of so many components. When you had spent a lot of time designing and building your home environment, it was something of an anathema to compromise that design for the sake of the home-entertainment equipment. For these people, the ideal system would be one that was notionally invisible; delivering content—whether audio or visual—on demand but in the most unobtrusive way.

Some of us are fortunate enough to devote a room to our stereo or AV system. We can ensure that the room is as acoustically perfect as possible and position the furniture and components as the requirements of the system demand. The results will undoubtedly be superb and the performance exceptional. But the rest of us have to make compromises. Our living spaces need to be multifunctional. Fortunately, the compromises we need to make to our home-entertainment systems don't need to be too marked. Many stereo systems (or stereo components of AV systems) can now

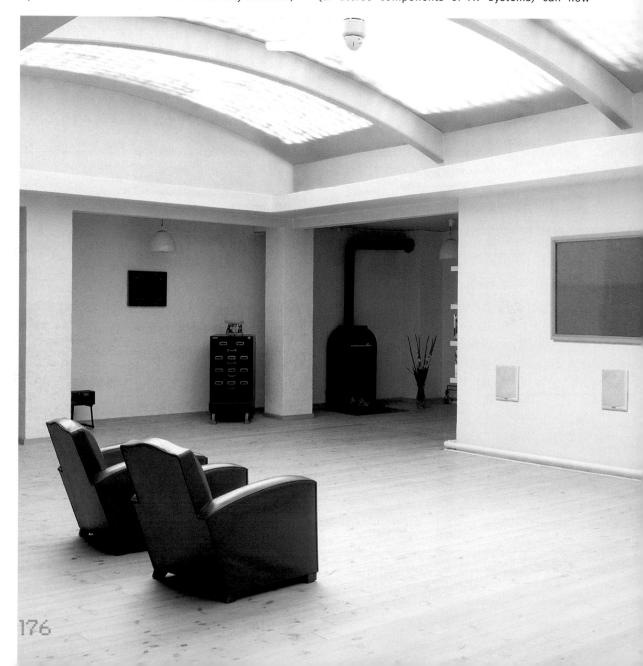

adapt to a room either by you making a manual adjustment of the sound characteristics or, increasingly, by the system mapping the acoustics of the room and automatically compensating for them.

The good news for those who like to hear their music but not look at delivery mechanisms is that discrete audio is now as potent and capable of delivering full sound as those monolithic speakers of just a few years ago.

Fig 13 — Discretion is increasingly the keyword. For those of you wanting music or sound effects that are floor-shaking but not the visual intrusion, there are systems that are subtle. Look hard, and you will see the speakers, but they don't conflict with their admittedly minimal surroundings.

How big is your sound?

What is the ideal size for media? That may sound like a strange question to ask. Surely it is the content that matters, irrespective of the medium? In fact, the size and type of medium can have quite a bearing, psychologically and practically, on the acceptance and adoption of a standard. The form of the compact cassette is often cited as the optimum. It is big enough to handle and to allow print on the case to be easily read. It is small enough for a large collection of tapes to be stored conveniently. It is also no coincidence that Video 8 (and, subsequently, Hi8) tapes were a similar size.

Media larger and smaller than this form has met with more resistance. A single 8-track tape, for example, occupied the same volume as a whole collection of compact cassettes. DAT tapes, conversely, were considered by many to be too fussy. Fortunately for that format, acceptance has increased with time, helped no doubt by the similar form-factor miniDV tape.

Similar arguments are now surfacing again as various memory-card formats vie for supremacy. In one corner, Compactflash: big and bulky but robust and easy to handle. In the other, the micro formats led by the xD Picture card. Tiny, high-capacity, and easy to incorporate into the smallest of devices.

Fig 14 — For the true audiophile, how about this? The Ulysses, from Sausalito Audio Works, uses the unique acoustic lens to ensure that a sound recorded in a studio perhaps thousands of miles away sounds exactly as the artist intended, no matter what the shape of the room. Courtesy Sausalito Audio Works.

TOWARD OUR DIGITAL FUTURE

Predicting the future is, at best, hazardous and, in most cases, futile. We recounted, at the beginning of this book, those astute (for the time) prophecies made by leading industry pundits that were proven so laughably wrong—and wrong in a shorter timescale than anybody might have imagined.

Let us add another entry to our quote list. It is now barely a century since Charles Duell, Commissioner of the United States Patent Office, made an equally sweeping statement. "Everything," he asserted, "that can be invented, has been invented." With scant regard for his own position if this were to be true, his comment came from a position of circumspection; a position that demonstrated with absolute clarity that there was no rationale for any new inventions.

It is easy now to be disparaging of all such predictions, so how do we avoid the same pitfalls as we seek to make meaningful ones regarding our own future?

Looking back just a few years to the mid-1990s, in the business world early adopters were making the first steps into e-commerce. For businesses looking to cut overhead and cost generally, the draw of a merchandising operation that had no need for brick-and-mortar retail operations nor for extensive call centers was immense. From these few modest operations came one of the greatest upheavals in business as countless companies—some established, many new—jumped aboard the virtual bandwagon.

By 2000, e-commerce had gone, to use the vernacular, ballistic. Shares in high-tech companies with precious little in the way of track record soared to levels that all industry experts presumed to be unsustainable. But sustained they were, and many continued onward and upward fueled by both hyperbole and the unquestioning faith of investors in this new market segment.

Newcomers—perhaps best characterized by the likes of Amazon and AOL—trounced the more established companies and, in the case of the latter, annexed "traditional" media giant Time Warner. Now, even the most sober of financial market players were having to sit up and take notice.

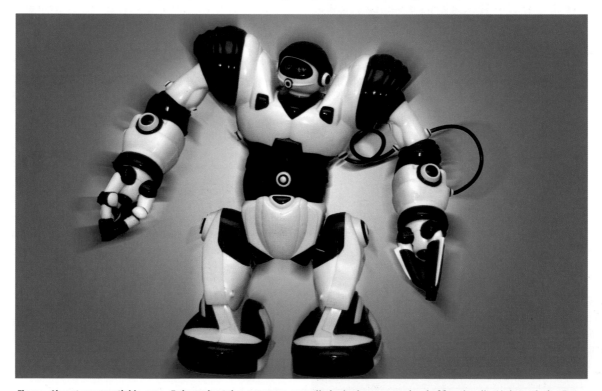

Fig 15—Almost an essential in 2004, Robosapien takes computer-controlled robotics to a new level of functionality and popularity. But soon, will we be chuckling over its naïve simplicity?

It was the same around the world. For example, Lastminute.com in the UK, A Web site acting, essentially, as a third-party clearinghouse for last-minute travel deals and accommodation, and aiming to sell otherwise unsold, short lead-time resources, was floated on the millennial stock market for £730 million—around US$1.1 billion at the exchange rate at the time. Only months later, the whole dot-com marketplace crashed. Many investors, realizing the virtual nature of their investments, cut and ran; even the big names saw their fortunes slashed, although most managed to acclimatize at a new, more modest and sustainable level.

But the migration of our world into a digitally based one was in full swing. Perhaps more surreptitiously, our levels of awareness of all things digital were being raised.

Christmas wishes

Christmas wish lists prove a surprising and interesting barometer of digital trends. Take 2004, for example. For the eight-to-fourteen age range, gone are the expectations for construction kits, Barbies (and her compatriots), or even board games.

In their place appear MP3 players (and, specifically, an iPod), full-blown computer systems, Xboxes, and PlayStation 2s. Kicking dolls, such as Action Men and GI Joes, further down the list is the news that at number 3 on the North American wish list (and with similar positions in other territories) is

WHAT WE WANT FOR CHRISTMAS

GIFT	CHILDREN	PARENTS
Film/DVD	32%	51%
GameBoy Advance SP	28%	8%
GameBoy games	27%	11%
Music CDs	26%	42%
iPod	25%	9%
PC	24%	8%
PC Games	24%	24%
Xbox	22%	6%
"New" PS2	22%	7%

Source: TNS Global

the NASA-inspired robot Robosapien. The report, commissioned by TNS Global, showed that the percentages of children wanting the latest digital accessories were somewhat higher than the percentages of parents willing to purchase the same items!

Of course, we could labor long and hard on these statistics (and similar statistics also apply to other celebrations), but the key deduction is how skewed we are to wanting and embracing digital technology. So let us take a circumspect overview of what we might expect to see in the future of digital technologies.

Computers and the Internet

Expect, in the short term, the Internet to become increasingly pervasive in our domestic environment, perhaps more so than in our work. Television and video is already being streamed via broadband in the manner of cable television, but an increasing number of devices beyond the PC will routinely access our residential connection. Toy designers, for example, buoyed by the success of the Robosapien, are predicting that its descendants will include wireless nodes that will allow updates and new functionality to be instantly downloaded.

Further ahead, the next generation Web, the Symantic Web, will transform Web use into a truly everyday medium that will be as easy to use and as "comfortable" for everyone—even the most ardent technophobe.

Inevitably, computers will continue to multiply their power and capabilities on a periodic basis, but the point will be reached where gains are so esoteric for all but the most potent of applications that consumers such as you or I will not have need for this excessive processing power. All the applications we will need to run will do so on more modestly supplied machines.

Television and radio

The big news in digital television will be the big turnoff. That is, the switching off of analog transmitters as digital becomes universal. Countries and territories have been guarded on precisely when the switch-off will happen, but by 2012 don't expect to see too many analog systems surviving.

Fig 16—Pointing the way to television–PC integration. MSN TV, formerly Web TV, acts as a media hub, allowing access on a television screen to all media resources, whether they are stored locally on a computer hard disk or distributed by conventional means. In due course, expect to see more effective integration of personal video recorders to give enhanced off-line services.

Eager not to disenfranchise viewers, set-top boxes for existing television sets (many of which, thanks to their unnerving reliability, will still be in use in the 2010s) will become commonplace and economic. Around the world we will see models similar to the UK's Freeview, offering a limited raft of digital channels free of subscription, suitable for serving the second, third, or fourth television in the house—not everybody will necessarily want to subscribe to digital packages for all the television sets in the home.

High-definition television is, and will further, become the norm on many channels. These will remain premium channels since some content does not justify the high-definition treatment. More specialized, these non-HD channels tend to attract smaller audiences and lower advertising income.

Digital radio will continue to grow and offer increasing choice. Its unique performance will make it mandatory in cars, while the falling price of the essential chips will ensure DAB appears in most radios within a very few years.

Music, audio, and visuals

The traditional demarcation lines between digital photography and digital video have, as we have already seen, become blurred. Although we will continue to see single-function devices (at least at the professional and semiprofessional level), the integration of cameras, camcorders, music players, and even phones will continue. Quality will improve as flexibility and ease of use become paramount. And all this will be achieved without compromising the use of these devices in any one role.

Conversely, as we have seen with the iPod, there will still be niche products devoted to one genre and excelling in operation within that niche. These will be championed by those with no wish (even if the functionality comes at no extra cost or with no increase in bulk) to adopt parallel technologies.

Mobile communications

Mobile devices—PDAs, phones, and to a lesser degree, laptop computers—will continue to play an important part in our lives. The crossing of technologies we have just described with regard to music player and camera will see PDA and phone integration continue, with a distinct separation between the two. PDAs with phone capability will be favored by those that demand or need a large screen. Smartphones, compact phones with PDA functionality, will remain in the hands of the dedicated phone user who needs a modest amount of PDA features (elaborate phone books, Web searching, and the like).

Fig 16—For some, digital technology needs to go with them everywhere—even when they indulge in extreme sports or face arduous conditions.

The digital divide

Few would argue that the Internet is a strange beast. Essential to many businesses, and equally so to many individuals, it has evolved—rather than been planned—and become a latter-day frontier land where tacit regulation nestles with laissez-faire economics. The result is an ever-more essential resource tinged with an element of anarchy. For many, this is the key to its potency. It is "of the people," an environment where the individual can be heard in equal measure to the corporation.

But there are still many people who do not, through choice, want to use the Internet. Furthermore, neither do they want to embrace digital technology in the same way that many of us have. Their argument is logical: nothing in the digital world offers them anything more than they currently have. Not wanting hundreds of television services, the limited analog raft suffices; happy with videotapes, DVD is of no interest and the ability to create or master your own DVD is irrelevant.

Many sociologists are concerned about this, considering it to be a social rather than a technological issue. No one social class boasts a preponderance of these "non-adopters." But with each new technology we risk leaving more and more people behind. A recent survey from telecom company BT suggested that in the UK—currently in the top rank of digital adopters—nearly 20 percent of the population risks being digitally excluded by 2025.

It is against this background that the digital marketplace needs to grow. It is crucial that new technologies present USPs—unique selling propositions—that clearly mark them as "better" than what they intend to replace. They must be simple to use—in an utterly intuitive way. And cost alone should not limit take-up. Only when technology offers these benefits can we truly describe it as inclusive. For now, it is up to the designers . . .

::PART TWO.::::.

12

...:CREATIVE

..:: DI

PART TWO: CREATIVE DIGITAL PHOTOGRAPHY

THE FOUNDATIONS OF IMAGE MANIPULATION

In this chapter we will:

- Explore why good image manipulation starts with the camera, when we actually take the photograph.
- Examine the key competencies of different digital camera types.
- Look at the digital process and mechanics of the digital image.
- Explore the importance of planning for image-manipulation options when taking photographs.

THE NEED FOR A HOLISTIC APPROACH

"No longer do you need to ensure that you take pin sharp images or that your shots are well composed." "You can forget about the rules of photography and make good your efforts when you edit the photographs later."

Sadly these words are not spoken by some marketing person adding spin to promote the sales of digital image-manipulation software, but by many photographers and writers on the subject. And, more disheartening, many who follow the words get swept along with the hype and, believing these sentiments, treat them as their mantra. Only later, as their latent skills appear and new skills develop, do they realize the error of their ways.

Good photography needs to be considered as a whole—hence our use of the term "holistic"—and it is difficult and unnecessary to divide the art and the craft into separate and essentially disparate elements. We need to approach image manipulation as just the final stage in our image-creation chain. And that stage needs to be built on the strongest of foundations.

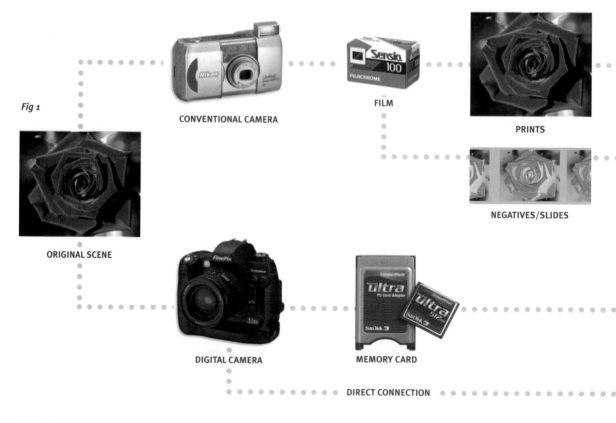

Fig 1

ORIGINAL SCENE

CONVENTIONAL CAMERA

FILM

PRINTS

NEGATIVES/SLIDES

DIGITAL CAMERA

MEMORY CARD

DIRECT CONNECTION

Digital or conventional?

Digital photography needn't be an activity that exists purely in the digital domain. We are able to use conventional cameras to deliver digital images. Likewise many opportunities exist, particularly in the consumer arena, to use a digital camera in much the same way as a conventional one: taking photographs and then delivering the memory card containing those images to a photo lab for prints to be made.

Digital-camera technology has moved on swiftly since its commercial introduction in the early 1990s. Long after the first digital cameras appeared, industry experts were saying that (based on the then-current technology) the day when digital cameras would rival their conventional equivalents was a long way off. Though they looked to be right in those early years, time has proved the wisdom of caution. We saw digital cameras quickly rival and surpass the quality of APS cameras and then make their bid to trounce the 35mm compact. In truth, cameras of similar quality had existed for some time, but they were expensive. High-quality, high-resolution cameras were then very much the preserve of the professional with deep pockets.

Now we are at the stage where digital cameras rival conventional cameras in virtually every respect—including price. This does not mean, of course, that digital cameras have swept the board. Many of us have made substantial investments in conventional equipment over the years, and without those large professional budgets to play with, it is no easy matter to re-equip ourselves.

Those with large SLR (single lens reflex) outfits, fortunately, have been thrown a lifeline. Many camera manufacturers offer at least one digital model that retains compatibility with the lenses, flashguns, and most other accessories used by the brand's conventional models.

IMAGE-CREATION WORKFLOW (FIG 1)

Whatever your approach, the photographic process begins with taking a photograph. Whether we use a digital or a conventional camera, the way we see the subject is the same. It is how the image is handled from this point that opens up different paths.

When we take a photograph, although the imaging ability of digital or conventional cameras is equivalent, there are some practical differences. A

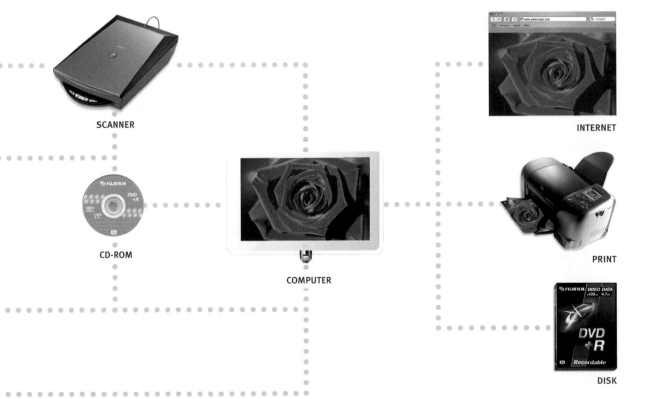

SCANNER

INTERNET

CD-ROM

COMPUTER

PRINT

DISK

conventional camera relies on film for recording images. There is a wide range of film types and brands on the market. We can, for example, make a choice on the basis of light sensitivity. We may want a detailed, fine-grain film for shots taken in bright light. Or to record dimly lit events, we need to use a more sensitive film. We might choose a black-and-white emulsion or one of the more specialized—infrared sensitivity, for example—films available, and we can also opt for films that produce prints or transparencies.

Digital cameras use an integral film sensor. However, we can change the sensitivity of this sensor, giving us the ability to mimic films of several sensitivities. An equivalent sensitivity range of between ISO 50 and 1600 is offered by many cameras.

Digital cameras also allow you to review shots on the built-in LCD panel immediately after shooting, or later if you choose, so poor shots can be discarded. This is where, in economic terms, digital cameras score highly. There are no ongoing film costs, and you can preview images before deciding which to proceed with.

The film that comprises a significant part of the running cost of a conventional camera must be processed before the latent images become visible. Typically most people choose print film, although enthusiasts and professionals are more likely to use reversal films (to give transparencies, also known as slides). These give a more accurate rendition of a scene because processing involves only one stage— developing the film to give a positive image. Producing prints involves two—processing the film to produce negatives and then printing the negatives to give paper prints. The latter stage, printing, can introduce inaccuracies since the equipment has to interpret the image.

Whether you choose prints or transparencies, you can have the results digitized by the processor or you can do it later yourself. We'll look more closely at the details later.

Once the images are on your computer, you are ready to manipulate. Manipulations can be minor— correcting an image fault, for example—or more significant, involving substantial post-exposure treatment. And this treatment can be photographic

Fig 2—Basic cameras can easily be carried and are great for grabbed shots on occasions where conventional cameras would be inappropriate.

in nature or artistic. Photographic manipulations include those that enhance the photographic nature of the image—perhaps altering the composition or correcting major flaws in the original—while artistic manipulations use the original image as the basis for the creation of potentially intriguing artwork.

In the flowchart, we have tried to emphasize the progressive work flow. From original, via the camera and computer, to end result: a print, Web site, or CD/DVD-based image collection. But there will be other entries to our manipulative scheme. We may have images of objects precious to us (or images that have some emotive resonance) that we want to improve or preserve for future generations to enjoy. There may also be images that are not our own (and may be sourced from libraries and clip-art galleries) that will contribute in some form to our imaging efforts.

DIGITAL CAMERAS: MAKING THE RIGHT CHOICE

The digital camera has come a long way in a short time, at least in terms of the history of photography. The question inevitably arises: "what is the best digital camera?" The smart answer, which doesn't explicitly answer the question, is: "the one that lets you take the most effective images." Let's qualify that slightly. There's an old anecdote about cameras and photographers. A guest at a photographic exhibition turns to one of the photographers exhibiting and says, "These are really good photographs—you must have an

excellent camera!" Of course, we can empathize with the photographer and possibly point to occasions where we, too, have faced similar situations. At the other extreme will be the photographer who (perhaps despising the latest advances in optical technology) will announce that the camera is immaterial; it is vision, technique, and skill that delivers great photos, and any camera will do.

You do need the vision, technique, and skill, but having a tool that responds to those key criteria is equally important. The ability to control all aspects of your picture taking is crucial if you wish to extend your creativity and develop your skills. So how does this affect our choice of cameras? Does it mean that only the most highly specified machine is worth considering? No. In fact, many photographers today realize that digital technology has made it possible to produce novel cameras that can fulfill many needs without bristling with controls. Moreover, many digital-camera users find that, to get the best images and maximize opportunities, they may work with more than one camera and will tell you how each has a unique place.

Basic cameras (fig 2)

Characterized by point-and-shoot philosophy (that is, with little or no opportunity to use any controls to set exposure), these cameras have less than 2-million-pixel resolution but are still capable of producing good images in ideal conditions. They also have the benefit of being relatively cheap and

can even be included in a multifunction device. Phones and PDAs are typical examples. Their compact size means they can be carried easily where a better-specified model might be inappropriate. It's worth noting that although the quality of images displayed on a camera phone (or by a PDA camera on the PDA display) look to be of poor resolution, in fact the image quality, once downloaded to a computer, can be surprisingly good.

Benefits:
- Compact
- Multiple uses
- Good image quality (in general)

Drawbacks:
- Sometimes expensive
- Limited control

Compact cameras (fig 3)

Like their conventional equivalents, digital compacts can offer a surprisingly potent specification in a small, easy-to-use package. Most are pocketable and offer a degree of control that is roughly proportional to their cost. The more you pay, the better the specification. Compact models are extensively used by enthusiasts and professionals as an adjunct to their "main" cameras, as they offer much of the quality with only a modest compromise in specification.

Benefits:
- Compact
- High specification of some models
- Very good image quality and resolution

Drawbacks:
- Lacks the ultimate control of more advanced models

Fig 3—Compacts give a degree more control than basic models yet are still eminently pocketable.

Hybrid cameras (fig 4)

It is only comparatively recently that digital SLR cameras have become affordable for the mass market. In the interim, many manufacturers produced cameras dubbed as hybrid designs. These offered the higher quality (over compact cameras) demanded by the serious enthusiast but did not command the high pricing. These models look like small-scale SLR cameras (they are built around smaller CCD imaging chips than SLRs) and offer a fixed lens and (usually) an LCD viewfinder, rather than a direct-vision one. The advent of reasonably priced digital SLRs has put pressure on this market segment, but there is still a useful range of models that are ideal for the user who does not want—or need—a full-blown SLR system.

Benefits:
- Compact for specification
- Highly specified (usually)
- All-in-one design

Drawbacks:
- Expensive (comparatively)
- Compacts and digital SLRs are squeezing the market at either end

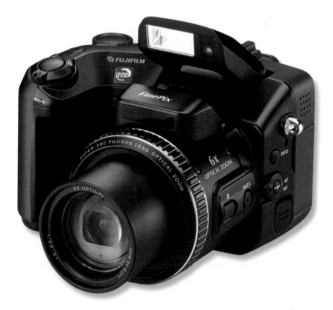

Fig 4—Looking like downscale SLRs, hybrid cameras give more creative control but without the expense of an SLR.

Digital SLRs (fig 5)

Serious photographers will almost invariably describe the SLR design as their favorite. They offer unprecedented levels of control and versatility, and interchangeable lenses, flash units, and other accessories make it possible to tailor a system to meet precise photographic needs. They also tend to feature larger CCD imaging chips, making for higher image resolutions and better-quality results. The obstacle is price. Although becoming more affordable, costs are still generally high.

Benefits:
- Versatile
- High resolution
- Very highly specified

Drawbacks:
- Bulky
- Expensive

Medium format

The professional photographer—especially those in commercial photography—would use medium-format cameras (such as the ubiquitous Hasselblad) as a staple. Their large image size yield far better quality images than 35mm, while the cameras remain portable and easy to use. The evolution of camera design has seen many manufacturers offer versions of their medium-format cameras that accept digital backs—replacing the conventional film backs. Hasselblad has gone one step further and produced their H1 model. This can accept either film or digital backs.

Benefits:
- Very high resolution
- Superb image quality
- Excellent specification

Drawbacks:
- Extremely expensive

THE MECHANICS OF THE DIGITAL IMAGE

For most people, the camera is a black box. Most people realize that it features a light-tight enclosure into which light is admitted via the lens. Few people

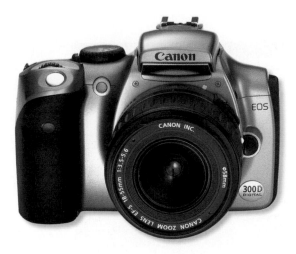

Fig 5—Digital SLRs look very similar to their conventional equivalents—and many are modeled on conventional designs.

know (or indeed care) about what happens within. The digital camera is even more of a mystery. But it's worth spending a few minutes reviewing digital technology generally and its application to photography.

Digital photography and its associated digital-image editing are two of the most popular activities to have emerged over the last decade or so. Why have they achieved this popularity when conventional photography and the photographic darkroom have never appealed to more than a small section of the population?

There is no simple answer. One reason is the proliferation of computers. As our acceptance of the personal computer and familiarity with its capabilities have grown, so has our willingness to adapt its use beyond the somewhat prosaic roles we assign it during the working day.

Another reason is simplicity. Digital photography is easy. Some people may take issue with this, but think about the process of taking a conventional photograph. You need to squint through a viewfinder, set some controls (which for all but the enthusiast are somewhat esoteric in their action) or hope the camera automatically makes appropriate settings for you. You press the button and take the picture. And that is it. If you are prolific in your image-taking, you might see the fruits of your labors in a few days; others might leave the film in the camera for months. There is no immediacy or expectation. If results aren't up to snuff, so be it.

With a digital camera, you can preview your shots and compose them using a convenient LCD display. This same display lets you enjoy—or examine—the images immediately after you've taken them. Disappointing shots can then be recomposed and reshot, and yet none of this requires any more skill or photographic acuity than in the predigital days.

The red herring in the exploration of digital photography's popularity is the word "digital" itself. Applying the word as a prefix to any activity seems to imbue it with mystical panache. Digital television is perceived to be something better than conventional; digital communications likewise are better than analog. The arguments that promote the digital nature are often false; digital television is a delivery method that does not, per se, deliver better television. And digital photography does not necessarily make for better photographers. It does, however, give unparalleled opportunities to become more proficient and more capable and to produce superior images.

The crux of all digital technologies is the use of numbers to represent all variables. With digital telephones, the infinitely varying sounds that we make are interpreted as discrete numbers. These numbers can be transmitted over the air or along telephone wires and even recorded to a computer disk without any degradation. This contrasts with the original sounds, which deteriorate, to some degree, when transmitted, recorded, or replayed.

With digital images, we reduce the colors and brightnesses in a scene to numbers. Not only does this form of recording as data make the image more robust, but it also allows us to perform modifications. We can alter the numbers mathematically to achieve virtually any form of transformation.

This is beginning to sound like an increasingly complex procedure. But it is not. When we record an image in a digital camera and subsequently manipulate that image on a computer, we see nothing and, indeed, need know nothing about the complex and extensive mathematics that underpin it. Thanks to modern computer operating systems and image-manipulation software such as Photoshop, we apply changes and observe the results practically instantaneously.

Bayer patterns (fig 6)

The individual pixels of a CCD are responsive only to the amount of light falling on them—they are essentially color blind. To record a color image, a fine filter is placed over the CCD to make each pixel sensitive to only red, green, or blue light. Sensitivity issues with regard to green mean that there are more pixels used to record this color. Some CCDs, however, use emerald/cyan filters in place of the additional green ones to provide better color rendition, particularly in difficult areas such as skin tones and skies. The filter pattern is known as the Bayer pattern.

The Bayer pattern filter has an important impact on color and resolution in an image. It requires three pixels to produce accurate color information for a discrete part of an image. However, every pixel in a digital image has its own color value. How can this be so? It's a process that mathematicians call interpolation. To arrive at a color value for every pixel, even though each records only a single color, the values from the neighboring pixels are added together and averaged. The process—to produce accurate color renditions—is complex, but as photographers we just need to know that it works!

Fig 6—Conventional Bayer pattern and the modified pattern featuring emerald filters.

The Pixel (figs 7–9)

To make it possible to describe every image uniquely as a series of numbers, we need to break it down into small, discrete elements to which we can assign values for brightness and color. We call these smallest of image elements pixels (a contraction of picture elements).

Digital cameras' imaging element, that part that records the image (the successor to film if you like), is broken up into pixels—each of which is, in effect, a tiny light-sensitive diode. Complex processing circuitry ensures that on each shot we take and the brightness and color from each of these can be recorded and later reassembled to create an image. A typical imaging chip (called a CCD or CMOS, depending on the technology used) can have between 2 and 12 million pixels. Some professional models have many more.

The image that results mirrors the pixel nature of the imaging chips, with each pixel reflecting the color and brightness of its respective scene element. But conventional images—photographs, negatives, slides, and even artwork—can be digitized using the relevant scanner. All that happens in a scanner is that the original image, from whatever source, is copied into a digital file by breaking it down into pixels. The methods may be different, but the end result is the same.

In the next chapter, we will look more closely at the computer and software and also explore one of the most important features of digital images—resolution.

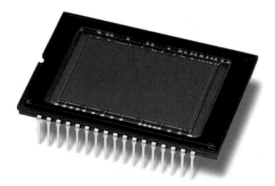

Fig 7—The CCD is a complex imaging and image processing chip. This Nikon model can record around five million pixels and allows shooting at multiple frames per second.

Fig 8—This diagrammatic representation of the chip from a Fujifilm camera illustrates the individual "photosites" that record pixel information. This design, called the Fourth Generation SuperCCD, has two light-sensitive elements to each pixel to ensure the highest fidelity in both detail and color.

PLANNING FOR SUCCESSFUL IMAGE MANIPULATION

When we set about creating a great image, we will (except on those rare occasions when good images just happen) have a vision. And to realize that vision we need to recognize not only the darkroom techniques that must be employed but also the best way in which the original images should be recorded. This becomes even more pertinent when we seek to produce very specialized types of image. Let's take a sideways step for a moment to consider all the issues that go to make the images recorded in the camera the highest—or at least the most appropriate—quality.

Resolution and quality (fig 10)

Resolution and quality are undoubtedly two of the most important issues in recording digital images. Newcomers to digital photography, constrained for years with the finite capacity of a film camera, are often surprised by how many images they can record with even a modest memory card. But that surprise

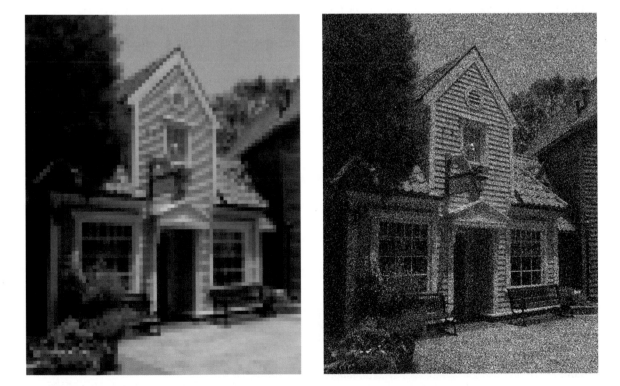

Fig 9—The pixel nature of images is clear when you view them close up. In essence, however, this is no different in resolution terms from the grain structure visible when conventional film-stock images are viewed close up.

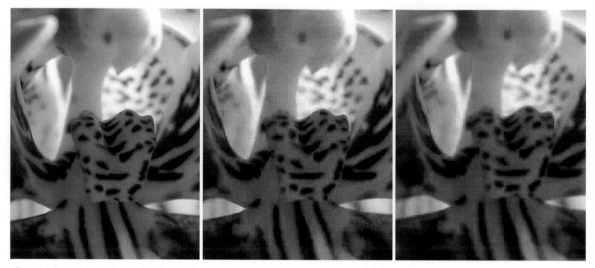

Fig 10—It is surprising the quality that can be achieved using digital images, but that quality is soon compromised if low-resolution or low-quality settings are used. These details come from a section of images recorded with a 5-million-pixel camera. One was taken at full resolution (left) and the highest quality. The next at full resolution (middle) but low quality and the final one (right) at 1-million-pixel resolution.

often turns to consternation when they examine the results and discover that their unique, unrepeatable images prove impossible to print with any clarity. They have fallen victim of the trap of using a low-resolution image file storage format.

Just about every camera will give the option of saving images in one of several formats. At the top of the tree is the uncompressed, unfiltered, and unprocessed Raw format that we examine on page 213. Beneath this in terms of quality come a number of options, each offering the opportunity to save greater and greater image numbers. Often these, nominally, offer the same ultimate resolution. But the names given to each—"Fine," "Good," and "Normal"—give the game away. As you move through the list, image files are stored with greater and greater amounts of compression. The "Normal" option, for example, would rarely be acceptable if you wanted to produce a quality image.

Of course there will always be compromises. Choose to store your images in Raw format, and you'll get great results but be able to record only a very limited number of images before the memory card gives the "CARD FULL" message. My advice would be to stick to the "Fine" format as much as possible, straying to lower quality only when absolutely essential. Make sure you carry more than

enough memory cards with you, and you'll never be caught short.

As for the lower-resolution image storage offered, steer well clear. Even if your argument is that your images are for Web use, take care. If you find you have a potentially great shot on your hands, you won't be able to do much more than view it on screen.

The drawback with digital cameras, despite the ongoing growth in CCD pixel numbers, is that most cameras (including digital SLRs) tend to offer a more modest resolution. That's no great problem, unless you consistently need to produce very large prints.

Shooting panoramas (fig 11)
Panoramic photography—shooting sweeping vistas or extreme vertical shots—has moved from being a specialized task to the mainstream thanks to digital photography. It's now simple to join adjacent shots to produce a panorama (of up to 360 degrees), but it is important to record shots accurately in the first place. We'll explain more about the practicalities of this later but, as a prerequisite, ultimate accuracy will depend on using a tripod.

Shooting 3D (fig 12)
Another technique experiencing a digital renaissance is three-dimensional (or stereo) photography.

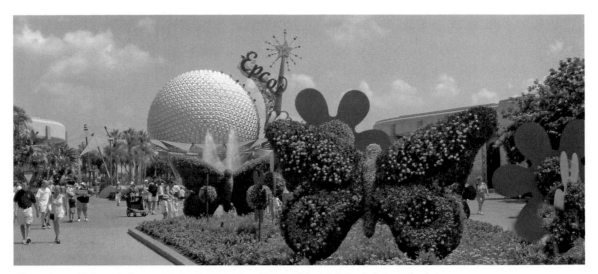

Fig 11—Large, high-resolution panoramas were once the preserve of the specialized photographer but are now easy to produce digitally. It's important to ensure that the consecutive images that comprise the panorama are precisely recorded, making a tripod an essential piece of equipment.

Photographers have long struggled to give their photographs true depth but have often been hampered by cumbersome viewing equipment and the need for very high levels of accuracy. New tools, such as Photo 3D's photo kit, make it easier to get the shots needed to build three-dimensional images. They'll work with different viewing tools.

Filters

On-camera filters are often rejected in the digital world. Effects can be applied later, avoiding the need to compromise the original image (since, once recorded, the action of a camera filter can't be removed). But some filters should stay in your gadget bag—polarizers, for example. Removing reflections and boosting color saturation can be done digitally, but why put yourself to the time and trouble when a little forethought can remove the problem at source?

We can re-create graduate filters digitally, too. But sometimes it is still crucial to get a balanced shot where the brightness of the sky does not compromise overall image quality. Being able to hold back the sky (by reducing its exposure) is the raison d'être of the graduate (and we're talking here of the gray, or neutral-density, graduate, not the polychromatic alternatives), and these are still a useful—if not crucial—tool.

Now that we have established the rationale for and the means of creating digital images, we need to take a closer look at some of the other stages in our holistic approach to digital-image manipulation. In the next chapter we'll examine the hardware credentials and also those of the crucial software. We'll also follow through on the concept of resolution and see why this is so fundamental to much of digital imaging.

Fig 12—Photo 3D's kit provides a mini tripod for recording stereo image pairs accurately aligned. The companion software allows you to combine the pairs for viewing with specialized glasses. The software can also be used to align images precisely for use in other viewing systems.

HARDWARE AND SOFTWARE ESSENTIALS

In this chapter we will:

- Look at the opportunities to produce digital images without resorting to a computer.
- Examine the requirements in a computer system to embark successfully on image-manipulation projects.
- Examine the software applications required not only to manipulate images but also to become an effective and organized digital photographer.

The key to successful digital imaging is having a digital darkroom that not only meets specifications in terms of hardware and software but also allows effective, efficient workflow. We don't want to spend time looking at an hourglass or a stopwatch icon as our edits are enacted on our images. Neither do we want (nor need) to hunt menus and submenus for an often used but elusive feature. Over the next few pages, we'll explore the requirements for an efficient light room. For those of us whose first love is photography, it is easy to be misled or misguided when it comes to computer hardware and, to a lesser degree, software. So we'll adopt a rather cynical approach and take an objective view about what we do need and what we don't.

DIGITAL IMAGING WITHOUT A COMPUTER (FIGS 1 & 2)

Do we need a computer at all? Most photographers, even many professionals and enthusiasts, never owned nor wanted to own a chemical darkroom when they worked exclusively with film. They would rely on laboratories to process their film stock and likewise to produce prints and finished artwork. We can still do that with our digital images, but there is another option, a "third way": the custom-made direct printer.

Direct printers connect to your digital camera and allow you to print selected images without any other intervention. These printers often work with the camera attached, using its LCD display to preview and select images for printing.

Regard these printers in the same light as those Polaroid instant printers that were once used to make fast prints from slides. They are great for getting prints quickly from the camera but are suitable only for proofing or delivering prints on location. You could, for example, use one at a wedding reception to produce sellable instant prints. Add a quality folder frame, and you can tap into that impulse-buy market.

Fig 1—Suitable for operation as a computer printer or using memory cards directly, this Fujifilm model can also connect to a television for reviewing the contents of a memory card prior to printing. Print size, as it is for most printers in this class, is small, but the quality is invariably very high.

Fig 2—Can it be any more simple? Plug the camera into the dock (which also recharges it) and select the images to print. The downside is that the printing unit (in this case a Kodak one) is matched to a particular camera.

GETTING THE BEST FROM YOUR COMPUTER

Computers in recent years have offered—and delivered—such incredible computing power that the warnings we once gave about ensuring you have sufficient memory and computing speed to use the demanding requirements of image-editing applications are now somewhat superfluous.

In fact, it's interesting to see how the specifications for software have evolved over the years. When Adobe released their Photoshop CS it had, compared to the computers available at the time, rather modest hardware demands. We can compare this to an earlier version of the same product whose requirements demanded the use of a very well specified machine. Here are those requirements for a Macintosh (the original version of Photoshop was not available for the PC), for comparison, separated by a decade:

We have seen with the most recent launches of Photoshop (and its peers) that there is something of a tailing off of the specifications required for each subsequent release. Of course, we can always gain by having a computer that is better specified than is demanded. And the other applications we may choose to run will undoubtedly ensure that we keep upgrading our computers long before they suffer any form of mechanical failure.

Buying new

If you're in the lucky position of upgrading to a new computer or buying a new machine outright, is it fair to be guided by, say, price alone, or are there other issues to be aware of? Probably the best way to evaluate the capabilities of a computer is to examine the recommended specifications required by the software you intend to run on it. This may be your image-editing software (which has traditionally been the most demanding), but it could be that an additional application, such as movie-editing software or a DVD-creation application, is even more voracious in its demands.

It is important to make the distinction between minimum specifications recommended and the (rarely published) desirable specifications. Historically it was important to the sales of a software product to define the minimum specification under which the software could run. This was real baseline stuff. Run Photoshop 3 under the bare minimum specification, and you'll find it painfully slow. Much of this is due to the computer needing to copy parts of the image to and from the hard disk when editing. If the computer cannot retain the whole of the image currently being edited in memory, it needs to use a part of the computer's hard disk as a so-called "scratch disk" for temporary storage. Copying and retrieving data in this way is

	Photoshop 3	Photoshop CS
Processor	Macintosh II 68020	Power PC G3, G4, G5
Operating System	System 6.0.7	Mac OSX 10.2.7
Recommended RAM memory	8MB	256MB
Hard-disk space	32MB	320MB
Monitor resolution	640 x 480 pixels	1024 x 768 pixels

Fig 3—The innards of any computer can be daunting to even the most stoic of technophiles, but follow simple instructions and you'll be able to install additional memory, graphics boards, and even disk drives.

much slower than using RAM memory. This alone is a good reason for adding as much RAM memory to your computer as possible.

Memory (fig 3)

Adding memory is perhaps the single simplest and most effective improvement that can be made to any computer destined to become an image-manipulation workstation. It's a case of never being able to have too much. It's also getting easier to add new memory—in the form of chips—to your computer. Macintoshes have, for many years, made it possible to upgrade memory without resorting to special tools or specialized knowledge. Now an increasing number of PC makers are seeing the advantage of making this process simple for the user. Have 500MB or RAM memory, and you'll be ready to fly.

An ideal system?

To be asked to define an ideal image-manipulation system would be to ask for trouble—and condemnation—if not today, then during the shelf life of this title. But it is possible to describe a system that will be adequate for some time to come. So what would this comprise?

The computer would need a fast processor, optimized for graphics-intensive work. For a PC, this would be a Pentium 4 running at 2Ghz. For a Macintosh, the equivalent would be a G4 or G5 processor running at 1Ghz or better. But remember: specifications lower than these are still capable of good results.

Hard disks are where all your programs, documents, and images are stored. And the more storage space you have, the better. A large amount,

100GB or more, is useful but not essential unless you are also heavily into digital video production. Around 100GB will be sufficient for you to maintain a healthy range of applications along with extensive image libraries.

Finally, a display. Not so long ago we would have without hesitation recommended the use of a cathode ray tube (CRT) display. Only these were capable of displaying images to a level of authenticity (in brightness and color fidelity) necessary to ensure perfect results. Now LCD panel displays have successfully matched their bulkier counterparts in quality (at least to the satisfaction of the vast majority of users) and allowed us to free up so much more desk space for other uses.

I have deliberately steered clear of suggesting whether you should select a Macintosh or PC platform for the core of your digital darkroom. Partly, this is because you might have no say: if you have peripherals or software, or an old computer you are upgrading, that decision has already been made.

Desktop or laptop (fig 4)

A more intriguing argument today is not Mac or PC, but laptop or desktop? Again, this is an area where the balance has shifted. Laptops would be avoided for image manipulation because they were perceived as being underpowered (at least compared with their desktop counterparts) and as having inferior viewing screens. It is still true that for raw power the desktop machines deliver the goods, but the

Fig 4—Laptops are often perceived as being inferior to desktop computers, but many models are more than up to the task. You also have the advantage of being able to take the computer with you on trips, downloading your camera's memory card whenever and wherever possible.

difference between those and a corresponding laptop is narrowing. Screens, too, are improving to the point where they are viable to use even on moderately exacting color work.

Communicating with your images

How you get your digital images onto your computer depends on the nature of the originals. Digital-camera images can be imported directly by connecting the camera to the computer. It's normal to find a USB lead as part of the camera kit (sadly, there is little in the way of standardization in camera connectors). Some better cameras may include the faster FireWire connection, which will download the larger memory cards typically found on these cameras at a much faster rate. Other cameras come complete with a dock, which is a cradle that makes connection simpler and handles housekeeping duties (such as recharging the camera's batteries and deleting the images from the downloaded memory card) automatically. Or you can choose my preferred option—a dedicated memory-card reader. It is quicker and less demanding on camera resources (see fig 5).

Scanners are required to digitize conventional images and flat artwork. These, too, connect via a USB lead. Originals can be scanned either by pressing a button on the scanner (which automatically launches a digitizing application) or from within an application such as Photoshop. Getting the best from scanned images involves a little remedial work, and we'll be looking more closely at how later (see fig 6).

Fig 5—This memory-card reader can accommodate up to six different types of memory card—ideal when you're using more than one type of digital camera.

The final method of delivering images to a computer is on disk. Conventionally, this is a CD-ROM, but larger images and larger collections of images are making DVDs a more viable option. Both of these have the benefit of being compatible with the drives on most computers on sale today. They also score by being relatively cheap, with blank disks of either type being substantially cheaper than many of the less common proprietary disk systems (see fig 7).

SOFTWARE APPLICATIONS

To create a successful digital image-manipulation workstation from your computer, you need some key software-application resources. These include products from two crucial software categories: image-editing applications and asset-management applications. Over the next few pages, we'll take a look at these and establish which applications are essential, which desirable, and which can safely be sidestepped.

Fig 6—Scanners come in all shapes and sizes. This curious model from HP not only conserves desk space by standing upright but also has a transparent lid, ideal for digitizing transparencies and transparent artwork.

Fig 7—CD-ROMs and DVDs are ideal for backing up images, storing images, and sharing them. The widespread availability of DVD/CD drives has made them cheap and efficient.

Fig 8—Photoshop's interface is daunting, but come to understand it and you'll find it's been beautifully conceived and is a great example of good ergonomic design.

For me, choosing computer software for image editing is not so much like choosing equipment for the darkroom but choosing a camera system. When we choose a camera, we are looking for something that will give us all the tools we need and all those that we think we will need as our skills and abilities improve. But it needs to offer this in a package we feel comfortable using. We need controls that, with just a little practice, we can use swiftly and with little conscious thought. But how does this relate to software applications?

When we use any computer software, we are using nothing more than a tool, a device that makes it possible to use the computer for a specific task. That task may be word processing, if we are using an office application, creating music, or editing videos. When we want to edit and manipulate images, we want to do just that—without undue thought about the mechanics of the computer. For optimum workflow, we need to be able to navigate the software as fluidly as possible. This is why it is so important to choose the most effective software for our needs.

Extending the camera analogy even further, once we have bought a camera we tend to set our sights on accessories that will make our system even more potent. With hindsight, we discover that some of these accessories are of more use than others; some will be with us every day, while others are unlikely ever to see light of day as they lie at the bottom of the gadget bag.

There are plenty of software applications that will, in a similar way, vie for our attention and budget. Some will be nearly essential to our image-creating objectives. Some will seem just as relevant but are unlikely ever to be used beyond an initial flirtation. Realizing what is good and what is bad is one of those unsung skills the digital darkroom worker must learn.

Image-editing applications (figs 8–10)

But first, the key application. It's the image-editing application that we'll spend most of our time sitting in front of, so it's essential that we choose one that delivers all the tools we need. For most enthusiasts and virtually all professional photographers, choice is limited to one application—Adobe's Photoshop.

Fig 9 –Two for the price of one! Buy Photoshop and you get ImageReady for free. This is a fully specified image editor in the mold of Photoshop but designed for producing Web graphics. Learn Photoshop, and you'll quickly pick up ImageReady.

Fig 10—Hints and recipes characterize Photoshop Elements. Otherwise, it has the same look and feel as Photoshop itself.

Those new to digital photography will often ask: why? Is Photoshop the best application? Is it the most comprehensive? The easiest to use? And why does it cost so much? Let's take a look at these questions in turn.

Often the most pervasive product in a category gains prominence for a variety of reasons, not necessarily for being the best. You could take a look at video recorders, for example. By general consensus, the VHS format was a poor relation in quality terms, but by good pricing and great marketing it gained a substantial foothold among an audience that was, for the most part, not particularly discriminating. Is it also the case with Photoshop? Thankfully, no. Photoshop is undoubtedly the most effective application for the serious photographer. I've carefully skirted the use of the term "best" here, because that term will depend to a degree on a user's needs. It is fair to say that the interface and working environment of Photoshop are the most slick and most effective when it comes to working day in, day out.

Any drawbacks? Of course there are. And this brings us to answering the last question: why does it cost so much? To many enthusiasts, the price is the obstacle to owning and working with Photoshop. It's unfortunate, but as a tool notionally designed for the professional user, it is priced accordingly and is used— for the most part—by those who don't foot the bill.

Neither is it the most welcoming nor forgiving of applications. Those who come fresh to Photoshop will know to their cost that it does not ease the newcomer in, not in the way that some image-editing applications do. Though the help menu is copious, it is very dryly presented and there are no other assistants—certainly nothing in the form of the wizards and shortcuts seen in lesser products. Learning Photoshop from scratch is an uphill struggle, but it's one that, through this book, you should find easier.

Adobe has long been mindful of

the professional nature of Photoshop and has offered junior products, such as the trimmed-down Photoshop LE (offering a similar interface but a cut-down tool set), and Photodeluxe, a basic step-by-step application designed for the burgeoning consumer market. Although both these applications have been successful, Adobe still recognized a need for a product that had much of the scope of Photoshop, that operated in much the same way, but had a friendlier face.

Hence the introduction of Photoshop Elements. It looks identical to Photoshop in most respects, but under the skin are a number of shortcuts and recipes that ease the newcomer through the initial days and weeks of image editing. Users can, at their own pace, move across to using the full features of Elements. All the key features of Photoshop are included, though some have been curtailed. Those that have been removed tend to be the features used by pre-press photographers and designers and have proved (given Elements' success) a good trade-off against the substantially lower cost of this product.

You might be forgiven for thinking I am in the employ of Adobe with the continued references to their products on these pages. Not at all—I don't even

Fig 11—Extensis's Portfolio has a simple thumbnail interface by default that belies the power that lurks beneath. When correctly configured and with images appropriately tagged, it makes image retrieval a cinch.

get a complimentary copy of any of their products. But it is a fact that Photoshop is the reference standard by which all other applications are judged and is the best (thanks to its pervasive nature) to use for demonstrating. But we haven't forgotten that there are many other competent applications besides those offered by Adobe, and you will find a rundown of these in the panel below.

Fig 12—Portfolio Express can be invoked in any application, making it easy to integrate image identification and editing.

The wide world of image editing

If, for whatever reason, Photoshop isn't your thing, here are some alternatives to consider:

- *Corel DRAW:* Ostensibly a graphics application, it includes the module Photo Paint, which is a very comprehensively specified image-editing application.
- *Paintshop Pro:* Another well-specified application that's bundled with a simple Web-animation package and cataloging application.
- *PictureMan:* An idiosyncratic application that's available online and contains many novel features. Different in approach to many image editors, but no less effective for that.
- *Painter:* Nominally a natural-media painting application, Painter is also an image editor. Best suited to those who want to produce artwork from their images.

Plug-ins: extending choice

Even an application such as Photoshop can't cover every need and eventuality. That's where plug-in filters come in. These are miniature programs in their own right but have been designed, as the name implies, to plug in to an image editor. Going back to our camera kit analogy, these are like conventional filters, in spirit if not implementation. Some are useful and can be used regularly. Others are less useful and some so bizarre as to defy logic. Fortunately, most are available on a trial-use basis, so you can discover how useful they will be to you before spending any money.

Later in this book we'll take a look at some specific examples and see how even some of the most obscure can be used in creating powerful images.

The one-trick ponies

There's a class of image-editing applications designed not for all-purpose image manipulation but rather for very specific techniques. Two obvious examples are panoramic software applications and software for creating three-dimensional images. Often you don't need these applications, but if such techniques are likely to figure heavily in your workload, they can prove to be great timesavers. And there is no doubt that armed with them you'll be a lot more successful in your image making. We'll be taking a look at panoramic software and 3D photography later, too.

Fighting the forces of chaos: organizing images (figs 11 & 12)

I rarely count the number of images that I edit or manipulate each day, but say between twenty-five and fifty, and you'd not be far out. And I'll save them all away, performing the necessary backups absolutely convinced that, when the need arises, I'll be able to track down any image from memory. Of course, I've been proved wrong time and time again. That's how I learned the hard way about the importance of good image management. The nature of the digital image is that, unlike conventional images where there will only ever be one prime copy of each shot you take, you may have many copies, each manipulated in some way to make them originals, too. Time is precious, and whether we

manipulate images for a job or for pleasure, you want to make the best of that time. Hunting through your hard drive for images should not figure prominently in your schedule.

Image-management software is another of those "must buys" that rarely figure on people's shopping list. For some people it is the belief (like mine) that your memory is up to the task. Others regard it as frivolous expenditure. Yet more appreciate the need but think that the process of cataloging and organizing images will be time-consuming and boring.

For the typical—if there is such a thing—user of Photoshop, the corresponding asset-management application would be Extensis's Portfolio. Like Photoshop, this is an application that has grown and flourished over the years and now provides the most comprehensive set of management tools. Again like Photoshop, there are many features that you would be unlikely to use day to day but will be very pleased you have when the need for them arises. Key features (which also apply to other, similar packages) are the thumbnail catalogues and keywords. By applying keywords to each image (the job that many perceive as time-consuming), you can then instantly identify an image or set of images simply by calling up the appropriate keywords.

Where Portfolio scores over most other applications is in the extent of its use—not only is it a virtual industry standard but it also supports networks and multiple users. Several people can simultaneously work on the same catalogue without any fear of loss of data or data integrity.

Fig 13—*Simple but effective, iPhoto handles downloads, image storage, and basic manipulation.*

Photoshop Album and iPhoto (fig 13)

These two spiritually similar applications (the former is for PC, the latter for Macs) provide a bridge between simple file browsers and image-management applications. Each allows you to view and select images easily using keywords or visual thumbnail arrays. They also make it simple to download images from digital cameras, organizing downloads according to date (giving another simple retrieval method). Unlike image managers, they tend to work with those images stored on the computer and don't manage non-image assets.

The application iPhoto includes some simple image-editing tools, but these really are very basic and not the sort of resource most photographers would use. Fortunately, like Photoshop Album you can specify Photoshop as your image editor and have this application automatically invoked when you want to edit.

Archiving and backing up

The natural extension to asset management is archiving and backing up. It's useful to have access (made simple by your management system) to your images directly from the computer's hard disk, but what if that disk or some other crucial part of the computer were to fail? Failures do happen but fortunately not very often. Of course this reliability does tend to lull us into the proverbial false sense of security. It's

often only when we experience a failure that we realize the importance of keeping copies of all our work.

But first, let's distinguish between backups and archives; though the mechanics may be similar, the detail is quite different.

Backups are made regularly of the files on your computer that are currently in use: those images that we are working on, the most recent downloads from the camera, and, of course, any other new or changed files on the computer. In contrast, archives contain those files—again of any nature—that you've finished using on a day-to-day basis and don't anticipate needing immediate access to.

Think of both as you would insurance: something you don't want to think about, don't want to spend any time sorting out, but will be so grateful that you did if the worst should happen.

For archiving important files, you don't really need any special software. You can drag and drop the relevant files to a recordable DVD or CD and burn them. For good measure, always make a couple of copies and, if the material is valuable (in emotional or financial terms), store each in a different location. Avoid using rewritable media, which can be a bit more idiosyncratic when it comes to playback in different computers.

Backups can be done by dragging and dropping files onto removable media but can also be written to another disk drive. An external disk drive makes an ideal medium for your backups: write speeds are fast, and you can back up frequently (perhaps several times a day) when working on important material.

Both Windows XP and Mac OS offer applications for automating your backups called Briefcase and Backup, respectively.

RESOLUTION

Resolution is one of those terms we all know a little about but often really don't have a thorough understanding. This is partly because the term is bandied about in several aspects of digital photography and each has a slightly different slant. For our purposes, we need to become familiar with the relationship that takes in the pixel dimensions of an image, how that image appears on screen, and how, ultimately, it will be rendered in print or, say, on a Web page.

The amount of detail in an image is determined by the pixel count for that image. We often describe this pixel count as the resolution, particularly if we extrapolate backward to the imaging sensor that produced the image.

When we view an image—on a screen or printed out—the resolution of that image is described as the number of pixels per inch (ppi). That's an absolute term used irrespective of whether units as a whole are described in imperial or metric terms. Now we also describe the size of the image by its pixel dimensions—a CCD chip that has a resolution of six million pixels may have pixel dimensions of 3,000 x 2,000.

As we manipulate our images, we'll come to see that by using an image-editing application we can change the resolution in pixels per inch at will (in Web-authoring applications, however, such as ImageReady, you'll generally find that resolution is maintained at 72 ppi, which is a standard for online, onscreen media).

How does this translate into printed images? A high-resolution image will contain a greater number of smaller pixels than one printed to the same paper size at lower resolution. The higher-resolution image will also be able to resolve (and reproduce) more subject detail.

Resolution and file size

Clearly a high-resolution file, containing more pixels, will deliver a larger file size, all other parameters being equal. This means they will take up more disk space and take longer to manipulate and print. This is almost a classic trade-off. You can have more quality, but you'll lose disk space, put more pressure on your computer system, and take longer working. Or you can compromise on quality, but you'll increase your storage capacity and be able to work more quickly.

For professional users the answer is clear cut: it must be quality every time. They can't afford to make compromises, so it's no contest. The rest of us should follow their lead, although economics and practicalities often dictate otherwise. The best advice is probably to strive for the maximum quality and compromise only where or when you need to.

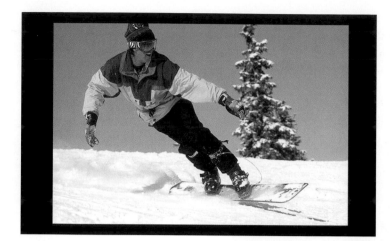

Fig 14 — Displayed at the same pixel resolution, this image takes up most of this 17-inch (43-cm) display when the display resolution is 800 x 600 (left) but is presented considerably smaller at the higher resolution of 1200 x 928 pixels (below).

Fig 15 — Larger monitors also give more space to work. Though the image has been displayed at the same physical size on these three monitors, it virtually fills the 15-inch (38-cm) screen (right) yet offers plenty of additional workspace when displayed on a 21-inch (53-cm) screen.

Monitor resolution (figs 14 & 15)

Only a few years ago, most computers came with small, about 15-inch (38-cm), monitors that offered limited resolution. Now many of us use 17-inch (43-cm) or even 20-inch (51-cm) displays that are capable of commendably high resolutions. Visually, this means that an image viewed on a low-resolution monitor will appear larger than that same image displayed to the same pixel scale on a similarly sized high-resolution monitor. Both are illustrating the image "correctly." Fortunately, zoom controls in the image-editing software let us explore details of an image in close-up no matter what our resolutions.

Printing and changing resolution (fig 16)

We measure printer resolution in terms of the number of dots per inch (dpi). We can treat dpi and ppi as synonymous in many respects. And, at the risk of being drawn into printer semantics, the dpi values may not correspond with the actual printing resolutions offered by the printer. The printing method, such as that of ink-jet printers, will give, on demand, an effective 300dpi resolution, say, even though the printing method delivers dots of a different size.

We can change the resolution of the image using the application's Image Size dialogue (Image⤳ Image Size...) We can change either the physical size or the pixel size and can specify a resolution. Though we'll explore the rationale later, it's usual not to increase the file size above the original size, either by changing the physical size or the resolution. If you do, there's a risk of losing quality, and the gain will only be in file size, not in image detail.

Fig 16—At the Image Size dialogue we can give new pixel dimensions for the image, new physical document sizes, or alter the resolution. With the Constrain Proportions box checked, you need change only the width or the height—the other dimension will be changed accordingly. The Resample Image option gives us the possibility of changing the sampling method if the image size or resolution is altered. We can use different mathematical calculations (which are handled invisibly for us) determined by whether we want to preserve the maximum quality or produce the fastest results.

Vector graphics

The images we produce from scanning original artwork or import from a digital camera are often described as bitmap images on account of their discrete pixel-based nature. But there is another type of graphic that we see increasingly in computer-based graphics programs. These are vector graphics. Any vector graphic features lines, curves, and shapes that are described not by pixels but by mathematical formulas. As such, they can be resized, moved, or otherwise altered without any loss of quality. When we enlarge a vector graphic—or rescale it in any way—there is no deterioration.

Photoshop features vector graphics tools, such as the Shape tool. The vector graphics it produces can be combined with pixel-based imagery. Only when we commit the vector graphic to the image does it become converted to a pixel-based image element.

What's in a name?

Resolution is a precise term often imprecisely used and with multiple interpretations. Here's a summary, starting with taking a photograph and ending at the output print:

- *Lens resolution:* described in terms of line pairs per millimeter (lpm), it is a measure of the fineness of pairs and lines that can be discriminated by the lens.
- *Sensor resolution:* described in terms of total number of pixels (normally megapixels), it is the total number of pixels that contribute to a digital image (usually slightly less than the total number for a CCD sensor).
- *Input resolution (ppi):* describes the fineness of the details scanned in an image or artwork.
- *Output resolution (ppi):* describes the spacing of the pixels in a digital file output from (say) a scanner.
- *Device resolution (dpi):* describes the actual resolution from a printer or other output device (not the maximum dots per inch that can be printed).

FIRST STEPS

FIRST STEPS

In this chapter we will:

- Look at getting the best from our computer system—whether it's the latest all-singing, all-dancing model or something more modest.
- Examine the alternatives when digitizing images.
- Look at how we can output images to the Web, introducing the concept of image optimization.
- Gain an understanding of color management, to ensure that the colors we record in the real world are reproduced accurately when we consign our images to print or the Web.

We all have the urge, when taking on something new, to pay little attention to the instructions (and any advice we may be given) and launch right in. It's often the same with digital photography and in the digital darkroom. We tend to load our software and start manipulating images. Such is the power and efficiency of computer systems: you can be guaranteed a good level of success right away. OK, so skills may need to be nurtured and developed, but simple edits will be forthcoming. So can we now begin to set out on that skill learning curve? No. We need to spend just a little time understanding the capabilities and limitations of our computer system and how we can make that system perform everything demanded from it.

We also need to study the relationship between cameras, images, and computers and what we can do with those images once they have been through our darkroom manipulations. These—and more— we'll discuss in this chapter.

OPTIMIZING PERFORMANCE

When we go about creating a conventional darkroom, it's something of a major undertaking. We may, if we are lucky, have the opportunity to devote a room to our hobby, configuring electrics, plumbing, and lighting to deliver the most efficient workspace. If we don't have a dedicated room, we may need to be more ingenious, devising a darkroom that can easily pack away when the room reverts to its original purpose.

In the digital domain, we rarely encounter the need for such domestic upheaval. The computer at its heart is the same one that sits in the corner of our living room or on the desk in our study. And, truth be told, this is often the appeal. You don't need to turn your house upside down to accommodate it; you simply turn on the computer and you're ready.

But we can carry out a few minor tweaks to make our experience more comfortable and to ensure we spend as much time as possible creating great images. How we interact with the computer becomes much more important when dealing with images than it does with text-based documents.

Creating an optimum environment

To get the best results—from yourself and your computer system—follow these simple guidelines.

Lighting Subdued lighting is best. Avoid lighting that reflects directly on the computer screen. Not only will it make it hard to see the image (obviously) but it can also affect any manipulations you make on screen. The best lighting is bright shade. Desk lamps provide a convenient source of indirect lighting, but ordinary bulbs can affect your ability to judge colors accurately on screen. The reddish hue of tungsten light bulbs will make a neutral screen appear cool and bluish (see fig 1).

Desks A large desk is pretty much essential. It gives you the space to position the monitor (or monitor and computer) and for any peripherals (scanner, printer, and so on), as well as any books or reference material. It is easy to compromise on desk space, but it's a saving that will come back to haunt you time after time as you struggle to juggle everything you need.

BRIGHT

TUNGSTEN

NEUTRAL

COLD

Fig 1—The background lighting to your screen will affect the way you view an image. A bright background will result in the image appearing dimmer than it actually is. A warm background (such as that from tungsten lighting) will give the perception that the image is more blue than it actually is. Conversely, a blue background (such as results from illumination from a blue sky) gives a warmer interpretation. The best is a neutral gray.

Desk space should also include room for food and drink. We're often told to keep these well away from the computer, but I certainly live in a real world where long image-editing sessions are fueled by endless amounts of coffee. It makes sense to accept this and make allowances.

Ergonomics A stand for your monitor is not only a wise precaution in case of coffee spills but it also serves as a means of ensuring that the monitor is in an optimum position. Ideally, the top of the screen should be approximately level with your eyes, or slightly higher if you are blessed with a particularly large monitor screen.

It's worth investing in a good-quality chair. It's not for image or status that executive chairs offer high comfort and a myriad of adjustments. Long stints at the computer can take their toll on our bodies, so it's essential that you have a chair that you can adjust to the best position in relation to your desk and monitor. Look for one that also keeps your back straight, and

don't be afraid to try these out in the store before buying. It's like buying a bed. So many people do this purely because of the design (or even the color of the mattress) even though the most crucial thing is ensuring a long, comfortable night's sleep.

Good sense Digital image manipulation is all-engrossing. It doesn't simply become addictive—it can become obsessive! Consequentially, you really can spend many hours at the screen honing and refining images in the quest for ultimate perfection. But it's a good idea to pay attention to those who have studied the health and safety of office workers who must, as part of their job, spend a long time sitting in front of a computer. They recommend that at least once an hour you take a break from the screen— just a few minutes will do—and take a walk around. Every two hours, take a longer break. This time, spend a few minutes allowing your eyes to rest—preferably by looking at distant objects. This avoids the stress on your eyes caused by constant close focusing.

Good practice

Given their complexity, computers and computer systems are remarkably reliable and can run continuously and trouble-free for years on end. Here are a few tips to make sure your computer runs in its optimum state:

- Computers are increasingly resilient to electrical surges and spikes in the household current, but a rogue event can still reap havoc. It makes good sense to install an electrical-protection system. These are relatively cheap and can be built into multiway adaptors.
- Install, use, and update virus software. Viruses are an increasing problem both in number and ingenuity. Together with the increasing amount of time people spend online, you have another recipe for potential disaster. Most viruses are Windows-based, but Mac users shouldn't be complacent.
- Back up the contents of your computer regularly and document files (which include images) more often. Make sure you also do this before installing major software upgrades, such as new operating systems.
- Ensure your computer will support software upgrades. It is tempting and desirable to install the latest version of your favorite software to take advantage of the current enhancements, but if the new software's recommended specifications exceed those of your computer, performance will be compromised.
- Keep your computer clean. Dust is a real problem, particularly around disk drives. You can clean the computer's interior periodically but only if you know what you're doing. A gentle but precise suction cleaner is best to use, but if you are concerned about potentially causing damage—resist the urge to clean.
- Don't move desktop computers unnecessarily, and avoid jolting either desktop or laptop machines.

Optimizing your computer system

It is ironic that the main sales feature used by computer vendors is increased speed and capacity. Ironic because most of the computers sold require little more computing power than that offered a decade ago. Image manipulation, conversely, requires every scrap of power your computer can muster.

Fortunately, as we have already commented, most computers are ready to run image-manipulation applications right out of the box. But we can make operation even swifter with just a couple of enhancements.

The first is to ensure the computer has as much RAM memory as you can afford. Most computers are well endowed now when it comes to RAM provision for digital images, but you just can't have too much. More RAM means you can work with larger images without recourse to the "virtual-memory" option on the computer's hard drive.

The second enhancement is application specific and involves no additional expense. Instead, we need to work with the Preferences menu of our chosen imaging application, ensuring that we have these configured ideally for our computer. Here, "ideally" does not necessarily imply we are configuring our computer for the most powerful implementation of the software. If we are using a computer that does not have the ultimate in specification, it can be self-defeating to set the highest level of functionality in the preferences. This can put intolerable demands on the computer and will drastically curtail performance. It is always better to set workable limits. You may not have, for example, a huge number of history states recorded (which lets you backtrack a specified number of steps), but this compromise alone will free up a substantial amount of memory for other tasks.

Understanding Preferences

So, configuring the Preferences can improve computer performance. But what changes should we make? Preferences vary according to the application, and even different versions of the same application, but here are some guidelines based on

Photoshop CS. Activating the History log causes further memory attrition, so if you can live without it, do so. Don't know what the History log is? Then you can certainly live without it!

General Preferences dialog History states gobble memory at an alarming rate. The default is 20, and you shouldn't need to increase this. If you find that you can live with fewer, you'll be able to grab back some more memory.

If Export Clipboard is checked, speed and performance can be compromised. Just a little, but every kilobyte or millisecond you can claw back goes toward better performance (see fig 2).

File Handling dialog The Image Previews offered in this window can also slow down your computer, but not to have them can be a hindrance when searching through your directories for images. The best compromise is to select Always Save and tick the Icon box rather than Full Size.

The Ask Before Saving option for TIFF files is a useful reminder if disk space is at a premium. This will prompt you to acknowledge that you are saving a layered file, which is often many times the size of a flattened file (see fig 3).

Display & Cursors dialog It won't improve speed or performance, but the settings here can help work flow. Selecting alternate cursor types helps with precision in selecting and brushwork by replacing the iconic cursors with precise cursors or brush-sized cursors that give a better indication of the actions being undertaken (see fig 4).

Memory & Cache dialog Here you can force the computer into using a determined amount of RAM. This can either ensure a large amount is dedicated to the application, or if this might compromise overall computer performance, you can set a deliberately lower figure.

This computer has 768MB of RAM installed. Of this, around 100MB is consumed by other processes, and here 50 percent of the remainder has been allocated to Photoshop (see fig 5).

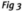

Fig 2

Fig 3

Fig 4

Fig 5

DIGITIZING IMAGES BY SCANNING

Despite the proliferation of digital cameras, most image archives are still based on traditional film originals. But before we can digitally manipulate these hand prints taken from original negatives or the original film stock itself, we must first produce a digital file from them.

Though we have it instilled in us from the earliest days of our photography that we should always work from an original (such as a negative or transparency) in preference to any copy made from it, it is often easier and better to scan a print produced from that original. This largely comes down to the dynamic range of the image—the range of brightness between the lightest and darkest elements.

A print has a dynamic range equivalent to six stops, where a difference of one stop is equivalent to doubling the brightness. For an original that transmits light, such as a transparency, you can expect the range to be closer to twelve stops. It is far more effective to encode an image with a six-stop range than twelve. It is also simpler to arrange a lighting and optical system to scan a print than a transparent original, a situation that is made more pointed given the high density of many contemporary films.

But how do we go about getting the best quality from a scanned image? Though the scanner itself will have a bearing on the ultimate quality delivered, much comes down to the way we configure it. It's probably fair to say that most scanners today are capable of producing very good scans; the more sophisticated (and expensive) are capable of excellent ones. In the following, we haven't discriminated between flatbed scanners or slide scanners, since the process of scanning is the same for both.

Bit depth

The bit depth describes the number of bits used across the red, green, and blue color channels to determine the amount of detail in the data recorded. Good scanners can offer a bit depth of 48, most 36. This equates to 16 and 12 bits per channel, respectively. Quality considerations aside, it is always better to use the highest setting possible, particularly where there is a wide dynamic range.

If you are using a slide scanner, then 48-bit is a must—and it's a good idea to preserve this data in the final digital file: some scanners, by default, may produce a 24-bit file by downsampling the original data. By "downsampling," we mean taking a high-resolution image and creating one of lower resolution by creating a smaller number of pixels, each formed from the average color and lightness values of the original. Though we may decide later to downsize, it makes sense to preserve as much quality as possible at the outset. Initial image manipulations and corrections can often be done on 48-bit files, which can then be saved at 24-bit.

Sharpening and filtration

Many scanner software applications feature a range of filters designed to modify the digital file by making corrections during the scanning process. Sharpening and color correction are often offered. I'd recommend bypassing these. Unless you've good reason to do otherwise, record a straight scan and

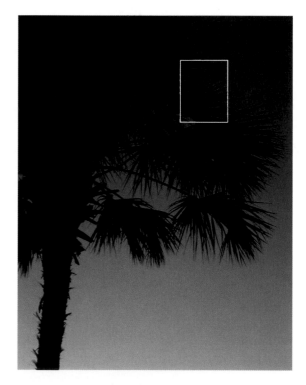

Fig 6—This section of a twilight image is dominated by very dark colors that correspond to dense sections of the original transparency.

then perform any sharpening or color corrections later when you've loaded the image into the image-manipulation application. It's the same argument we use about camera filtration. Do you apply a strong filter to the camera lens (indelibly applying the effect to the image) or apply it later, on the computer? In the latter case, if the effect doesn't "work," you can change it; in the former, you are stuck with it.

It's also quicker to record an unfiltered image than a filtered one, which can lead to quite a bit of time-saving if you have multiple images to scan.

Dust and scratches

One type of filter that you may want to give more consideration to is that which removes dust and scratches. It's inevitable that films and prints attract dust and that the dust will then be scanned along with all the other detail on the image. Even when we take every precaution with our originals, they will still attract dust or show minuscule scratch marks.

Though we could postpone the removal of such marks until we have scanned the image, it's better to remove the problem at the source. Many scanner software applications feature an automatic dust and scratch filter. Unlike software filters (which are rarely satisfactory and can often compromise image sharpness) the scanner software works by shining infrared light across the image to detect blemishes; these can then be mapped and a high-resolution scan performed taking the blemishes into account.

Using multipass scanning (figs 6–8)

Slide scanners often provide, either right out of the box or by means of upgrades to their software drivers, the option to do multipass scanning. In this system, the scanner will scan the original several times, squeezing the best results out of your transparencies. It's a technique that is particularly useful for high-contrast transparencies, such as the color photographer's favorite, Fuji Velvia.

Fig 7—A detail of the scan (marked in white on the main image) shows some noise around the edges of the leaves, but otherwise the noise is well suppressed. This is an example of a multipass scan.

Fig 8—The single-pass scan has handled noise less effectively. There is considerable noise in the blue sky, and the leaves have been lightened (though not obvious on the printed page) thanks to the high noise levels.

The nature of such emulsions means that very little light gets through the denser parts, which means a much lower signal is produced. At low signal levels, noise (electronic noise, not the audible type)—due to random electronic fluctuations—becomes much more significant and can compromise image quality. By repeating the scan, the scanner is able to interpret the best signal information and reduce noise levels. Drawbacks? Just the one. It takes longer to complete a scan.

Multiple image scanning

If you have a large scanner or a number of small originals, you can scan them all together using a single pass of the scanner. Once scanned, you can use the Rectangular Marquee tool to cut each out and paste it into a new document.

After choosing the first image with the Marquee, select Copy, then New File, and then Paste. New files are always created to the dimensions of the image copied to the clipboard. If your images weren't quite square on to the scanner head, you will also need to straighten them—see Rotating skewed scans (below)—accurately.

In Photoshop CS, Adobe has thought about the demands of multiple scanning and has given us Crop and Straighten: apply this to your multiple scan, and each image will be cropped and aligned if skewed, and then save each to a separate file.

Rotating skewed scans—accurately

If you've scanned multiple originals at a single pass or have not been diligent about the alignment of your original, you may find the image is skewed when you display the digital file.

Here's a simple way to rectify this problem that does away with arbitrary rotations or using the Transform····≻Skew command.

1. Select the Measure tool from the toolbar. You won't see this right away since it shares a space with the Eyedropper tool. Click on the Eyedropper tool to reveal the pop-out menu and then select Measure (see fig 9).
2. Use the Measure tool to measure along one side of the skewed image. It's easiest to click on one corner and then the next (see fig 10).
3. Now open Image····≻Rotate Canvas····≻Arbitrary. Rather than having to guess the amount of turn required, you will find the rotational amount has been entered automatically. Accept the amount (see fig 11).
4. Your image is then rendered perfectly straight (see fig 12).

It's a good idea to make every effort to keep your images square on the scanner head to avoid this process. Not only is it time-consuming, but small rotations can cause image softening as pixel color and brightness values are interpolated to produce the new pixel structure in the rectified image.

FILE FORMATS

Image files can, as we are aware from using digital cameras, be stored in different formats. A consumer digital camera, for example, will store images in the widely used JPEG format. It's a convenient and portable format that scores well in being able to store relatively large files in a compressed state. However, this compression involves data loss and we may choose (if the option is available) to store the images in an alternate format such as TIFF. TIFF files, too, can be compressed (though to a more modest amount than JPEG files) but without loss of data.

But for the purist, both of these formats are unsatisfactory in as much as they require the camera to process the raw data received from the imaging chip before storage. There is a degree of averaging and approximation involved in this processing that can compromise ultimate image quality. Raw data will also be free of any image-processing filtering and other in-camera settings (such as white balance). So many cameras (mostly those

Fig 9

Fig 11

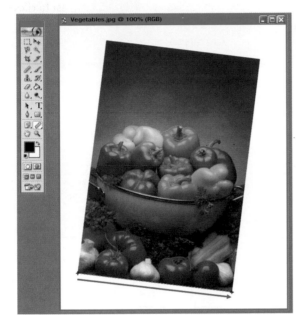

Fig 10

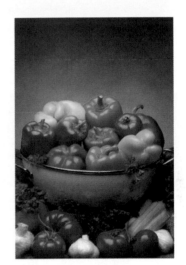

Fig 12

designated for the professional, or "prosumer") also allow the storage of the raw data directly from the CCD. Post processing—necessary to produce an image—can then be handled in Photoshop.

Raw data is not strictly a format, as the nature of the data varies from camera to camera, but the plug-in for Photoshop (designed to read this data) can interpret data from most currently available cameras along with an increasingly large number of superseded models. Adobe also releases periodic updates so that data from new cameras can be used. Some camera manufacturers also release software to handle the data from their models.

Using raw data will certainly deliver the best results, but there are drawbacks. File sizes are large (often much larger than the nominal resolution of the camera), so memory cards fill up fast. And it is usually impossible to replay the data in the camera.

Saving image files

Once we have loaded an image into our application (whether it originally was a TIFF, JPEG, or raw data format) we will need to save it, along with all the editing and manipulation we've carried out on it. Photoshop, like most applications, allows images to be stored in upward of twenty different formats. We could save back into the original JPEG or TIFF format (though not raw), although our exact choice will be dictated by the nature of the image and how we want ultimately to use it.

Take a look at the Save options (you'll see them when you select Save As... when saving an image), and you'll see the full list of options available to you. Many of these are for specialized use or are there for reasons of historical compatibility, but here are the most important and significant formats for everyday use (detailed descriptions of the other formats are given in Photoshop's help

Fig 13—JPEG images feature a compression system that divides the image into blocks of pixels and then averages the image information in the block. This is not obvious when viewing an image in its entirety but becomes very obvious in close-up, especially at high-contrast transitions such as edges.

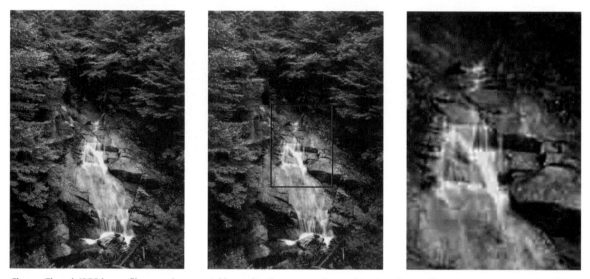

Fig 14—Though JPEG image files can give acceptable results, the compression routines introduce artifacts that are accentuated each time an image is saved. In this image, modest edits were performed and the image saved. This was repeated another four times. Overall, the "after" image appears a little softer than the original. Close up, the JPEG artifacts are very obvious and make the image unacceptable except for the most undemanding of uses, such as a small Web site image.

and the corresponding documentation of other applications). Here's our shortlist and, following, a more detailed analysis of their use:

- JPEG
- JPEG 2000
- TIFF
- Native/Photoshop Format (PSD)
- PDF

JPEG Named after the Joint Photographic Expert Group, this has become the de facto standard for simple image distribution. It is used where constraints (in image file size, or time and bandwidth—such as on the Internet) prevent the use of other formats. Files can be reduced to a fraction (a few percent) of their original size, but the greater the compression the more data is discarded. This has consequential problems when the image is displayed and is compounded when the image is resaved and opened repeatedly. The benefit is that a modest amount of compression does not unduly

compromise image quality and allows a great number of images to be stored in a comparatively small space (such as on a CD or a camera memory card). If your camera delivers JPEG files, select the highest quality option on the camera and save the files in the TIFF format when downloaded and edited. JPEG files will not save image data such as alpha channels or layers (see figs 13 & 14).

JPEG 2000 Created to answer the objections to the use of JPEG format files in exacting applications, JPEG 2000 has the option of "Lossless Compression," which means that files can be compressed without data loss. It also incorporates a Region of Interest (ROI) feature that allows the photographer to specify crucial regions in an image that can have the image quality preserved absolutely and those areas that can be heavily compressed without affecting overall image quality. JPEG 2000 is not universally available on all computers (unlike JPEG), and in Photoshop CS it requires the installation of a (provided) plug-in.

TIFF The Tagged Image File Format is supported by virtually all computers and supported in all painting, image-editing, and even page-layout applications. The way the data is stored differs between Macintosh and Windows computers, and you will need to specify a byte order when saving a file. Photoshop will also preserve image layers (although when an image is opened in another application, the layer structure may be lost and the image opened in flattened form). A lossless compression is possible when saving TIFF files.

Native/Photoshop PSD Each image-editing and painting application features its own native file format, a format that retains the maximum image editing data. Layers, channels, and other information will be retained, along with any other application-specific data. For Photoshop files, this is the PSD format. PSD files can also be opened by most other Adobe applications preserving most of the Photoshop features. Because the functionality of Photoshop has increased over the years, with each new version you may need to select

an alternate format to maximize compatibility if you are exchanging files with someone using an early version.

PDF The Portable Document Format is another Adobe format that allows documents with embedded images and text to be shared across platforms and computers, even if those computers don't contain the necessary fonts normally required to display the text correctly. Files saved in this format are known as Photoshop PDFs, but Photoshop can open PDFs from any source.

File compressions

Most file formats have the option of at least one compression technique to reduce the file size. These can either be Lossy (where data is actually discarded in the compression process) or Lossless (where no data is lost). Here are the key compression types:

- *JPEG:* The lossy technique used in JPEG files but also selectable for use on TIFF and PDF files. Photoshop offers a slider (with a range from 0 to 12) for selecting the image quality required and, consequently, the amount of compression.
- *LZW:* The Lemple-Zif-Welch technique is lossless and is supported by TIFF and PDF files. The amount of compression varies according to the content of the image with the maximum compression offered where images contain large areas of a single color (in skies, for example)
- *ZIP:* Another lossless system for PDF and TIFF files and offering a similar compression strategy as LZW.
- *RLE:* Run Length Encoding. A lossless system limited to some Windows formats.
- *PackBits:* Supported only in ImageReady, PackBits is a lossless RLE scheme used with TIFF image files.

Image size

Though it is not an issue for most images, most applications, including versions of Photoshop prior to CS, could not handle images greater in size than 2GB. In Photoshop CS, larger files can be stored in Large Document Format (PSB), Photoshop Raw, or TIFF formats.

Large Document Format needs to be enabled prior to use, using Photoshop Preferences.

CREATING IMAGES FOR THE WEB

Once, not so long ago, image-manipulation books would all conclude with—or at least feature somewhere—a section on outputting your images. And invariably this would discuss the printing options available. Though printing still comprises a significant element of image outputting—we still enjoy passing prints around to friends and family, for example, or perhaps displaying them on a wall—we are now equally likely to want to use our images as an e-mail attachment or even as part of a Web site.

For some time, image-editing applications have reflected the need to provide output images for printing and for reproduction in books and magazines and on the Web. In Photoshop, as we've already mentioned, we have the companion ImageReady application devoted to Web image creation and Web graphics. But the pervasive nature of the Web has led to many of the tools we might expect an application such as ImageReady to host making the transition to the elder sibling.

There is nothing difficult about creating Web images. Even perceived complex tasks such as the creation of Web image galleries is now reduced to an automated task, requiring us, as creators, only to specify a look and to provide the necessary words and captions. Let's take a look at some of the essential tools for adapting images for a life on the Web. We will then look at how Photoshop's Web Photo Gallery can give you an easy route to a Web presence.

Image optimization (fig 15)

"Bigger is best" is the mantra for digital image resolution. But big images take a long time to transmit over the Web, even when you have fast connections. Although quality must always be paramount when creating original images, when you want to send copies of those images over the Web we need to compromise.

We can convert our images (or, rather, a copy of our images) from a robust format such as TIFF to JPEG. This allows us to compress the image and send it faster. Clearly there will be quality issues, but these are offset by the time (and resource) savings. Many photographers also prefer JPEG for Web images because of the image degradation: it makes it less likely that images will be stolen from the Web site.

Both Photoshop and ImageReady feature optimizing tools (Save For Web in Photoshop, the Optimization palette in ImageReady) that will allow you to set compressions and observe the effects on the image prior to exporting it.

Slicing

Image slicing, once a Web-exclusive tool that can now be found in Photoshop, lets you cut an image into rectangles, each of which can be compressed in different ways. We take a look at this when we explore the selection tools beginning on page 224.

Rollovers and animation (fig 16)

Neither rollovers nor animations are strictly image enhancements, but they do contribute to the experience of visiting a Web site. The tools for both features are strictly Web-based, so they will be found in ImageReady. Here you can set rollovers (which determine how an image will react to a mouse rolling over it, clicking on it, etc.) using the Web Content Palette. Typically (as you'll recall from visits to most Web sites) rollovers are used to highlight parts of an image or button by making it lighter, surrounding it with a glow or (in the case of a button) to look as if it has been pressed.

Animations—created in the Animations palette—let you create simple animations from a sequence of images. Animation creation is really outside the scope of this book, but if you have, say,

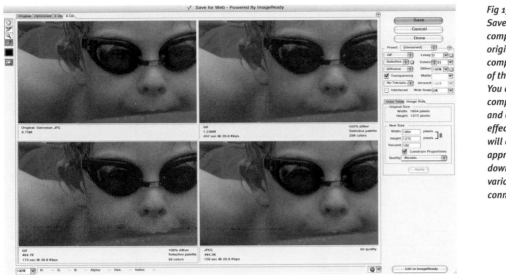

Fig 15—Photoshop's Save For Web compares an original image with compressed copies of the same image. You can vary the compression ratios and observe the effect. Photoshop will even calculate approximate download times for various Internet connection speeds.

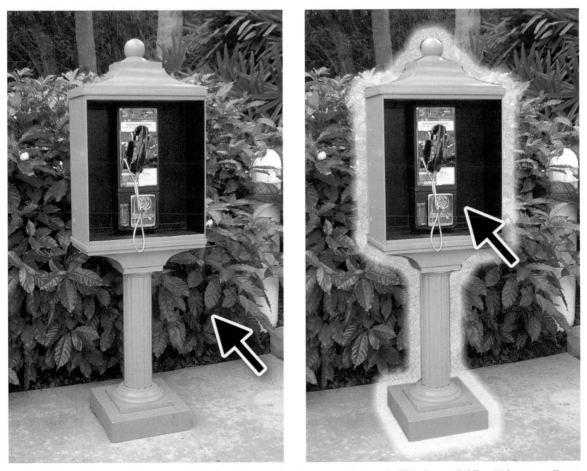

Fig 16—To communicate to visitors to your Web site that parts of an image are active—and will lead to a subsidiary Web page—rollovers are essential. When the mouse rolls over this part of an image, an outer glow (a Layer Styles effect) appears, indicating that clicking with the mouse will initiate some action (usually a link to another page).

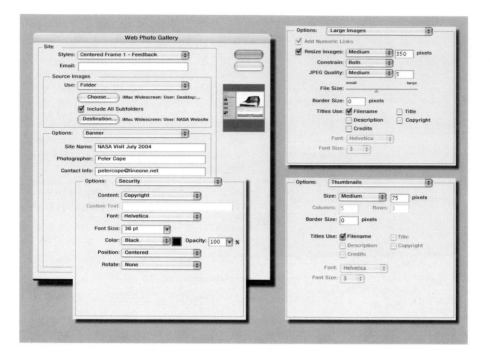

Fig 17—The Web Gallery Dialog seems onerous, but it is pretty straightforward. Enter details of where Photoshop can find your images, where to store them, and how you want the gallery to look. Other information—such as captions and descriptions—is essentially optional, but for visitors to get the best out of the site it should be comprehensive without being verbose.

time-lapse images that you want to run as a short movie, this is a convenient place to assemble the production. You can then export the result either as a GIF file (an image file format that supports animation) or a Flash SWF file, the format used extensively for Web graphics.

Web Photo Gallery (figs 17 & 18)

Photoshop's Web Photo Gallery will create a Web gallery from a selected range of images. These need to be images that have been sorted, edited, and optimized. By "Web photo gallery" we mean a Web site that includes a home page—the front page of a site—that displays thumbnails of all the included images and then numerous gallery pages that can display each of these thumbnails in a larger form. Any visitor to the Web site would arrive at the home page, click on a thumbnail of interest, and get to see the corresponding image, full size.

There is a wide range of styles for the gallery included in Photoshop, and you can find similar facilities in many other applications. You'll even find some third-party designs on the Web that you can import to give your creation a less obvious style.

Creating a gallery is very straightforward. You'll find the option to generate the gallery at File····⟩Automate····⟩Web Photo Gallery. You will need to provide a folder containing the original images (which should be sorted into the order you wish them to display, if this is important) and follow the onscreen instructions. It's important to give some thought to the naming of images, captions, and any other words you want included. Once the automated process begins, all this information is indelibly embedded in your Web gallery and a change will mean recompiling the whole project.

Once that process has been initiated, you have no need (nor any chance) to intervene. The process can take a few minutes, depending on the number of images, but once complete it will have created a folder with JPEG versions of your images, HTML code to describe the page layouts and their text, and the JPEG thumbnails to populate your home page.

So, is that really all there is to it? No, not quite.

We've created the Web site on our own computer. To make it visible to the whole world (or, at least, to the Web-connected world), we need to upload all the files generated to our file space. This is where your Internet Service Provider, or ISP, will come to your aid. You'll need to make contact and see how much file space you have, how much you need, and the preferred method of uploading. Again, this is not difficult or complex.

PRINTING AND COLOR MANAGEMENT

There is no doubt that the Web has given us many opportunities to distribute, share, and show off our images. But printed images are still the way most of us prefer to display our work. And this is where attention to detail will show its mettle. Printed images show—sometimes cruelly—any shortcuts or deficiencies in the image. So it is important not only that we make our images as perfect as possible in the first place but that we also ensure our efforts are accurately reproduced and no additional problems are introduced.

Understanding color management (fig 19)

Newcomers as well as some seasoned users of digital imaging technology are often disappointed that the images they see onscreen rarely look the same when printed. Some of this is unavoidable: the brightness range—or dynamic range—of the screen is greater than that of paper, so a screen image will always look brighter. But part of the difference in appearance also arises because of variations in color interpretation at different stages. A monitor will interpret colors in one way and a printer in another. Differences are small but significant. There are no absolutes in color rendition: in the same way that you can choose how your TV displays colors, contrast, and brightness, so you can with your computer monitor.

If we are to get results that are consistent from screen to print, we need to ensure first that each component is calibrated so that it conforms—as far as is practical, because we will never achieve perfection—to a standard. Then we need to use a color profile. Though color profiles themselves are

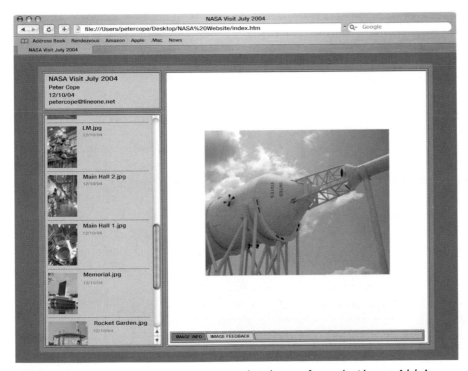

Fig 18—It may not be groundbreaking, but as a convenient showcase for your best images, Adobe's gallery options are just fine. When you become more demanding, you can look at other Web-authoring applications that allow you more freedom and flexibility.

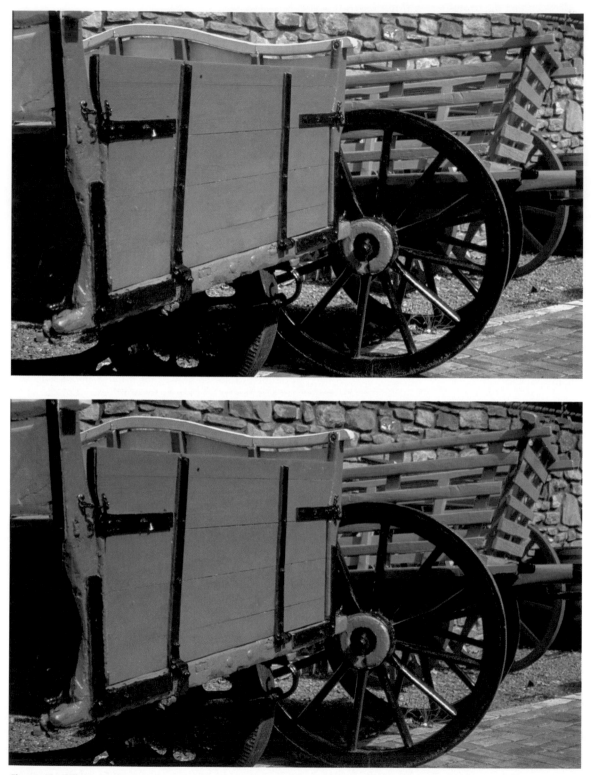

Fig 19—The difference between a screen and a print image can be quite marked. Here, the screen image (which, necessarily, has been simulated here) shows the greater chromatic and brightness range possible. The printed image is similar in terms of color but has a more compressed brightness range and less contrast.

rather complex (and their management often takes entire volumes to explore), we can consider these in their most basic form as a data tag that is passed from an image file through our computer system to ensure color consistency.

Monitor calibration

Calibrating your monitor so that it displays authentic, standard colors is the most important step. This will make it conform to an accepted standard. Brightness, color, and contrast will all be taken into account. We can then use our calibration to define a color profile for the monitor. Our software applications will recognize this and manage colors accordingly.

There are various calibration routines available. Some can be found as part of the computer's operating system, others are supplied (on a disk or online) by the monitor's manufacturer. Photoshop includes Adobe Gamma, while Mac OS X computers feature a calibration routine as part of the Monitors option in the System Preferences.

Printer calibration (figs 20–23)

Printer calibration can be more problematic, because printers use different paper and media as well as different inks. In addition, the place where you correct color and brightness inconsistencies can

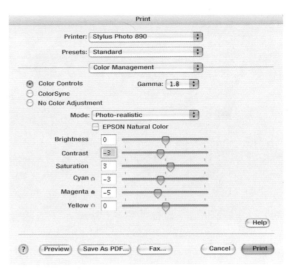

Fig 20—ColorSync ensures color fidelity.

vary depending on the application being used. The example shown here is a simple option provided as part of a printer driver. Adjustments can be made by moving the sliders to compensate for differences between the print and the screen. In this Mac printer driver, we can use Apple's proprietary ColorSync to ensure (with a fair degree of automation) accuracy throughout the image chain (see fig 20).

Calibration becomes more problematic at the printing stage, because we can introduce more variables here than we would normally tolerate.

Fig 21—An image from a well-calibrated system using an Epson Stylus Photo 890 printer and matched media. Colors are vibrant and the definition sharp. Compare it with the two shots overleaf.

Fig 22—Substituting a generic ink cartridge produces a print that is very similar, but the reds are less vibrant. This may be due to the ink or an incompatibility between the ink and the media.

Fig 23—Printing on third-party paper that is described as compatible with the printer produces an acceptable print, but this time the colors in general (and the yellows in particular) are paler.

Calibration is all about defining and implementing standards: a standards regime that applies across the board.

Our printer will require to be fed both inks and paper. Inks (or pigments in the case of some printers) are generally produced by the manufacturer of the printer to a precise chemistry. This ensures—as far as is possible—that when used with the recommended media, the color will be consistent. As many users find, however, this combination of printer and authorized media can be very expensive and many turn to third-party, generic products. Savings can be substantial, but you will notice a quality difference. And, more significantly, there will be color issues that will nullify some part of our hard-won calibration.

Purists will argue that we should never stray from the recommendations of the printer manufacturers. But most of us do not have unlimited budgets and, in the real world, I certainly find it acceptable to reserve the high-quality, high-cost media for my best prints and use cheaper alternatives for day-to-day printing.

Getting it right

Monitor calibration is a step-by-step process that establishes the best (or optimum) characteristics for the monitor.

1. This calibration routine (from the Mac OS X operating system) has normal and "expert" modes. The expert mode adds extra controls, but for most users the basic set of adjustments is sufficient (see fig 24).
2. The first correction is the gamma setting: this adjusts the contrast to match typical screen types. Often, as here, there is a default setting that can be retained (see fig 25).
3. The White Point determines the tint of the screen. Native or D50 are normally the recommended settings. Once you've made these adjustments, you can store the settings as a new profile (see fig 26).

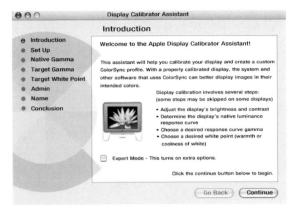

Fig 24—Display Calibrator Assistant takes users through calibration steps.

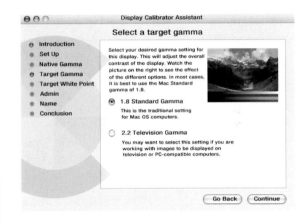

Fig 25—The gamma setting determines overall contrast.

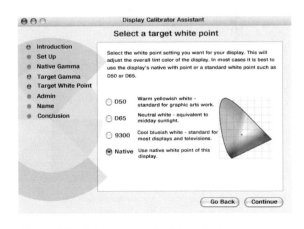

Fig 26—White Point sets any color tint required.

MASTERING IMAGE-MANIPULATION SOFTWARE

In this chapter we will:

- **Get a grounding in the key image-manipulation tools.**
- **Gain an insight to the concepts of masks and channels.**
- **Look at how brushes are used throughout Photoshop to apply effects and color.**
- **Develop an overview of filters, effects, histograms, and levels sufficient for us to begin developing our image-manipulation skills.**

MAKING SELECTIONS

We make selections in image manipulation when, logically enough, we want to apply some manipulation to a select collection of pixels. Those pixels may be those that comprise a contiguous subject, a collection of diverse subjects in the same image, or even those of a specific color. Making a selection and then performing an edit are essential elements in our work flow.

Photoshop, in common with most image-manipulation applications, provides a range of tools for making selections, each of which can take more than one form. Let's take an overview of them.

The Marquee (figs 1–3)

The Marquee is, by virtue of being at pole position on the toolbar, the first. In a photographic sense, it is one of the less useful tools. We rarely need to draw rectangles or ellipses on our images other than when cropping or creating vignettes. And that, in essence, is the point of this tool. It's for defining regular selections and works by clicking on one corner and dragging across to the opposite.

The Circular Marquee works in an identical way. Despite the name, the default shape drawn is an ellipse. To constrain the dimensions and draw a perfect circle, hold down the shift key when dragging. Holding down the alt key (with regular or circular marquees) will change the mode so the respective selection expands from the center.

Two little-used modes of the Marquee tool are the Single Column and Single Row. Again rather

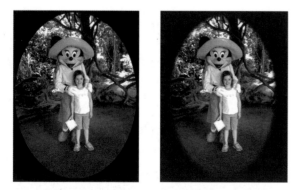 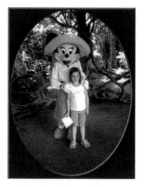

Fig 1—Though the visual effect is powerful (at least among the general, consumer market), the vignette is easy to achieve. Select the Elliptical Marquee, drag a selection across the image, invert the selection, and press delete. By varying the background color and the Feather amount (in the Options bar), different effects are easily achieved.

Fig 2—This is a variation on a theme. By creating a new layer (Layer⋯▸New) and painting in the selection with the same color paint, we can use Layer effects (Layer⋯▸Layer Effects). Here the Bevel and Emboss effect has given the vignette the appearance of having been cut from a thick card.

Fig 3—We can add texture to the Bevel and Embossed image to give a pseudo-leather effect. There is a range of preset textures that can be varied in extent from the subtle to the overt.

Fig 4—With a low Tolerance setting (here, 20) a limited color range is selected.

Fig 5—Increasing the Tolerance to 60 appends a greater number of pixels across a wider color range. But with the Contiguous box selected, all the pixels comprise a single, contiguous selection.

Fig 6—At the same Tolerance (60) but with the Contiguous option deselected, pixels that conform to the tolerance throughout the image are selected.

obviously, these will select a single column or row of pixels. So what use is this? It's very useful for trimming off the edges of selections. Where you have used the Marquee to crop an image, you can use one of these to nibble away at the edges to get the selection precise.

The Magic Wand (figs 4–6)

If you want to identify areas of similar color in an image, the Magic Wand is the tool. It identifies the color of the pixels in the area you click and then appends all those of the same or a similar color to the selection. The amount of similarity in color is defined by a Tolerance setting. A high setting will append a broad range of tones, a lower setting a smaller range. By pressing the shift key when selecting areas, we can add noncontiguous areas of color to the selection. You can also toggle between contiguous and noncontiguous selection by clicking on the button in the Options bar.

Color Range (fig 7)

An evolution of the Magic Wand is the Color Range command. You'll find this in the Select menu. It allows you to select a single color, as with the Magic Wand, but a selection will be made of all parts of the image of a similar color. By sliding the Fuzziness control, you can broaden the color range that is included in the selection.

The Lasso

The Lasso tool is essentially a freehand selection tool. You can describe any shape by drawing on-screen, and once the line is closed—by connecting with the start point—all pixels enclosed will be selected.

The Lasso has two variants. The Magnetic Lasso will automatically follow the edge of a subject. You need only follow the edge approximately for it to snap to the edge precisely. This does need a degree of fine tuning to get right, however—it can sometimes follow a nearby stronger edge or wander aimlessly where contrast is low.

The Polygonal Lasso draws polygonal shapes by clicking where you wish to place a corner. Polygons can have as few as three sides to many hundreds.

You can use the Alt key to switch between modes as you describe a selection: pressing Alt when in polygonal mode switches to normal Lasso,

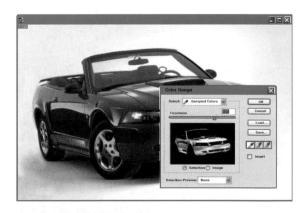

Fig 7—The Color Range dialog makes it simple to see the extent of a selection across the image. The selected area is shown white against a black background. Grays indicate partially selected pixels.

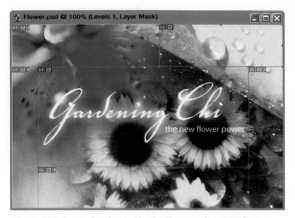

Fig 8—This image has been sliced. When used on a Web page, we can change the compressions used to ensure that details (such as the text) are not compromised, while other areas that are not so crucial can be, cutting down on the downloading time. This example can be found in Photoshop's "samples" folder.

the Magnetic Lasso will change to Polygonal, and with the normal Lasso active, pressing Alt switches to Polygonal.

Slices (fig 8)

Slices are a more specialized selection tool that come into their own if you work extensively with Web imagery. We use the slicing tool to cut up an image into smaller rectangles, each of which can be regarded, for the purposes of Web downloading, as an individual image. We can then apply different compression regimes to each, preserving the quality in important areas and compressing heavily in others. In this way, we can optimize the time and quality of image downloads.

Efficient selection (fig 9)

Of course, when it comes to making a real-world selection, we find that none of these tools—except in exceptional, undemanding circumstances—delivers a perfect selection directly. Selection shapes never precisely conform to the criteria of specific tools, and more importantly, we may need soft edges rather than the abrupt edges delivered by selection boundaries.

Fortunately, all these problems are addressed in Photoshop.

First, we need not confine ourselves to the use of a single selection tool. It's quite possible to use

multiple tools—for example we could use the Magic Wand to select an area of reasonably flat color and then the circular Marquee to "mop up" any unselected pixels within the boundaries (though we will learn that there are better ways to attend to these problems).

We can also use the Boolean buttons on the Options bar. These four buttons allow us to perform operations on the current selection. The default New Selection setting means that each time we use a selection tool, a new selection is begun and all previous selected areas are discarded.

In Add mode, any selection made when this button is pressed (no matter what tools were previously used to make the selection) is added to any existing selection. This is the mode that many people tend to use as a default, bearing in mind that most selections tend to involve multiple selection events.

Subtract mode removes areas from a selection. Drawing a circular marquee inside a larger circular selection will result in the center being deselected, leaving a toroidal selection.

The final Intersect mode generates a new selection using the intersection of a previous selection and a new selection.

Going soft

We don't always want the edge of our selection to be sharply defined. If, for example, we are copying an image element to be pasted into another image, a sharp edge will not look convincing when the action is carried out. The sharpness of the edge should match the sharpness of the image, and we can alter the sharpness of the edge by feathering it. By setting a value of just 1 or 2 on the Feather box on the Options bar, we can get a softer edge that makes selections more effective.

Fig 9—The selection tools' buttons, on the Options bar, are important allies in creating complex selections and represent, from the left, Normal mode, Add to Selection (selected here), Subtract from Selection, and Intersect with Selection.

Note, too, that selections do not have to be solid. You can create a selection where some pixels are 100% selected and some less, giving soft gradients when montages or effects are applied.

BRUSHES: NOT JUST FOR PAINTING (fig 10)

Back when computer-painting and image-manipulation tools were in their infancy, brushes were seen very much as tools for applying color. And little else. Mind you, in those long-gone days, the simple ability to paint over the surface of an image or create your own digital artwork was viewed with the same enthusiasm as contemporary exponents view the subtle offerings from the latest version of Photoshop.

Now, although brushes can be used to apply paint ad hoc, they are actually more pivotal to many of the tools in our arsenal. We can apply masks, sharpen parts of an image, change local saturation, and even clone elements using the same humble brush. Humble, however, is perhaps an inappropriate term. The brushes we have access to today don't just come in a range of sizes but also shapes and textures. And should we find that there is nothing in the default selection that fits our precise needs, we can create a custom brush of our own.

Brush dynamics

No matter where we choose to use brushes, there are certain parameters that apply in all cases. We call these the brush dynamics. Here are the key ones that you will use increasingly as your skills develop.

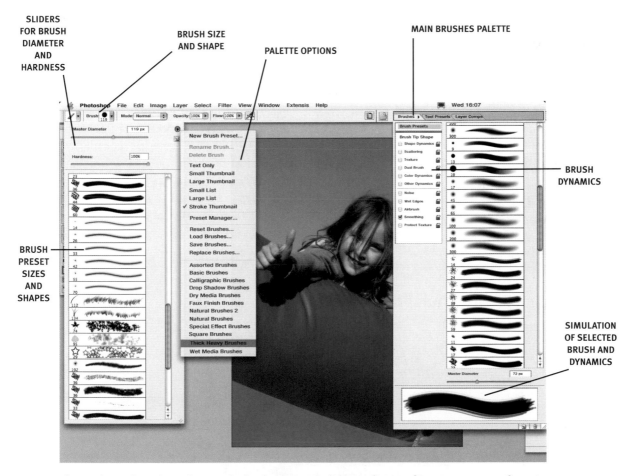

SLIDERS FOR BRUSH DIAMETER AND HARDNESS

BRUSH SIZE AND SHAPE

PALETTE OPTIONS

MAIN BRUSHES PALETTE

BRUSH DYNAMICS

BRUSH PRESET SIZES AND SHAPES

SIMULATION OF SELECTED BRUSH AND DYNAMICS

Fig 10—The Brushes Palette: The extensive brush palette controls let us select any of an enormous range of preset brushes and also to modify any of these for a specific purpose.

Opacity This is a simple one. We can vary the opacity with which we paint (and for simplicity here, we use the term "paint" even if we're using a tool or effect other than paint itself). At a low opacity, we will build up density or apply an effect very slowly. When we use brushes to apply effects such as the traditional darkroom favorites of "dodge" and "burn," the term "opacity" is replaced with "exposure." We will look more closely at dodge and burn (the digital equivalents of the darkroom techniques for lightening and intensifying parts of an image) on pages 250 and 251.

Flow, wet edges, and airbrush Photoshop used to feature an airbrush tool, but given the plethora of other techniques now available, it's been relegated to the dynamics palette. Here, too, you'll find other controls such as flow (which simulated the paint flow from a paint brush, becoming weaker the more you drag the brush) and wet edges. The latter gives the illusion that you've laid down a puddle of wet paint that's more dense at the edges (see fig 11).

Color dynamics The color dynamics comprise a set of controls that can be set to vary the color saturation and brightness of a selected color. This swathe of maple leaves (see fig 12) was produced by selecting the maple-leaf brush and setting a modest amount of "jitter" for the color, saturation, and brightness. Though obviously not photographic, the result can be charming and informal.

The best way to understand the way brushes work in each of their incarnations is to experiment. Use them to overpaint your images in natural textures. Or create new artwork using some of the more esoteric brush types and brush dynamics.

CLONE AND RUBBER STAMP (fig 13)

It has entered the realm of photographic folklore, but still it happens. You take a photograph that is well composed, perfectly exposed, and "right" in every respect—until you examine the image later and find that your subject has a tree (or telephone pole, flagpole, or signpost) appearing to sprout from his or her head. The time when this caused a degree of merriment has long passed, especially when you have friends—or, worse still, clients—anxious to examine the prints.

Fig 11

Fig 12

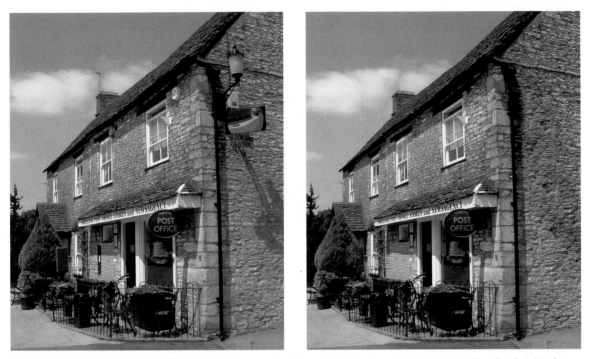

Fig 13—For many users, the Clone tool is used to remove unwanted elements from a scene. Just imagine that otherwise chocolate-box country cottage blighted by a TV aerial or satellite dish, or spoiled by modern street signs and lighting outside. The Clone tool makes it easy to take adjacent parts of an image and obscure any offending subject elements.

But with digital techniques, such problems are no longer of any significance. In fact, it was the ability to hide or (more impressively) move selected parts of the image that grabbed the headlines when the embryonic image-editing software first entered the public domain. Now the simple Clone tool (sometimes called the Rubber Stamp) has blossomed from a simple hide-or-move tool into a set of corrective and creative features.

The reason that cloning drew so much attention in the early days of digital image manipulation was down to the drama of the action. You could (as far as the layperson was concerned) take pixels from one place and magically drop them into a new location. Of course, this was neither magical nor an actual move. In cloning, we merely copy the pixel values from one area and paste them to a new location. Where we perform the apparently impossible—removing an unwanted element from a scene—we are actually painting over it with background image elements and pixels copied from elsewhere in the scene (or even another scene).

HEAL AND PATCH (fig 14)

While the public as a whole was being wooed by the magical abilities of the Clone tools, the more intensive users of early image-manipulation software were finding a more practical use: as a digital cosmetic. In fashion and commercial photography, it was crucial that models in magazines and promotional material looked as near perfect as possible. Cloning would seem an obvious solution to achieve this—and it will work to a degree—but the delicate texture and equally delicate gradations in color required for realism can make the operation very difficult. The slightest variation in texture or color can mar the effect.

With traditional cloning techniques, we could achieve successful results by careful use of the tool in concert with blending modes. For example, if there is a red spot or birthmark to obscure, setting the blending mode to Color before cloning ensures the brightness is unaffected but the color is removed.

Circumventing this process, a newer variation of the Clone tool has arrived. Dubbed the Healing

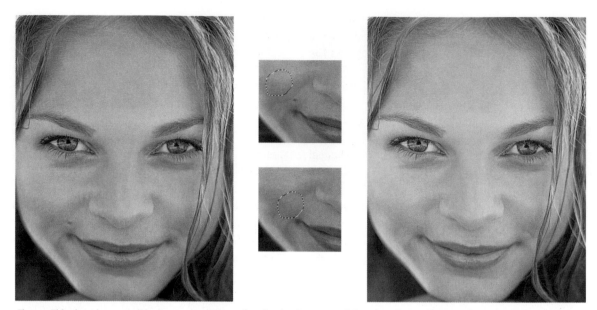

Fig 14 — This charming portrait is, in every respect, perfect. But for the commercial market, the small spot on her right cheek would not be acceptable. With the Patch tool, we can select an area of unblemished skin from nearby and pull it over the spot. Instantly, the spot disappears and her skin is flawless.

Brush in Photoshop, this is essentially a one-stop corrective tool that overcomes the shortcomings of the Clone tool for dealing with, particularly, difficult skin areas. With the Healing Brush we can paint with the texture of one part of the image over another, blending the new and original pixels together.

The Healing Patch tool takes this a step further. Using a Lasso, you can select a region of clear skin, say, and drag this over a blemish. When you drop the patch into position, the pixels are blended but in an intelligent way: dark spots and marks are diminished before being overlaid with the new texture. The result is a very clean repair.

SELECTIONS MASKS AND
CHANNELS (figs 15–17)

Though not selection tools per se, masks can be considered alongside them, because the process of masking protects areas of an image from any effects enacted on the image as a whole. Only unmasked areas will be affected. Unmasked areas are, effectively, selections. Photoshop offers several masking tools, of which Quick Mask is an ideal adjunct to the selection tools. When you create a Quick Mask, you can instantly convert it to a selection and back again.

This is a great way to produce complex selections that can't be produced easily with one of the selection tools. We've just seen that it's possible using the Boolean buttons on the Options bar to contrive selections that can be added to, subtracted from, or even intersect with an existing selection. But sometimes even this is not enough.

Switch to Quick Mask mode, and the original selection becomes a clear area on the image. The nonselected area has (by default, though it can be changed) a translucent red overlay. When we are in this mode, we can see details of the selection that are not visible when the selection is marked by the dashed "marching ants" line. We can, for example, see feathered edges on the selection shown as a transitional area where the opacity of the mask diminishes in concert with the feathering.

More significantly, we can now modify the mask by using the painting tools. We can choose a painting tool and, with black paint selected, add to the mask. Conversely, with white paint selected we can remove areas from the mask. Use intermediate grays for semitransparent masking.

This is a potent way of refining the edge of a selection, particularly those made using the Magic Wand or Magnetic Lasso, which can often have a

slightly ragged edge. Choose a paint brush and paint with black paint and you can add to the mask. Paint with white paint and you subtract areas from the mask (that is, add to the selection).

We'll work more with the Quick Mask on pages 262–64.

Alpha channels

We can also save a selection as an alpha channel mask, more often described simply as an alpha channel. This overcomes one of the problems with selections: they are transient and exist only for as long as the image is open on the desktop. Close the image, and the next time it's reopened you have to start again. Even if you make a new selection in the image without closing, the prior selection is lost.

In some cases—where the selection is modest and easy to re-create—this is of little consequence, but if you have labored long and hard, perhaps using multiple tools and the Quick Mask, then it can be much more frustrating. Alpha channels get us around this problem.

You can save a selection by choosing Select····⟩Save Selection. The Save Selection dialog prompts us to give the selection a name (see fig 18). You can have numerous selections saved for each image.

When you hit Save, you can open the Channels palette and see, appended to the conventional color channels, a new, alpha channel, illustrating your selection. The black area indicates that part of the image outside the selection (see fig 19).

Fig 15—Selecting a boundary, such as the edge around this bird, is normally a role reserved for the Magnetic Lasso. With optimized control settings, you can describe an accurate boundary.

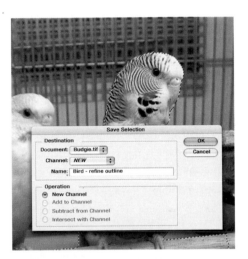

Fig 18

Fig 16—But zoom in and you'll see that some errant pixels have not been included in the selection and that some pixels in the background have also been appended.

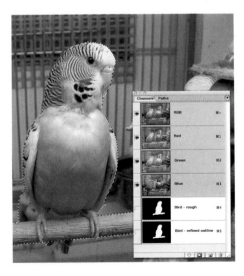

Fig 17—When we switch to Quick Mask mode, we can instantly correct deficiencies by simply painting on more or less masking, using black or white paint respectively.

Fig 19

When you need, at some later time, to reapply the selection, you can regain it by choosing Select····}Load Selection and then choosing the name of the alpha channel.

FILTERS AND EFFECTS

For many users of image-manipulation applications, filters and effects comprise a slightly frivolous aspect. While adjustments of tonality and color could be described as corrective (even if such changes do more than compensate for shortcomings in the original image or scene), filters and effects tend to be perceived in a more jaundiced way because they distort (sometimes very literally) original scenes.

Part of the contempt in which filters and effects are held is due to the way they are often used. Newcomers to digital photography will often slap a filter on to an image and proffer the result as "art." To those with only a modest knowledge of digital imaging, the nature of the effect will be all too obvious and the artwork will be paid scant regard.

So should filters and effect be given short shrift and passed over for something more "serious"? No. Filters and effects can be extremely useful. The skill comes in knowing which ones are important and how they can be used to improve an image.

It's probably worth stressing here that there is a distinction between the filters we will be familiar with from traditional photography (some of which can also be used in the darkroom for creative effects) and those found in image-manipulation applications. Filters here have a much broader interpretation, and you'll find none of the effects you'll be familiar with from traditional filters.

Filter collections

All image editors feature extensive collections of filters and effects. To make navigation simpler, you'll find them grouped into collections. Names for the collections may differ between applications, but in general you'll find the following.

Sharpen filters You can't regain the sharpness and detail lost through camera shake or incorrect focusing, but you can improve the perceived sharpness in an image using these filters. You'll find several options, including Sharpen, Sharpen More, and Sharpen Edges, but the Unsharp Mask is the only tool that we will concern ourselves with. This is a controllable sharpening tool that can be tuned to match the needs of the subject, ensuring that sharpness effects are applied only where required (see fig 20).

See more about sharpening on pages 308–10.

Blur filters The complement of the Unsharp Mask is the Gaussian Blur, a filter that lets us add a controlled amount of sharpness to an image. In this collection, you'll also find options such as Motion Blur (which gives a streaked effect in the direction of implied motion) and Radial Blur (which is ideal for creating zoom and rotational effects) (see fig 21).

See more about blurring on pages 308 and 312.

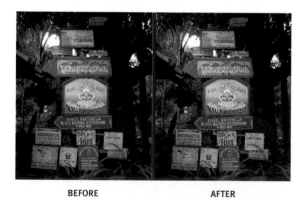

BEFORE AFTER

Fig 20—The Unsharp Mask can't restore detail not recorded due to incorrect focusing or camera shake, but it can give the perception of sharpness in an image that is not critically sharp.

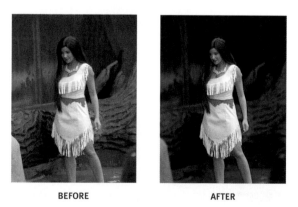

BEFORE AFTER

Fig 21—Blur filters can help enhance depth of field and make good the tendency of some digital cameras to keep too much of a scene in sharp focus (check the background).

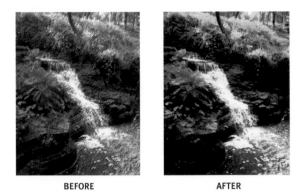

BEFORE AFTER

Fig 22—Artistic filters can be rather obvious in their effect and demand careful selection and application for a convincing effect.

EXTRUDE EMBOSS

Fig 23—The Extrude and Emboss filters (from the Stylize collection) are examples of extreme filters that are quite obvious in use. But even these have their place in your arsenal, particularly when you are creating graphic (rather than photographic) images.

Artistic filters Perhaps it's stating the obvious, but artistic filters give your images the look of being artwork rather than photographic. This may be by re-creating the image in the form of a watercolor or pastel drawing, or the filter may just apply brush strokes. Used with care, they can produce fine-art images. Overuse can lead to clichéd results. Many third parties produce specialized filters (artistic and otherwise) to extend the range. In Photoshop there are additional collections of Brush Stroke filters and Sketch filters (see fig 22). See more about artistic effects on pages 286–89.

Noise filters This eclectic collection of filters is designed to add noise (useful for adding texture to painted areas of color) and remove noise, dust, and scratches.

Distort filters Because digital images are essentially interpretations of numerical sequences, it becomes easy to apply operations to those sequences that can transform the image in a myriad of ways.

Further collections include Render filters (which feature a comprehensive suite of lighting effects), Pixellate (used for enhancing pixelation or creating mosaiclike images), and Stylize (which is another eclectic collection of very extreme effects) (see figs 23–24).

UNDERSTANDING HISTOGRAMS AND LEVELS

The histogram, which is displayed as a palette in Photoshop CS and is also the key feature of the Levels dialog, is great for giving your images a quick health check. The bar graph shows the relative distribution of tones in the image, from black on the

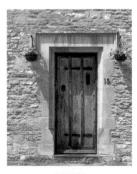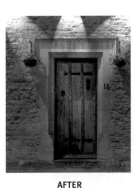

BEFORE AFTER

Fig 24—You can use lighting-effect filters to change the lighting of a scene either subtly or more overtly.

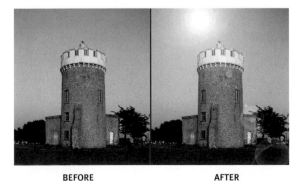

BEFORE AFTER

Fig 25—The Lens Flare filter does what lens manufacturers have striven long and hard to combat: adds lens flare to an image!

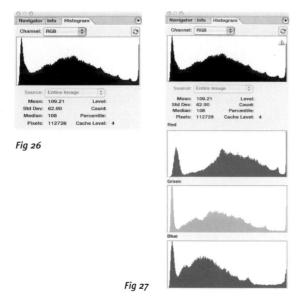

Fig 26

Fig 27

All Channels view. We can now see the red, green, and blue tonal distributions separately (see fig 27).

You can analyze the image in more detail by making a selection from the image using any of the selection tools; the histogram will change to reflect the new selection. We can also easily diagnose problems in the image. If the tonal range is compressed, we will see areas at the extreme ends of the histogram that do not have any levels data and it will take on a compressed appearance.

We can restore full tonality to these images by using the Levels dialog. Select Image····⫸ Adjustments····⫸Levels to open this dialog. The histogram here is identical to that shown in the Histogram palette.

left through 255 levels of brightness to white at the right. In a typical image, we would expect to see a constantly varying graph with entries at every one of the levels, rather like the one shown here (see fig 26).

The Photoshop CS Histogram palette can give us more detailed information, showing us how each color component contributes to the distribution. Select the pull-out menu by clicking on the small arrow at the top right of the palette and then choose

Adjusting the tonal range

Where an image suffers from a compressed tonal range (that is, it does not have a histogram that stretches from black to white), we can make corrections relatively simply.

1. This image is lacking in contrast and has a correspondingly reduced number of levels (see fig 28). There are obvious parts of the histogram at the extremes where there is no data. This indicates there are no true blacks or whites (see fig 29).

2. Move the left and right triangular sliders beneath the histogram until they are under the start and end of the histogram curve respectively (see fig 30).

3. The image's tonality has been restored, with the lightest parts represented in white and

Fig 28

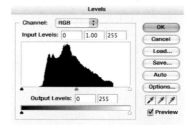

Fig 29

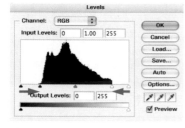

Fig 30

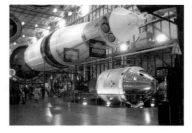

Fig 31

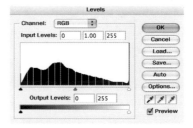

Fig 32

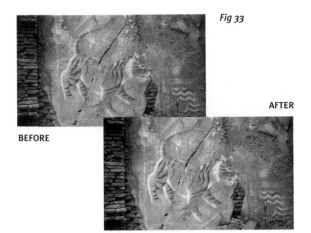

Fig 33

AFTER

BEFORE

Modifying the tonal range for printing

Now that we've extended the image's tonal range, we have a problem. Though the images will display well on screen, when we print them we find that this range is too great for the paper to reproduce.

For this problem, use the sliders on the lower grayscale bar in the palette. Move them in a modest amount (around 10%). This will make the image appear to lack the edge in contrast when viewed on-screen but will result in a better print (see fig 34).

the darkest shadows black (see fig 31). If we now check the histogram again we can see that the levels curve has been "stretched" to fill the whole width (see fig 32). When we stretch the original number of levels (which will be less than 255) to fill the full width of 255, there will inevitably be some levels that don't contain data. These are represented by the white vertical lines visible in this dialog. Discrete empty values like these will have no effect upon the image.

4. The middle slider represents the midtones in the image. This can be slid to the left or the right to alter the tonal balance. This is a subjective adjustment.

High and low key

High-key images are ones in which the lighter tones predominate and where there are few, if any, darker ones. The technique is often used in portraiture. In such cases, we will see a histogram that is missing components at the darker end of the graph but is well populated toward the right. Don't make any corrections to these images, as restoring the tonal range will entirely remove the effect; similarly for low-key images, where dark tones predominate.

Note that overexposed and underexposed images will give similar graphs to high- and low-key images, respectively. Corrections are quite acceptable here.

Using the eyedroppers

We can also make corrections using the eyedropper icons. These additionally allow us to make corrections for the color balance of the image. Click on the left eyedropper and then click on a point in the image that is (or should be) bright white. Do the same with the rightmost eyedropper and the blackest point in the image.

The middle eyedropper is used to identify a neutral tone in the image. This can be of any tonal value, but it is best to use one that is a midtone. Take care when selecting a neutral element; if the color of the target point is not neutral, you'll see the image take on a very severe color cast. If this happens, don't panic! Click on another point (another neutral) and you have another chance. Here a slight magenta cast has been removed along with the improvement to the tonal range (see fig 33).

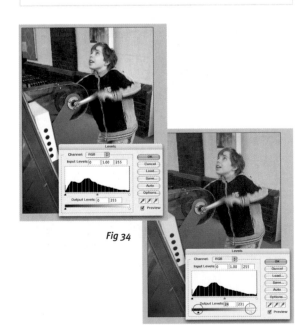

Fig 34

Fig 32—Original Image

Fig 33—Auto Levels

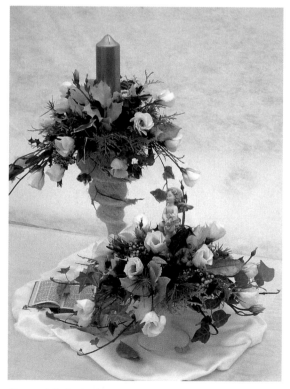

Fig 34—Auto Contrast

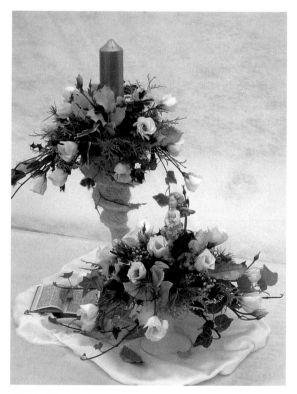

Fig 35—Auto Color

Using Auto Level and Color Correction (figs 32–35)

Listed in the Image▸Adjustments submenu, (which you'll find just below Levels), are the tantalizing trio of Auto Levels, Auto Color, and Auto Contrast. Photographers tend to have a somewhat ambivalent attitude toward these controls. On the one hand, they offer a quick fix that circumvents the adjustment necessary with the Levels palette. On the other hand, their automated nature does not provide sufficient leeway for image interpretation. They apply an absolute correction irrespective of whether you wish a particular parameter to be corrected.

So should we give these a wide berth? No, as they are actually more useful than many photographers realize.

Let's take a look at the Auto Levels function first. This automatically adjusts the black and white points of an image in much the same way that we did when moving the sliders in the Levels palette. The lightest and darkest pixels of each color are adjusted to become black or white. As a matter of course, the extreme ends of the histogram are clipped by 0.5 percent to remove any anomalous bright or dark pixels.

Auto Contrast works in a similar way for contrast. Auto Color adjusts both the color and contrast in an image by identifying shadows, highlights, and midtones. But it also neutralizes any color bias in the midtones.

Do each of these corrections give nominally similar results? Here's an image that has been taken using a digital camera on fully automatic. We've then applied Auto Levels, Auto Contrast, and Auto Color, individually. The results are indeed similar but still subtly different.

Though these controls offer a quick-fix approach, the way in which this fix is enacted can be modified by using the Auto Color Correction Options. You'll find this by clicking on the Options button on the Levels dialog (see fig 36).

To customize these controls for your own use, this is what you need to do:

1. In the Algorithms pane, select an algorithm. Enhance Monochromatic Contrast will clip all the color channels identically, which means there will be no modification of the color balance; changes will be limited to making the shadows deeper and the highlights brighter. Enhance Per Channel Contrast treats each color channel individually. This has the effect of producing a more obvious correction but at the risk of introducing a color cast from channels that are more heavily modified. Find Dark and Light Colors identifies the lightest and darkest pixels and assigns these as the lightest and darkest parts of the image.

2. Click on the Snap Neutral Midtones button to identify automatically and use a neutral midtone for color correction. This is the technique used by Auto Color as default.

3. In Target Colors and Clipping we can specify how much of the extremes of the histogram we want to clip. Nominally, as we've already mentioned, this is 0.5 percent, but you may want to increase this amount if there is a greater amount of anomalous pixel levels at each end.

4. Assign color values to the shadows, highlights, and midtones by clicking on the box for each option in turn and choosing a swatch. If you want to use these new values for all future Auto commands, make sure that you click on the Save as Defaults button.

Now you have auto controls that will do just what you want them to. Okay, so the full manual approach will always give the most precise results (when used correctly), but the modified Auto controls will give much better results than the default settings on the same commands.

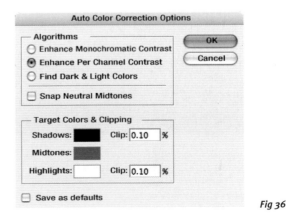

Fig 36

DARKROOM EFFECTS—THE DIGITAL WAY

In this chapter we will:

- Discover how conventional darkroom techniques are implemented digitally.
- Examine the often overlooked but crucial aspects of perspective control.
- Produce a workflow sequence for correcting brightness, color, and contrast deficiencies.
- Take a look at a simple but effective way to boost color in lackluster images without introducing artifacts.

Many people who make the jump from the conventional darkroom expect the digital equivalent to merely replicate the tools and effects that they have used in the past. While it is true that although in our digital world we can achieve very much more, many basic techniques are common. The reason is that these are fundamental to producing good images. Through this chapter we'll take a look at

these and discover how, digitally, we can extend and develop basic techniques.

CROPPING AS A COMPOSITIONAL AND CORRECTIVE TOOL (fig 1)

It's surprising how little we crop images to improve composition. Composition, so the manuals tell us, should be established and refined at the time of taking the photograph. Though we may pay lip service to this principle, the truth is that, due to time constraints or other distractions, most of us don't. And even where we do compose our shots, discrepancies between the viewfinder and recorded image may still require some remedial action.

The Crop tool makes it simple to trim an image into any regular shape we require. And we can base this trimming on our personal preferences or on some simple and—in some cases—rather obvious rules. The caveat in all cases of cropping is that you need to bear in mind the original resolution of an image. If you want to crop away a substantial part of an image, what's left over may be of very low resolution.

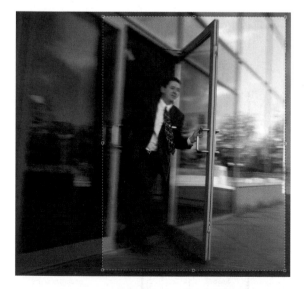

Fig 1—You can use the rectangular Marquee or the Crop tool to select a crop area. The Crop tool has the useful benefit of dimming the cropped area, making it easier to concentrate on the composition of the selection.

Tips for cropping to improve composition (fig 2)

There are some "rules" for composition. Like most rules, obeying them to the letter can lead to rather predictable results. But it is good to be mindful of them nonetheless.

- Crop away any unwanted, distracting elements at the edge of the image.
- Don't let horizontal or vertical lines divide the image into two. It's better to position such lines off-center. This is a corollary of the Rule of Thirds (see page 240).
- It's usually a good idea not to place the principal subject dead center in the image. The best place is to the left or right, above or below the center line. This is a loose interpretation of the Rule of Thirds, a strict, but effective compositional device that originated with Renaissance artists (see box page 240, bottom left).

ORIGINAL

Fig 2—The original shot of some runners includes a lot of wasted space. We can crop this down substantially. As we noted in our rules, it's better to trim down in front of the subjects so that they appear to be entering the scene. This gives more impact than when we crop in front and behind equally.

CROPPED EQUALLY

- The horizon should always be horizontal, verticals should always be vertical. The exception here is that if you are aiming to dramatize or emphasize the height of, for example, a building, you may need to tilt the camera back slightly when shooting so that the building's vertical sides appear to converge.
- Subjects—whether people or vehicles—seen in side view should have more space in front of them than behind: their position should imply they are entering the scene rather than leaving it.
- Be prepared to break any of these rules for deliberate and effective creative purposes. Rules represent good sense in image creation but don't necessarily extend creative thinking.

CROPPED BEHIND RUNNERS

The Golden Section (fig 3)

The question often arises "what is the best format for an image?" Many people will say 10 x 8 inches (25 x 20 cm), mostly because they have become conditioned by the formats of commonly available photographic paper. Artists, architects, and even philosophers over earlier centuries devoted a considerable amount of time to the question and, analyzing the greatest works of antiquity, arrived at the proportions of 1:0.618 as being the most pleasing. This they described as the Golden Section. You can see examples of it in ancient Greek architecture (the Parthenon is built on a sequence of Golden Sections, for example), medieval cathedrals, and in many paintings. Should you use it for all your

Fig 3 – To assess the value of composing to the Golden Section, the photographer here has produced an overlay using a template in the proportion 1:0.618. This was created by making a new image of these proportions and adding a Stroke line (Edit···⫸Stroke). This can be copied and pasted as a layer on to the new image.

photographs? No. Be guided by what looks best for each image. But you'll probably find most landscapes and portraits will have more impact when displayed at this ratio.

Rule of Thirds (figs 4 & 5)
One of the most overused but still very compelling compositional tools is the Rule of Thirds. This rule insists that we divide an image into three roughly equal sections horizontally and three vertically. Where the dividing lines intersect, we place our principal subjects. Other important image elements—the horizon, for example—should follow these dividing lines.

LINEARITY AND PERSPECTIVE
Linearity—keeping vertical lines vertical, horizontal lines horizontal, and each at right angles to the other—is crucial if you want to accurately record real-world scenes. The ability to manipulate them makes it possible to correct errors—or exaggerate them for dramatic effect.

Unless aiming for the deliberately creative or absurd, when photographing a scene we are endeavoring to make an accurate record. But it is all too easy to compromise that accuracy in a way that becomes obvious only when we see the shots in print or on our computer screen—a sea horizon, which should (by definition) be horizontal, tilts drunkenly, and buildings swagger across the landscape in precarious ways that would defy engineering.

Even when we exhibit utmost care there can be issues beyond our control. We may use a level to ensure the camera is mounted accurately square to a horizon, but the vertical sides of buildings will often appear to lean inward toward the top. We call this effect converging verticals, and it is, for conventional optical systems, inevitable.

Tilted horizons and leaning verticals
Of course the simplest way to achieve perfect linearity is to spend a few more seconds at the viewfinder. Many digital cameras' LCD viewing panels feature vertical/horizontal overlays that can

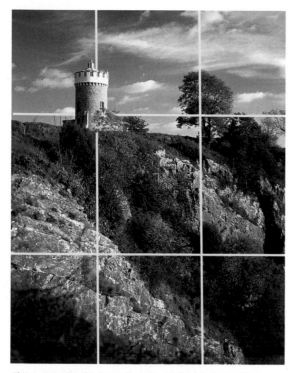

Fig 4—Cropping this image has placed the principal subject at the intersection of two dividing lines.

Fig 5—Even when we crop to a square shape, we can introduce more impact by using the Rule of Thirds. Here, it is the puppy's eyes that define the intersection.

Fig 6

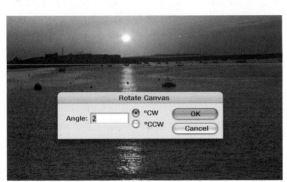

Fig 7

Fig 8

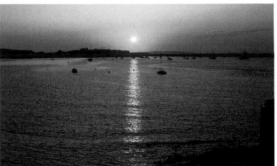

Fig 9

be used to ensure that principal lines in the image are accurately aligned. But when we don't have the luxury of this time—when we are going for those grabbed shots—or when we don't realize our error, there's a simple digital solution to correct the deficiency.

1. Identify the approximate amount of tilt. We can drag a vertical or horizontal guideline from the edge of the image frame to overlay, say, the horizon (you can toggle the visibility of these guides by selecting View····>Show····>Guides) (see fig 6).

2. Select Image····>Rotate Canvas····>Arbitrary. A dialog box opens and prompts us to suggest an amount of rotation. Here, two degrees clockwise should be sufficient (see fig 7).

3. Apply the rotation. Check, using the guideline (which will remain horizontal), that the rotation has been successful. If it has not, repeat with another rotation amount (fractional

degrees are permitted) (see fig 8).

4. Trim the image to remove the additional border areas that have been introduced by rotation (shown in blue on the previous image) (see fig 9).

The Measure tool can also be used to correct tilted images—as we demonsrated with skewed scans on page 213.

Go for color

After you rotate an image, it is enclosed by a new rectangle. It's much easier to trim away the rotational triangles if they're shown in a bright color rather than the normal black (the default background color). Change the background color to blue, as here, and accurate trimming becomes a cinch.

Fig 10

Fig 11

Fig 12

Fig 13

Converging verticals

The problem of converging verticals has plagued photographers since the earliest of days. An in-camera solution is provided by tilt-and-shift lenses. Because converging verticals are due to the tilting of the camera (so that the recording medium is no longer parallel to the subject), which often occurs when you tilt the camera back to include the top of a tall building, these lenses allow the camera to be held squarely to the building. Rather than tilting the camera back, you shift the lens upward— a process that involves shifting the optical path through the lens—to ensure the full height of the building is recorded.

The drawback with these lenses is their high cost. In the large, old-style plate cameras, in which a flexible bellows separated the lens and camera body, shifting the lens relative to the film was simple, but with solid cameras, such as those today, achieving this same effect requires a dedicated and expensive lens.

For those who could not afford this specialized lens, the darkroom provided an alternative correction facility. Enlargers can be equipped with tilting baseboards (on which the photographic paper is placed) that can counteract image convergence. Only limited corrections could be made in this way, however, as there was a risk that— unless a very small aperture was used on the enlarger lens—the image would become progressively out of focus the more the baseboard was tilted.

The digital solution to convergence is altogether different and uses a variation of the simple Crop tool. The Crop in Perspective option lets us trim the image and correct the distortion. Here's how:

1. Bear in mind that the correction removes some of the surroundings of the scene. If you are aware of this when shooting the image, leave

larger margins than you might otherwise (see fig 10).

2. Select the Crop tool and ensure the Perspective button is checked. Drag the Crop selection over as much of the image that you can. If you plan to crop the image slightly at this stage you can make an appropriately smaller selection now (see fig 11).

3. Click on the top corner points of the Crop selection and move them inward so that the sides of the Crop selection converge to the same effective point as the verticals in the image (see fig 12).

4. Hit the Okay button to apply the crop. You'll notice that the areas outside the crop are discarded but also that the shape of the selection—which was trapezoidal—has been corrected to rectangular. In this way our converging verticals have also become "true" (see fig 13).

Fig 14

Using the grid (fig 14)
Gauging the degree of convergence is difficult to do objectively, but you can overlay a grid on your image that makes identification simpler. In Photoshop, select View····⟩Show····⟩Grid. This grid appears only on-screen; it will not print or be saved with your image. You can change the look and number of lines comprising the grid in Photoshop Preferences.

Working in two dimensions
The Crop in Perspective tool gives you free range to correct perspective problems in two dimensions. You can rectify a rectangular image element no matter what shape it adopts in your images.

1. We can apply this to three-dimensional objects too. Let's use Crop in Perspective to get a square-on view of this desk (see fig 15).

2. Apply the Crop tool over the area of the desk and, as before, drag the corners so that the sides of the cropped area correspond to the vertical and horizontal dimensions of the room (see fig 16).

3. Perform the Crop. We get a square-on view. Notice that the image has become slightly softened by the process. In "stretching" the image to the new dimensions, there has been a degree of pixel interpolation. To correct this, you could apply a modest amount of Unsharp Masking (see pages 309–10). Don't sharpen too much, or you will generate digital artifacts (see fig 17).

Fig 15

Fig 16

Fig 17

In the following example, we can see how the Crop in Perspective feature differs in its results from a transformed selection:

1. This is the image we want to correct. We want to crop in on the horse shop sign. The photographer originally took the photograph at an oblique angle because she realized that converging verticals would compromise an upright shot (see fig 18).
2. The simple way to trim the image would be to draw a rectangular selection around the sign and then rotate the selection using the Transform command. The result looks okay, but the sign is still at an oblique angle (see fig 19).
3. Using Crop in Perspective, we can correct all these angles and get a square-on result. Although the sign is still obviously up high, we get none of the foreshortening or distortion produced by a simple trim (see fig 20).

It's important to make a crop in a single move. If you realize after cropping that you have either over- or underestimated the corrections, use the step backward facility to undo your error and repeat the trimming again. Repeated use of perspective cropping causes too much pixel interpolation leading to a lowering of image quality.

MANIPULATING BRIGHTNESS, COLOR, AND CONTRAST

Brightness, contrast, and color modifications were a staple of darkroom manipulation. By mainly using filters and by making exposure compensations (either generally or selectively), we could improve color rendition, correct uneven exposure, and remove color casts. Digitally, we can do all this and more.

The simple way to make corrections to the brightness, contrast, and color of an image is to use the basic commands such as Hue/Saturation and Brightness/Contrast. Each can make a great improvement to deficient images. But it is better to see each of these corrective measures in the context of overall image improvement.

Establishing a work flow

When you have a potent tool set at your disposal, as Photoshop and other image-manipulation programs offer, getting the right tool for the job can require a little thought. It can also be tempting to make minor, ad hoc adjustments using one or more tools. To make our work efficient and to ensure that we don't compromise image quality (which is always a risk when working haphazardly with multiple controls), we need to establish a logical work flow. This will also ensure that we don't apply techniques or make adjustments at one point that conflict with others

Fig 18

Fig 19

Fig 20

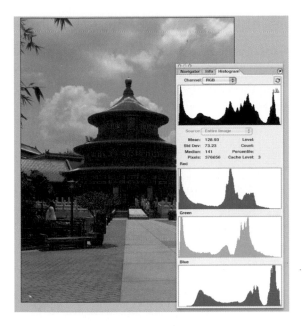

Fig 21

Fig 22

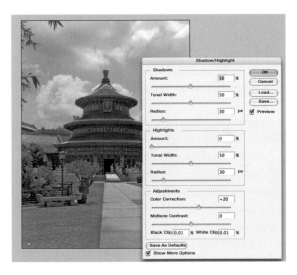

Fig 23

we may make at a later stage. As a step-by-step process, here are the key stages.

1. Any analysis will begin with the histogram (see pages 236–38). Here we can study the tonal range of the image in each of the color channels for any obvious flaws that need attention. Here, this image shows (both visually and by studying the histogram) a blue color bias and compressed tones (see fig 21).

2. We need to remove color casts and adjust the color saturation, if necessary. This is where things could get tricky, as there are more than ten different features in the current Photoshop release concerned with color modification. They are detailed in the side panel (see side panel on page 246). Some, like the Auto Color command, will take care of much of the guesswork but at the cost of an ultimately nonrigorous correction. Others, such as Channel Mixer and Curves, offer a baffling amount of control. It's a good idea to stick with a core set: Hue/Saturation, Replace Color, and Color Balance, say, to begin with, as these will serve the majority of needs. Explore the other options as opportunities arise (see fig 22).

3. Adjust tonal range using the Levels command. Adjust the input sliders (those immediately beneath the histogram) as we discussed earlier. The balance between shadow and highlights can be adjusted using the Shadow/Highlight command (Photoshop CS). The Shadow/Highlight command here has lifted some of the darker shadows and darkened some of the overbright areas (see fig 23).

Fig 24

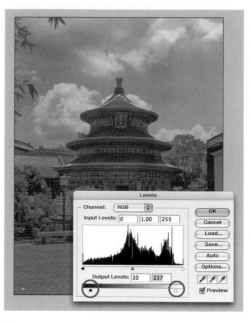

Fig 25

4. Sharpen the image. It's often said that sharpening should be the final stage of any process, but in this case we need to apply any necessary sharpening prior to making any adjustments to the levels. This is because the sharpening process can often produce small (and acceptable) image artifacts that could fall outside the printing or display gamuts (the range of colors that can be successfully printed or displayed) (see fig 24).

5. Levels adjustments. To prepare our corrected image for print, we now need to adjust the output sliders (the lower set) to reduce the levels of the extreme highlights and shadows so that they can be accurately printed (see fig 25).

There will, of course, be exceptions to this work flow. For example, when we look later at some remedial corrective work on old photographs, we'll see that it would be difficult—where the print is faded—to make accurate color judgments without first adjusting the tonal range. So in these cases we would reverse steps 2 and 3.

Tools for adjusting color

Photoshop offers numerous tools for adjusting color—some we've already explored. Here's a summary. Each has their uses and benefits, and they are ranked here in alphabetical order:

- *Auto Color* A quick-fix tool that corrects overall color balance in an image. You can fine-tune the method employed to correct color balance—see page 260.
- *Channel Mixer* Used to modify the individual color channels and make unique color changes.
- *Color Balance* Allows the mixture of colors in an image to be changed manually using complementary color pairs.
- *Curves* Enables the input-output correlations of color and brightness to be varied by reshaping the curves graph.
- *Hue/Saturation* Permits the hue, saturation, and brightness (lightness) of the image to be adjusted manually. A drop-down menu allows selective corrections to individual colors.

- *Levels* Allows the pixel distribution to be adjusted for individual color channels and for color biases to be corrected.
- *Match Color* A feature introduced in Photoshop CS that matches the color balance of one image with another, or one layer with another. Color ranges and luminance (brightness) are also adjusted. A great way of equalizing color balances between image elements used in montages.
- *Photo Filter* Simulates the effect of solid-color photographic filters, mostly equivalent to the Kodak Wratten series; ideal for correcting color balance problems with daylight/indoor film stock
- *Replace Color* Replaces user-specified colors across an image or selection with new color values.
- *Selective Color* Allows the amount of process colors in an image to be varied.
- *Variations* The simple visual version of Color Balance that enables changes to be made by comparing thumbnails.

Channel Mixer (figs 26–32)

The Channel Mixer command can appear somewhat abstruse in the way it affects images and severe in its application. But its operation is logical if you appreciate the result of moving the sliders. You can drag any source channel's slider to the left to decrease its contribution to the output channel or to the right to increase it, and you can view the results live on the image.

The Constant slider will add a black or white channel to the mix (moving to the left, black, to the right, white). This will be interpreted as an overall color cast of the color of the input channel.

Corrective measures will normally only involve small adjustments to the settings (10 percent or less), but larger corrections can produce wilder color

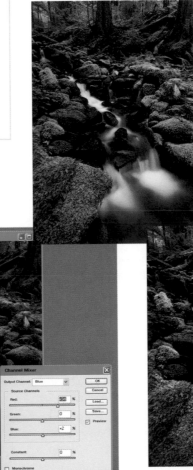

Fig 28– Result of applying large channel adjustments.

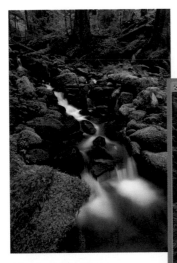

Fig 26—Original image.

Fig 27– Channel Mixer dialog.

Fig 29—Result of a more subtle adjustment.

Fig 30—Color image prior to conversion to grayscale using Channel Mixer.

Fig 31—Grayscale image produced with Channel Mixer, optimized to render blues and reds dark.

Fig 32—Simple grayscale image produced by desaturating the original image.

changes, as here, that are hard to duplicate using other tools. Perhaps most significantly, or perhaps ironically, the Channel Mixer comes into its own for producing grayscale—black and white—images. You can alter the contribution of channels to the grayscale image to produce results that emulate the sensitivity of specialized monochrome films, such as orthochromatics and even infrared.

UNSHARP COLORATION

Boosting the color saturation in an image is something that has long been exploited. The travel industry, particularly, has been an exponent of the technique, realizing that it could achieve greater interest in its vacation destinations if it depicted them in supersaturated color. The perfect blue skies and vibrant landscape colors prove too tempting to consumers burdened by predominantly overcast weather.

This is a technique we can all use to add interest to shots that are a little washed out. It would also seem a simple process: open the Hue/Saturation dialog and nudge the Saturation slider until we get the desired result. But, sadly, the results produced in this way rarely prove satisfactory, with colored artifacts generated and an unpleasant graininess affecting image quality.

Much of this is due to the small-scale structure of the image. Look very closely at the pixels in an image and you'll see that, even in broad areas of constant color, there is a degree of variation. And there will be anomalous pixels of colors totally at odds with the main. Boost color saturation and these colors become rather more prominent.

This problem is exacerbated if we subsequently attempt to sharpen the image. Anomalous color gets treated by the sharpening routines as image structure, with the net result of enhancing (in a negative sense) these artifacts. Add to this the probability that there will be compression artifacts (which further enhance color variation), and you can see that we need to find an alternative solution if we are going to enhance successfully the color in digital images.

A better alternative is to use unsharp coloration. It's not a technique you'll find in most imaging dictionaries, but it is one I've found works particularly well over a range of subjects and colors. Here's how we can apply it to shaded scene to give more memorable results.

1. Our starting point—a fine array of tulips—should be spectacular, but shaded light in the tent gives rather dull results and colors that are less saturated than we would expect in full sunlight (see fig 33).
2. Begin by creating a copy of the image in a new layer by selecting Layer⌁Duplicate Layer. We will

be increasing the saturation in this layer copy of the image (see fig 34).

3. Increase the saturation of this layer using the Hue/Saturation dialog. You can increase this by between 10 and 20 percent. Don't worry if results look rather garish, but don't increase the saturation so much that colored artifacts appear (see fig 35).

4. Apply the Gaussian Blur filter to the layer. Aim to blur the image so that the form of the subjects is still visible but the details are obliterated. This will vary according to the resolution of the image, but start with a setting of between five and ten pixels (see fig 36).

5. Using the pull-down menu on the Layers palette, change the blend mode of the layer from Normal

to Color. Now only the saturated color of the layer is blended with the background. We have the saturation of the layer and the sharpness of the original (see fig 37).

6. Adjust the opacity slider on the palette until you have a saturation level that is appropriate. Compare the saturated image with the original to ensure you don't end up with an oversaturated result (see fig 38).

Why does this work? The blurring masks all the color variation, giving smoother gradations. Although blurred, the new color layer appears to our eye as a close match to the original. Only under the closest inspection do we see color extending beyond the boundaries.

Fig 33

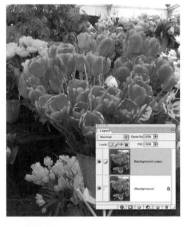

Fig 34

Fig 35

Fig 36

Fig 37

Fig 38

Going further

Sometimes you can boost the color in your image using unsharp coloration in this way and still not achieve a satisfactory result. Remember you are only boosting the color that already exists in the image—if that color is insufficient or is not appropriate, boosting it could make matters worse.

Skies often prove to be the most contentious of subjects. Boosting a pale sky will always give more saturated results, but if the original tone is tainted— say, by high cloud or even poor color rendition in the camera—you may need to take more drastic steps:

- You could select the sky (using the Magic Wand) and then the Hue slider (from the Hue/Saturation dialog) to alter the color to a more appropriate one.
- Replace the sky using a color gradient. Select two colors, a deep blue for the sky and a slightly lighter one, making the deep blue the foreground color. Then draw a gradient down the selected sky area using the Gradient tool.
- Replace the sky using a skyscape from a different image. We do this for an image shown on page 105.

DODGING AND BURNING

If there is a darkroom technique that could be described as a "classic," then it must be dodging and burning. It has long been used by photographers to overcome the limited dynamic range in printing media. When faced with an original image (usually a negative) with a high dynamic range between highlight and shadow areas, it would prove impossible to print the image and retain subject detail in both. But by increasing exposure of the printing paper in certain areas, those parts of the image could be darkened (burning, or burning in). And by reducing exposure of the paper (often by shading it with the hand or impromptu screening tools), areas of the subject could be lightened—or dodged.

Photographers needed to use their skill, experience, and judgment to get good results, because they were working blind—not in total darkness but with only a latent image on the paper. In the digital world, we are more fortunate—we can see the results of our actions immediately and, unlike our predecessors, can backtrack if our actions have been misplaced or are too severe.

Although we can reduce dynamic range using these tools, it's still important to get the exposure right when taking the photograph. Highlights, for example, if washed out, cannot have any of the original detail restored by any amount of burning.

Fig 39

Fig 40

There is simply no detail there to burn in.

The Dodge and Burn tools operate in three modes: Highlights, Shadows, and Midtones. You can select the relevant mode from the Options bar. In the default setting, the Dodge tool will operate in the Highlights mode and burn in the shadows.

1. Dodging and burning is all about making a good thing better. Here's a great portrait taken against the light but with some foreground reflection. The nature of the reflection means that there are some modest but essentially unflattering shadows. We'll begin by lifting there. Select the Dodge tool and set the exposure to no more than 10 percent. Anything more than this will produce very abrupt corrections (see fig 39).

2. Let's turn our attention now to the midtones. Use the selector on the Options bar to select Midtones and continue to work on the shadows in the cheek and the area under the eyes. Again, use a low exposure and multiple strokes to build lightness in the shadow areas (see fig 40).

3. Finally the highlights. The neck is disproportionately dark, as are the areas around the nose. Lightening these slightly makes for a more even result. Better? I think so (see fig 41).

The Sponge tool

A spiritual cousin to the Dodge and Burn tools (though not one that featured in the conventional darkroom worker's arsenal) is the Sponge tool, sometimes called, more descriptively, the Saturation Sponge.

This has the same brush attributes as the Dodge and Burn tools but can be set to Saturate or Desaturate, and the rate at which it works is set using the Flow option.

If you are working in Grayscale mode, the Saturation Sponge increases or decreases the image contrast when applied.

Fig 41

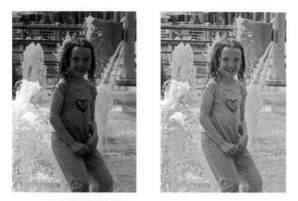

Fig 42—The Highlight/Shadow command helps even the apparent exposure in scenes with a high dynamic range. Here the child, lit from behind, has been lightened without compromising the color or contrast.

Highlight/Shadow command (fig 42)

Auto-correction tools were provided with a new fix not unlike dodging and burning with the release of Photoshop 8. It is called the Highlight/Shadow command. This automatically evens the exposure across an image, lightening shadow areas and suppressing overbright highlights. Recognizing that automatic corrections are not always appropriate, there is also a dialog that accompanies the facility to vary the parameters of the command.

BLACK AND WHITE

Black and white photographs differ from color in that it is form and texture, rather than color, that dominate the images. Many photographers consider black and white a more significant medium because of this: it needs us to view a scene more subjectively and see through what we might call the chromatic veneer. It is rather contentious to say—as many exponents of black-and-white photography do—that black-and-white images are somehow more powerful and more significant (their words, not mine). I would rather we put down the difference to one of preference. Many people, myself included, like taking color images but also enjoy conceiving black-and-white ones, too.

Whatever the reasons or philosophy, how do we get black-and-white images from the color ones produced by digital cameras? There is a surprising range of options. Which you use depends on the amount of control you need over the final result and the time you wish to spend on the conversion process. Here are our options ranked from fastest to slowest, in terms of speed of action. As we will see, as we convert this image of fishing boats to black and white, speed is inversely proportional to quality (see fig 43).

Desaturate (fig 44)

The Desaturate command is instantaneous in its effect. It merely strips away the color information in the image, leaving only the brightness information. The result is certainly black and white, and the image shows a full contrast range. Yet the image is unremarkable. We might equate this to machine-printed black-and-white imagery: technically correct but without emotion.

Grayscale and Lab Color (fig 45)

Change the Image Mode (Image⋯⟩Mode) to Grayscale, and you'll get a similar result as with desaturate. The Lab Color mode will split the image into four channels, but rather than the conventional (if you use the default RGB mode) red, green, and blue, you'll get Lightness, a, and b. Click on the Lightness channel (in the Channels palette), and you'll get a black-and-white image. Again, similar to Desaturate but with slightly less-flat results.

Channels (figs 46–48)

If we don't change mode and remain in RGB, we can split the image into the channels that correspond to viewing the scene in red, green, and blue light. In red light, red objects look bright and blue and green dark; likewise for the other channels. We can then split the image into the constituent channels. The red channel is ideal for dark skies (in the same way that we would use a red filter in black-and-white photography), but the blue channel gives very pale skies. Noise—and artifacts due to image compression—is often very significant in the blue channel.

Fig 43—Original color image.

Fig 44—Desaturated original.

Fig 45—Grayscale image.

Fig 46—Red channel.

Fig 47—Green channel.

Fig 48—Blue channel

Channel mixing (fig 49)

In splitting the image into channels, we are getting results that could be described as more "interesting." But, when you inspect the individual images separately, you'll probably conclude that the best black-and-white image might contain the sky of the red channel image, vegetation of the blue channel, and red objects viewed in the green channel. It's possible, you probably won't be surprised to hear, to combine elements of each channel using the Channel Mixer dialog

Fig 49—Lightness channel.

Fig 50

Fig 51

Fig 52

Fig 53

(Image······▷Adjustments······▷Channel Mixer).

Click on the Monochrome box and adjust the sliders to mix the channels. There's no right or wrong with regard to the settings, but you'll get best results when the arithmetic total of the channel values adds up to around 100. Here we've set Red to 65, Green to 50, and Blue to -20.

THE HISTORY BRUSH—
AND THE HISTORY PALETTE

The History Brush is a difficult tool to categorize. It's one of the unsung heroes of digital image manipulation. It made its appearance with little fanfare in one of the later incarnations of Photoshop, but ask many users—even those who use Photoshop daily—what precisely it does and how it works, and you'll get a look of puzzlement. Which is something of a shame, since this is a very powerful tool indeed.

It is best explained by describing its companion, the History palette. Every action you perform in Photoshop is recorded. And each action is also displayed, sequentially, in the History palette. Not only does this give us a convenient overview of the stages of your manipulation but it also allows us to backtrack. If we arrive at an image that doesn't look entirely as we intended, we can click on a previous history state and return the image to that state. You can think of it as a shortcut through multiple levels of Undo. The number of History (or Undo) steps is finite. You can specify the number

in the Preferences, but specifying too many can compromise computer performance—each state needs to be stored and takes up a lot of your computer's resources.

The History Brush lets us backtrack in the same way—but selectively. Set the History Brush to the required state by clicking on the small icon next to the appropriate history state. Now, when we paint with the Brush (having selected any paintbrush type or opacity) we paint with pixels from the image at the corresponding historical state. Here we use the History Brush to modify an image's depth of field. This is something we would normally do using a combination of selection and blurring tools (see chapter 19), but is something we can achieve simply using the History Brush. In this example, we can emulate the look of a Soft Spot filter.

1. This image, taken with a compact digital camera, shows a commendable depth of field. As such, it does not give sufficient emphasis to the subject (see fig 50).
2. Begin by blurring the entire image using the Gaussian Blur filter. This is a useful blurring tool, because we can precisely control the amount of blur applied (see fig 51).
3. We now need to make the subject sharp. We could have used a mask or selection to protect the area,

but by using the History Brush we can get a more gradual build-up of sharpness. Click on the History state of the image prior to blurring (see fig 52).

4. The finished image has the sharpness of the original restored. Those regions near the subject have been partially sharpened, giving a soft-focus result (see fig 53).

Don't change the scale

There is a caveat to the History Brush. It won't work if, at any point between the current state and that which you want to paint from, you've changed the scale of the image. The History Brush, though powerful in effect, only actually copies pixel values from the historical state to the corresponding pixels of the new state. Change the scale, and this correlation becomes impossible.

The Art History Brush (figs 54–56)

Photoshop, ostensibly a tool for the photographer, also panders to the needs of artists who might want to use images as the basis for their work. Photographers, in general, shy away from some of these overtly artistic effects because of their dubious photographic merit—too much of the original image can be lost. The Art History Brush is one, but since it offers considerable control, it is worthy of mention in a darkroom title. In fact, results can emulate those of Polaroid-based media.

Unlike the History Brush, you don't need to specify a particular history state before painting, but you do need to ensure that you are working with an eight-bit image. You can set this in the Image····▸Mode submenu.

Now just paint away, selecting a painting type from the Options bar. There are no rules about how to paint, but the best results seem to come by using a broad soft brush first and then painting over using a finer brush, which restores some of the final detail.

Fig 54
Choose a simple image as your original, as these tend to work better than more detailed ones. Landscapes and portraits are more effective than city or industrial scenes.

Fig 55
Applying a broad brush gives a rather bland, mottled result, but it is a good basis for further work.

Fig 56
By painting over the initial broad-brushed canvas, we can restore some of the finer detail, but it still gives a great impressionist look.

IMPROVING SELECTION TECHNIQUES

In this chapter we will:

- Look more closely at the practical use of selection tools.
- Study ways of making selections more precise or more effective.
- Examine masks and extraction tools more closely.
- Gain an understanding of ways to modify and transform selections.
- Explore practical examples of effective selections.

"Simple but effective" is a phrase often used to describe the selection tools. Often, however, the practical emphasis is on the "simple." That's the line we've taken so far, but to really understand and exploit these tools, we need to discover more about how they work. We also need to understand the circumstances in which they don't deliver the results we might expect.

EXPLORING THE SELECTION TOOLS
The Magnetic Lasso

Though the Magnetic Lasso was something of a late entrant to the selection tool arsenal (in Photoshop, if not other applications), it has rapidly become the default option for many users. It's easy to see why: it makes selections simple—just drag around the edge of your intended selection and the job's done. And you don't even have to hold a mouse button down. You simply draw around the perimeter.

The mechanics of the tool are such that you need to define only a starting point, and then you can release the mouse button. As you describe the perimeter of the selection, anchor points—fixed points along the selection edge—are automatically added. You can also add additional anchor points manually by clicking with the mouse, or you can remove anchor points (such as those that have

anchored themselves to a point other than on your chosen course) by pressing the backspace button.

For anyone who has used the Magnetic Lasso, this description will sound simplistic. True, this is an easy-to-use tool but, unless you are very fortunate, it's unlikely that you'll be able to make a selection precisely matching the border of your subject the first time. Since the tool does not detect an edge as such—rather, it detects an area of high-contrast change (which normally signifies an edge)—it can be fooled when your intended edge is low in contrast. Here's a typical selection that might be appropriate for the Magnetic Lasso (see fig 1). We want to select this girl, but we don't want any of the background.

Fig 1

Fig 2

Fig 3

Fig 4

Fig 5

1. Begin to make the selection by clicking on a convenient point at the edge of the selection. Drag the Lasso along the boundary (you don't have to follow it precisely—even if you are a few pixels away, the Lasso's selection line will "jump" to the nominated edge). This is easy when following the boundary between the white shirt and grass, and the girl's face, but a forced anchor point has been placed at the inner corner where her face and shirt meet to ensure the corner remains crisp (see fig 2).

2. When we get to the hair, the contrast levels fall and it becomes harder for the Magnetic Lasso to determine which course it should follow. Though it makes a very good guess, it is clearly off the mark in quite a few places. We can overcome the problems here either by making extensive use of forced anchor points (clicking frequently around the selection boundary) or or by reducing the Edge Contrast level in the Tool Options bar. Set a lower level and edge detection will be more precise under these conditions, but it will also be more sensitive to edges generally—and it can still follow the wrong edge (see fig 3).

3. When we come to the white box behind the girl, the contrast between the box and the grass is greater than that between the box and the girl's shirt, so this is the course the Lasso instinctively follows. To make it adopt the intended path, we need to anchor the first point manually on the boundary between the box and the shirt; after this, the lower-contrast edge here will be detected and followed (see fig 4).

4. Where there's a number of different paths the Magnetic Lasso could jump to, you can increase the Frequency on the Tool Options bar. Now the Magnetic Lasso will analyze the image area for edge contrast more frequently. This will make it more likely to follow a precise course and less likely to "jump" to a more obvious course that may be nearby. Here we can even select the plant this girl is holding, even though it is the same color as the background and exhibits very small contrast changes from the background (see fig 5).

Magnetic Lasso summary

- Set manual anchor points to secure the path where there is a risk of error (such as sharp corners or multiple possible paths).
- Use the default Edge Contrast setting as a matter of course, but reduce it for accurate determination in low-contrast areas.
- Set the Frequency control to a higher level where there is low contrast or multiple paths. This will increase the frequency of analysis, thus making it easier to follow indistinct paths.
- If the overall selection is difficult using the Magnetic Lasso, don't be afraid to add to the selection using a different tool.

Fig 6

The Magic Wand

Perhaps second only to the Lasso in terms of use, the Magic Wand is a great selection tool for those selections that comprise areas of constant color. So far we've identified where to use this tool and the basics of how it works. But, like the Magnetic Lasso, successful use requires a little more understanding of the mechanics of the tool's operation. It also requires awareness of small-scale detail in the digital image.

When using the Magic Wand, it's possible to be a little blasé. We see, for example, an area of clear color and click on it. By refining the Tolerance setting, we can apparently append the whole of the colored area with one, or perhaps two, clicks. But when we then apply the effect for which the selection has been made, we are often disappointed to find that, at the macro scale, our selection has not been as effective as we might have thought.

To understand this, we need to look closely at an image. Here's a flower that has broadly similar colored petals (see fig 6).

We can make a selection using the Magnetic Wand tool. Because of color variations, we need either to adjust the Tolerance setting or add to the original selection to achieve what appears to be a complete selection of the colored area (see fig 7).

We can now use the Hue/Saturation control to change the color. Immediately we notice that, although the hue change is effective, there is a problem—some of the original color is still visible (see fig 8).

Move in a little closer, and the nature of the problem is revealed. There are isolated pixels that were not visible in the original selection that still retain the original color; by our original selection criteria, they were not selected at all (see fig 9).

The reason is simple: at pixel level there is noise and random fluctuations in color that push individual pixels beyond the permitted tolerance. And if we have stored our image as a JPEG, we are likely to find that the com-

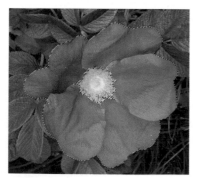

Fig 7

Fig 8

Fig 9

Fig 10

- Append any pixels that remain by using the Smooth command. We'll explore this later in the chapter.
- Always try to use the smallest Tolerance value possible. Like we can "miss" some pixels, so can errant pixels that fall within the tolerance range outside the main selection end up being appended when a large Tolerance value is used (and when the Contiguous option is turned off).

pression regime has introduced other color artifacts that similarly create pixels that are outside of our color range. Here's a close-up of the original image showing some of these exceptional pixels (see fig 10).

It's important to recognize that many areas of apparently continuous color are, in fact, quite pronounced color gradients. Clear blue sky is an obvious example (and one that we tackle in this book) where both the color saturation and tone can vary imperceptibly but sufficiently to require multiple selection with the Magic Wand tool.

Magic Wand summary

- If you want to ensure only those pixels of a single subject are selected, make sure the Contiguous option in the Tool Options bar is selected; otherwise you will select pixels from throughout the image.
- Use Color Range (see the following section) in preference to Magic Wand if you want to select pixels partially for transparent effects.
- If you want to select colors from the current layer of the image only, make sure that the Use All Layers button is not selected; to base the color selection on all the layers in the image, make sure the option is selected.

The soft touch

You can smooth the hard edges of a selection to make composites more effective. The key tools for this, which can normally be selected from the Tool Options bar, are Feathering and Anti-aliasing.

Feathering We've discussed feathering already (see page 226). It's the process that blurs any sharp edge by creating a transitional gradient over a number of pixels that you determine and describe as the feather radius.

When you enter an amount in the box on the Tool Options bar, this amount will be applied to any selection that you subsequently make. If you have already made a selection but have not specified a feather radius (or have specified an inappropriate amount), you can enter an amount retrospectively using the Select⋯⟩Feather menu option.

Anti-aliasing The anti-aliasing function is designed to smooth jagged edges of a selection that occur as a direct consequence of the pixel nature of an image. Because an image comprises discrete pixels, close inspection of an edge will reveal the step-by-step transition. Apply anti-aliasing, and the color transitions are softened. This affects only the edge pixels, hence there is no radius that can be specified. You must also specify this option prior to making any selection, as it cannot be applied afterward.

Color Range

When we use the Magic Wand command with the Contiguous option not selected, pixels throughout the image that correspond to the tolerance level set will be selected. The Color Range feature (Select⸱⸱⸱⸱⸱⸱>Color Range) is an evolution of this command that lets us specify a certain color but vary the tolerance more easily, by using a Fuzziness slider. The more fuzziness we specify, the greater the tolerance and the more pixels that are appended to the selection.

We can use the Color Range command to select a specific color (or colors) from within a current selection or from an entire image. Here's how we can exploit it for making precise selection.

1. Open the dialog box by choosing Select⸱⸱⸱⸱⸱⸱>Color Range. The Color Range dialog box will open. Be sure that you don't have a selection active on the image if you want to make a new selection using this command (see fig 11).

2. Click on one of the two radio buttons. Clicking on Selection will display a thumbnail only of the selected pixels as we create our selection. Click on Image if you want to preview the entire image. This is useful when working with large images and you want to select a color or region that is not currently displayed (see fig 12).

3. Click on the area (or color) that you want to preview. You can do this either on the image itself or the dialog box thumbnail (see fig 13).

4. Use the Fuzziness slider to increase or decrease the range of colors appended. The crucial difference between Fuzziness and Tolerance is that increasing the tolerance amount will increase the range of colors that are fully selected, whereas the fuzziness control can partially select pixels that are at the extreme of the fuzziness scale. This can lead to smoother results when effects are applied to the selected pixels (see fig 14).

5. We can now modify the selection using the eyedropper tools on the dialog box. To add colors (which can be similar to the original selection, or different), click on the plus eyedropper and then the selected color. Remove colors by selecting the minus eyedropper and then clicking on the colors to remove (see fig 15).

6. Once we have made our selection, we can click on the OK button to apply the selection to the image. We can also save this color range for later use (much in the same way that we can save a selection made by any of the selection tools) (see fig 16).

7. When we now apply our effect to the selection, it will be applied to the pixels, including any transparent pixels. This simple blue fill (which is unlikely to be the effect we would actually apply but helps clearly to illustrate the results) shows this, with partially selected pixels taking on a blue hazy appearance (see fig 17).

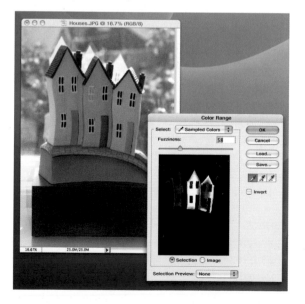

Fig 11

Fig 12

Fig 16

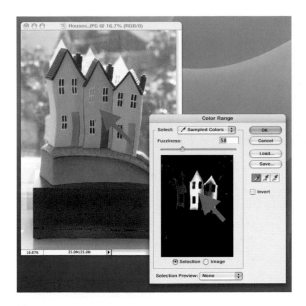

Fig 13

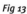

Fig 14

Fig 17

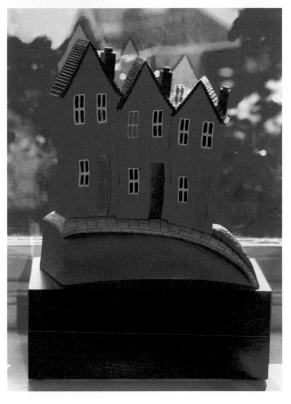

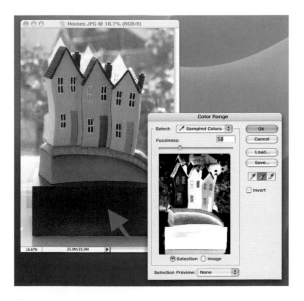

Fig 15

Modifying selections

The Modify option in the Select menu provides four additional tools to modify your selection further. These are Border, Smooth, Expand, Contract.

Expand and Contract are likely to be the tools that are used most. Select either of these, and you'll be prompted to enter the number of pixels by which you want a selection expanded or contracted. The selection boundary will be increased or decreased by the appropriate number of pixels, measured radially out from the geometric center of the selection.

Fig 18

Fig 19

Fig 20

Fig 21

selection boundary and that defined by the border amount remains selected. This command is more useful for presentational use than for refining a selection. You can, for example, use it to give decorative key line around a selection, as shown here (see figs 20 & 21).

THE QUICK MASK

The selection tools, between them, do a great job of making selections simple, but there will always be cases where, even when they are used in combination, they will not provide the ideal solution for you. The Quick Mask feature is designed to work with the selection tools to make selections more precise. Once we've made our approximate selection using whatever combination of selection tools we wish, we can switch to Quick Mask and see our selection represented by a mask. It is then comparatively simple to adjust the mask, adding to or subtracting from it, to modify our selection.

Using Quick Mask

Selecting people in an image is often a difficult job for the selection tools. Colors vary too much to use the Magic Wand, and the edge contrast is too low for the Magnetic Lasso. You can add to this the difficulty of capturing both smooth edges (represented by clothing) and softer edges (such as hair). We can use the Quick Mask here to select the subject of this informal portrait (see fig 22).

1. Rather than painstakingly using the Lasso tool to describe the edge of the subject, draw a loose selection around the subject. This really can be very approximate. Try not to cross over on to the subject, but if you do, don't worry—you can correct the error later (see fig 23).

2. Click on the Quick Mask button on the toolbar. The area outside our selection is now shown with the characteristic red masking tint. (You can double click on the Quick Mask button to open the corresponding dialog box, where you can change

Contract is the more useful option. It's ideal for removing the color fringing that often results when a selection is made from a subject standing against a strong, contrasting color. The edge pixels inevitably incorporate some of the pixels that are discolored by the background color. Contracting the boundary by just one or two pixels can remove this color fringing without any obvious effect on the edge of the subject itself (see fig 18).

The Smooth command is ideal for cleaning up selections where there are stray pixels that have not been included in a selection. Every selected pixel is analyzed to find any adjacent pixels (within the specified radius) that have not been selected but fall within the specified tolerance range. Then, if the majority of pixels are selected, any remaining ones will be appended to the selection. If there are more unselected pixels than selected, the selected pixels become unselected. The net result is a smoothed selection. Here (see fig 19), those pixels of similar color to the main selection have been appended, while the boundary of other selection areas have been smoothed.

The Border command produces a frame around a selection with a width corresponding to a specified number of pixels. After applying the command, only the area corresponding to that between the original

the density and color of the mask. You can even change the shading to cover the selection rather than the unselected area) (see fig 24).

3. Now we can make our selection more precise. Select the Paint Brush tool and a hard-edged paintbrush. In Quick Mask mode, the paintbrush will add to the masked area when painting with black and remove the mask when painting with white. If you select an intermediate gray area, you will partially select pixels, giving a semitransparent mask. Gently add to the mask in those areas where the selection needs a harder edge. Adjust the size of the brush to attend to finer details (see fig 25).

4. Switch to a soft-edged brush to refine the selection around softer parts of the image, such as hair and loose-textured fabric. Use a fine brush for this, otherwise you risk the transparent area at the selection boundary being too large. This would result in any effect applied to the selection also affecting this area of the background, which, ideally, you would not want affected (see fig 26).

5. Once you've completed the selection, switch back to Normal mode by clicking on the button next to the Quick Mask button. You'll see your new selection displayed by the usual marching ants. This may not look entirely as you expected: where you used the soft-edged brush, or if you used a gray paint color, the selection boundary will actually indicate that part of the image where 50% or more pixels have been selected (see fig 27).

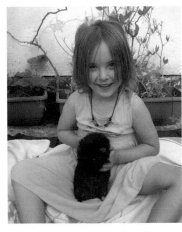

Fig 22

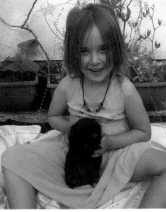

Fig 23

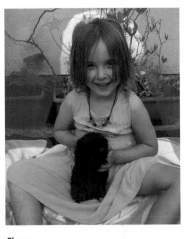

Fig 24

Fig 25

Fig 26

Fig 27

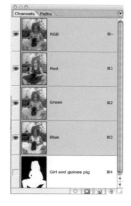

Fig 28

Fig 29

6. If you are happy with the selection, now it is a good idea to save it. This means you'll be able to recall it in the future, and if you accidentally deselect it at any point, choose Select⋯Save Selection. Give the selection a name, and you're done. Your selection will be displayed as a new channel (an alpha channel) on the Channels palette (see fig 28).

7. Now you can proceed with the modification or manipulation that prompted the original selection. In this example, to add prominence to the girl, the photographer has reduced the color saturation in the background surroundings and added a little blurring (see fig 29).

When not to use Quick Mask

The Quick Mask is an expedient method of honing a selection, but it tends to work best when a selection is being made to apply an effect to part of an image. It is not necessarily a good tool to use when you want to select an image element for use in a montage or collage. Because of the way the soft-edged brush and painting with grays handles transparency, when you select in this way, color and texture from the edges of the original image will be transferred to the montage. For a more effective treatment of image elements in montage work, use an image-extraction utility, such as Mask Pro, Knockout, or even Photoshop's Extract. We'll take a look at this option on page 268.

SELECTION BY PIXEL REMOVAL

So far, our selections have been based on defining those pixels that will comprise the selection and then applying an effect to those pixels or copying them to use in another image or composite. But we can also isolate a selection by removing unwanted pixels. That is, deleting any pixels that are not required for the selection. Clearly this very destructive method is best applied to a copy of an image rather than the original copy.

We'll explore two similar tools for doing this semiautomatically—Photoshop's Extract commands and Extensis's Mask Pro. But we'll begin with the simpler (and somewhat rudimentary) Eraser tools.

The Eraser tools

The standard default eraser is a simple tool that tends to belie the power available with other variations. Apply it to a single layer image, and it'll erase image pixels to reveal the currently active background color. Apply it to a layer in a multilayer image, and it will erase through the layer to reveal the pixels of the layer—or layers—beneath. You can also erase back to a previous history state by clicking on the button in the Tool Options bar. The only other controls here are Opacity and Flow to

determine how much of each layer is removed when the brush is applied (see fig 30).

Option 2, the Background Eraser, is a quick way to remove the background to a subject. It deletes all those pixels that match the color of the Hot Spot. When we select a brush size for the tool, the Hot Spot is indicated by a cross at the center of the brush. As we brush the Eraser around the edge of a subject, the color of the background will be picked up by the Hot Spot and the corresponding pixels deleted. Though effective in subjects such as that shown here (see fig 31), the Background Eraser is less successful where the subject itself contains colors similar to those in the background. In this case, the tool will not isolate the subject.

Extending the concept of the Background Eraser, the Magic Eraser works a lot like the Magic Wand. When we click on part of the background, all those pixels of a similar color (and those that fall within the Tolerance set on the Tool Options bar) will be selected and deleted. We can click multiply to delete further arrays of pixels, as shown here (see fig 32). Assuming that the background colors are exclusive to the background, we can quickly delete the background to leave, in the case of a single-layer image such as this, just a transparent background.

With the Magic Eraser, it's usually safest to leave the Contiguous box selected. When unselected, pixels throughout the image that conform to the tolerance will be deleted.

Fig 30—The default Eraser deletes pixels of the currently selected layer through to the underlying pixels, or background. But as a selection tool, it's rather fussy and it's not the most practical.

Fig 31—As the Background Eraser is passed around the edge of this building, the Hot Spot picks up the blues, whites, and grays of the sky and deletes all corresponding pixels to isolate the building and landscape.

Fig 32—The Magic Eraser quickly deletes areas of background but can, particularly if the Contiguous button is not selected, also append parts of the subject; it then becomes an indiscriminate tool. Here (see right), roof tiles that match the gray in the clouds have been identified and deleted.

Fig 33

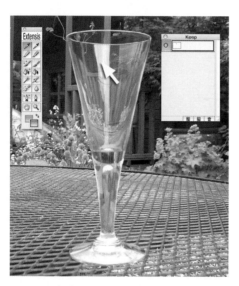

Fig 34

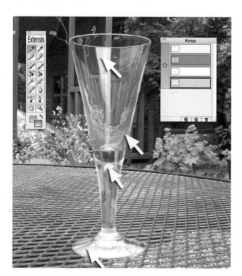

Fig 35

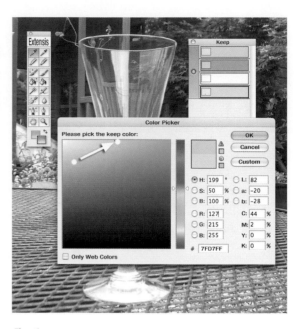

Fig 36

MASK PRO

Mask Pro from Extensis is an ideal tool if you spend a lot of time extracting subjects from backgrounds and find Eraser tools imprecise. It scores in being able to extract subjects accurately no matter how difficult. It's even reasonably simple to extract transparent objects. This glass, for example (see fig 33)—we can remove the background that here not only surrounds the subject but is also visible though it.

1. Begin by selecting the green Eyedropper. This is the Keep Eyedropper and defines the colors in the image that we wish to retain. Click with this on one of the most prominent parts of the glass (see fig 34).
2. Next, click on the New Color button in the Keep Colors palette to add a new blank color swatch. Click on another color in the glass. Repeat with any further colors. Be careful not to select colors that are in the background and visible through the glass (see fig 35).
3. Click on each color swatch one-by-one and, when the color picker opens, increase the color saturation. This will ensure that only those colors that are in the glass are kept, and not those that

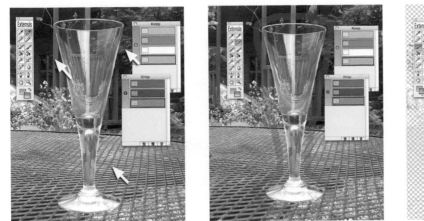

Fig 37

Fig 38

Fig 39

Fig 40

Fig 41

may also be in the background (see fig 36).

4. Now repeat this process, but using the Drop Color Eyedropper and selecting those colors that feature in the glass that you want to remove (see fig 37).

5. Take the red Drop Highlighter from the toolbox and draw around the glass, as close as possible without actually touching it. The closer you can get the better, but err on the side of caution—if you stray onto the selection, you'll need to start again (see fig 38).

6. The background can now be removed. Select the Magic Brush and brush over the selected area and around it. The background will, as the tool alludes, magically disappear. If the disappearance is not complete, you may need to refine the Magic Brush

by adjusting the sliders. Move the Threshold and Transition sliders to the right (see fig 39).

7. You can now copy your image to the new image. When in place on this new image, the transparency is obvious, but the distortion normally caused by the thickness of the glass is not present (see fig 40).

8. To render the image more convincing, a square of the background immediately behind the glass was selected and copied into a new layer, between the background and glass layers. The Transform tools were used to push this into a triangular shape to mimic that of the glass. In situations such as this, it can help to return to the original image to check on how transparent objects distort light (see fig 41).

Photoshop's Extract (fig 42)

Photoshop boasts its own image-extraction tool that does a fair job of emulating much of that achieved by Mask Pro. You'll find it under the Filter menu heading. You extract subjects using a similar highlighter pen to Mask Pro to define the colors inside the selection. Edge touch-up tools can then be used to refine the selection boundaries. It's easy to use, but I've never found it as comprehensively successful in performing difficult selections as Mask Pro. But it does come free with Photoshop and is worth experimenting with.

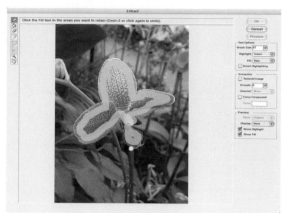

Fig 42

SELECTION MASTERY:
NEW SKIES AND REFLECTIONS
Assessing skies

When it comes to applying a new sky to an image, I like to assess the scene to see which of three difficulty classes the image falls under.

Images in class 1 I regard as those having a crisp horizon and the sky limited to only one continuous area. In this class, you don't have to worry about discontinuous areas—parcels of sky visible through foliage, for example—nor are there any reflections (either in water or windows) to worry about. We can make a simple selection of the sky and paste in our new one. Cityscapes are perhaps one of the few subjects that fall into this class (see figs 43 & 44).

Class 2 adds that discontinuity mentioned above and is probably the most common type of image requiring attention. Most landscapes can be found here, because even if there is a distant tree-lined horizon, you will find small areas of sky visible through the branches and these will need to be appended to any selection. Failure to do so will be all too obvious. You also need to be attentive to the edge of your selections. Natural subjects tend to have a softer edge. When you make a selection of the sky in this case, you can leave an intermediate edge that has color and tone that falls between the original sky color and that of the landscape. Expanding the selection by one or two pixels is often sufficient to prevent this, but take care: any more can isolate clumps of foliage and maroon them in the new sky (see figs 45–47).

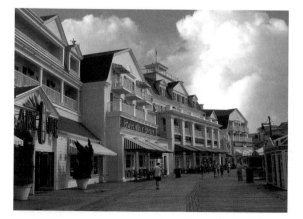

Fig 43

Fig 44

Fig 45

Fig 46

Fig 47

Class 3 adds reflections to the equation. In principle, this should never prove difficult, but realism depends on how you interpret the reflection. You will need to position it accurately with respect to the horizon and also allow sufficient texture from the original surface to show through. No reflection is truly mirrorlike. The following example illustrates how we handle a class 3 reflection.

This example makes great use of the Magic Wand tool and shows the effectiveness of layer masking. We'll take this image of a bright, colorful landscape with a rather lackluster sky and introduce a new sky (see figs 48 & 49). As there is water in the scene, we will also have to ensure that we provide a "new" reflection.

1. Begin by selecting the sky. Select the sky area to the left of the tree using the Magic Wand with a Tolerance setting of about 40. Ensure that the Add to Selection button is pressed and add to the selection until the entire area of the sky to the left of the tree is selected (see fig 50).

Fig 48 — Our new sky.

Fig 49 — Original landscape.

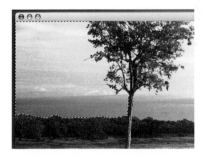

Fig 50

Fig 51

Fig 52

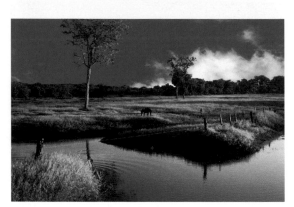

Fig 53

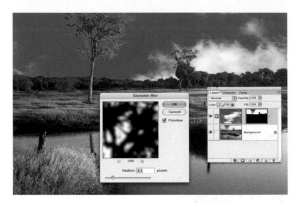

Fig 54

2. Use Similar (Select⸺Similar) to append all similar pixels in the scene. This will select the remaining parts of the sky, including those noncontiguous regions that are visible through the foliage and branches of the tree. It also appends the reflection of the sky in the river; remove this from the selection by using the Lasso or Rectangular Marquee to encircle all of this area, with the Subtract from Selection button pressed (see fig 51).

3. Open the image containing the new, "donor" sky, Select the entire image (Edit⸺Copy), and then paste it into the selected sky area in the landscape. It's important that you use Edit⸺Paste Into rather than Paste. Paste Into creates a mask over the unselected parts of the image and allows the sky to be seen only in the selected area (see fig 52).

4. The skyscape was slightly smaller in resolution terms than the landscape, so it will need to be stretched to fit. Use Transform⸺Scale to widen the image to fill the full width of the landscape's

selection. It's normally not recommended to enlarge an image to fit a selection, but here the sky contains little detail that could be compromised by the action (see fig 53).

5. Look closely at the image, and you will see that the tree is rather ragged. This is an artifact of the Magic Wand selection process. It is rather abrupt in selecting or not selecting pixels, leading to this very rough outline. Click on the mask in the layers palette and soften the edge using the Gaussian blur filter. This will give a more natural edge to the mask and make the result more natural (see fig 54).

6. Choose Deselect (Select⸺Deselect) to remove the selection, and select the area of the river that is reflecting the sky. Do this in the same way as in steps 1 and 2, but this time deselecting the sky area that gets selected again by the Similar command (see fig 55).

7. Invert the sky image to create a mirror image reflection of itself. Do this by selecting Image⸺

Fig 55

Fig 56

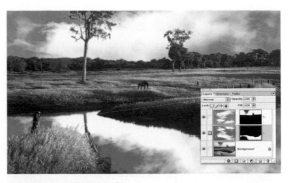

Fig 57

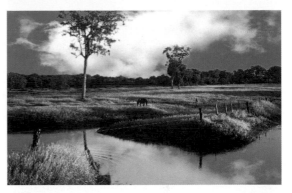

Fig 58

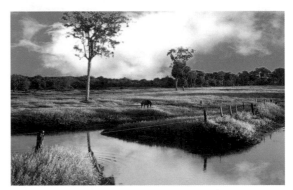

Fig 59

Rotate Canvas⋯⟶Flip Vertically (see fig 56).

8. Copy and paste this into the selection. You will need to adjust the width again and also move the sky vertically so that the reflected area represents an accurate reflection of our new sky. Soften the edges of the selection (which again are somewhat abrupt) in the same way as we did for the tree—using the Gaussian blur on the mask (see fig 57).

9. Our reflected sky looks too obvious at the moment. We need to make it adopt something of the texture and form of the river. To do this, use the Layer palette-opacity control to make this sky semitransparent by moving the slider to the left. You'll have to use your own judgment as to what is the best; around 50–70 percent is often about right (see fig 58).

10. Because you still have all the layers preserved in the image, along with the masking, you can change the position of the sky image (and consequently will need to reposition the reflection) by clicking on the appropriate thumbnail and using the Move tool to reposition. You can also change the opacity of sky and reflection or vary the saturation of each to better mimic the landscape's color and saturation (see fig 59).

Fig 60

Fig 61

Fig 62

Fig 63

TRANSFORMING SELECTIONS

Once we've made a selection, we can copy it, paste it into another part of an image, or even paste it into an entirely different image. We can also apply transformations to the selection. We've already touched on transformations when, for example, we transformed a crop to compensate for perspective effects (see page 242). But the Transform tools allow us to do much more than this. Over the next few pages, we'll explore how we can manipulate a selection to rebuild an image and also how we can combine the Transform tools with Pasting tools to produce composite images.

The red car: reflective transformations

At a classic car show, a photographer took a picture of the front of this red car (see fig 60). It's a good image that has been selected, because it will be a great way to illustrate, in Chapter 10, the Radial Blur filter. However, the car's right-hand engine cover has been raised, making this an implausible image to use to illustrate motion. But can we digitally close the cover? Of course!

1. As the image of the car has been taken pretty nearly square on to the front, we could take the left-hand engine cover and manipulate it to produce a symmetrical reflection. Select the engine cover using the Rectangular Marquee. In fact, to copy accurately all the elements needed, we would have to use three intersecting Rectangular selections, as shown here, with the new selection pasted in its own layer and dragged to the new position (see fig 61).

Fig 64

2. We can use the Transform tool to convert the selection from a left-hand piece to a right-hand one. Select edit···▹Transform···▹Flip Horizontal. This produces the required piece to mask the open engine bay (see fig 62).

3. Drag the new piece, using the Move tool, into position. At first glance it looks like a perfect fit, but closer inspection of the edges shows the alignment is not perfect on all sides. We could use the Transform tool again, this time selecting other modes, such as Skew or Distort, to make the match better, but as the inaccuracies are minor, we can attend to them later using the Eraser tool (see fig 63).

4. To complete the job, we've now also copied over (and reflected) the lower dashboard, to hide the engine cover section that rises above the hood

line. In addition, to prevent the symmetry being too obvious, the Smudge tool has been dragged over the new hood cover to blur the reflections. As a final fix, the car's rearview mirror has been made complete by copying one side to the other (see fig 64).

The Transform tools

In the Transform submenu, you'll find the following options. Here's an overview of what they do.

- *Scale* This changes the scale of a selection, and it is useful for refining the size of a selection to make it better fit its new location—but take care not to overly enlarge a selection, as it will lose resolution very quickly.
- *Rotate* This rotates the selection around a central axis. Grab any corner with a mouse and drag it around to the appropriate position (see fig 65).
- *Skew* Using this option, you can push or pull the horizontal or vertical axes to create trapezoidal shapes (see fig 66).
- *Distort* Here you can push or pull horizontal and/or vertical axes to change the perimeter of the selection in any way (see fig 67).
- *Perspective* This allows you to achieve perspective corrections or exaggerations (as when using Crop in Perspective).

Fig 65

Fig 66

Fig 67

Fig 68

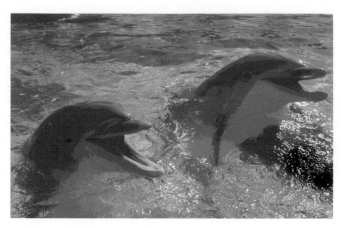

Fig 69

Fig 70

Back to the drawing board

Here's an example (see fig 68) that uses the Transform tools more fully, both in free-form mode and also when pasting into selections.

Our source image in this case is a girl sitting at an architect's drawing board. By the end, we'll make it look as if she has used this board as the basis of a painting and also give a view from the window that corresponds to the painting.

1. Use the Lasso tool to select the surface of the drawing board. Switching to Polygonal Lasso is the easiest way to select this areas. This image of dolphins is the one we will be placing on the board, although clearly it is not now in the correct form for the effect to be convincing (see fig 69).

2. Select the image of the dolphins and use the Paste

Fig 71

Into command on the drawing board image to paste the image into the selection. Only part of the image will be visible. Select Image⋯⟩ Transform⋯⟩Distort. An outline of the full image will be visible with adjustment handles (corner and midline points) for reshaping the selection (see fig 70).

3. Push and pull the handles until the shape of the selection matches that of the drawing board. It's probably better to make the selection slightly larger; this will prevent any problem of the drawing-board surface appearing at the edges (see fig 71).

4. As an additional flourish, a pen has been placed in the girl's hand. This was done by drawing a fine rectangle selection and then filling it with a gray/white gradient. There's no need to be too precise with this, since it will be very small in the final image (see fig 72).

5. Now we can turn our attention to the view through the window. We need to select all the glass areas of the window panes. The Polygonal Lasso is ideal for this, aided if necessary (as it was here) by switching to Quick Mask mode to refine the selection (see fig 73).

6. Here's the image that we'll be pasting behind the windows. Don't be put off by the strange composition. Remember, this is not meant to be an image in its own right but merely part of the backdrop. All that we do need to consider (and make adjustments for, if appropriate) is that the color balance is similar to that of the rest of the image. For this we can use the Color Balance or Match Color commands (see fig 74).

7. We can now repeat the Paste Into process to incorporate this image into the scene. We can switch to the Move tool if necessary to adjust the position of this image. There's no need to use the Transform tools here, because we were careful to ensure that perspective issues were taken care of prior to compositing the image. By looking at the Layers Palette, we can see how the layers have stacked and also the masking that has been applied to achieve the composite (see fig 75).

8. The final image. No, it does not exist in reality, but it could. And that is the secret of successful digital imaging (see fig 76).

Fig 72

Fig 73

Fig 74

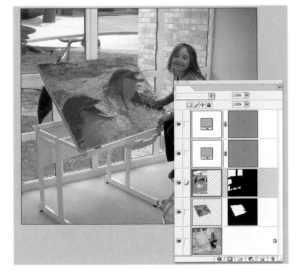

Fig 75

Fig 76

EFFECTIVE CLONING

In this chapter we will:

- **Undertake a complete image repair and modification using the Clone tools.**
- **Examine more ways of cloning pixels for creative purposes.**
- **Look at solutions for more expedient image repairing using Clone tools.**

The Clone tools, as we've seen earlier (see pages 228–29), are remarkably potent and for many people represent the key feature of image manipulation. But an understanding of the tools is only part of the process. As with using all corrective tools, part of the process involves a thorough and complete analysis of the image and having a vision for what the end result should be. We'll explore the mechanics and ethos of cloning in the following project—The Country Cottage—before looking at what other ways we can exploit the concept of cloning.

CLONING PROJECT: THE COUNTRY COTTAGE

It may be a cliché, but the Clone tool set comes into its own when we attempt to manipulate images of traditional landscape scenes. Take a good look around, and you will find plenty of those idyllic scenes that, superficially, could be described as "chocolate box." On closer inspection, however, many show at least some of the scars brought about by time and "progress." And we are not talking just about the natural decay that sometimes adds charm to the scene. It's the deliberate changes—some say disfigurements—brought about by the need to provide electricity, telephone lines, TV transmitter masts, satellite dishes, and so on, along with the painted lines and street furniture of contemporary urban life, which all seem to conspire against the beauty of the landscape.

So when we take on a project like this, our work is certainly cut out for us and what's called for is a period of evaluation. We need to assess what needs to be done and whether, in the case of cloning tasks, we have the means to achieve all our corrections.

Some scenes could defeat us not through any lack of skill or the appropriate manipulative tools but because we don't have sufficient material to achieve our objectives. If, for example, a stone wall is so disfigured by spurious accoutrements that there is insufficient remaining that can be used to clone from, then what do we do? With a paucity of source material, we may have either to accept the damage (and perhaps effect only minor corrections) or possibly use another image with similar structure to apply corrections.

Let's examine a real image—one that is perhaps typical of many we may find in picturesque villages. At first sight, this image appears pretty much all right (see fig 1). But look closer, and we begin to notice that as well as the obvious airborne wiring, there is a collection of TV aerials attached to the chimneys and also a number of cables crossing the roof and dropping down the front wall of the house. We may not be able to see the underground water supply pipes, but their presence is betrayed by the signs against the front wall. Not immediately obvious is the new house to the left of the building, clearly of twentieth-century vintage.

Fig 1

Fig 2

Fig 3

Fig 4

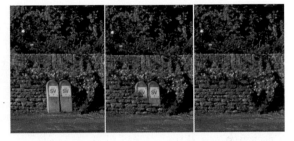

Fig 5

A close-up of the left chimney stack (see fig 2) shows the amount of paraphernalia that will need to be removed if we are to restore the cottage to what might be described as its original state. Fortunately, although there appears to be a significant amount of hardware on the stack, there is sufficient undisturbed image structure to make cloning possible.

By taking a section of the chimney stack below where the aerials are fixed as our "clone-from" point and using these to paint over the aerials themselves, we can easily remove these (see fig 3). If we were to examine the image very closely, we would see that we've repeated the clone-from point a couple of times but, given the small size of the stack in the image, this is not of any consequence. Sometimes we fall on our feet and discover that chimneys feature several caps or pots—making it easy to clone one from another.

Removing the wiring at the front of the house involves cloning from nearby brickwork using a soft-edged brush. Fortunately in this case, the brickwork is actually fairly haphazard, so we don't have to worry about matching up layers of bricks (as would

be the case if the brickwork were more regular). It helps to zoom in on the area being worked on. Then we would see, as here (see fig 4), that there are shadows cast by the security light that also need attention by cloning if a completely convincing effect is to be achieved.

The signs indicating the water-supply hydrants can be given a similar treatment—selecting a nearby part of the wall and cloning from it. We need to be careful about alignment to achieve a clean—and level—edge to the wall in the area we are hiding. If we are not sufficiently precise here, it would be a sure sign that manipulation had taken place (see fig 5).

You might have wondered why we have not paid any attention yet to the telephone and electricity wires crisscrossing the scene. In fact, removing these is rarely the simple task you might think; the sky, which appears constant blue in color, actually varies in color over very small distances. Because this change in color is steady, we don't really notice it. But start cloning over the cables using pixels from close by, and you will quickly see the problem. So, instead, we will attend to this as part of the bigger

Fig 6

Fig 7

Fig 8

task of removing the modern house—we'll replace the entire sky along with the house.

Use the Magic Wand tool to select the sky. Make sure that the Contiguous button is left unselected. In this way, we can also append those pixels that are visible through the foliage in the tree to the right of the image. Now, also append the house to the selection (using, say, the Lasso tool). We can switch to Quick Mask mode to check that we have appended all the region that we wish (see fig 6).

When we are happy with the selection, it's time to apply a new sky. This could be a different "real" sky culled from another image or, as in this case, a simulated sky (see fig 7). For the foreground and background colors, sample the real sky colors from the top of the image and that closer to the horizon,

respectively. Then use the Gradient tool to apply a gradient over the selected area. The result is a new, clear blue sky. Often a pure painted result looks too obviously false, so it's a good idea to use the Noise filter to add a little realistic texture to the sky area.

We are now in the home stretch. We've removed all the clues that indicate that the picture was taken in the present day, but there is still a somewhat incongruous roadway outside the front gate. Wouldn't the house look better presented if it were to be placed in a meadow? Unfortunately, this is a situation where we can't use extant imagery to clone over the foreground. But, fortunately, there is another image containing some meadow grassland that was easily transplanted by cloning from that image onto the one being worked on here. Only a modest amount of color correction was then needed to give a convincing effect (see fig 8).

Alternative interpretations

It is only occasionally that cloning alone produces a final result. Rather, cloning is more often used to give a partial means to an end. In the case of our cottage example, the photographer not only wanted to remove unattractive and modern intrusions but also wanted to show the scene at different times of the day.

In this first case, the replacement sky, rather than being artificial, was taken from a photograph taken in midafternoon. No other changes have been made, but the atmosphere of the shot has changed from the morning freshness of our original composite (see fig 9).

For the next interpretation, the sky has been replaced with that from an evening scene (see fig 10). To compensate for the change of sky, the photographer also slightly altered the color balance. Using the Color Balance command, the Midtones were adjusted to increase the yellow and the Shadows adjusted by increasing the blues.

Finally, in a much more obvious change, a late-evening sky has been substituted (see fig 11). This time the foreground has been heavily modified. To give a moonlit effect, the Blue Omni lighting effect (Filter⋯➔Render⋯➔Lighting Effects) has been applied, adjusted to give offset illumination. The room lighting was achieved by selecting the window

panes and then painting them with a yellow paint. The lighting uses the Lens Flare filter applied with a modest setting to give a convincing amount of scattered light.

Fig 9

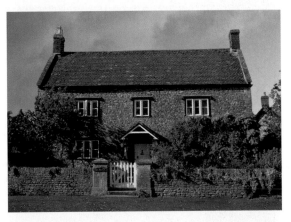

Fig 10

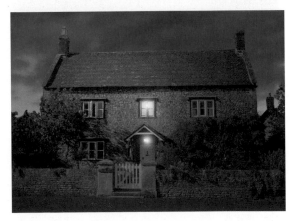

Fig 11

BETTER PORTRAITS WITH THE PATCH TOOL

We've seen how the Heal and Patch tool can be used to remove spots and blemishes (see page 230), but the Patch tool has another string to its bow: it can be used to clean up those snatched portraits to correct blemishes we either missed or are beyond our control.

This charming wedding portrait (see fig 12), which has been taken to illustrate how accessory reflectors can help illuminate an image, in this case a Lastolite reflector, would look fine in any album, but can we make it even better? By now, we know that the answer is obviously "Yes."

Clearly, the subject has been standing for some time in the heat of the sun, as her skin has taken on a mild amount of shine. There are also some minor wrinkles and folds (which I'm sure she would not mind losing) and some spots (see fig 13). We can use the Patch tool to remove all of these. Best of all, that patch of clear, perfect skin on the subject's chest provides an ideal "clone-from" area. This is a terrific bonus as well as the stumbling point for many Patch corrections.

1. Let's begin with a simple correction—smoothing out the skin on the woman's lower lip. After selecting the Patch tool, describe a shape on her chest that approximates the shape of the lower lip and then drag this patch into position (see fig 14).

2. Position the patch close to the lower lip but not overlapping it. If you do overlap an area such as the lip, or perhaps some strands of hair, then the color of this area will be incorporated into the average for the patched area, and the result is unwanted discoloration (see fig 15).

3. Now repeat this process to create patches to go under each of the eyes. Again, take care when moving the patch not to contaminate the color by positioning it over the eyelashes. You can worry less if you move over, say, the bridge of the nose or the outline of the jaw (see fig 16).

4. A shiny nose and shiny cheeks can be treated in exactly the same way (see fig 17).

5. Finally, some tidying up involves removing spots and ensuring that skin texture is consistent throughout (see fig 18).

6. Though it has nothing to do with the cloning tools, we can finish off the photograph by applying a soft-focus effect. This is something covered in more detail on pages 316–317, but it's a useful trick to add a romantic feel to an image (see fig 19).

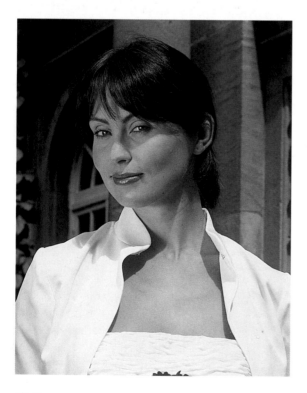

Fig 12

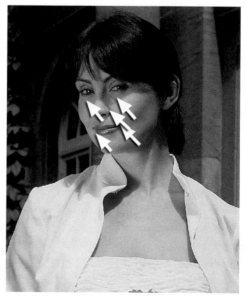

Fig 13

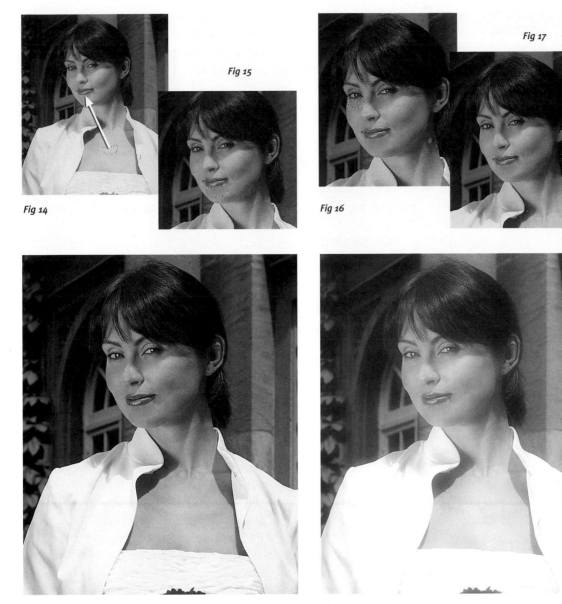

Fig 15

Fig 17

Fig 14

Fig 16

Fig 18

Fig 19

CLONING WITHOUT THE CLONE TOOL

That cloning is a powerful feature of image-manipulation software is without doubt. But beyond the obvious Clone and Rubber Stamp tools, there are other opportunities to clone—either to conceal problems or to be more creative.

The History Brush, for example, lets us clone onto the current version of the image using pixels and elements from a previous history state. This is extremely useful if you need to reapply a texture or scene element that has been modified or removed when applying subsequent processes.

The "Erase to History" mode of the Eraser tool actually lets us repaint an image with those pixels from a previous history state (that is, at a stage prior to our most recent manipulations) by returning selected pixels to their previous state. It's important to recognize that you can't clone pixels from another part of the image using this technique, only restore pixels to their previous color or tone.

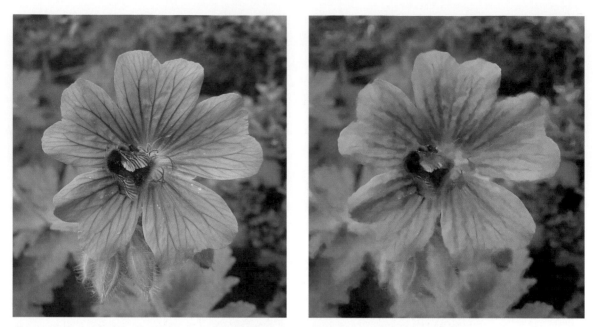

Fig 20—The Impressionist option of the History Brush lets you clone in an artistic way from a chosen history state.

Those who retain their older versions of Photoshop (5 or 5.5) when upgrading will have an additional tool at their disposal—the Impressionist option of the History Brush. This allows (or allowed) a previous history state to be used to clone and paint to give the allusion of being hand painted. Fortunately for devotees, the feature lives on in Photoshop Elements (see fig 20).

The Color Replacement tool (fig 21).

Hidden from the sight of all, apart from the most curious of Toolbar explorers, is the Color Replacement tool, which you'll find sharing a position on the bar with Heal and Patch. Despite its fanciful name, it is nothing other than a red-eye remover. Many applications provide red-eye removing features that are dedicated, for obvious reasons, to desaturating red. Color Replacement will also, should you find the need, remove any selected color (excellent news if you take portraits of cats and dogs, which are both prone to green eye). Here's how to use it on a pet facing this unfortunate affliction.

1. After selecting the Color Replacement tool from the Toolbar, choose a brush from the Options bar. A small head about ⅔ the size of the area to be treated is a good choice.
2. Choose a Sampling option. This could be:
 - *Continuous*—if you want to sample colors as you drag.
 - *Once*—to replace a single, targeted color (typical for the red-eye option).
 - *Background Swatch*—only erases those areas containing the currently selected background color.
3. Set the Limits option:
 - *Discontiguous*—replaces the sampled color anywhere in the image where it occurs, subject to rubbing over it with the mouse pointer.
 - *Contiguous*—replaces the color contiguous with that currently under the pointer (again, the red-eye option).
 - *Find Edges*—replaces connected areas but preserves any sharpness in edge areas.
4. Select a foreground color to be used as a replacement for that to be removed and then select the color to be removed.

5. Drag across the area you wish to correct. That's it!

Of course, the best cure for red eye is to avoid it happening in the first place. The direct lighting from the camera flash never gives the most flattering lighting, so use bounce or ambient flash wherever possible.

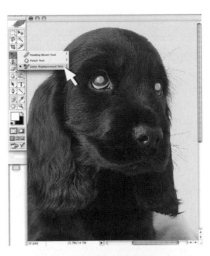

Fig 21—
Replace Color allows any selected color to be replaced.

IMAGE DOCTORING

There is no doubt that successful cloning is an acquired skill. So it comes as no surprise that enterprising software companies have seen an opportunity to semiautomate the process and make cloning simpler for those of us terrified by the practicalities. Alien Skin Software's Image Doctor is one such application. It's actually a suite of four programs designed to make traditional cloning processes a cinch.

The first, JPEG Repair, is concerned with image cosmetics. We've noted that the JPEG compression routine is successful at compressing files to a truly small size, but it does so by compromising image quality. The image is broken into blocks and the color information averaged. Enlarge a JPEG—even one that has been compressed to a modest degree— and you'll see the damage that has been done. It becomes particularly noticeable where there are areas of color change and near edges.

JPEG Repair analyzes the image on the basis of the JPEG artifacts and, by counteracting the compression algorithm's averaging technique, can successfully remove them. Simple and effective. It won't restore an image to its state prior to compression; detail is also lost through the averaging process and this simply can't be restored, but otherwise you will end up with an image that appears to be invisibly repaired.

Spot Lifter deals with cosmetic damage to your subjects. It's designed to remove slight skin blemishes, such as spots, freckles, and—assuming it's not too severe—acne. It will also work to remove physical damage on original images—such as mold marks. It's very similar to Photoshop 7+'s Healing

Brush but works more efficiently and can also be used to make skin look younger by removing small lines and wrinkles.

When the contrast of marks is higher—as would be the case with dust and scratches, for example— we can employ Scratch Remover. It is a simple tool to use that involves ring-fencing the scratch. Then the scratch and surrounding pixels are identified and the latter are used to overpaint the scratch. It is particularly successful with major marks and blemishes that can be difficult to remove using simple cloning tools. The averaging used ensures

that any gradients required in coloration exactly match the background. You can also use Scratch Remover to remove text from an image or even the time/date stamps imprinted by some conventional cameras' databacks.

Completing Image Doctor's quartet is Smart Fill, and this is where the software shows itself to be a true, intelligent cloning tool. With this we can remove major distractions—road signs, a car, or telephone poles—at a stroke. You can even remove those people who so thoughtlessly wandered into your shot. In principle, it works rather like Scratch Remover, but this time Image Doctor analyzes the color and the texture of the surrounding background and generates a new, random texture based on these characteristics. It then fills in with this texture.

With Smart Fill, you get cloned texture without the telltale signs normally associated with cloning—elements of texture sampled from elsewhere in the scene, for example. You also get near-seamless results, with the cloned texture and the original background blended together (see figs 22–25).

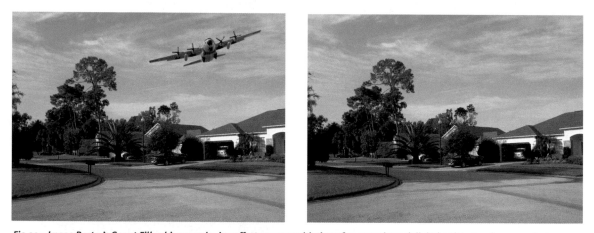

Fig 22—Image Doctor's Smart Fill achieves a cloning effect on a par with that of an experienced digital artist, covering unwanted areas with novel texture and color that exactly matches and blends with the surroundings.

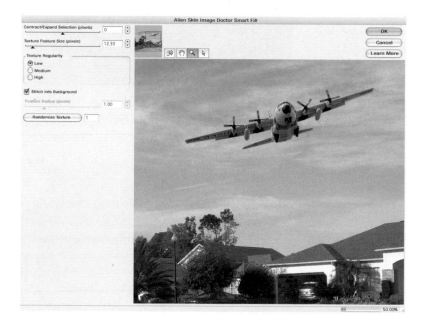

Fig 23—Given its potency, the Smart Fill dialog is surprisingly uncluttered. Getting exact results requires fine-tuning of only the Contract/Expand and Texture controls.

Fig 24—Images that have been compressed using JPEG (either on your computer or digital camera—or both) exhibit artifacts even under low magnification, as shown here.

Fig 25—JPEG Repair corrects these artifacts without otherwise affecting the image.

EFFECTS FILTERS WITH ATTITUDE

In this chapter we will:

- **Experiment more with filters.**
- **Look at how to exploit filters.**
- **Study how to create powerful images with filter plug-ins.**
- **Discover how filters can improve visual defects in images.**

Filters are the most overt manifestation of digital image manipulation. That we've already said. So, given that our approach is photographic rather than graphic, should we sidestep filters altogether? That's a view taken by many photographers who consider the effects of even the most subtle of filters too obvious. They argue that a good photograph does not become a great one by the application of a contrived filter. While respecting this opinion, we also acknowledge that with careful use, filters can produce very effective visual effects.

It's also important to recognize that among the ranks of filter effects are Sharpen and Blur filters. These, however, do have clear and obvious photographic application, so we will examine these more closely later in the book (see chapter 19).

PHOTOGRAPHY INTO ART: THE ARTISTIC FILTERS

Most prominent among the ranks of effects filters provided with virtually every image-editing application are the so-called Artistic filters. Dating from the earliest days of image manipulation, these endeavor to simulate the effects of natural media painting, drawing, and brush use. They are often the first stop for those new to digital photography, because they appear to offer, at a stroke, powerful effects and turn their images into works of art.

The trouble with many of these filters, however, is that the effects they produce bear only scant similarity to those they seek to emulate. Add to this the fact that photographic-quality images don't necessarily lend themselves to the application of an

artistic effect, and you can see why such filters are often held in contempt by photographers. But if we acknowledge these imperfections, and even learn to exploit them, we can achieve some noticeable artistic success.

Identification

Perhaps the most basic requirement for using these filters successfully needs to be the identification of a technique that will enhance a particular subject. When you examine the list of effects offered by the Artistic filters (which include those filters listed under the subheading of Brush Strokes and Sketch), consider those subjects you know to benefit from this treatment. Watercolor, for example, is often used for landscapes and portraits. Likewise, pastels. Neon and neonlike effects should be reserved for vibrant subjects: contemporary subjects and portraits designed to shock.

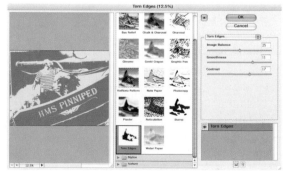

Fig 1

Application

As you begin to explore the opportunities of the filter menu, it seems as if every filter has its own distinct dialog box. In many cases this is true: quite a number of effects require a unique range of control parameters to govern, for example, the length of paint stroke, amount of blurring, black/white balance, and so on.

Perhaps as recognition of this and in an effort to introduce a degree of standardization, later versions of Photoshop include an effects browser—a standard dialog that allows the image to be previewed with the effect applied to the left and the controls adjusted to the right. The center of the pane includes literal thumbnails of effects that can be applied in each submenu. It's no easier to compose an image in this format, but it does make it easier to quickly change from one effect to another should the original selection not "work" (see fig 1).

To be honest, there are no shortcuts here: getting the look of an image right depends on adjusting the control sliders. Fortunately, as the changes you make are mirrored immediately in the preview pane, you can assess results as you perform them.

Application opportunities

The obvious way to apply a filter is over the whole image. But this is often not the most appropriate course to take, since it gives little control in modulating the strength of the filter (other than by using the rather crude Fade Filter command). It's usually preferable to apply any filtration in a more selective way.

Selections Once we've made a selection in an image, we can choose to apply that filter to it—or perhaps to apply the filter to the surroundings, leaving the subject untouched.

In this first example, the Lasso has been used to apply a very rough outline to the singer. Then the Palette Knife filter has been applied to the selection. To add further emphasis and make the composition less cluttered, the background has been reduced to monochrome (using the Desaturate command) and blurred using Gaussian Blur. The area behind the singer's head has also been lightened to make her hair outline more obvious (see fig 2).

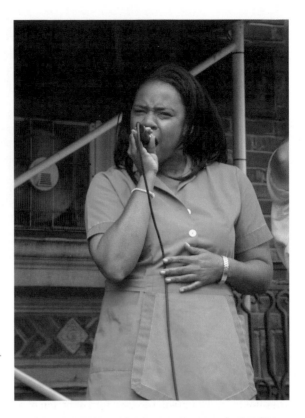

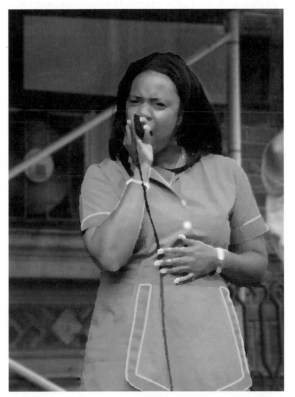

Fig 2

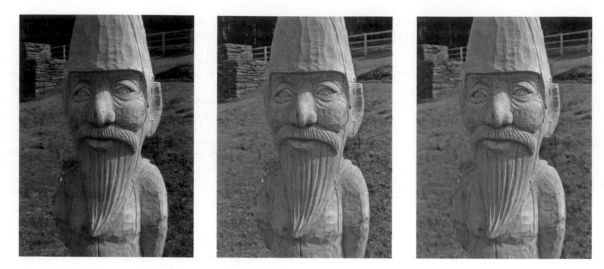

Fig 3 Fig 4 Fig 5

In this second example, the idea of the photographer was to add emphasis to the subject by making it appear to be set against a painting background. The original also suffered from high contrast, which meant there were strong shadows compromising image quality (see fig 3).

Applying the Highlight/Shadow feature will even out the exposure, although this also compromises image quality. As a standard image, this is unacceptable (see fig 4).

But when we now select the background (by selecting the carving and then inverting the selection) and apply the Crosshatch brush filter (increasing the settings by 50 percent), we get a very effective result (see fig 5).

Of course, you could extend this concept to a montage: the montaged elements could comprise filtered and unfiltered subjects and background. It's a good idea in this case to keep to a single effect: a composite scene comprising multiple elements each with a different effect applied will look chaotic.

Layers Using a Brushstroke filter, as in the case of the gnome carving, can work well in reducing the impact of a background, but when we use a similar filter for the entire image, the result can be to produce a general blur—unless it is viewed close up. In these cases, it often helps first to copy the background into a layer (Layer⋯▸Duplicate Layer) and then apply the effect to that layer. Controversially, do so with a stronger effect, nudging the sliders slightly to the right. Then, change the opacity of the layer from 100 percent to around 67 percent. This helps to add definition to the image by

Fig 6 Fig 7

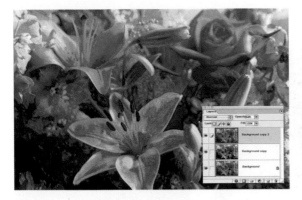

Fig 8

Fig 9

allowing the sharpness of the original to show though but permit the effect in the layer still to be clearly visible (see fig 6).

Similarly, for very potent (in terms of color and form) subjects: using the opacity slider here gives the image definition, yet the filter (Dry Brush, in this case) gives the colors a solid, graphic appearance (see fig 7).

Though the use of multiple filters is often, for good reason, eschewed, it can sometimes lead to dramatic and successful results. Here, two copies of the background layer have been created. The background was sharpened using the Unsharp Mask filter to add to the perceived sharpness. Then the first layer was, as before, subjected to the Dry Brush filter and its opacity reduced to 50 percent (see fig 8).

The unusual Plastic Wrap filter has been applied to the top layer here, and again the opacity reduced, this time to 60 percent. The Plastic Wrap filter in its default state gives images the appearance of having been shrink-wrapped, but here, by reducing the intensity, it gives the impression that paint of finite thickness has been applied to a canvas (see fig 9).

Other opportunities In a similar manner to applying a filter to a layer, you can also apply a filter to an individual channel. Open the Channels palette and then click on a single channel to select it. Then apply the filter.

Gradients and gradient masks allow you to apply the filter in a graduated way. In this way you could, for example, add a grain-type filter that becomes more obvious across the frame, concentrating attention on, say, foreground subjects.

PHOTOGRAPHIC FILTERS

Digital implementations of conventional photographic filters have rarely made an appearance in image-manipulation applications. With the host of other techniques available, they have long been deemed irrelevant. But in recent releases of software applications, custom tools for emulating filters have appeared—and have been well received by photographers who have found both corrective and creative uses for them.

Photo filter (figs 10 & 11)

Photoshop's implementation of the corrective photographic filter feature is called, unsurprisingly, Photo Filter. More surprisingly, you won't find it in the filter section but, rather, under Image 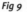 Adjustments. You'll find a range of filters provided in the pull-down menu. Select the appropriate one and

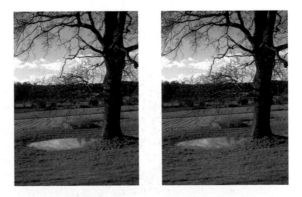

Fig 10—When the original shot (see left) was taken, the photographer hadn't reset the white balance of the digital camera from the Tungsten light setting. The result is a bluish cast that is easily removed using the Warm Up filter 81 with a density of around 40% (see right).

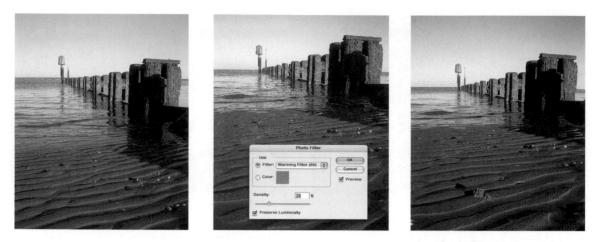

Fig 11—Photo Filter can also be used to alter the lighting mood in a scene. This original image (see left) is correct in terms of color balance. But applying a strong Warm Up filter (85A), we get an effect more in keeping with a late-afternoon shot. Reducing the density ensures that we don't have too much of a sepia effect (see right).

apply it. I tend to find the strength of the filter rather high, and it pays to reduce the intensity, using the slider, to obtain the best results.

Filter-SIM (figs 12 & 13)

In some applications—and Photo-Brush is a very good example—filters are implemented in a literal and very visual way. The Filter-SIM feature in Photo-Brush overlays a metaphorical filter on the basic image, illustrating the correction within the filter ring. You can reposition the ring to assess the correction over different parts of the image.

The range of filters offered in Photo-Brush closely follows the color-compensation (CC) range offered by most filter manufacturers and denoted by the near-universal Wratten number (this is the number of the filters in Kodak's Wratten gelatine series, well known to professional users requiring precise color compensation).

A useful feature of Filter-SIM is the ability to apply the filter to a black-and-white image. Now when we apply the same range of filters, we get effects that emulate the use of color filters with black-and-white film. Use a deep red filter—for example, a Kodak Wratten 24 – and blue skies will be rendered dark, almost black, while red objects are lightened and green objects are little affected.

Color-correction filters vs. other corrections

The more practiced image manipulator may spot a potential conflict in the photographic filter features. It is all well and good providing color-correction tools, but aren't these somewhat redundant given that all image-manipulation applications feature one, or in some cases several, color-correction features already?

Those behind Photo-Brush and Filter-SIM are up front about it: it's for correcting wrongly set white balances (on digital cameras) and adjusting the color balance of conventional films used in the wrong circumstances (for example, outdoor film used indoors under domestic tungsten lighting). They also suggest an educational use for the filters, useful in interpreting their effect on an image.

In practice, these filters are useful both for making quick corrections where the color cast is obvious in nature and also for applying color casts where they are wanted for creative purposes. The warm-up filters, particularly, are ideal for injecting warmth into those shots taken in the early morning or late-evening sunlight where the auto white balance might remove any natural warmth in the scene.

LIGHTNING

Electrical storms are one of the most spectacular of natural phenomena but also, in photographic terms, one of the most elusive. Though some locations can boast storms on a basis that may be as regular as clockwork, successfully recording them can raise

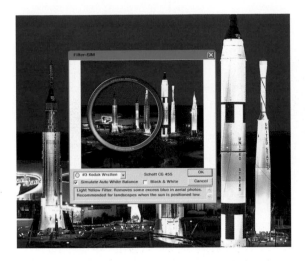

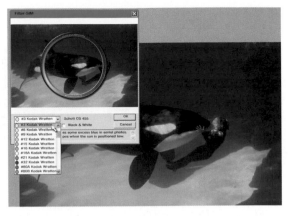

Fig 12—Filter-SIM (Image····⸬Adjust····⸬Filter-SIM, in Photo-Brush) clearly illustrates the effect of applying a filter over a portion of an image. You can choose from one of many presets mostly corresponding to Wratten presets. The descriptive panel at the base of the dialog gives a description of each filter.

Fig 13—Corrective filters allow corrections such as this, for underwater shots. Underwater photography with digital cameras is increasingly popular, but water introduces color casts. Filter-SIM helps negate these casts at a stroke.

problems. Lightning strikes last only microseconds, and the chance of that coinciding with the camera's exposure are small indeed. But digital techniques make it possible to add a bolt of lightning to almost any landscape.

Alien Skin's Lightning filter is a plug-in from the Xenofex collection. Lightning allows you to place lightning into any scene, although clearly, for authenticity's sake, scenes should be chosen that give credible results: dark clouds, stormy sunlight, and so on.

The filter lets you alter the characteristics of the lightning. You can, for example, increase or decrease the amount of branching in the lightning fork, or you can increase the amount of spread in branching and also how jagged the fork is. Like a

real lightning event, you can also add glow to the top of the bolt, illuminating the cloud from which it appears to emanate.

1. This scene with ominous storm clouds and colorful sunset will be ideal for our lightning effect. But we can make it better still (see fig 14).
2. Use the Layers command to make a copy of the image and paste it into a new Layer (Layer····⸬Duplicate Layer). In the Layers palette, change the Blend mode from Normal to Multiply. This gives an effect similar to sandwiching two copies of a transparency together: a darker, more intensely colored one results (see fig 15).
3. We only want our lightning bolt against the sky, not the foreground. To achieve this, begin by selecting the foreground using the Magic Wand tool. Since it's virtually black here, this is relatively simple (see fig 16).

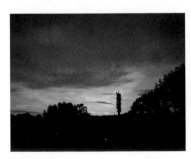

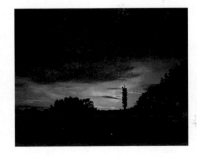

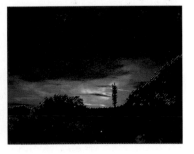

Fig 14

Fig 15

Fig 16

4. Add a new layer to the image (Layer····⟩New····⟩ Layer) and then select the Lightning filter. The dialog box looks like this (see fig 17). Because we have applied it to a new, empty layer, you won't see the image. The two targets can be moved to define the start and end points of the lightning.

5. Apply the filter and then press the delete button. This will delete that part of the lightning that has been applied over the foreground (see fig 18).

6. By changing the parameters in the filter dialog box, we can achieve a quite different result. Like real lightning, the randomizing feature of the filter ensures that applications are unique (see fig 19).

For more ambitious results, you can create the effect of lightning reflected in water. To create this scene (see fig 20), the photographer copied the image layer containing the lightning and then used the Transform tools to invert it before positioning it. To complete the illusion, a minor amount of rippling (created using the Ripple filter) was applied so that the texture of the reflected lightning matched that of the water's surface.

USING FILTERS TO ENHANCE NATURE

Some filters are subtle in their effects, others extreme. Extreme filters can deliver eye-popping graphic effects, while others can deliver photographically accurate embellishments difficult or impossible to create any other way.

It is hard to categorize Flaming Pear's Flood filter. It's so overt in nature that it demands being consigned to the "cliché" category. But this easy-to-use filter is so effective, you may well find many an

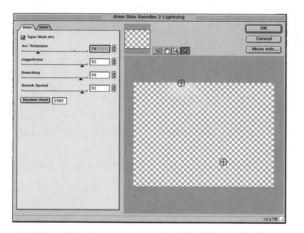

Fig 17

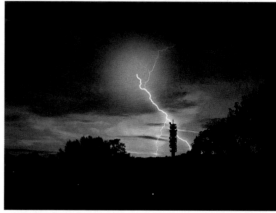

Fig 18

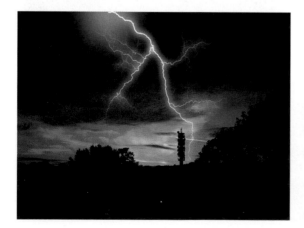

Fig 19

Fig 20

excuse to do just that. And since it is clearly designed to enhance the photographic nature of images, it's worth closer inspection.

What it does is literally create a flood in your image or selection. But this flood is extremely effective, mimicking both the look of real water (whether lake, river, or sea) and giving reflections that are utterly realistic.

As with most filters, the key to successful implementation is thinking about the end result first. Here's an image where we can use the filter to great effect (see 21). Obviously playing to the camera, these two girls are sitting in their land-locked canoes at a sculpture park. Apart from a short period in the autumn and winter, the canoes sit on ground that is merely damp. But even when the conditions get wetter, the ground becomes only a modest stream. We can change that, however, and cast them adrift in a virtual lake.

1. We need to apply the filter to give the impression of water beneath the closer canoe and also lapping up the sides. Begin by using any appropriate selection tools to nominate the parts of the canoe you want to remain out of the water. Here, a combination of Freehand and Magnetic Lasso tools proved the most effective. Switching to Quick Mask mode, this is the effect of the selection (see fig 22).

2. Invert the selection (Select····⟩Inverse). We want everything but the girl and canoe to be the selected area for the application of the filter. When the Flood filter is selected, we get a comprehensively specified dialog on screen. Note that the nonselected canoe is absent from the image shown in the dialog (see fig 23).

3. The dialog contains a number of controls, most of which are best explored by trial and error (bearing in mind there is no "right" or "wrong" with filters of this type), but the most useful is the View set. Here you can position the water relative to the frame and also vary your own viewpoint on the water to ensure that it matches the perspective of the scene (see fig 24).

4. Apply the filter. The result, as you can see, is remarkably convincing. To make it more so, here we've used the History Brush to remove some of

Fig 21

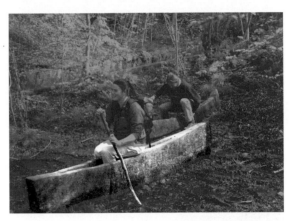

Fig 22

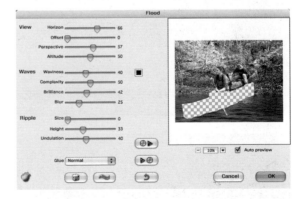

Fig 23

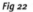

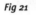

Fig 24

Fig 25

Fig 26

the reflection around the base of the "oar" and the same brush (at a lower opacity setting) to soften the edges of the water against the canoe (see fig 25).

5. Did your notice the small dice icon in the Flood filter's dialog box? This randomly alters the filter settings to produce different water effects. If you are uncertain about how you should configure the settings, this is a great way to cycle through a good

Fig 27

collection of presets. A couple of presses, and this more tranquil setting for our canoe image was produced (see fig 26).

We can be as dramatic or as subtle as we like with a filter such as Flood. We can use it to enhance a scene—such as the case of our canoeists—or to create results impossible in nature.

The Potala at Lhasa in Tibet is built on a high hillside that, as far as I know, never suffers from flooding. But with a little judicious use of the Flood filter, we can transform it into a waterside scene. To make the deceit more realistic, the foreground foliage was excluded from the filter effect (see fig 27).

TIPS

- Successful use of filters such as Flood depends on getting the context right. You need to establish how water would appear were it actually to flood the scene, taking note of where you would and where you wouldn't expect to find it.
- Flood is more useful than many extreme filters, but again don't use it too often. A shot or two in a collection could be eye-popping, but transforming every other scene just won't work.

A PUZZLING FILTER

Some digital effects filters, like their optical counterparts, appear to have a rather dubious raison d'être. Either their effects are so esoteric as to defy credible use or so overt as to betray their origins. Does this mean that we should ignore them? No, with sensible and, perhaps, sensitive use, even the most

apparently absurd filter can find a useful application.

The Puzzle filter, one of the Xenofex collection, is a case in point. It applies a jigsaw puzzle overlay to an image to give a result that looks exactly like a completed jigsaw puzzle. It does a remarkably good job: rather than a simple overlay that merely marks the edge of the pieces, it gives texture to the edges, producing a real impression of a die-cut puzzle with shading and highlights giving each "cut" a more three-dimensional look (see fig 28).

But we can go one better and, with just a few minutes work, make the puzzle look incomplete. We can—digitally—remove a piece of the jigsaw and leave it scattered, apparently aimlessly, elsewhere on the image. Here's how.

1. Begin by applying the Puzzle filter. If you don't have a copy of Xenofex, you can do much the same using a sharp-edged paintbrush tool. Use the Magnetic Lasso tool to draw around the edge of your chosen piece of puzzle. You'll find that, unless you are trying to select a particularly dark piece of the image, that the default settings are sufficient to quickly describe the perimeter of the piece (see fig 29).

2. Copy this selection and paste it back into the image. It will appear in a new layer. You can now use the Move tool and Transform tool to place this piece elsewhere in the image and rotate it at will (see fig 30).

3. Apply Drop Shadow (Layer····▷Layer Effects····▷Drop Shadow) to the piece to add to the realism and make it appear to be resting on the surface of the puzzle. You will need to adjust the angle of the lighting, using the light wheel in the dialog box, to ensure that the lighting effect matches that of the rest of the image (see fig 31).

4. Now we need to create a "hole" where the original piece came from. Choose Select····▷Reselect to restore the selection boundary to the original piece. Next, select a background color that would be appropriate (like the brown, here) and then press the Delete or Backspace key. The selection will disappear, leaving the background color exposed (see fig 32).

5. You may need to give this hole the drop shadow treatment as well, but make sure that the lighting

Fig 28

Fig 29

Fig 30

Fig 31

Fig 32

Fig 33

direction is 180 degrees different from that applied to the puzzle piece. This will give the effect of a hole through the puzzle rather than another object on top (see fig 33).

With a little more work, you could remove other pieces and produce a more casual, semicomplete puzzle effect.

But even now that we have found an effective use for this filter, it does not mean that it should be used too often. Such overt filters as this do tend to give results that border on the clichéd and test the patience of those viewing your images. The first time they may think it clever; on each repeat, they will probably just groan . . .

USING FILTERS FOR CORRECTING DISTORTIONS

The lenses that we tend to take for granted on our cameras are, for the most part, very precisely configured and represent the zenith of decades of optical design. The production of specialized glass types and computer-aided design has led to increasingly more versatile lenses, and optics that were once considered exotic can now be found in the most humble of gadget bags.

But pushing lens technology to the limits has not been without its problems. It's not unusual, even in the case of some midmarket cameras and optics, to find that the extreme flexibility in optical terms comes with a degree of image distortion that critical users may find verging on the unacceptable. This is the unfortunate side effect of compromises that have to be made, first, to deliver a product at an acceptable cost and, second, to deliver the lens in a compact size. The most pronounced lens distortions are pincushion and barrel, and they manifest themselves most visibly when there are rectangular elements in the scene. Pincushion distortion renders rectangles with rather pronounced corners and convex sides. Barrel distortion, conversely, bows the sides outward in a ballooning effect.

Both of these effects are at their most noticeable when zoom lenses are used at the extremes of their focal lengths: pincushion at the telephoto end and barrel at the wide-angle end. The latter problem tends to be made worse because barrel distortion is also a natural consequence of photographing regular-shaped objects close-up with wide-angle lenses.

Fortunately, we can correct images that fall victim to these problems relatively easily using dedicated filters. Here we're using the Barrel Distortion feature in Photo-Brush. This has a very clear representation of the correction that makes precise adjustments simple. You can type in the amount of correction in the appropriate box or use the incrementors to increase or decrease the amount until the correction is made to your satisfaction.

Fig 34

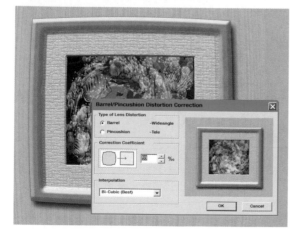

Fig 35

Fig 36

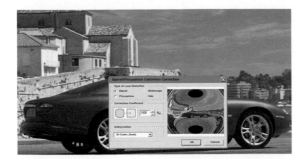

Fig 37

Fig 38

Photographing artwork up close (copyright permitting) will really test the mettle of your lens and immediately show up any distortions. In this image (see fig 34), there is a modest (but significant) amount of barrel distortion due to the need to use a wide-angle lens to record this image. The bowing of the sides of the image and the frame are unacceptable.

Selecting Barrel Distortion brings up the appropriate dialog box, and we can then make the necessary corrections. Click on the Barrel button first and then enter an amount in the window (see fig 35).

Our corrected image features straight sides—both horizontally and vertically—and the stripes on the wallpaper, too, are linear (see fig 36). You can always use a grid to establish a precise alignment.

Although corrective tools, distortion tools such as Barrel Distortion can also be used to create dramatic wraparound effects. Applying extreme

amounts of distortion to a conventional image can, for example, replicate fish-eye lens effects or wild multiple-reflection effects. In this example (see fig 37), an image with no notional distortion has been subject to the same Barrel Distortion feature as used in the previous example. This time the controls have been set to an extreme level (the maximum allowed is 1,000 percent).

The image that results is undoubtedly eye-catching (see fig 38). It is one of those effects you'll find works well with some images and not at all with others; it's also an effect to use sparingly. Once is eye-catching; twice is tedious.

Photoshop's Liquify filter (fig 39)

Liquify is a free-format-distortion filter that applies a mesh warp surface over an image in order to correct—or exaggerate—distortion. Unlike those filters designed for the specific correction of barrel or pincushion distortion, the tools in Liquify allow the distortions to be applied with a brush. As such, the effect can be applied to the whole image (like Barrel Distortion) or can be more local in its application. In Photoshop parlance, the Pucker tool corrects barrel distortion and Bloat, pincushion.

Fig 39—Liquify is ideal for correcting distortions, but many users prefer to exploit the ability to add distortion to the creative limit.

LAYERS AND LAYERED IMAGES

In this chapter we will:

- **Learn to understand the importance of layered images.**
- **Explore the different types of layers that can comprise an image.**
- **Discover the importance and uses of layer blend modes.**

We've seen in several of the worked-through examples in this book the importance of layers. Layers make it possible to produce composite images that can be manipulated and have elements juxtaposed even after we have saved our images to disk. The best description of layers is to think of them as transparent sheets of acetate. On each sheet, we can place selections or objects. Then we can arrange these acetates in any chosen order over a background and alter the order of the acetates in the stack.

In fact, thinking of layers in this fashion works very well when we turn to the Layers palette, which is the palette that figuratively illustrates the layer composition of an image (see fig 1).

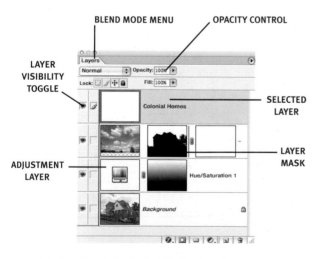

Fig 1—The Layer palette shows the layers that compose an image but can also be use to manipulate those layers and make it possible to hide, reveal, delete, and create layers.

When we copy a selection to an image (by dragging it from another, or using Copy/Paste), a new layer is automatically created. But a layer containing an image element is just one of the range of layers, a range that also includes adjustment layers, fill layers and layer styles. Let's explore each of these in turn.

Flattening images and merging layers

There's no doubt that preserving layers makes the manipulation and refinement of images simpler. A flattened image—one in which the layers have been removed and all image elements indelibly added to the background—would be hard to manipulate in all but the most rudimentary of ways. But multilayer images are more demanding on disk space, often requiring many times that of a flattened image. Some image file formats (such as JPEG and older versions of the TIFF format) will automatically flatten an image when it is saved. To ensure that layers are preserved, you'll need to save files in the native file format of the application (.PSD in the case of Photoshop) or in a TIFF format that supports layers.

Be aware that if you save a multilayer image in the native format of one application, you may be able to retrieve the layer information if you open it in another application, if the file format is supported in that application. But this is not always the case, so it is worth checking when sharing files.

If you want to partially flatten an image—flattening those image elements that you might want to manipulate together—you can do so by using the Merge Visible command in the Layer menu. Make those layers that you don't want to flatten together invisible by clicking on the eye icon adjacent to the layer. Then choose Merge Visible. Now, when you make the invisible layers visible again, you'll be left with your reduced set of layers.

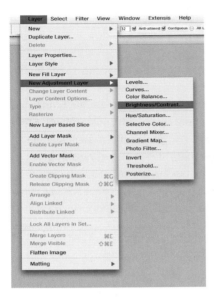

Fig 2—You can invoke a new adjustment layer via the Layers palette (see above) or Layers menu (see left).

With adjustment layers, we can vary color, tonal, and other parameters of our image layers without applying any irrevocable changes.

Creating adjustment layers

Adjustment layers are identical in many respects to conventional image layers. We can move them relative to the other layers in a stack and can also hide, copy, and delete them.

Creating an adjustment layer is simple. Click on the New Adjustment Layer on the base of the Layers palette. A menu list opens, and you can choose the type of adjustment layer. You can open the same list by selecting Layer⋯New Adjustment Layer (see fig 2).

When an adjustment layer has been created, you can use it as you would the corresponding feature. For example, if we selected a Levels adjustment layer, the Levels dialog box opens and permits us to make any adjustments to the levels required (see fig 3).

We can also make a selection first, if we only want the adjustment layer's effects to be applied selectively to parts of an image. We will see those parts of the image to which the adjustment layer's effects are not applied masked in the thumbnail in the Layers palette. Here (see fig 4), a Color Balance layer has been applied only to parts of the subjects of this image.

ADJUSTMENT LAYERS

Layers, then, are considered virtually essential not only for creating obvious image composites but also for a wide range of image effects. Their key competence is that you can, in a multilayered image, reconfigure that image by rearranging the layers or manipulating them.

But what if you don't just want to rearrange or manipulate them; assume instead that you want to remove or change an effect (such as a change to the levels or color balance) that was previously applied to the layer? The simple answer is you can't. But if we had the foresight to apply effects to a layer using an "adjustment layer," such changes would be simple.

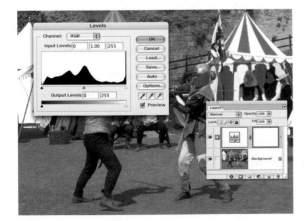

Fig 3

Fig 4

FILL LAYERS

Like adjustment layers, fill layers apply effects that can be altered or even discarded at a later point. Fill layers allow us to add colors, gradients, or patterns quickly to an image. But, unlike adjustment layers, fill layers don't affect the layers below.

LAYER STYLES

Sometimes called layer effects, layer styles take the interaction of layers a step further and allow us to produce shadow effects, glows, and patterns. Layer styles don't exist as separate, distinct layers but rather they are effects that modulate the appearance of an existing layer. A layer that contains layer styles is indicated by a small "f" symbol to the right of the layer's name; click on this, and you'll see a list of the layer styles associated with the layer. You can remove any of these by dragging them to the trash icon at the base of the palette (see fig 5).

Although it was introduced with Photoshop Elements, Photoshop CS introduced a Styles palette that includes a number of preconfigured layer styles. You can see a basic set by opening the Styles palette (Window····⋗Styles) and can append further ranges by selecting the set from the pullout menu—click on the small arrowhead to the top right of the palette (see fig 6).

But most photographers will consider all the options available here as rather contrived in nature and lacking subtlety. It's often better to create your own using the Layer Styles dialog. Select Layer····⋗ Layer Styles to open the default dialog (see fig 7).

The makeup of the dialog box will depend on the nature of the layer style selected. In the case of the Drop Shadow, shown here, you can alter the direction of light (which obviously affects the direction of the shadow), the distance of the shadow from the selection, the spread of the shadow, and the density.

The light direction figures extensively in layer styles, and it's important to ensure that if you apply multiple styles, or if you apply a similar style to multiple layers, that the lighting always appears to be coming from the same direction. You could do this by adjusting the lighting angle in each and every layer style or take a shortcut: select Layer····⋗Layer Style····⋗Global Light, and you can set a lighting angle for the entire scene.

Layer styles and text

Photographers tend to use little of the comprehensive text capabilities of most image-manipulation applications. When we create images we often consider text—even when used for captioning—as despoilers. But there will be times when text can be used with an image, such as when we create posters, greetings cards, and even postcards. Clichés though these may be, the use of layer styles can lift the results above the prosaic and aid legibility and composition.

Here's a rundown of the most appropriate layer styles to use with text. You can use one, two, or even more together, but make sure that you don't hinder legibility through overuse. In addition, stick

Fig 5

Fig 6

Fig 7

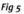

Fig 8

Fig 9

Fig 10

Fig 11

Fig 12

with the simpler styles of typeface, such as Arial or Verdana, to improve legibility.

- *Drop Shadow* Excellent for visibly "lifting" text clear of the image. You can vary the opacity, position, and spread of the shadow according to the subject. You can also use different shadow depths to emphasize different pieces of text (see fig 8).
- *Stroke* A stroked line around the edge of letters helps to improve legibility where the color of the text and that of the background are similar. Choose a simple color, such as white, black, or gray, for clarity, or a complementary color for more dramatic impact (see fig 9).

- *Inner Shadow* This gives the look of text being punched through the image, apparently revealing a background color behind. Don't use this with dropped shadows, but it can be combined, as here (see fig 10), with a stroke for emphasis.
- *Inner and Outer Glows* Use these for a more dramatic emphasis than the previous layer styles. Bright, luminous colors offer the most powerful results, but they should be used with care (see fig 11).
- *Bevel and Emboss* Great for pseudo-3D effects. Again, go for simple styles rather than the more complex of profiles (see fig 12).

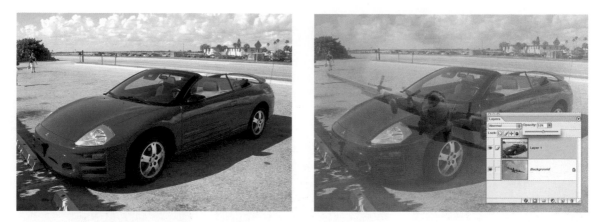

Fig 13—An image in Normal mode with the opacity set to 100% and 50%, respectively.

LAYER BLEND MODES

No matter where you are in Photoshop, you are never far from a blend mode dialog or blend mode pull-down menu. Click on one of these, and you'll see an initially baffling array of options. Despite being so prolific, it will be on the Layers palette that you'll most often encounter and use blend modes, which is why the term layer blend modes is also often ascribed to them.

Part of the reason blend modes appear so baffling is because of the number of them, which seems to increase with each new Photoshop version—CS boasts no fewer than twenty-three. But the principal reason we find them bewildering is that their effects appear, at best, idiosyncratic. Some seem to deliver very similar results, while others vary wildly as you change the opacity of one layer and according to the content of the image.

In truth, most photographers find the whole collection perplexing and tend to use only a select few. Once mastered, they will be used extensively and the power of blend modes quickly becomes obvious.

We'll take a look as some of the key blend modes—the ones that will become useful in our day-to-day image creation. For the more ambitious, there's a description of the others in the panel (see

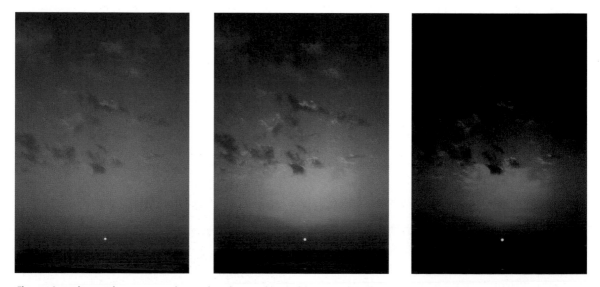

Fig 14—A good sunset becomes more impressive when combined with a copy of itself blended using Multiply. Repeating the process gives an even richer result.

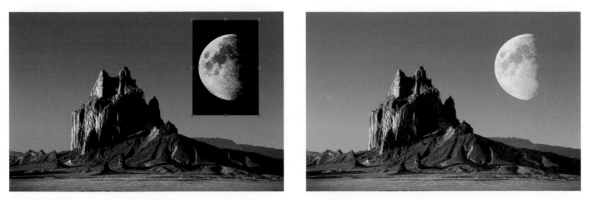

Fig 15—Adding a moon to a landscape is a simple job—if you know how to use the Screen blend mode (see page 305).

page 304), but the best way to explore their capabilities is to try them out on different images and image combinations.

Layer blend modes determine how a layer interacts with the background. We generally describe the layer as the paint layer, although you may also see the terms blend layer, donor layer, or even source layer used in some texts. Likewise, the background layer on which changes are enacted by the paint layer is sometimes known as the base, lower, or destination.

- *Normal* This is an easy one—it is the default setting, and in this setting a paint layer will, unless there are any transparent pixels or the opacity is set to anything other than 100 percent, totally obscure the background (see fig 13).
- *Multiply* A darkening mode. The best analogy is that it's like the effect you get when combining two transparencies in the same mount. Dark areas in the background or paint layer will always obscure elements in the complementary layer. Combining an image with a duplicate layer will result in a darker image with more saturated colors. It's ideal for building up density in a sunset, for example (see fig 14).
- *Screen* Imagine projecting two transparencies from different projectors on to the same spot. This is the net result of using Screen. The resulting image will always be brighter and less dense than either original (see fig 15).
- *Color* Adds the color and saturation only of the image layer to the background. It's most effective when you are trying to tint or hand-color a monochrome image. By painting on a layer (or series of layers), you can produce authentic-looking results and control the amount of color by using the opacity slider (see fig 16).

Fig 16—A hand-colored result is possible by careful use of the paint brush and then applying the Color blend mode.

Fig 17

Fig 18

Fig 19

Fig 20

Fig 21

More blend modes

- *Dissolve* One to avoid! Gives a Powerpoint-transition-like effect that has little if any pictorial merit.
- *Soft Light* Good for blending two images; altering the opacity varies the domination of layer over the background.
- *Overlay* A stronger form of Soft Light.
- *Hard Light* An even stronger version of Soft Light.
- *Pin Light* Varies the replacement of colors in the background based on the blend color. One of the more unpredictable modes.
- *Color Dodge* Uses grays to dodge the background; white makes the background lighter but with added contrast. Black has no effect.
- *Color Burn* The converse of Color Dodge. Darker grays and black burn in the underlying layer.
- *Hue, Saturation, and Luminosity* Hue will apply the hue of the paint layer to the background but not affect the background's saturation or luminosity; similarly, Saturation will apply the saturation of the layer to the background and Luminosity the paint layer's luminosity.

Using blend modes

Here are a couple of examples of using blend modes. In the first, we'll look at how we can use Multiply to add density to a faded image without needing to resort to more abrupt tools, such as Contrast. In the second, we'll look more closely at the case of placing the moon in a new sky, demonstrating the Screen blend mode.

Improving contrast

1. This image is badly faded. Our first reaction would be to use the Brightness/Contrast command to boost the contrast. Unfortunately, this image has such low contrast in the first place that it won't be too successful (see fig 17).

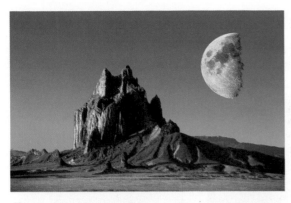

Fig 22

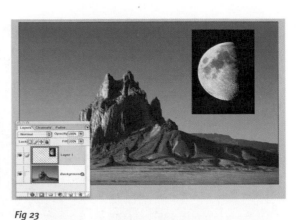

Fig 23

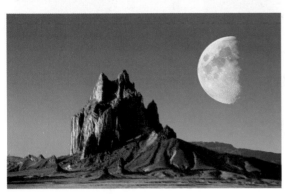

Fig 24

Fig 25

2. Instead, Select Layer⋯→Duplicate Layer... to add a duplicate of this layer to the image. At this stage, you'll notice no change in the image itself (see fig 18).

3. Switch the blend mode from Normal to Multiply. Multiply, as you will recall from earlier, gives the result similar to that of combining two transparencies in the same mount. It was successful in boosting a sunset, and here it will add density to the image while having little effect on those parts that should be light or white (see fig 19).

4. In extreme cases, a single application will have some success but will not result in a full tonal range. Unlike many effects (where we suggest only one application), here we can repeat and get a more substantial increase in density (see fig 20).

5. For a final adjustment (and to ensure that the full tonal range is included in the image), use the Levels dialog or (if you are in a hurry) Auto Levels (see fig 21).

The moonlit sky

1. At first it would seem simple to place an image of the moon in a twilight sky. Trim around the shape of the moon and paste it on to the new background sky. But the result is unconvincing. Why? There are parts of the lunar image that are black, but for realism's sake we should have no part of the image that is darker than the sky itself (see fig 22).

2. Instead, paste the image of the moon into the sky in its own layer. Again, don't worry about the look at this stage. We will remove the black at the next step (see fig 23).

3. Switch blend modes to Screen. Now only those parts of the lunar image that are brighter than the background sky are painted to the background: all the black and dark shadows adopt the color of the background sky (see fig 24).

4. Switching to Lighten blend mode can sometimes give a better effect. Study both blend modes and judge for yourself which gives the best pictorially pleasing results (see fig 25).

Fig 26

Fig 27

Fig 28

MAKING MONTAGED IMAGES WORK

It's crucial when compositing a montage that all the disparate image elements work, visually, as a whole. This means it's important to get the appearance of each element correct, not only individually but also as part of the whole. This means paying close attention to the following aspects of the image.

- *Resolution* A composited image element must be of the same, or better, resolution than the background or main scene.
- *Color* The color balance of elements taken from photographs taken at different times in different places and in different circumstances will need to be made similar to that of the scene. Often it is considered easiest to reduce all elements and the background to a neutral condition, but this may not be appropriate to the work. In Photoshop CS, you can use the Match Color command to match the color balance between image elements placed in different layers.
- *Tonality* The tonal range of the image elements will vary but will also need to be adjusted with regard to their new setting. For example, the tonality should match the lighting in the new scene and be appropriate for the position. In general, the closer an object is to the camera, the higher the contrast it exhibits. And objects positioned in the shadows will exhibit different characteristics to those in direct lighting.

- *Texture and grain* To even out discrepancies in grain structure and resolution, grain (or noise) can be added to give the whole image a coherence. Only the minimum amount required should be applied.
- *Lighting* It's crucial to analyze the lighting conditions of all elements and make any relevant corrections. When elements are drawn from different sources, it is inevitable that the lighting—in type and direction—will differ. Contrast and color corrections can make good differences in lighting types, but lighting direction errors can be more difficult to put right. Flipping an image element or applying dodge or burn effects can often be the solution in such situations.

Let's now put these rules into practice with a montage that is notionally a simple one but is useful for demonstrating these techniques. We've taken a shot of a traditional Chinese doll (see fig 26). Lighting was poor—a mix of muted daylight and incandescent bulbs. In fact, it was shot on a shelf in a toy store.

The object of this exercise is to place her in this Yellow River landscape, shot in bright, summer sunshine (see fig 27).

Extracting the doll from her plain background should be a relatively simple task now. We could use the Magnetic Lasso, Background Eraser, or

Fig 29

Fig 30

Fig 31

even the Magic Eraser. The latter two proved the easiest, as we can see from this work-in-progress shot (see fig 28).

We can now copy the doll on to our landscape. As both images were taken with the same camera and have been composed full-frame, there will be no resolution issues. If there was a dramatic difference between the two images, we would have needed to adjust the resolution of one or the other to ensure consistent quality throughout (see fig 29).

The front-to-back focus is often a dead giveaway with montaged images. If we really had shot this scene as a single image, even with the smallest lens aperture, we would have been unable to get both a close-up doll and distant landscape in critically sharp focus. We would normally produce depth of field effects for the landscape, but here, since it is all essentially at a similar distance, we can simply apply a modest Gaussian Blur to the background (see fig 30).

We now need to attend to the lighting. The doll is brighter lit from the front, while the background is side-lit. We can overcome much of this imbalance by applying a simple correction using the Shadow/Highlight command. We also have to invoke Match Color to ensure that there is a better color balance between both layers (see fig 31).

Now that we have even lighting throughout the scene, we need to ensure that the lighting directions match. With light coming in from the left, shadows

are being cast on the right. But the front-lit doll needs to have shadows added using the Burn tool. Use a low exposure amount and build up shadow areas gradually to the right of the face, the right side of the kimono, and where there are folds of fabric (see fig 32).

Fig 32

SHARPENING AND BLURRING

I n this chapter we will:

- **Learn why blurring occurs and how it needs to be corrected.**
- **Get to love the Unsharp Mask filter.**
- **Use deliberate blurring to create depth-of-field effects and soft-focus portraits.**
- **Use modified blurring features, including Motion Blurring and Radial Blurring.**

Blurring is often seen as an image defect and sharpening its cure. But in the digital world, all is not quite what it might seem. Blurring and sharpening can both be used as creative tools as well as corrective measures, as we shall see.

IMAGE SHARPENING

One of the cardinal rules of photography is that some part of the image should be sharp. Except where blurring is used deliberately for creative impact, it's essential that an image—in whole or part—is sharp. To this effect, many digital cameras include special algorithms that automatically apply a degree of sharpening to an image either to compensate for modest amounts of camera shake or to overcome—dare we suggest it—slight lens softness.

Often, however, it's best to dispense with any in-camera corrections of this sort and use the sharpening filters included in the image-manipulation application. But there is much more to sharpening an image than simply applying a sharpening filter. So we need to begin by understanding the rationale for sharpening and see where image softness is introduced.

Low-pass blurring (fig 1)

Let's start with the camera itself. Whether we chose a bargain-basement special or the latest superresolution digital SLR, CCD sensors of digital cameras feature a low-pass filter placed immediately in front of the imaging surface. This acts to improve the image in several ways, the most significant being a reduction in noise levels; the filter tends to even out random fluctuations in noise levels in the pixels. Filtration can also remove moiré fringing, which is the color line patterning that can result when an image features repeating detail of the same scale (when imaged by the lens) as the width of the pixels making up the CCD chip.

Fig 1—Without low-pass filtering, moiré patterning can compromise an image, giving it an appearance similar to half-tone screening used when printing images in magazines and books.

Fig 2—Manipulative sharpening can be very subtle, but the deteriorative effect on an image is more obvious and (with additional edits) cumulative. The original image (left) was opened and saved in Photoshop five times. Already the detail of the stamens in this macro shot of a flower are lost (right).

Manipulative softening (fig 2)

It's unfortunate that some of the techniques we use ostensibly to improve our images actually cause degradation due to image softening. Often this occurs as a consequence of interpolation. When we change the size of an image—whether enlarging or reducing—new image pixels are created by averaging the values of those in the original image. In this process, we tend to lose the critical sharpness of the original image. The effect is even more marked if we use a tool such as Rotate to change the alignment of an image, whether to correct a slanting horizon or when producing a creative crop.

Output softening

Even if we are successful in maintaining sharpness throughout the manipulation process, we can still fall at the final hurdle: printing. When we send an image to a printer, the physical process of laying ink onto paper causes modest amounts of softening. We can't avoid this, although we can compensate by applying an equally modest amount of over-sharpening prior to printing.

When to sharpen

Sharpening, so many image experts tell us, should be the final stage in your image-editing regime. This makes good sense, since we are introducing sharpening after applying other techniques that could (and probably would) soften the image. The same wisdom also demands that any sharpening is undertaken just once—the argument being that compound and multiple sharpening will introduce artifacts that, while adding perceived sharpness, actually degrade the overall image.

The most successful sharpening policy that I have discovered suggests a two-stage approach. The first stage compensates for low-pass filter softening and manipulative softening. This is applied before we adjust the size and resolution of the image for printing (or sending to the Web) but after we have imported and manipulated the image.

The second stage is a more modest affair, used to compensate for the final output softening. This two-stage regime presumes that no in-camera sharpening has occurred.

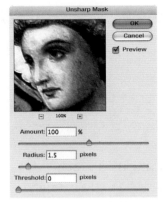

Fig 3—It's the three interdependent parameter sliders that frighten so many users from exploiting the Unsharp Mask (USM) filter.

Using sharpening tools

Filters such as Sharpen or Sharpen More sound like the ideal panacea for a soft image. But these simple filters, which can be found in virtually every image-manipulation application, will confer no favors on your images. Both (Sharpen More is identical to Sharpen but applies its effect about four times more strongly) give an image a sharpened look but do so without fear or favor of the content of the image. In doing so, they can achieve our objective in certain parts of the image but enhance and exacerbate defects and artifacts in other parts. No, our ideal image-sharpening tool is one that can be applied in a controlled fashion, delivering the appropriate amount of sharpening for specific elements of an image. And we find this in the Unsharp Mask filter.

The Unsharp Mask is not the easiest of filters to master. Unlike the simpler sharpening tools, it features three control parameters that need to be subtly and crucially adjusted to get the best from the image. These are Amount, Radius, and Threshold (see fig 3).

- *Amount* Perhaps obviously, this describes the amount of sharpening effect applied. It's important to recognize that the process of sharpening doesn't restore any missing image detail (that is lost for good, and nothing can be done about it) but adds edge contrast to give the perception of sharpness. Adjusting the Amount slider will determine how much edge contrast is applied.
- *Radius* Adjust this, and we increase the distance in pixels from an edge over which edge contrast

Fig 4—To sharpen this informal portrait, which is a low-frequency image (see left), we set the Amount to 110, the Radius to 2, and the Threshold to 10. This is sufficient to avoid sharpening the skin but ensures that the clothes and hair are rendered with sufficient crispness (see center). Increasing the Radius to 3 and the Amount to 200, in the final image, gives an oversharp result. Sharpening artifacts are visible on the face, while the hair and grass take on an unnatural look (see right).

is enhanced. As we increase the radius, more pronounced sharpening is achieved that rapidly gives way to halo effects, signifying oversharpening.

- *Threshold* There will be some areas in an image where we don't want the contrast enhanced to give an edge effect. Think of blue sky, for example, or soft skin tones. With no threshold specified, there will be a risk that previously unnoticed noise in these regions of an image will be enhanced and made significantly more obvious. A good threshold setting avoids sharpening being applied to these areas but allows those areas with "real" transitional edges to have the sharpening effect applied.

Unsharp Mask filter settings (figs 4 & 5)

The precise settings used will vary from image to image and will also depend on the resolution of the image. High-resolution images will require a greater radius setting, for example, to achieve a visually similar effect to the same image at a lower resolution. But we need to define some starting points from which we can then hone and refine the settings to achieve the best results. This is most easily done by distinguishing between two different types of image.

The first are dubbed high-frequency images. By high frequency, we actually mean those images that contain a lot of fine detail, fine detail that is important to render as sharply as possible. Images in this class would include landscapes—especially those with large amounts of foliage where individual (or clumps) of leaves need to be discriminated. Rooftop cityscapes, where we see a large number of buildings each with a considerable amount of detail, also fall into this class. For these we need to apply sharpening to all parts of the image, so we set the Threshold to 0. To preserve small-scale detail, we need sharpening to take place over a small scale, so we must set the Radius to 0.5. The Amount setting will vary between 125 percent and 250 percent, depending on the subject matter (cityscapes respond best to higher values).

Our second class principally includes portraits. We call these low-frequency images. A portrait needs to be critically sharp, but parts of the face and skin react adversely to sharpening, introducing artifacts and giving an unflattering appearance. For these we would take as our starting point an Amount of 100, a Radius of 3 pixels, and a Threshold of between 5 and 15. This threshold ensures that random color and tone fluctuations in the skin are not exaggerated by the sharpening process.

MODIFYING DEPTH OF FIELD (fig 6)

Harnessing the power of a lens's depth of field (the perceived area of sharpness both in front of and

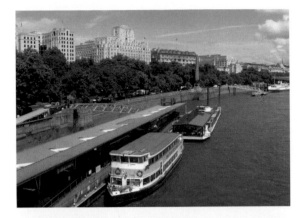

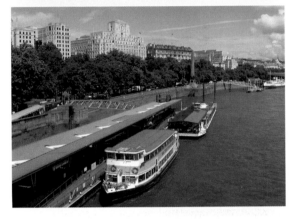

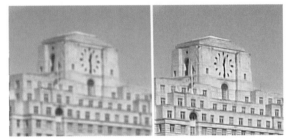

Fig 5—For this cityscape (see top)—which also includes a certain amount of foliage for good measure—settings of Amount 150, Radius 0.5, and a Threshold of 0 gives an appropriate sharpening effect (see center). The actual effect is more clearly seen by examining the close-up of the clock on the Portland Stone building (see above).

benefits, not least being you can be pretty certain that shots will be in focus, even if the focusing system of the camera did not precisely target the key subject. It also improves the perceived quality of the shot. We instinctively consider a sharp shot "better" than one that is slightly soft in focus terms.

If you have a compact camera or simply need to exaggerate the shallowness of the depth of field in an image, there are two ways to achieve the result. The first is manually to select and blur specific regions in an image. It sounds complex and a little fussy and, up to a point, it is, but the task is by no means onerous. It also allows you to get the most controlled effects. We'll use that in a moment to discover how best to implement the technique.

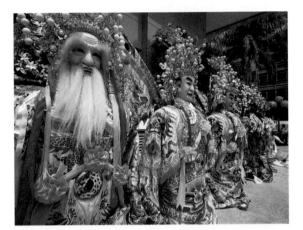

Fig 6—Left to their own devices, many cameras strive to deliver the greatest depth of field (see top). In cluttered scenes such as this, it makes it difficult for the eye to settle on a key element. Increasing the depth of field helps draw attention to just one element (see above).

behind the point actually focused on) is a powerful tool. Shallow depth of field can help isolate a subject and draw attention to it without unduly separating it from that environment. The trouble with many digital cameras (along with many conventional compact cameras) is that their lenses offer a very extensive depth of field. This has many

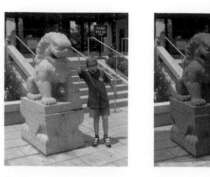

Fig 7

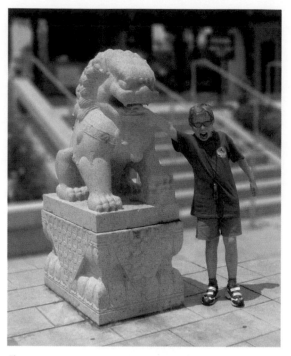

Fig 10

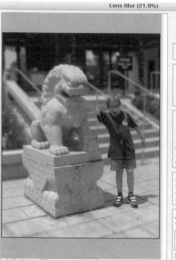

Fig 9

The Lens Blur filter

Users of Photoshop CS have an additional, semi-automated alternative in the form of the Lens Blur filter, which is one of the Blur filter sets. In its simplest form, you select that part of the image that you want to remain in sharp focus (normally the main subject), and the filter will blur the surroundings. For more sophisticated and realistic effects, you need to create a depth map of the image. This indicates to the filter which parts of the scene are further away and hence need to be blurred more.

In this example, the subjects are the child and the dragon statue (see fig 7). We need to select this first. Moreover, we also need to select all those parts of the image that are equidistant from the camera. These are those parts of the image that would also

be in focus were the depth-of-field effects in this image real. In this case, it's the paving beneath both the child and statue that needs to be included. They are shown here shaded blue (see fig 8).

The Lens Blur filter allows us to emulate the blurring produced by different lens irises. The number of blades in a lens's iris will determine the actual type of blurring, and the options provided let us apply blurring from irises with three to eight blades. For most people, this is extremely pedantic; the look of the blurring invoked by each is different, but subtly so. Where the feature comes into its own is where there are lots of specular (mirrorlike) highlights. This doesn't have a particularly pronounced effect in images such as this, but if we were applying blurring to a backlit shot of a seascape, for example, then we would notice a difference as each highlight on each wave was blurred into a shape dictated by the shape of the iris (see fig 9).

The end result of applying Lens Blur is remarkably effective (see fig 10). If we had taken the time to create a depth map, then we could have achieved even better results with those parts of the image that are more distant (the gateway in this case) blurred further.

Fig 11 LENS BLUR 0 LENS BLUR 20 LENS BLUR 40 LENS BLUR 80

More about the Lens Blur filter (fig 11)

With the Lens Blur filter, it is easy to adjust and compare the effect of blurring by moving the Iris Radius slider. Here, for comparison, is the same image with 0-, 20-, 40-, and 80-pixel radius blurring applied. No setting is correct, but each has a different effect on the image.

DIY adjustment

Whether we are going to create a depth map (the full details of which are beyond the scope of this book but are detailed in Photoshop's copious help menu) or manually alter the focus in an image, we need to begin by analyzing the image and breaking it into different "focus zones." These will be areas to which progressively more blurring is applied. By feathering the selection of these we can produce results that are pretty much seamless.

Take a look at the schematic (see fig 12). The camera at "A" is taking a photograph of the subject at "C." There is foreground detail at "B" and background detail at "D." In the distance we also have the cityscape at "E."

In the majority of images, it is the most distant parts of the image that are the most unfocused. Middle-distance objects will also be less in focus. But the amount of blurring that needs to be applied to foreground objects is different to that which needs to be applied to those further away. The red shading shows, approximately, how the amount of blurring changes with distance. Here we would apply a similar amount of blurring to the foreground elements at "B" as we would to the background "D," even though the latter is considerably further from the subject. Items very close to the camera (such as overhanging foliage) would need to be rendered very much out of focus.

Let's apply this theory to this image (see fig 13). It's a small-scale one and we might have expected even a compact camera to give a narrow depth of field. But alas, no! We'll need to accentuate it ourselves.

Fig 12

Fig 13

Fig 14

Fig 15

Fig 16

Fig 17

Fig 18

Fig 19

Fig 20

Fig 21

1. Select the table and the cereal box. Though the latter is already slightly blurred, we will need to make it more so. The Magnetic Lasso works well for this, but set a Feather amount of around 5 pixels to avoid sharp boundaries. If we were to switch to Quick Mask mode, this is how the image would look (see fig 14).

2. Apply a Gaussian Blur of about 2 or 3 pixels. If the blurring looks too strong, reduce it. Similarly, if the effect is too mild, increase the amount. Gaussian blurring is based in absolute pixel dimensions, so the amount you apply will depend on the resolution of the image (see fig 15).

3. Select only the cereal box. Though this is not substantially closer than the table, the closeness to the camera does demand a greater degree of blurring. In this case, it is particularly important that you feather the edge of the selection so that there are no abrupt boundaries (see fig 16).

4. Apply a similar amount of Gaussian Blurring to the selection. This will soften the already blurred box further and give a strong out-of-focus result (see fig 17).

5. Now we can turn to the background. The near background, though some way behind the subject, needs only a modest amount of blurring. This equates to the region "D" in the focus diagram (see fig 12) and should be a little less than that applied to the table in step 1. Select all the background and then apply our modest amount of Gaussian Blur (see figs 18 & 19).

6. Our final mask contains only the more distant parts of the room. Granted, in scene like this there will be little in the way of "distant," but for maximum effect, we can apply a further modest amount of blurring to the furthest reaches of the room (see fig 20).

7. The net result is a convincing image with shallow depth of field. As a result, it is an image where the emphasis on the subject is strongly enhanced (see fig 21).

SOFT FOCUS

Prized by the portrait photographer, soft-focus effects are key to a romantic, dreamy style of portraiture. But often the effect is often misinter-

preted. Soft focus doesn't mean out of focus. On many occasions, photographers have attempted to achieve the subtle, dreamlike look by simply defocusing the lens slightly. Sadly, the results are never anything more than what they are—blurred. The irony is that creating a genuine soft-focus result is a simple process.

The essence of soft focus is to record a critically sharp image of the subject but combine it with a soft, out-of-focus image of the same subject. The result is an image in which we see the subject in sharp focus but, by virtue of the overlaid softened image, fine detail becomes softened and the whole image given a romantic mistiness.

Over the years, a number of solutions to soft focus have been produced. We've seen soft-focus lenses that deliberately soften images by not correcting some of the (normally) damaging aberrations and distortions introduced by optical systems. Hasselblad—with their Softar range—and others have produced soft-focus filters. These use a pattern of glass blisters over the surface of a clear-glass lens to produce the image softening. But all these in-camera solutions have one problem—once you've taken the shot, you are stuck with that degree of softening. A digital darkroom solution gives far greater control. We'll examine this approach by applying it to an informal portrait.

Fig 22

1. Choose the image you want to soften. We've selected this girl with a seal toy. But the background is cluttered and intrusive and less than inspiring. Let's begin by cutting the girl from this image and placing it in another (see fig 22).

2. A combination of the Magnetic Lasso and the Quick Mask (to give a soft edge to the child's hairline) was used here (see fig 23).

3. This is the image we will use for the new background. Since both images were taken within minutes of each other, the color balance needs little attention and the scaling of both is similar (see fig 24).

4. We can now copy our selection from the first image and place it on the second, verifying our presumptions about the color balance. We can, at this stage, adjust the position of the child and crop the image if required to improve the composition (see fig 25).

5. To emphasize the child—before applying the soft focus—we can deliberately blur the background. Make sure that the background layer is selected and apply the Gaussian Blur filter. The amount will vary according to the resolution of the image. You need to apply sufficient to blur the detail but not so much that the scene looks unrealistic (see fig 26).

6. Now we can produce the soft-focus effect. Flatten the image and make a duplicate copy of it (Layer····⟩Duplicate Layer). Blur this layer using the Gaussian Blur. Make this blur greater than that you applied to the background. Don't worry that at this stage the whole image now appears blurred (see fig 27).

Fig 23

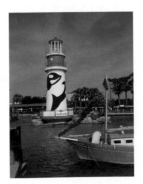

Fig 24

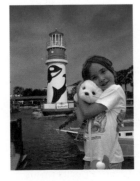

Fig 25

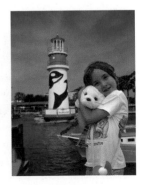

Fig 26

Fig 27

Fig 28

Fig 29

CREATIVE BLURRING

We tend to consider blurring a negative—the result of poor technique or using a camera outside its sensible operating range for the conditions. Hand-held long exposures and the use of extreme telephoto lenses without adequate support both tend to produce fundamentally unsharp images due to camera movement. But blurring can also be introduced in a controlled way to emphasize movement and increase the dramatic impact. We traditionally do this by panning the camera with a subject to keep the subject sharp and render the surroundings blurred. Or we may choose to do the converse—keeping the camera rigidly mounted and allowing the subject to move and blur as it is recorded.

Blurring techniques can often be a hit and miss affair: get the timing fractionally wrong and results will be unacceptable. Digital blurring gives us far more control and only requires that we take a sharp original. We can choose later the type of blurring we want—subject or background—and even its extent. Furthermore, we can be even more selective in our blurring, as this first example shows.

7. On the Layers palette, ensure that the new layer is selected and move the opacity slider to the left. A setting between 35 percent and 55 percent will give the result we are after. This will give sufficient blurring to soften the image but with enough of the original image showing through to maintain sharpness (see fig 28).

8. In this case, we can embellish the effect by adding a further layer, a copy of the blurred one. This time, rather than change the opacity we will change the blend mode. Change it from Normal to Screen or Lighten. This gives a modestly high-key look to the portrait (see fig 29).

Looking at the image in close-up shows the difference between a blurred and a softened image. In the blurred image (see fig 30), there is softness but no detail. The softened image preserves all but the finest detail but combines it with a soft glow. The finest, low-contrast detail that is lost tends to be that which is least flattering—skin blemishes or unwanted texture for, example.

Enhancing motion

1. Shooting a subject like this roller coaster (see fig 31) illustrates how problematic it can be to convey a sense of movement through blurring. To fill the frame, you need to get close to the action; but at this distance there will be a modest amount of blurring even when high shutter speeds are chosen. The result is an image that looks compromised. We do have blurring due to the motion, but this does not appear to the viewer as a creative technique—rather, the image simply looks unsharp.

2. Let's begin by enhancing the motion. Use the standard Lasso tool and select a Feather amount. This should not be too large in this case: what we want to do is select the cars but without

Fig 30—The original and final image details compared.

Fig 31

Fig 32

Fig 33

that it aligns with the direction of the roller coaster. We can also use the slider to increase or decrease the amount of blurring (see fig 34).

5. Now we can combine our new layer with the original background to achieve a result that more clearly illustrates the motion. The result is much more powerful, and by feathering the edge of the selection, the result is a very smooth graduation between the moving and nonmoving parts of the scene. The problem, though, is that in blurring the roller coaster—the subject of the photograph—we have taken away the detail of this key subject. Looking at the photograph, the eye tends to drift around the scene and doesn't settle on any one point (see fig 35).

6. So, we need to restore a central subject to the image. We can do this by selecting some of the riders on the roller coaster and making them appear less blurred. Use the Lasso tool again and draw around a pair, or perhaps two pairs, of riders. Use Edit····⟩Copy and Edit····⟩Paste again to paste this selection into a new Layer. This new layer should appear at the top of the stack, but if not, drag the layer upward. Turning off (with the eye icon) the background and blurred layers now reveals our pasted selection (see fig 36).

making the selection too abrupt. For this four-megapixel image, a radius of 10 has been selected. Anything more will partially select too much of the background, causing problems later (see fig 32).

3. We can now copy this into a new layer by choosing Edit····⟩Copy and then Edit····⟩Copy. If we click on the little eye icon in the Layers palette corresponding to the background of the original image, we can see our selection in isolation (see fig 33).

4. Apply the Motion Blur filter (Filters····⟩Blur····⟩ Motion Blur). This will blur the selection only in a chosen direction. Use the little wheel icon in the dialog box to adjust the angle of motion to ensure

Fig 34

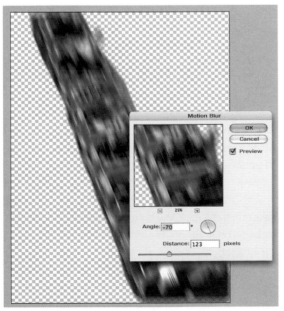

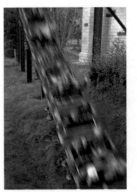

Fig 35

Fig 36

Fig 37

Fig 38

7. If we were to apply a modest amount of blurring to this selection, we would still have a blurred result and, in compositional terms, there would be little improvement. Instead, use the slider on the Layers palette to reduce the opacity of this new selection so that we retain the sharpness of this layer but allow a slightly blurred copy to show through (see fig 37).

8. The net result of our efforts is a much more compelling image: we have conveyed the speed of

Fig 39

the roller coaster but also retained detail that gives a more personal view of the action (see fig 38).

Rotational blurring and motion

Photoshop doesn't just give us the Motion Blur tool to help us in our movement deceit; it also provides the Radial Blur filter. This is, if anything, more powerful than its stablemate when it comes to creating motion effects. It boasts two modes, Spin and Zoom.

Zoom applies axial blurring that simulates the effect we might achieve were we to operate the camera's zoom lens feature when making an exposure. The image appears to explode from the center. It's great for concentrating attention and is widely used in sports photography and in car advertising to imply strong motion toward or away from the observer. It's an unsettling filter: the sense of movement can make for dramatic impact that really grabs attention, but it's not an image technique that you would want to use for images you intend to view for long periods (see fig 39).

We can achieve more intriguing effects using the Spin mode, particularly if we need to inject motion into a scene where there was actually no motion at all. The Spin mode produces rotational effects that can, for example, make static wheels look as if they are rotating. For best results, you need to work with an image of a vehicle taken from the side, as square-on as possible. Our target image is this rear quarter of an MG sports car (see fig 40).

Use the Elliptical Marquee tool to select the wheel and tire. Because we are square-on, this will be a circle, or very nearly so. Applying a grid over the image can help in accurately defining the circle (see fig 41).

We could apply the spin directly to this selection. Unfortunately, getting the center of the spin corresponding precisely to the center of the wheel

axle can be difficult, if not impossible, to achieve. I find it easier to copy the selection and paste it into a new image. When you do this, you create a new image that exactly fits the wheel, so the axle will be dead center. Note that there are still some stray areas of grass visible beneath the tire and through the wheel spokes (see fig 42). Don't worry about these—they will be of no consequence in our final image.

Apply the Radial Blur filter (see fig 43). Vary the amount using the slider to get the amount of spin you require. For convincing motion, I find an amount of 30 to be a good starting point. The spin is not previewed as you nominate it, so you will need to apply and then use Edit····⟩Step Backward to return to apply a different amount. Use Draft quality when testing the amount of spin, but use Best quality for the final application. Draft takes considerably less time to render the image.

We can now paste the spinning wheel back into the original image. It may be necessary to trim the position slightly using the Move tool. The spinning

effect is remarkably realistic, because we were able to achieve precision in the spin-center's position. Sadly, though, the scene is quite spoiled by the obviously static ground (see fig 44).

To overcome this, select the grass area under the wheel using the Lasso tool and copy and paste it into a new layer. This layer should be positioned between the background and our new spinning wheel (see fig 45). We can then apply Motion blurring to this layer to give a better impression of motion.

Motion blur can be applied in exactly the same way as we did with the roller coaster. By placing this blur layer between that of the background and the spinning wheel, we ensure that we don't get any blur smearing of the grass region over the top of the wheel, giving a true perspective to the image (see fig 46).

If you were attempting a whole car, you'd need to apply spin to both visible wheels, of course, but you'd also need to ensure that any of the surroundings visible through the car windows was blurred as well.

Fig 40

Fig 41

Fig 42

Fig 43

Fig 44

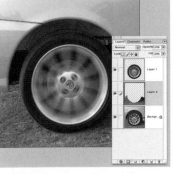

Fig 45

Fig 46

CREATIVE IMAGE TECHNIQUES

CREATIVE IMAGES

In this chapter we will:

- **Explore the potential of adding grain to images.**
- **Look at ways of reducing the color in an image for added emphasis.**
- **Discover opportunities in panoramic and stereo photography.**
- **Look more closely at the techniques and creative work flow required in image restoration.**

Creating a great image with our computer-based skills and knowledge of photographic technique is not just a matter of applying a digital filter or any other digital effect, creative or corrective; it's also about seeing and exploring the potential of the immense tool set that we now have at our disposal. Through this chapter, we'll explore some useful techniques and opportunities. We'll work by exploring new techniques but also exploit those that we have gained an understanding of already. We'll start by looking at how we can add mood to an image though the creative use of grain.

ADDING MOOD WITH GRAIN

Photographers have always viewed grain (the visible appearance of the dye clouds or clumps of silver halides that make up the image-carrying layer of conventional films) with a certain ambivalence. One argument considers it a necessary evil. It exists, but we do our best to conceal it. We can do this through using a fine-grained film, such as the low-speed Kodachromes and Fuji's Velvia, or we can process the film in a way that reduces the appearance of any grain.

A counter argument defines grain as essential and the key to making an image successful.

Of course, in general photography there will be situations where grain does add to an image's mood or potency and others where it simply detracts. We

can think of, for example, the sun-drenched beach scenes where we seek to capture areas of pure color, unadulterated by any texture. Conversely, there will

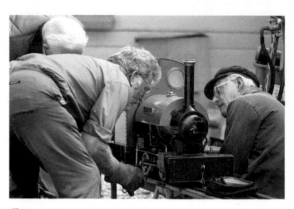

Fig 1

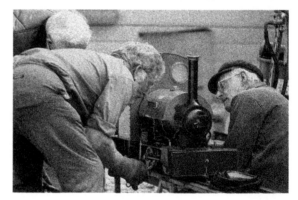

Fig 2

Fig 3

be times when we want to convey grittiness, whether in a landscape or in a portrait. Here, the grain can actively contribute to the success of the image.

In our digital world, we have traded grain for pixels. Benefit or loss? Sadly, pixelation doesn't seem to have as much emotional power as grain. But, answering the cries of many photographers,

BLUE

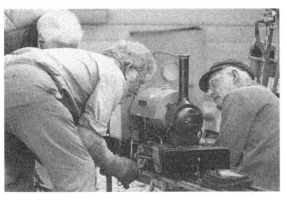

GREEN

Fig 4 **RED**

image-manipulation applications include at least one way to add grain to an image. And that grain can mimic the characteristics of almost any film and do much more besides, giving images a unique texture.

Applying grain

Some subjects positively cry out for the addition of grain. We can probably think of many of these instantly, but to exploit the mood successfully is not as simple as applying an appropriate filter. Here we have an image of some amateur engineers working on a small-scale locomotive (see fig 1). Taken with a high-resolution digital camera, it boasts that almost pixel-free look so prized in many types of photography.

1. Begin by applying a simple grain structure to the image. But rather than the Grain filter, here we've used the Add Noise option of the Noise filter submenu. This allows us to apply a controlled amount of random noise to the image (see fig 2).

2. The grain—or rather, noise—has given the image that grittiness that so ideally suits the subject matter. But, and unusually for such a subject, the result is still rather colorful. There is too much color in the image competing with the grain and the overall composition. Let's reduce the color range by selecting the Hue/Saturation command and lowering the saturation of yellow and magenta. Use the Edit pull-down menu to select each color and then move the Saturation slider to the left (see fig 3).

3. With only the essential colors preserved, the image is much more balanced. But we can go further. We can split the image into its component channels and see it in red, green, or blue light. Viewing the images as monochrome images in each of these colors gives quite a different look. In the blue channel image, for example, the blue of the locomotive becomes white, whereas in the red channel it becomes virtually black. Split the image into separate images by selecting Split Channels from the pull-out menu on the Channels palette (see fig 4).

4. Though we lose the locomotive color, it is probably the blue channel that gives the most successful

Fig 5

Fig 6

result, more so than the red (the green channel almost invariably proves somewhat lackluster). In particular, the people's faces have more character and color in this version (see fig 5).

Tips

- Grain can be successfully used in montaged images. Where elements of an image have come from different sources, or you have added areas of continuous color (using a painting tool, for example), results can look obviously jarring. Adding a very mild amount of grain or noise can help give the image an integrity it was previously lacking.
- Alternative treatments can give intriguing results. This is the Grain filter, set to Contrasty. The result is almost a graphic, posterized image (see fig 6).

REDUCED COLOR IMAGES: BRINGING SEPIA INTO THE NEW CENTURY

Digital sepia toning is something I have personally shied away from. It's partly because the effect is so overdone that it's become a digital cliché. And, in many cases it serves no useful purpose. It is rarely that an image is given greater impact by the simple replacement of a panchromatic palette with a simple color tone, no matter what the devotees of monochrome might suggest. Giving an antique, heirloom print this treatment may work for some but not for me. Part of my aversion to the technique is that, in the digital world, it's something of a cop-out. We can take a mediocre image, apply a monochrome tint, and feign that the result has merit by pretending it is older than it is.

Digital technology really does offer us the opportunity to do much more than this. But whatever technique we choose, it's important to begin with an image that is at least competent and that will benefit from the changes made. Reduced-color images need to have not only technical potency but also artistic merit.

A useful shortcut to the former that also delivers the latter comes in the form of a Photoshop filter plug-in from Flaming Pear Software. Called the Melancholytron, Flaming Pear suggest that it imbues images with a "certain sadness." Whether sadness is a quality of photographs (rather than their content) is debatable, but there is no doubting that the Melancholytron is adept at transforming the mood, color palette, and focus characteristics of an image. The result is a range of effects that can be likened to sepia tones but are free from the hackneyed associations.

The Melancholytron interface

Giving an image the dreamlike, aged quality requires one of those apparently intimidating interfaces that we explored with Alien Skin's Lightning filter (see page 292) and Melancholytron's stablemate, Flood (see pages 293–94). Understanding how it works is best done by breaking the controls into groups (see fig 7).

The top pair of sliders control the shape of the area over which effects will be applied. This could be a central vignette or soft, horizontal, or vertical bands. The extent of the vignette or width

of the bands can be altered by using the second of the sliders.

The next set of controls, labeled Focus affect, naturally enough, control the focus of the effect. These comprise the amount of overall blurring and also the degree and width of color blurring.

In the Saturation controls, we can change the saturation of the modified colors and the color of the vignetting. The Sepia slider determines how much sepia is introduced into the image. There's no getting away from this color, but at least here it's being used in a creative sense. The Glue pull-down menu offers a range of features that are, essentially, blending modes.

With this wide range of controls available, it can be perplexing to configure for a particular image. So the button at the bottom of the dialog marked with dice lets you make random settings. Each selection can be previewed in the dialog. Find one that you like, and you can adjust the sliders to make a more precise configuration.

Fig 7

Bear in mind that with filters as overt as this, there is no right or wrong. If the results look good to you, then they probably are; just try a few tweaks to the settings to see if you can further improve the results. Just as an example, here are four random interpretations of images of a church interior and exterior (see fig 8).

Fig 8

Fig 9—Original image.

Fig 10—Colorized image.

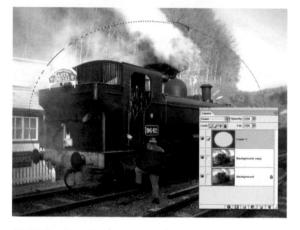

Fig 11—Layered image.

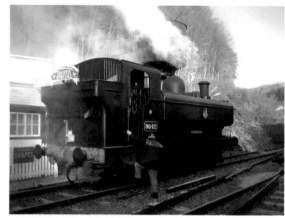

Fig 12—Final, reduced-color image.

Reduced color from your image editor

If you don't have Melancholytron, you can still produce reduced-color results using conventional tools. To produce an atmospheric interpretation of this image of an old steam train (see fig 9), we first produced a duplicate layer and then, using the Hue/Saturation dialog, clicked on the Colorize box. The result is a sepia-toned image (move the Hue slider to obtain the precise color you want).

Next, the opacity of this layer was reduced to allow the original image to show through. With a vignette applied, using the Elliptical Marquee, the borders were blurred with the Gaussian Blur. Finally, a brown gradient was applied to the vignette in a new layer and the Blend mode changed from Normal to Color to give the brown tint to the blurred borders (see figs 10–12).

PANORAMIC PHOTOGRAPHY (figs 13–16)

Panoramic photography is one of those holistic photographic subjects where it is impossible to divorce the taking of photographs and the visualization of a scene from the darkroom work we need to perform to create the final results.

But before we begin, let's spend a little time on the terminology of landscape photography. We need to begin by looking at the different types of panorama and being a little more explicit about the term—the word "panorama" tends to be bandied around whenever a picture is substantially wider than it is tall.

The generally accepted definition of a panorama is an image that shows, widthwise, a view that is at least as wide as the eye is capable of seeing. This can extend all the way to a 360-degree view. This would typically be wider than the view given by a

wide-screen TV (which has a ratio of width to height of 16:9—called the aspect ratio) and more so than the 20:9 ratio used in wide-screen movie films. But aspect ratio alone is a rather ambiguous way of describing a panorama. If we use a conventional 35mm camera with a 50mm lens (or the digital equivalent in terms of field of view), a 360-degree panorama will produce an image with an aspect ratio of around 6:1. Use a wider-angle lens, and this ratio falls. With an 18mm lens it becomes 4:1. The wide-

angle view will contain the same view as the standard lens but will also show a greater amount above and below.

The extreme panorama will capture 360 degrees horizontally and 180 degrees vertically. This, known as a spherical panorama, will have an aspect ratio of 2:1 and will capture everything in sight from the viewpoint of the camera.

We've said here that a panorama is a wide, horizontal image. This is perhaps being a too pedantic, as it is possible to produce panoramas that are tall and vertical. For our purposes here, we'll regard both horizontal and vertical images as panoramas, and the techniques apply equally both.

Cameras for panoramic photography

Panoramas can be shot with any camera, digital or conventional. And because our final image will be produced by joining multiple images together, we can achieve high-resolution results from digital cameras with comparatively modest resolutions.

You can, if you are serious about panoramas, buy dedicated cameras that will photograph an entire panorama in a single shot. These tend to divide themselves into fixed- and swing-lens types. All commercially available swing-lens cameras are film-based.

Fig 13—16:9 aspect: similar to a wide-screen television.

Fig 43—20:9 aspect: a wide-screen movie film.

The fixed-lens panoramic camera simply offers a wide-angle field of view. The most common of these will have aspect ratios of 2:1 (which is relatively modest) through to 3:1. Fujifilm's 6 x 17 (cm) camera is probably the best known of these.

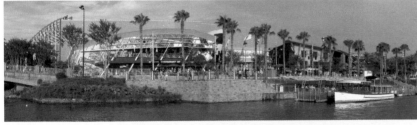

Fig 53—6:1 aspect: panoramic image from a "standard" lens.

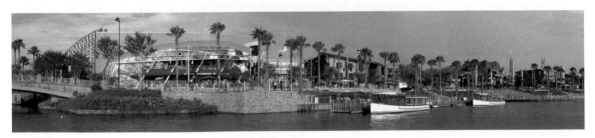

Fig 16—4:1 aspect: panoramic image from a wide-angle (18mm) lens.

This range-finder-type model also has interchangeable lenses. The benefit of a fixed lens (the term "fixed lens" describes a lens that is fixed in relation to the film, not permanently fixed to the camera) is that you can take shots of moving objects easily. Shots are instantaneous and capture the entire scene in one try.

Swing-lens cameras, popularized by the Russian Horizon and Horizont models, use a lens that, during the exposure, scans through an angle of 120–150 degrees, creating an image along a curved path on conventional film. Because it takes some time to swing the lens, up to ten seconds for 150 degrees (and even longer for those cameras offering 360 degrees), recording motion can be problematic.

Both these types of camera deliver a conventional—albeit wide—image that can be digitized and manipulated as any other conventional image. The type of panoramic photography that concerns us here is that which employs conventional cameras and involves digitally joining shots together to produce a panoramic effect.

Shooting images for a panorama
Getting the shots for a panorama involves shooting images side-by-side around the whole of the chosen view. Each of these should overlap by as much as 50 percent (though 40 percent is more usual). It makes

good sense to use a tripod when shooting to ensure that all the shots are level and to allow you to concentrate on getting the consecutive shots correctly positioned (though the precise amount of overlap is of little consequence).

You'll also need to ensure that the camera is set for a wide depth of field, using as small a lens aperture as possible (if your camera permits). Lock the focus, too, if possible, to prevent the camera from autofocusing on different distances in consecutive shots and ruining the overall effect.

When using a digital camera, it's important to keep the same color balance throughout. When swinging the camera through wide angles, there is every likelihood that the color balance—as evaluated by the camera's automatic white-balance control—will adjust to different elements in the scene, thus giving entirely different color shifts in different shots. Set the camera to an appropriate daylight or indoor setting and keep it constant throughout.

Exposure changes can cause a similar problem between shots, especially on sunny days when changes of four or more lens apertures or shutter speeds can occur in the same sequence. Locking the exposure is one solution, but when there is such a potentially wide exposure latitude, there is a risk of some frames becoming hopelessly over-

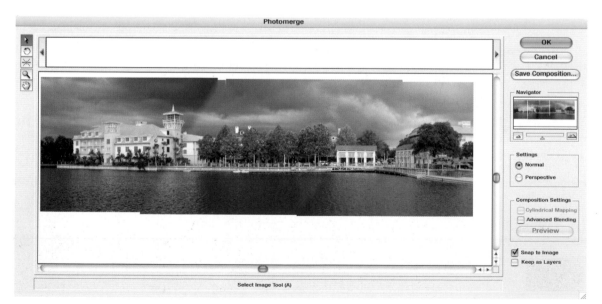

Fig 17

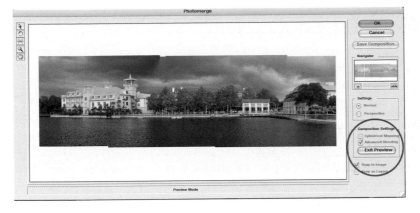

Fig 18

in some image-editing applications that provide panorama stitching. So, for our first foray we'll use the one in Photoshop, called PhotoMerge. This debuted in Photoshop Elements and made its way into Photoshop itself shortly after. In terms of complexity it's fairly basic, but it's successful in automatically stitching together images so that only minimal remedial attention is required.

Like most applications, the first step is to load the images; it's a simple matter of loading each, from left to right, and then pressing OK. Then the application will automatically conjoin the images, presuming that there is sufficient information to do so (see Where panoramas go wrong, below).

or underexposed. I tend to keep the exposure on automatic and make the corrections (to balance the scene) later.

A first panorama

Creating a panorama involves the following steps:

- Shooting the individual pictures.
- Importing the images into the computer and the panorama application.
- Stitching the images together.
- Editing or refining the results.

We'll assume now that we have some images taken using the techniques described above. We now need to import the images into a panorama application.

But what is a panorama application? Like general-purpose image editors there are a number of packages out there ranging from the basic through to the very complex. There are also modules

1. Once the images have been joined you'll see this dialog (see fig 17). You can see that, position-wise, the images have been successfully joined, but not seamlessly. Notice how the sky has some soft but obvious join marks.
2. Tick the Advanced Blending box and there will be a better attempt made. This makes an improvement but doesn't make the joins invisible (see fig 18).
3. The errors are even more obvious when the image is saved. There are overlap artifacts and, visible at the top and bottom edges, alignment problems (see fig 19). These illustrate the virtue of using a tripod.

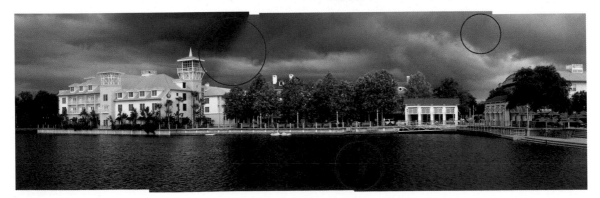

Fig 19

Fig 20

4. With a little sleight of hand via the Clone tool, we can correct all of these errors, cropping the image to remove the top and bottom edges (see fig 20).

5. To finalize the image (see fig 21) we have increased the color saturation using the unsharp color technique discussed earlier on pages 248–249.

Photomerge is simpler than some programs in that it analyzes the picture and makes appropriate assumptions without the user needing to intervene. In some applications, you can manually adjust the relative positions of different images (for those rare occasions when the auto-algorithms have failed to link the images successfully). You may also need to specify the lens used to take the images. This will ensure that the angle of views and any corrections made echo those of the original lens type.

Where panoramas go wrong

Panorama creation is pretty straightforward, but things can go wrong. Here are a few examples, along with the remedial steps you need to take to correct them.

- Images don't stitch together, or don't stitch together well. There is not enough overlap between adjacent images or there are confusing details in the images. Manually correct (or retake the images if possible).
- Join artifacts are visible in areas of flat color. The brightness levels between adjacent images are too high for the program to correct. Use the Clone tool for minor corrections or to replace areas of flat color (such as the sky).
- Badly distorted images. You've specified the wrong lens type, and the program is trying to compensate. Rerun the panorama generation using an alternate setting.
- Very stretched panorama. The program is trying to produce a 360-degree panorama. Uncheck the 360-degree box.

THREE-DIMENSIONAL PHOTOGRAPHY

Three-dimensional (3-D) photography has much in common with panoramic photography. It, too, needs specialized equipment to take photographs. But, again like panoramic photography, we can use

Fig 21

Fig 22—Kits of cameras and viewers make it possible to both take and view 3-D images using conventional media. These examples are by the prolific exponents of 3-D photography, Loreo.

simple, conventional equipment and produce the unique imagery by using digital techniques.

To get a 3-D effect—to re-create the depth of the original scene—we need to view the images so that the image corresponding to the view from the left eye is seen only by the left eye and the right view by the right eye. Traditionally, this was achieved by mounting the two images side-by-side and placing them in a viewer that screened the view to opposing eyes. This device is known as a stereo viewer and was popular in the nineteenth century, and it uses a similar optical geometry to the Viewmaster viewers that are still available today (see fig 22).

Alternate systems have been devised that do away with some or all of the cumbersome viewing apparatuses. Freeviewing is a technique that is designed to view a pair of side-by-side, 3-D images using no viewing equipment whatsoever. It's a skill that needs to be learned; it involves looking at the two images and then letting your eyes overlap the images while keeping them in focus. The skill comes in keeping the focus: when the images cross over (as when we go cross-eyed) our eyes interpret this as an attempt to focus on a close object (see fig 23).

A variation on this technique is to have the images reversed and use the similar technique of parallel viewing. Rather than needing to go cross-

eyed to see the combined image, you need to focus on a point beyond the images and then let your eyes regain focus on the near images. It is harder to achieve but is generally more restful on the eyes and gives a better effect.

Anaglyph images separate the images for each eye by using complementary colors (usually red and blue or red and cyan) and tinting each image appropriately. By wearing glasses with the corresponding tints, each eye will see only the image with that tint, the other being darkened. In fact, you will see some ghosting because the color tint is never precise and so some of the complementary image will be visible to each eye.

Shutter Glass images are rather like anaglyphs, but the separation is not achieved by color—instead images are alternated on the screen. Using a high screen-refresh ratio on the computer monitor, each image is displayed for around 1/25 second. With special LCD shutter glasses, each eye can see only the appropriate image before the LCD turns black to blank out the alternating image. This tends to give great imagery in full color. The drawbacks are that it only works generally with CRT monitors—LCD displays tend to have an image lag that means it is not possible to swap images fast enough for the effect to work. Costs, too, are also high.

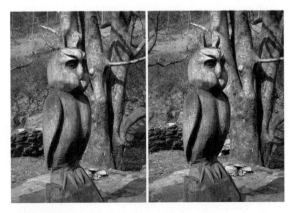

Fig 23—With practice, you can train your eyes to superimpose these two images to create a three-dimensional view.

RECORDING THREE-DIMENSIONAL IMAGES

The ideal way to record two identical images to make up our 3-D pair is to use a dedicated 3-D camera. Though there are some models available today, they tend to be high-priced, specialized products. There are also older cameras that appear in the classifieds of photographic magazines and Web sites and can often be found on eBay. More recent models, such as those from Nimslo, Nishika, and ImageTech, were designed for use in lenticular systems (those using a special fine-lens-like overlay to the print to help create an image with apparent depth), but can still be used by taking the outermost of the four or three images recorded for each shot.

There are no off-the-shelf 3-D digital cameras. Some pioneers have crafted their own by putting together two identical cameras, but these can be problematic in use and, obviously, represent a rather expensive solution. A beam splitter, which sits over the lens and splits the image into two separate images corresponding to left and right views, will work with full-frame digital SLRs, but this device is not currently suitable for any other camera types (see fig 24).

So, for those of us who can't justify the cost of buying specialized equipment, we need to find an alternate solution. This involves using a single camera and taking two shots. These shots will clearly be separated in time, so they are not suitable for moving objects.

The simplest approach is to take one shot of a subject, making sure that your weight and center of gravity are over your left leg. Then, without moving the viewpoint of the camera, shift your weight toward the right leg and take the second shot. Use a slightly wider-angle lens (or a wider setting on a zoom lens) than would be ideal for the shot. This provides some leeway for trimming the images to account for the inevitable lack of alignment.

For those bitten by the bug, there is the Mission 3D kit, which precisely positions the camera for the left and right eye. The bonus of this kit is that it also compensates for macro and long-distance shots.

Creating a three-dimensional image (figs 25–27)

Once we have our two images, we need to ensure that they are suitably matched to produce a stereo pair. This applies even if you use a kit such as that from Mission 3D.

1. Load the left-eye image into your image editor and enlarge the canvas slightly (by around 20 percent).
2. Open the second, right-eye image. Copy and paste it into the left-eye image, where it will appear as a new layer.
3. Reduce the opacity of the layer so that you can see the background through it.
4. Use the Move tool to overlay the central part of the right-eye image over the corresponding part of the left, and then crop the image.
5. Use Canvas Size to double the width of the image and then drag the right-eye image layer over to the right to create the stereo pair.

Fig 24—Beam splitters currently work only with full-frame digital and conventional SLRs.

Viewing digital images without a viewer

If you don't have a stereo viewer or want to use anaglyph techniques, here's how to view images unaided. It takes some practice, but perseverance will pay off.

1. Display the combined image on screen so that each half is around 5 x 7 inches (12 x 18cm).
2. Look at these from the normal viewing distance. This is around 20 inches (50cm).

Fig 25—Match the central part of the image (or the principle subject) in the two images prior to cropping.

Fig 26—Your stereo pair is now ready for viewing either in a viewer or using the technique detailed in the box (see below).

Fig 27—Anaglyphic images—designed to be viewed with appropriately colored glasses—need to be tinted and then overlaid. This tint should correspond to the color of the glasses and can be applied using the Photo Filter feature. When the images are overlaid, the opacity of the overlaid image needs to be reduced to 50%.

3. Hold a finger over the join of the two images and bring it toward your eye, keeping it in sharp focus.

4. Lower your finger. You will find the two halves of the image superimposed (or nearly so), although very much out of focus.

5. Keep staring at the image, but avoid your eyes correcting the displacement. Slowly, you will see the images gain focus. You may need to repeat the process several times to build up your ability.

6. Eventually you'll be able to keep both images superimposed and focused. Then you'll see a single, three-dimensional image.

Achieving this is something of a skill—so perseverance is very much a key word.

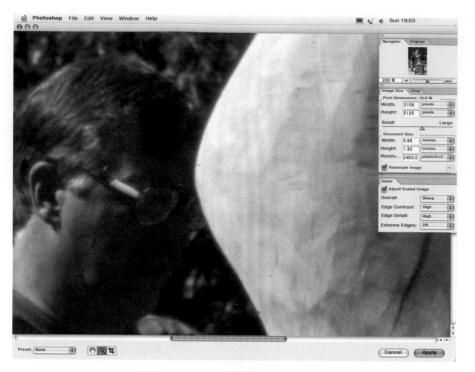

Fig 28

Fig 29—The Detail dialog box.

CREATING LARGE IMAGES AND CHANGING IMAGE SCALE

You may know from your days of working with conventional images that there is a finite amount you can enlarge an image before the quality—depending on the size of the original negative or transparency—suffers. Enlarge even a good-quality 35mm original to, say, 20 x 16 inches (50 x 40cm), and the grain structure and "softness" in the camera lens compromises results. Any further enlargement will merely enlarge and exacerbate these optical limitations.

Digital images, too, suffer from this finite enlargement limit. Enlarge a digital image beyond its limits, and you make the pixel nature of the medium obvious. There are times when this will make no difference—if you are viewing the resulting print from a distance, for example, or the pixel structure is being used for deliberate creative effect—but as a rule, there's an upper limit to the size of enlargements.

Image-manipulation software allows you to resample an image—that is, create a new version of the image at a higher resolution—with the "new" pixels produced by taking an average value from the fewer original pixels. Rarely is this successful: you simply can't add detail to an image where there was no such detail in the first place. Resampled images—or those resampled to a larger size—just don't work.

But the designers of digital image-manipulation software are rarely ones to concede defeat and have sought to overcome this constraint. One of the fruits of their labors has been a product called pxl SmartScale, from Extensis. This exists as a plug-in to Photoshop that lets you increase the size (in resolution terms) of an image by up to 1,600 percent without the usual problems and artifacts normally associated with resampling.

When an image is enlarged by resampling, the higher resolution is achieved by, as we've already mentioned, averaging the color and brightness values for each new pixel from those of the underlying, larger ones. This is more accurate than you might imagine, but it does tend to give a soft, unfocused result.

Dedicated applications such as pxl SmartScale give more convincing results by analyzing the image while resizing. It identifies features in the image, such as edges, and also analyzes the image for sharpness. Then, as the image is resized, this

sharpness, the edge detail, and contrast profiles can all be preserved. A sharp edge remains a sharp edge, rather than becoming a more gradual transition, as would be the case in a resampled image.

pxl SmartScale uses a Photoshop-like interface to help you enlarge your images. It benefits from having very intuitive controls that let you enlarge an image in terms of pixel dimensions, document size, or even by using a smaller-larger slider (see fig 28).

These controls enable your image to be resized, but to get ultimate quality we need to look at the Detail palette (see fig 29). It is here we can refine the image and enhance the details. In particular, we can improve:

- Overall sharpness: This is how much our "new" image is sharpened or blurred over the original. Sharpness here is perceived sharpness. The more the better, generally, but too much can sometimes cause image artifacts (anomalous noise) to appear.
- Edge contrast: Use this to enhance the contrast on all edges in the image. More contrast gives the perception of a sharper edge.
- Edge detail: Allows control over the representation of detailing in the edge.
- Extreme edges: We'd normally eschew this for photographs. It makes edges very sharp for graphics and computer-generated images. This is too abrupt for natural subjects.

With just a little practice and understanding of these controls, it really does become possible to produce very sharp, high-resolution images (see figs 30 & 31).

Tips
- Don't consider applications such as pxl SmartScale as an alternative to sourcing large, high-resolution images. It should be considered something of an emergency tool for those occasions when extra resolution is demanded.
- The more you enlarge an image the less successful even pxl SmartScale will be at rendering. Extensis suggest 1,600 percent as the maximum enlargement amount; you may find that even this is too much but, on occasions, greater enlargement will be possible.

ORIGINAL

Fig 30—Enlarge a small original by even modest amounts and the results are, at best, disappointing, as this close-up of an image enlarged by 400% shows.

ENLARGED 400%

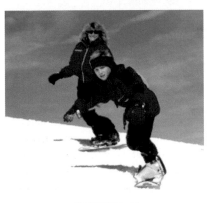

ENLARGED 600%

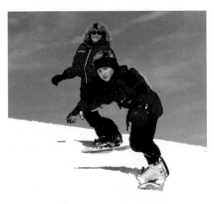

ENLARGED 600% USING PXL SMARTSCALE

Fig 31—Using pxl SmartScale, the results are much more acceptable, with edge detail preserved and perceived sharpness increased. This was a 6X (600% increase).

Fig 32—For this discolored print, we were able to use the Levels command to restore balance. We were lucky: the white snow provided our white point and the dark shadows in the hut, the black point.

IMAGE RESTORATION

The fact that photography has been around so long means that there are an awful lot of pictures out there. Care for them well, and they'll last for years. Be negligent, however—even unwittingly—and they can deteriorate quite quickly.

It was on the premise of restoring such pictures that image-editing applications made their name in the early days of digital. The draw of being able to bring back to life old, cherished images was significant and for many marked their first steps in image manipulation.

Before embarking on any restoration, it's important to analyze the contributory factors in the original's deterioration. It's also important, if you are undertaking such restoration on behalf of a friend or colleague, to provide reassurance. Though we talk about restoring an old image, we should say that we'll be working on a copy of that old image. Though the originals may not be of any intrinsic value, people would still be loath to part with them if they thought any actions might further compromise them.

Let's begin by looking at the causes of deterioration and outline how we can deal with correcting them. We will then look at two restoration projects. The first involves a vintage image: a monochrome picture we might have in our family album dating back to the early decades of the twentieth century. Then we'll look at a more recent color image. The advent of color emulsions brought new opportunities for photographers but also a whole raft of new problems regarding print longevity.

Discoloration (fig 32)

This can be due to a number of causes. If it is a general effect, it can result from the action of time on the original chemistry of the image. The sepia toning so beloved of those seeking to emulate heirloom prints is a case in point. Old prints were never meant to turn this color (no matter how attractive you do or don't consider it to be), but the action of airborne chemicals, deterioration of chemicals in the print itself, and many other reasons can produce very similar results over time.

On more recent images, there can be similar effects due to imprecise printing. Those of us who have worked in the conventional darkroom have all been guilty at some time or other of taking shortcuts. Cutting the time a print is in the fixer (after all, it didn't seem to need the full ten minutes, did it?), leaving the last print of a run in the solution overnight, or cutting back on the washing time. All compromise print quality—not today necessarily, but certainly in the years to come.

Localized discoloration can have atmospheric causes, but is more likely to be due to contact with other materials. Photographic emulsion, even years after being used to produce a print, remains sensitive and can be adversely affected by a range of common household substances. Over time, the innocuous adhesives used to attach a print to an album page can cause the print to discolor—as can sticky tape. Even contact with some plastics and cardboard can cause yellowing.

Discoloring can be cured as part of an overall

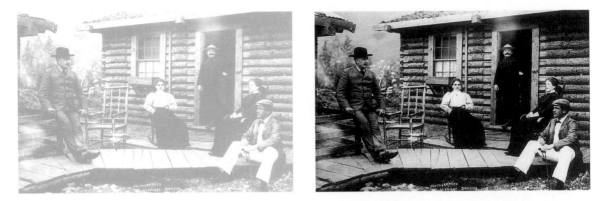

Fig 33—With no physical damage, just significant fading, it was easy to use the Levels command to restore balance here. We then boosted the contrast slightly and also applied the Unsharp Mask filter to correct some softness in the original image.

enhancement, neutralizing any color casts using the Levels commands. In black-and-white images, we can also restore the contrast range at the same time.

Fading (figs 33 & 34)

The sensitivity of the emulsion is such that, place a print on a board mount or even in a cardboard box and, over time, it can fade. Chemicals in the cardboard slowly leach out and affect the emulsion. This explains why "chemically inert" or "archival" mounting boards for display prints cost so much compared with similar, nonarchival boards.

Of course, keeping the prints in the open can cause equal or greater damage, as the prints fade due to the effect of atmospheric gases and—most damaging of all—sunlight. The action of sunlight affects different dyes in the print to differing degrees, lightening some and causing a color shift in others. This requires the greatest degree of analysis before undertaking any restoration.

Fading, like discoloration, can be corrected by restoring the contrast range (the Levels command can be of use here again), but color shifts need more radical treatment, adjusting each of the primary color components. There is no way that we can be truly objective about the results that we get in this way, for we only have our own judgment of what should be considered, for example, an accurate blue sky or the correct color of foliage.

Fig 34—Not only was this color print faded (as a result of remarkably little exposure to sunlight), but the magenta and cyan components of the image had become visually stronger. Correction not only involved restoring the contrast range, but also using the color-balance commands to correct the changes to the colors. Most of this needed to be done by guesstimating, as there were no objective data around the colors in the image. Here, skin tone was the determining factor.

Crumple zone (fig 36)

Physical damage is inevitable when prints are handled extensively and stored in less-than-perfect circumstances. Over the years, the folds—in themselves not necessarily major damage—can dry and crack, the image can tear, and surface abrasion can remove areas of emulsion. Tears and splits, along with abrasion marks, need cloning to replace the pixels defining the damaged areas. Missing pieces, torn off or cracked away, will need more inventive solutions, involving matching the damaged areas with other parts of the image or even re-creating new backgrounds. Where the damage affects a major element of the image, we may need to be artistic as well as creative, repainting or patching these areas.

Fig 35—In clear areas, such as the sky here, mold damage is at its most obvious. The simple way to correct this would be to use the light gray color of the sky and paint over it.

Fig 36—Tears, missing pieces, abrasion, and scratches have rendered this image in a poor state. But rebuilding the missing pieces and hiding the smaller marks makes the image appear as good as new. Even though the authenticity of the new elements may be questionable, the overall result is aesthetically more than satisfactory.

Animal damage (fig 35)

We may know enough to keep images in optimum conditions today, but that probably can't be said of the whole history of your prints. Seasonal and daily changes in temperature and humidity, combined with (from the point of view of insects) the delicious nature of gelatine and other photographic media can also take their toll. In addition, the ingress of mold and other growths lead to localized damage.

Some damaged can be carefully removed prior to scanning the original. This is something that should be undertaken only if you are completely certain that you will not make the damage worse. Dead surface mold can often be gently brushed away with a paintbrush as can any long-departed guests. Since this damage is localized, it's often sufficient to use the Clone tools to overpaint the areas of damage.

Fig 37

Fig 38

Fig 39

Fig 40

Fig 41

Fig 42

Restoration 1: Monochrome image

This print (see above) will be typical of many passed down from generation to generation. It has spent some of its time in a frame, some time mounted in an album, and some time loose in a box. Other events in its history have also taken their toll, introducing staining.

Our repairs will involve restoring contrast and removing the yellow overall coloring. We will then clone away the marks and scratches (some of which, no doubt, date back to the original printing of the image). We will then repair the missing corner. Finally, we'll review the image and establish whether there are any ways in which we could enhance its final presentation.

1. The original image, taken around the turn of the twentieth century, would have once had solid blacks and a full contrast range (see fig 37).
2. Use the Levels command to restore the contrast range. Click on the White Point eyedropper and then select the missing corner: this is the lightest part of the image. Choose the Black Point eyedropper and select the darkest part of the image. Make sure this is a "real" black; otherwise, if it is merely a dark gray you will lose shadow details (see fig 38).
3. After making the corrections to the contrast, we can see that the image is discolored, particularly in the corners where sticky tape or album mounting corners have produced noticeable yellow staining. We can remove this residual color by selecting the Desaturation command. The areas of mold and staining in the top right-hand corner are typical of the effect you get with old pictures that have been handled with greasy fingers. Over time, it produces localized staining and makes an excellent medium for mold growth (see fig 39).
4. Those corner marks are still present. To remove them we can either select them using the Poygonal Lasso and reduce the brightness, clone over them using adjacent donor areas, or try a combination of both approaches. Use whichever technique works best in the circumstances (see fig 40).
5. After cloning, we have an apparently continuous landscape. Now for that missing corner. Again, cloning is the best policy here, as it adds texture from the print. You will have to ensure that it is not too obvious where the pixels were cloned from (see fig 41).
6. To finish the print, we've given it a black key line to define the edges. Applying a modest amount of Unsharp Masking (Amount 50, Radius 1, Threshold 5) has increased the perceived sharpness of the image and given it an impressive degree of clarity (see fig 42).

Fig 43

Fig 44

Fig 45

Restoration 2: Color image

In the case of this color image, the principal defects are related to color shifting due to fading and chemical discoloration. We need to restore contrast again, but since this will tend to exacerbate any color shifts, we must then correct these shifts (see fig 43).

1. Use the Levels dialog to restore the tonal range. When you do this you will probably find that color casts are somewhat more obvious than they were previously. Note that it is sometimes possible to correct a faded color print purely using the Levels dialog, selecting the Black, White, and Neutral points (using the appropriate eyedroppers), but because different colors in the image fade or discolor to different degrees, the end result can still feature an unfortunate tint (see fig 44).

2. Use the Color Balance dialog to correct the color balance. The dialog allows you to change the balance for the image highlights, midtones, and shadows. Begin by adjusting the shadow areas modestly (here, setting the Magenta–Green slider to +20). Then adjust the highlights (Magenta–Green to +40 here). Color correction is an iterative process: you will need to adjust continually until you get a satisfactory result (see fig 45).

Tips

- You can use the Variations command for a more objective comparison. This will compare the image before and after changes so you can follow the progress of the color corrections (see fig 46).
- Skin tones are often the most difficult to get right. In Photoshop versions from CS (8.0), you can use the Match Color command to match skin tones in the image you are correcting using tones from a reference image (see fig 47).

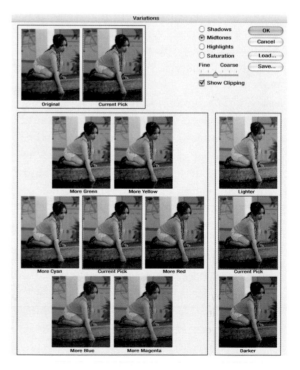

Fig 46

Fig 47

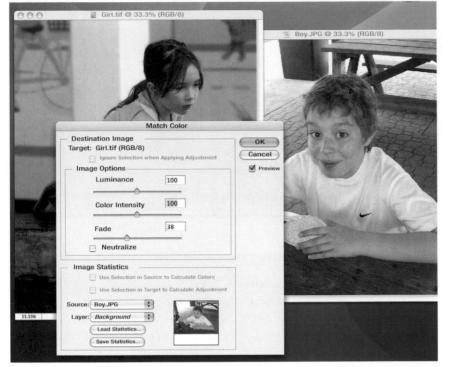

Rescue program (fig 48)

Although you can restore most images, the time the process takes can preclude widespread reparations. So what's the answer if you have many prints to attend to? First, scan all the images to the highest quality. At least with a scan of the image, you can be sure that you have a copy before any further deterioration can take place (remember that image degradation is an ongoing process). You'll now have digital files of your cherished images to work on whenever you wish.

Though it does not remedy all problems (especially those of a localized nature), using the Levels command and even Auto Color can perk up images that have undergone fading or discoloring. Badly torn images can be fixed by creative cropping. By cropping more tightly in the central part of the image, you can remove those areas— edges and corners particularly—that are most prone to damage and most likely to be dog-eared.

Fig 48—The badly damaged print we looked at earlier (see page 336) has been given a new lease on life here by merely cropping in more tightly and applying Auto Levels. Only the scratches needed additional attention. Not ideal and not thorough, but quite sufficient to make the print presentable once more.

Printing your restored images

Of course, once you've worked so diligently to restore an image to better than its former glory, you'll want to ensure that your efforts will last. It's unfortunate, but the prints you produce are likely to suffer many a similar fate to the original—

Fig 49—The Xacti is a hybrid camera that offers digital video and digital imaging in a single package. Still imagery of better than 3 megapixels is possible, and good-quality movies are possible, but the duality of functions means that neither mode offers the ultimate in quality.

ORIGINAL

ink-jet prints have yet to prove their longevity. To make sure that your efforts can be enjoyed to their full, ensure that:

- You keep at least two copies of the digital image file. This means that should anything happen to the new prints, you can immediately produce new ones
- You use only the recommended inks and papers for your printer, unless your favorite alternative is of proven quality and longevity
- You store the prints away from chemicals and pollutants that can cause discoloring. Look out for "archival"-quality materials, which (though more expensive) offer guarantees on permanence.

VGA

MOVING IMAGES (figs 49–51)

The nature of digital imaging is such that the traditional and rather strict line that marked still cameras and movie cameras as separate (and disparate) product lines has become so blurred as to be, in the eyes of many, irrelevant. Many digital still cameras are adept at recording digital movie sequences, and still images can be recorded on

QVGA

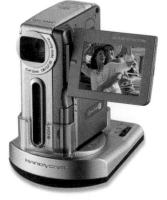

Fig 50—This digital video camera from Sony is capable of multimegapixel still images as well as top-quality movie recordings. But the functionality of the camera as a still camera is restricted compared with even a reasonably modest digital still camera.

Fig 51—Movie modes from a digital still camera produce movies in either VGA or QVGA modes. For those of us used to images of several million pixels, this is very low resolution, as the examples here show.

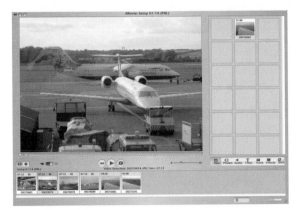

Fig 52—Still photos taken out of an aircraft window can often be disappointing, whereas movies can be more inspiring. So combining still images of the ground with movie footage of the flight can produce an intriguing presentation. Here, still images and movie clips are used almost interchangeably, with still images regarded as "still" movie frames that are nominally displayed for seven seconds each.

digital video cameras (or can be plucked from digital video sequences).

Most consumer digital cameras feature a movie mode, even many of the models we'd often describe as "budget." Only on those cameras designed for professional use do we see this feature missing. This is undoubtably on the pretext that professional or "serious" users would want the levels of quality only offered by digital video cameras.

Does this mean that we can dispense with a multiplicity of cameras when we head off on that day out or vacation? Probably not. We say "probably," because it depends on your photographic needs. If you want to take great digital photographs and just the odd video clip to record a specific event, then a digital still camera with a movie mode will be fine. If you want the best in digital still images and digital video (the latter perhaps to edit and produce a masterpiece in an application such as iMovie), then you'll need to stick with two specialized cameras.

The movie modes offered by digital still cameras tend to be either VGA (640 x 480 pixels) or one quarter of this, 320 x 240 pixels, or QVGA. QVGA is suitable only for modest applications such as Internet and Web pages where the low resolution is excusable on account of the fast downloading.

VGA, on the other hand, is, technically speaking,

a similar resolution to that of a conventional television picture. A good movie mode will deliver high-quality movies, though the frame rate may compromise ultimate quality. The frame rate describes the number of consecutive images recorded per second. Many cameras offer only ten or fifteen, which can lead to jerky motion; thirty frames per second, offered by an increasing number of cameras, gives smooth motion.

Editing Movie Clips (fig 52)

Once you've recorded your movie clips, you'll want to do something meaningful with them. They come into their own when you produce slide shows. The term "slide show" is something of a misnomer in this context, because what we actually mean is a sequence of visuals. Those visuals can be still images or movies.

Applications such as iMovie and offerings from Ulead (to name but two) allow still and movie images to be combined along with commentary or music. Add in features such as the Ken Burns effect (in iMovie), and you can pan and zoom your still images, too, to give subtle pseudomovie effects.

Movie Mode Tips

If you get bitten by the movie-mode bug, here are a few dos and don'ts for using the mode:

- Use the mode as you would with a conventional movie camera, holding the camera as still as possible and recording each shot for around seven seconds.
- Don't shoot in portrait mode! Sounds obvious, but you'd be surprised how easy it is to do.
- Carry enough memory. Movie clips can consume memory cards at an alarming rate— make sure you have sufficient capacity.
- Use movie editing applications to edit your movies as you would conventional images, cropping and deleting unsatisfactory or unsuitable material to leave only the best in your portfolio.

ARE YOU READY TO EXPLORE THE DIGITAL WORLD FURTHER? OVER THE NEXT FEW PAGES, YOU'LL FIND A SELECTION OF SOME OF THE BEST RESOURCES AVAILABLE TO HELP YOU ALONG YOUR JOURNEY OF DISCOVERY. WE'LL SURVEY THE SOFTWARE THAT CAN HELP YOU EDIT MOVIES AND PHOTOS AND EVEN CREATE ARTWORK FOR YOUR MOBILE PHONES. WE'LL ALSO TAKE A LOOK AT SOME OF THE BEST WEB SITES TO KEEP YOU ABREAST OF ALL THAT'S NEW IN THE DIGITAL WORLD.

SOFTWARE

Throughout this book, specific applications have largely been used, for the sake of clarity and consistency. However, there's a whole range of similar—or more advanced—alternatives to explore. Here's a quick survey of the marketplace. Version numbers are not mentioned —they tend to go out of date very quickly—but the relative capabilities of each tend to remain similar.

DIGITAL PHOTOGRAPHY

Adobe Photoshop Elements (PC and Mac)

The trimmed-down version of Adobe's image editing behemoth loses only top-end features but makes image manipulation simple and intuitive. Unless your ambitions are of the highest order, this will be more than sufficient for all your image-editing needs. www.adobe.com

Adobe Photoshop (PC and Mac)

This is the leading light in professional image editing. If Photoshop can't do it, it's probably not worth doing—and there's enough here to keep even the most avid enthusiast fully occupied. The drawback for most of us is the cost, decisively placing it in the realm of the professional and the serious enthusiast.

Ulead PhotoImpact (PC)

PhotoImpact gives the inexperienced—or those not wanting to investigate all that the Photoshop variants have to offer—the chance to create great images fast. Basic and Advanced modes let you see only the commands and features essential to the work at hand. www.ulead.com

Adobe Photoshop Album (PC) and Apple iPhoto (Mac)

Both these applications provide calendar-based filing of your digital images and will automatically download photos from your camera. Better still, both will synchronize with the iPod photo, letting you download and enjoy your portfolios. www.adobe.com and www.apple.com

Jasc Paint Shop Pro (PC)

This is a powerful Photoshop wannabe application that delivers powerful image-editing techniques fast. Alternatives, such as PhotoImpact, may be more appropriate for the less experienced, but Paint Shop Pro allows greater control and more creativity—if you know what you are doing! www.jasc.com

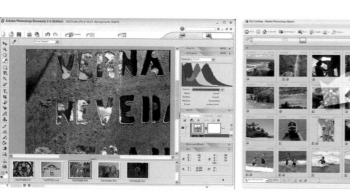

Photoshop Elements

Photoshop Album

DIGITAL VIDEO

Adobe Premiere Elements (PC)

Premiere is Adobe's powerhouse video-editing application, but it doesn't lend itself to simple editing of those ad hoc recordings that you don't necessarily want to compile as mini-blockbusters. Like Photoshop Elements, the key professional tools are gone, but you have all the basic tools—and more—for quickly compiling movies.
www.adobe.com

Adobe Premiere (PC)

Adobe's omnipresence in the media-editing market continues with Premiere. It's the choice of many professional video editors, but that should not preclude it from the keener enthusiast. It's pricey, though, so you'll need to ensure that you need all its features and won't be satisfied by anything less.

Pinnacle Studio Software (PC)

This is an easy-to-use package that boasts an attractive price, too. It includes a major collection of special effects, titles, and music for use in your productions and also has an instant-touch image-enhancement button for giving slightly below-par footage a boost.
www.pinnaclesys.com

Canopus Let's EDIT (PC)

A camcorder-to-DVD application that lets you edit your movies and burn direct to DVD. It scores highly for its speed in applying effects and not needing

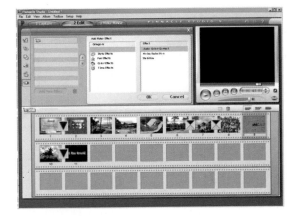

Pinnacle Studio Software

time to render (apply) even sophisticated effects.
www.canopus.com

Apple iMovie, Final Cut Express, Final Cut Pro (Mac)

These are Apple's complementary products to the Adobe offerings. You'll get iMovie free with any new Mac, but you'll need Version 05 if you want—or need—to edit high-definition video. Final Cut Express and its Pro sibling equate with Premiere Elements and Premiere, respectively.
www.apple.com

HOME DVD CREATION

Roxio Easy CD and DVD Creator (PC)

This is a well-established application that can take data of almost any sort and create CDs and DVDs. It is also useful for creating Video CDs and other less common disk formats.
www.roxio.com

Roxio Toast Titanium (Mac)

The Mac version of Easy CD and DVD Creator, this application can create disks in any native format.

Dr DivX (PC)

A simple application for converting any video source (DVD, DV movies, or

Premiere Elements *Premiere Pro*

digitized analog video) into a DivX file for playing on any DivX-compatible DVD player or computer. www.divx.com

DivX Pro (Including DivX Player) (PC/Mac)

This is an advanced DivX encoder that can achieve compressions 30% better than the basic DivX codec. www.divx.com

DivX with DivX Player (PC/Mac)

The basic codec for encoding your video. Not very versatile but has the bonus of being freeware.

DIGITAL COMMUNICATIONS

Ulead Photo Express 5 Special Edition (PC)

Edit, manipulate, and retouch your mobile-phone photos and then use them as the basis of eCards to send to friends or family. Go on to create your own image messages and even design your own personal stand-by screens. www.ulead.com

Ulead Video Toolbox 2 Home Edition for Mobile Phones (PC)

With this, you can take your mobile phone's video capabilities to a new level. This full-fledged video editor is designed specifically for mobile video editing. Trim and combine video clips, remove or change audio tracks, and more.

VideoStudio M-Style

WEB SITES

Web sites provide a useful set of resources including up-to-the-minute news. Here are some of the sites we've found particularly useful. Please note, however, that Web sites do come and go, change their address, and can even change ownership. Google and other search engines can help you find precise and up-to-date information on digital resources.

DIGITAL PHOTOGRAPHY

www.dpreview.com: the number-one site for information and impartial advice on all digital cameras and associated equipment.

www.stevesdigicams.com: another great site for digital news and information.

www.ephotozine.com: a UK-based megasite for all things photographic, conventional as well as digital.

www.shortcourses.com: a gateway site for accessing well-regarded courses on all aspects of photography.

www.dcviews.com: more tutorials and news at this comprehensive site.

www.photoxels.com: another tutorial site with useful and effective One-Pager tutorials.

MP3 PLAYERS AND DIGITAL MUSIC

www.mp3.com: a key resource for digital music, and news and views. Also features reviews and discussions on digital music players.

www.artistdirect.com: MP3, music videos, and CDs from artists you won't always find in the more popular sites.

www.ipodlounge.com: all you need to know about the iPod.

www.everythingipod.com: billed as the superstore for the iPod. Users of other digital music players will also find it useful for those hard-to-find or must-have accessories.

www.mpeg.org: all about MP3, video software players, and anything vaguely connected to MPEG.

DIGITAL VIDEO EDITING

www.dvmoviemaking.com: Adobe Premiere–based tutorials for moviemaking. No previous experience necessary.

www.computerarts.co.uk: tutorials and info on digital video and other digital arts.

DIGITAL TELEVISION

www.digitaltelevision.com: online version of the foremost magazine for the television business: broadcasting, technology, and programming.

www.dtg.org.uk: Web site of the UK's Digital Television Group. Great resource for news and industry links.

www.digitaltelevision.gov.uk: info site for UK digital television featuring a useful jargon buster.

www.fcc.gov/dtv/: the US version of the above site with a portal for FCC info.

www.digitalspy.co.uk: an entertainment and technology Web site that is mainly UK focused but also features a strong US presence.

MOBILE CoMMUNICATIONS

www.3g.co.uk: UK-originated Web site on the world 3g telephony business.

www.smartphonethoughts.com: "Daily News, Views, Rants and Raves." Great for keeping up with the smartphone world.

www.pdastreet.com: promotes itself as the largest PDA information center.

www.pdabuyersguide.com: another major site that offers information and advice on PDAs, smartphones, and even notebook PCs.

www.pdalive.com: a slightly more eclectic collection of news and info on the PDA world.

SUPPLIERS

Adobe Software	www.adobe.com
Apple Computers	www.apple.com
Bang & Olufsen	www.bang-olufsen.com
Belkin	www.belkin.com
Beyond (Home Hub)	www.beyondconnectedhome.com
Blackberry	www.blackberry.com
Bluetooth	www.bluetooth.com,
	www.bluetooth.org
Blu-ray	www.blu-ray.com
Bose	www.bose.com
Canon Cameras & Printers	www.canon.com
Creative	www.creative.com
DirecTV	www.directv.com
DivX	www.divx.com
Dolby Laboratories	www.dolby.com
Freecom	www.freecom.com
Fujifilm, Fuji	www.fujifilm.com
	www.fujifilm.co.uk
Griffin	www.griffintechnology.com
Home Automation	www.homeauto.com
HP	www.hp.com
Jamo	www.jamo.com
Jasc Software	www.jasc.com
Konica Minolta	www.konicaminolta.com
Kodak	www.kodak.com
LG	www.lge.com
Macromedia Software	www.macromedia.com
Microsoft	www.microsoft.com
Nikon Cameras	www.nikon.com
	www.nikon.co.uk
Nokia	www.nokia.com
Olympus Cameras	www.olympus.com
Panasonic	www.panasonic.com
Pentax	www.pentax.com
Roku (Soundbridge)	www.roku.com
	www.soundbridge.co.uk
Roxio Software	www.roxio.com
Sandisk	www.sandisk.com
Sausalito Audio Works	www.sawonline.com
Sony	www.sony.com
Sony Ericsson	www.sonyericsson.com
TiVo	www.tivo.com
Ulead Software	www.ulead.com
	www.ulead.co.uk
XM Satellite Radio	www.xmradio.com

DIGITAL PHOTOGRAPHY

AVI: Audio Video Interleave. A file format like MP3 but one that (unlike most other file formats) supports different codecs. An AVI file can, for example, contain DivX video, WMA audio, or even pulse code modulation audio.

Backlight: Light illuminating a subject from behind causing underexposure unless compensation is applied.

Backlight Compensation: A setting that increases exposure (by a factor of between two and four times) to prevent underexposure of backlit subjects.

Bayer Pattern: Pattern of red, green, and blue filters on the CCD of a camera sensor designed to allow a CCD (which only responds to light and dark) to "see" in color.

Blu-Ray: Disk-based format for video, audio, and data with a greater capacity than DVD (not compatible with HD-DVD).

Burst Mode: Feature of a camera that allows series of consecutive shots (equivalent to motor drives on conventional cameras).

CCD RAW: Data output from the CCD imaging sensor of a camera, prior to any in-camera processing. Often preferred by professional photographers since it is not tainted or biased by any of that processing.

CCD Sensor: The light-sensitive imaging element found in most digital cameras. Comprises a matrix of individual photosensitive photo sites that correspond to the individual pixel elements of the image.

CMOS Sensor: Alternative to a CCD, often used because of lower power consumption.

Codec: Coder/decoder. Software that enables a medium (audio and/or video) to be compressed and decompressed, often an essential process to place video on a CD or DVD. MPEG-2, MPEG-4, and DivX are examples of codecs.

Color Balance: The relative levels of red, green, and blue in an image. In a balanced image, these mimic the colors of the original scene.

CompactFlash: Common form of memory card used in digital cameras.

Compression: 1. The process of compressing an image file so that it takes up less space on the memory card. Compression can be lossy (when information is lost in the process) or lossless. 2. In digital video, the process of compressing data in each frame to reduce the amount of data required to be written to disk or tape. Compression can be interframe or infraframe. Interframe compression compresses by removing information that is repeated on consecutive frames, whereas infraframe compresses each frame individually. Infraframe compression is typically used with digital video and is the best method for nonlinear editing.

Data Rate: In video and DVD applications, the amount of data written or read per second. Bit rates can be fixed (where a constant amount of data is written every second, irrespective of the content) or variable (where more data is written for "busy" action scenes in a movie).

Depth of Field: the distance between nearest and farthest points in an image in sharp focus.

Digital Zoom: Technique used in still and movie digital cameras to produce a zoom effect by expanding the central region of an image to full frame. More acceptable when using digital video cameras than still cameras, but image degradation becomes obvious at zoom ratios more than 3X.

Digitize: The conversion of analog source material (such as VHS or 8mm video) to a digital format.

DivX: A codec-based on MPEG-4 video compression. The codec is continually evolving and is usually suffixed by a version number. DivX software is freely available or offered at low cost, compared with commercially priced MPEG-4 software. An open-source freeware version of the codec is known as XviD. DivX was a failed disk-rental system, summarized in the main text.

DTT: Digital Terrestrial Television. Digital television transmitted over conventional TV transmission systems. First used by the now-defunct ONdigital network in the UK in 1998.

DTV: Digital Television. Any television transmission system (terrestrial, satellite, or cable) that uses digital encoding.

DV: Widely used digital-video format offering near-broadcast-quality images and high-quality digital sound. Refinements of the basic format offer enhanced quality and are used for professional and semiprofessional recordings.

DVD: Digital Versatile Disc. The overall format that describes video disks, audio disks, and data disks.

DVD Ripping: The copying (generally without CSS) of DVD video and audio content to the hard disk of a computer. Where the content is changed (say from MPEG-2 to MPEG-4 or DivX) during the copying, the process is known as DVD conversion.

Electronic Image Stabilization (EIS): Electronic mechanism that compensates for camera shake when hand-holding a camcorder. Works by recording a smaller area of the imaging chip and varying the recording position according to any perceived movements.

Exposure: The amount of light allowed-by the aperture of the camera and shutter speed-to reach the camera's sensor.

FireWire: Standard connection for linking camcorders to a PC. Also known as iLink (by Sony) and IEEE 1394. FireWire 800 (800Mbps data transfer) operates at twice the speed of standard FireWire.

F-stop: A ratio (of a lens' focal length to diameter) used to describe the amount of light that can enter through a lens.

HD-DVD: A successor to DVD designed to support high definition (HDTV) and data recording/playback.

HDMI: High-definition multimedia interface. Industry standard interface connection designed to link audio and video sources such as set-top box (STB), DVD players, and televisions, compatible with high-definition sources.

HDTV: High-definition television. Television system that delivers more lines of resolution than standard definition television. Typically 1080 horizontal lines.

HDV: Enhanced version of DV that uses DV-format tapes to record high-quality MPEG2 video and with support for high-definition recordings.

Interactive Television: Interactive content included on digital television stations. Ranges from alternate program feeds (different camera angles), support information, or enhanced teletext-like text information.

JPEG: Popular file format on consumer digital cameras. A lossy compression format, JPEG allows a large number of images to be stored on a memory card.

Landscape: A horizontal photograph.

Megapixel: Concatenation of a million pixels. Describes resolution of digital cameras, camcorders, and even television screens.

MPEG: Motion Pictures Expert Group. The group tasked with setting standards for video encoding.

MPEG-1: Low-grade codec used for VideoCDs (equivalent to VHS video).

MPEG-2: Codec used for DVD, miniDVD, and SuperVCDs.

MPEG-4: Low-bandwidth, high-quality video used in some digital camcorders and for DivX codecs.

Nonlinear Editing: Video editing process where scenes or clips are (typically) stored digitally on a computer and can be selected or accessed at will, without the need to wind or rewind a videotape.

Panorama/Panoramic Mode: Sequence of shots taken (usually) around the horizon and stitched into a single wide shot.

Pixel: Smallest element of a digital image, corresponding to a single photo site on the CCD or CMOS.

Portrait: Picture mode when the frame is held at 90 degrees from the landscape.

PVR: Personal Video Recorder. Video recorder that uses predictive technology to automatically record favorite programs. Often uses a computer, or computer-like hard disk to save recordings.

RCA Connector: Simple coaxial connectors used to connect stereo and video components. Mostly used in North America and Asia.

Red-eye: Effect caused by camera flash reflecting from a subject's retinas giving a bright red appearance.

Resolution: A measure of the detail in an image; the greater the number of pixels, the greater (all other things being equal) the resolution.

SCART: 21-way connector used for audiovisual connection in Europe. A SCART lead contains all the connections necessary for AV, irrespective of whether the devices will actually use them.

SLR: Single Lens Reflex camera. Camera in which the optical system allows the user to view a scene through the same lens as that used to take the photo.

STB: Set-top Box. External box that enables digital television signals to be displayed on a conventional television or one without a respective tuner.

SuperVCD: Super Video CDs. Video CDs originally specified in China as an alternative to DVD. Records MPEG-2 video on CDs but at a lower bit rate (and hence lower quality) than with DVD.

Surround Sound: Any sound system that gives the illusion that sound is emanating from all directions.

TIFF: File format used by many digital cameras. A lossless system, files are not as compact as JPEG but are generally of higher quality.

VideoCD: Precursor to DVD video. VideoCD discs contain lower-quality MPEG-1 video on standard CDs. Widely used in the Far East, even after the arrival of DVD.

White Balance: Feature of still and movie digital cameras that (automatically or manually) changes the color tone of an image to compensate for color casts in the scene or lighting.

Zoom Lens: Lens with a variable focal length that allows a scene to be magnified or reduced in scale.

INDEX

Acknowledgments

The majority of photographs, illustrations, and screenshots used in this book come from my own personal archive. However, I would like to thank the following sources for their kind permission to reproduce certain pictures in this book:

Apple Computer, Beyond, British Sky Broadcasting, Canon, Corel Royalty Free, Digital Vision Royalty Free, DirecTV, El Gato Systems, Extensis, FujiFilm, Hewlett-Packard, HP Compaq, Jamo, KISS, Kodak, Lastolite, Microsoft, Nikon, Nokia, Pace Electronics, Sausalito Audio Works, Scandisk, SES Astra, Sony, and SonyEricsson.

Every effort has been made to acknowledge correctly and contact the source and/or copyright holder of each picture, and Carlton Books Limited apologizes for any unintentional errors or omissions, which will be corrected in future editions of this book.